'PATAPHYSICS

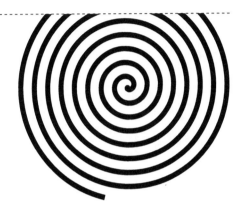

'PATAPHYSICS

A USELESS GUIDE

Andrew Hugill

The MIT Press Cambridge, Massachusetts London, England

MIT Press books may be purchased at special quantity discounts for business or
sales promotional use. For information, please email special_sales@mitpress.mit.edu
or write to Special Sales Department, The MIT Press, 55 Hayward Street, Cambridge,
MA 02142.

This book was set in ITC Stone Serif by The MIT Press. Printed and bound in the
United States of America.

Library of Congress Cataloging-in-Publication Data

Hugill, Andrew.
'Pataphysics: a useless guide / Andrew Hugill.
 p. cm.
Includes bibliographical references and index.
ISBN 978-0-262-01779-4 (hardcover : alk. paper) 1. Pataphysics—History. I. Title.
CB430.H84 2012
153.3—dc23

 2011052634
10 9 8 7 6 5 4 3 2

THIS BOOK IS DEDICATED TO THE MEMORY OF **STANLEY CHAPMAN** (1925–2009), DATARY OF THE FIRST ANNEX OF THE ROGATION AT LONDON-IN-MIDDLESEX, REGENT AND VICE-ROGATORY OF THE COLLÈGE DE 'PATAPHYSIQUE, OULIPIAN AND FOUNDER OF THE OUTRAPO, PRESIDENT OF THE LONDON INSTITUTE OF 'PATAPHYSICS, TRANSLATOR OF VIAN AND QUENEAU, DEAR OLD FRIEND AND LIVER OF A PATAPHYSICAL LIFE THAT EFFORTLESSLY COMBINED A DEEP ERUDITION WITH A PLAYFUL SPIRIT.

CONTENTS

ACKNOWLEDGMENTS

First thanks must go to the late Stanley Chapman who, over three decades or more, encouraged me both to engage with and to write about pataphysics, and with whom I discussed this book several times before his apparent death.

Next, deep thanks to my esteemed editor at the MIT Press, Roger Conover, and his team. Roger's perceptive advice has been important in shaping the book, and his enthusiasm has been essential to its creation. I would like to thank the copy editor, Gillian Beaumont, for her painstaking work, and special thanks go to Thieri Foulc, Proveditor-Editor General of the Collège de 'Pataphysique, whose detailed reading and generous comments have helped to ensure accuracy.

Then, many thanks are due to a group of special friends who have provided critical feedback or assistance during the writing of the book: Jos Atkin, Anar Badalov, Philippe Cathé, Milie von Bariter, Terry Hale, Rebekah Harriman, Jim Hendler, Neil Salley, Yves Simon and, of course, Louise Hugill.

Further thanks are due to the people who, over the years, have shaped my understanding of pataphysics: Gavin Bryars, who introduced me as a young man to the Collège de 'Pataphysique; Alastair Brotchie, who has opened up so many of the key pataphysical texts to the Anglophone world; Chris Allen; Marc Battier; Jean Baudrillard; Remy Bellenger; Marcel Bénabou; Matthijs van Boxsel; Jacques Caumont; Andrea Cohen; Gary Crounse; Marc Décimo; Paul Edwards; Catherine Ferri; Paul Gayot; Sylvain Goudemare; Jennifer Gough-Cooper; Greg Lucas; Harry Mathews; Line McMurray; Ramuntcho Matta; Antony Melville; Ted Nelson; Basarab Nicolescu; Barbara Pascarel; Tanya Peixoto; Dominique Petitfaux; Guillaume Pô; Walter Redfern; Howard Rheingold; Cosima Schmetterling; André Stas; Linda Klieger Stillman; Daniel Teruggi; Mark Thomson; Peter Warden; George W. Welch; John White; Nicholas Zurbrugg; and many others to whom I apologize for the omission.

I would like to thank my academic colleagues at De Montfort University, Leicester, UK, for all their help and support, especially: Professor Philip Martin, Professor Tim O'Sullivan, Professor Hongji Yang, Professor

Leigh Landy, Dr. Simon Atkinson, Dr. John Richards, and Professor Simon Emmerson, whose "just do it" gave me the shove that I needed.

I also acknowledge the kind permissions given by copyright holders to include extended excerpts from the following texts. While every effort has been made to trace copyright holders, I would be grateful to hear from those who may have escaped my notice or who did not respond to my queries.

Collège de 'Pataphysique. *Qu'est-ce que le Collège de 'Pataphysique?* (*What is the College of Pataphysics?*) © Collège de 'Pataphysique, 1970. Translation by Paul Edwards © Atlas Press, 1995. Reproduced with permission.

Collège de 'Pataphysique. *Statutes.* © Collège de 'Pataphysique, 1948. Reproduced with permission. Translation by Roger Shattuck © Evergreen Review.

Collège de 'Pataphysique. *Subsidium 0.* © Collège de 'Pataphysique, 1965. Translation by Andrew Hugill © Atlas Press, 1993. Reproduced with permission.

The excerpt from René Daumal's *'Pataphysics and the Revelation of Laughter* is copyright 1991 by Mark Polizzotti, the translator, and is reprinted by permission of City Lights Books.

Gilles Deleuze. *Comment la pataphysique de Jarry a ouvert la voie à la phénoménologie.* (*How Jarry's Pataphysics Opened the Way to Phenomenology*). © Semiotext(e), 2004. Translated by Michael Taormina. Reproduced with permission.

Gilles Deleuze. *Un précurseur mal connu de Heidegger: Alfred Jarry* (*An Unrecognized Precursor to Heidegger: Alfred Jarry*). © University of Minnesota Press, 1997. Translated by Daniel W. Smith and Michael A. Greco. Reproduced with permission.

Paul Gayot and Bélisaire Monomaque. *Approches historiques d'une praxis marxiste: Rhétorique et action.* (*Historical Approaches to Marxist Praxis: Rhetoric and Action*). © Collège de 'Pataphysique, 1970. Translated by Andrew Hugill. Reproduced with permission.

Alfred Jarry. *Les jours et les nuits* (*Days and Nights*). © Atlas Press, 1989. Translated by Alexis Lykiard. Reproduced with permission.

Alfred Jarry. *Gestes et opinions du Docteur Faustroll, pataphysicien.* (*Exploits and Opinions of Doctor Faustroll, Pataphysician*). © Methuen, 1965. Translated by Simon Watson Taylor.

Asger Jorn. *La pataphysique, une religion en formation* (*Pataphysics: A Religion in the Making*). © Donation Jorn, Silkeborg, 1961. Reproduced with permission.

Line McMurray. *Entretien avec Eugène Ionesco (Interview with Eugène Ionesco).* © Éditions Liber, 1980. Translated by Mark S. P. Mason. Reproduced with permission.

Raymond Roussel. *Comment j'ai écrit certains de mes livres (How I Wrote Certain of My Books).* © Sun Press, 1977. Translated by Trevor Winkfield. Reproduced with permission.

Raymond Roussel. *Impressions d'Afrique (Impressions of Africa).* © John Calder, 1966. © OneWorld Classics. Translated by Rayner Heppenstall. Reproduced with permission.

Irénée-Louis Sandomir. *Testament.* © Collège de 'Pataphysique, 1959 [1956]. Translation by Roger Shattuck © Evergreen Review, 1960. Reproduced with permission.

Roger Shattuck. *Superliminal Note.* © Evergeen Review, 1960.

Julien Torma. *Lettre à René Daumal (Letter to René Daumal).* © Collège de 'Pataphysique, 1952 [1929]. Translation by Terry Hale © Atlas Press, 1995. Reproduced with permission.

A NOTE ON SOME OF THE PRIMARY SOURCES IN ENGLISH

--

The major source of pataphysical texts in translation is Atlas Press, London, which has been publishing them since the 1980s under its own imprint and those of The Printed Head and the London Institute of 'Pataphysics. They have recently reprinted Simon Watson Taylor's translation of the *Exploits and Opinions of Doctor Faustroll, Pataphysician* and most other works by Jarry in translation. The Methuen *Selected Works of Alfred Jarry* from 1965, translated by Roger Shattuck and Simon Watson Taylor, is still in circulation. The Cyril Connolly translation of *Ubu* remains the standard edition, although there are several others available. The *Evergreen Review* issue 13, *What Is 'Pataphysics?*, is freely available online as a download, as are relevant texts by Baudrillard, Ballard, Étienne, Jorn, the Marx Brothers, and others.

There are print editions in English of works by pataphysicians such as René Daumal (City Lights, The Overlook Press), Jacques Prévert (City Lights and others), Eugène Ionesco (Grove Press), and Marcel Duchamp (Thames and Hudson). Raymond Queneau and Boris Vian are also still available in classic translations by Barbara Wright and Stanley Chapman (Penguin, Quartet Encounters, etc.).

The Oulipo has been thoroughly documented in English by both Warren F. Motte Jnr. and Atlas Press. Translations of works by Georges Perec (Collins Harvill) and Italo Calvino (Penguin, Vintage) are readily available in standard editions.

Other writers whose works refer to pataphysical themes include Antonin Artaud, André Breton, Jorge Luis Borges, and Gilles Deleuze, all of whom are available in translation. Arthur Cravan and Jacques Vaché, along with the pataphysician Julien Torma, are translated with biographical commentaries in the excellent volume *Four Dada Suicides* (Atlas Press, 1995).

There are many translations of Raymond Roussel available, both online and in print, especially those from Atlas Press. Older versions of *Impressions of Africa*, *Locus Solus*, and *How I Wrote Certain of My Books* can also be tracked down fairly easily. Jean-Pierre Brisset is rather untranslatable, but attempts by Sorrell, Hugill, Redfern, and others do exist. Walter Redfern's *All Puns Intended: The Verbal Creation of Jean-Pierre Brisset* is a thorough discussion of his work.

There is a full bibliography of all these and many secondary sources at the end of this book.

PREAMBLE

How to write about something that exists mainly in the imagination, that constantly resists clear definition, is purposefully useless, and is regarded by many as a pseudophilosophy, a hoax, a joke, or a schoolboy prank? The enterprise is fraught with dangers. There is a risk of reduction: pataphysics is rich and complex, so anything that resembles a simplified "explanation" will fail to do it justice. Conversely, there is the problem of taking it all too seriously. Everybody knows that a joke explained is not a joke at all. Since pataphysics recognizes no distinction between humor and seriousness, there is always a possibility that any statement on the subject will end up pricking its own balloon. There is the ever-present danger of factual error in a history filled with myth-making, inconsistencies, deliberate hoaxes, and, sometimes, downright lying. Worst of all, there is the fear of the disapproval of the worldwide community of pataphysicians,[1] whose deep erudition and independence of mind make them supremely intolerant of any traducement of that which they hold so dear, even if it emanates from one of their own. In the face of these perils, one may well wonder why this book exists at all.

Of all the French cultural exports of the past 150 years or so, pataphysics has, perhaps surprisingly, turned out to be one of the most durable, and today is attracting ever-increasing attention. The word was invented by schoolboys in Rennes in the 1880s and is most strongly identified with one of their number: the poet and playwright Alfred Jarry (1873–1907). It is generally agreed that it lies around the roots of many of the key artistic and cultural developments of the twentieth century, including absurdism, Dada, futurism, surrealism, situationism, and others. The fact that relatively few people are aware of its existence is part of the secret of its success. Unlike other, more familiar, "isms" that have been fully documented and historicized, pataphysics has managed to retain its vibrancy by perpetually eluding "ism"ism. It has never fully become either a "movement" or a "philosophy," even though at times it shares some characteristics with both of those. It has managed to permeate both culture and society, but in ways that are somewhat shadowy. How could the ravings of an inebriated nineteenth-century French poet have penetrated the collective consciousness to such an extent? It is hoped that this book will contribute to a greater understanding of this phenomenon.

The pataphysical presence in the world has been partly conscious and acknowledged, partly unconscious yet acknowledged, and partly (the greater part) unconscious and unacknowledged. It has secured a place in the history of literature, without question. It has also had a demonstrable impact on theater, music, painting, sculpture, and so on. Its influence on politics, economics, philosophy, critical theory and the wider social sciences is less clear, but can nevertheless be traced. Its presence in the sciences is still less obvious, and yet with a little digging it can be detected. Both scientists and pataphysicians have too much to lose to admit that there are many similarities and connections between them, but the subject does pop up in quantum physics, in computer science, or in scientific research in general.

Beyond all this lies a layer of pataphysical ideas that have made their way into the wider culture. Gauging the true extent of this layer is difficult, not least because each nation, each generation, and even each individual tends to interpret it differently. Thus, US pataphysics differs somewhat from Canadian pataphysics, which itself divides into Anglophone and Francophone pataphysics, of which the latter differs again from French pataphysics, and so on. And it is also transformed as it passes down the generations: even Jarry himself articulated at least two versions of it during his lifetime as the concept matured. These differences may be subtle but are often highly significant.

It is important to understand what distinguishes pataphysics from other "radical," "anarchic," or "left-of-field" impulses. The word is often used quite loosely to evoke *anything* that seems wacky, weird, or bizarrely incomprehensible. This is a misrepresentation which this book hopes to correct. Pataphysics, although complex and difficult, is in fact quite a cogent body of exploits and ideas, which has a history and certain fixed precepts. While the contradictory and the exceptional are woven into its very fabric, the sloppy, the woolly, and the "hip" are not. Pataphysics sets no store by what it calls the "grimaces on the face of a century," the passing fads and fashions of intellectual life; rather, it is imperturbable in aspect. It may never be understood, which is perhaps why it is so frequently misunderstood. These are the academic reasons for writing this book: to contribute to knowledge and to combat ignorance.

On a personal level, I have been involved in and researching pataphysics for more than 25 years. For the majority of that time, I have been a member of the Collège de 'Pataphysique, in which I am currently Commandeur Requis of the Ordre de la Grande Gidouille. As a composer, I am frequently identified as a maker of "pataphysical music." As an academic, pataphysics

has been a constant presence in both my research and my teaching. I have written articles, given conference papers, published translations, delivered lectures, directed workshops, staged performances, and generally engaged in dialog about pataphysics with undergraduates, postgraduates, Ph.D. students, fellow staff members, and researchers worldwide. At the same time, I have maintained a continuous involvement with pataphysics outside the academy, attending events, joining groups, corresponding with individuals, and contributing to publications. While some people have experienced great tension between the academic and nonacademic worlds, I have found that I can move fairly freely between the two. Perhaps it is the result of being a musician, for music is extremely good at flowing across barriers.

At any rate, I have been emboldened to write this book by repeated requests to do so from all quarters. Certain influential individuals, such as the late Stanley Chapman, have been encouraging me that way for many years. Despite their confidence, I have been (and remain) quite timid. During the occultation of the Collège de 'Pataphysique, which began before I became a member and only ended in 2000, I tried to avoid discussing pataphysics at all, and this is a habit which I have found hard to drop. I am sure that some people will say that it would be better if I had remained silent. But, for better or worse, I am an academic and I cannot leave unrealized a project on which I have been working for most of my adult life, of which this book is but one partial yet necessary outcome.

Daily requests for information and questions about pataphysics flow into my inbox. People constantly engage me in conversation on the subject. On one alarming occasion, a clearly inebriated young stranger emerged from the crowd in the center of town on a Saturday night, staggered over and accosted me, demanding that I tell him "all about pataphysics." In 2009, Professor Jim Hendler, one of the leading computer scientists in the world, progenitor of the semantic web and, among many other achievements, a member of the US Air Force Science Advisory Board and Chief Scientist of the Information Systems Office at the US Defense Advanced Research Projects Agency (DARPA), asked me if I would provide him with a collection of key texts and notes about pataphysics. Shortly after that I received the request from the MIT Press that was the final trigger for the creation of this book. I confess I find it impossible to stand against such demands.

Ruy Launoir observed that "there is no key to 'Pataphysics. . . . To pretend that one can explain (i.e., *reduce*) 'Pataphysics by methods that are not pataphysical, is a little, even greatly, pataphysical" (Launoir 2005, 7).[2] The aim of my book is therefore modest: *to trace the lineaments of pataphysics* and, in doing so, to offer some critical insights. It is intended for a reader

unfamiliar with pataphysics, although, to be sure, it may contain material of interest to pataphysicians. It attempts to draw out various themes, be they philosophical, literary, artistic, historical, anecdotal or analytical. However, it does so in the full knowledge that it is merely describing an outline, nothing more than an imprint that the idea of pataphysics has left on our culture to date. These are merely the swaddling clothes that surround the invisible body of pataphysics itself. When you have read this book you will not "understand" pataphysics. You will know somewhat better the extent and reach of its influence, and the depth and richness of its insights. You may also perhaps understand why the "crying need" for it, first identified by Jarry, continues to be felt to this day.

Given these remarks, it might be concluded that pataphysics is a rather earnest affair. It is certainly serious, but in its seriousness is its humor. As Jacques Prévert said, responding to a journal's questionnaire about humor, and anticipating (rightly) the likely seriousness of the replies of the other correspondents: "For too long now, humor has been taken lightly, we now intend to take it heavily. Come now, gentlemen . . ." (Prévert 1951).

The irony is pataphysically double-edged, since the substance of pataphysics is a deeply serious humor. This has itself been characterized in several ways—surreal, absurd, anarchic, and so on—but it does not readily fall into a single type. As with everything else in pataphysics, it is full of contradictions.

So, where to start? Does the pataphysical spiral begin in the middle or at the edge? Let's examine the word itself . . .

1 GENERAL INTRODUCTION

--

'Pataphysics. *La 'Pataphysique*. This is a word that tries to exclude itself from the dictionary, in the same way that Groucho Marx refused to belong to any club that would have him as a member. It is a word that has been variously defined, yet continually eludes definition. It is the slippery fish that has surprisingly survived, leaping and jumping on the fishmonger's slab. The concept it embodies turns out to have staying power beyond the short life of its prime exponent, Alfred Jarry, having existed throughout history and having found renewed vigor in the digital age. For some, pataphysics is a cosmic fart, an ultimate spoof, a schoolboy prank, a raucous piece of nonsense; for others it is an attitude of mind, a way of life, a discipline, a doctrine, a deeply ironic religion, even. It is profoundly useless or, as pataphysicians prefer to say, *inutilious*, but nevertheless manages to inform and inflect the world. To this day, when physicists make questionable science, their colleagues will shout: "That's not physics. That's pataphysics!"[1]

To understand pataphysics is to fail to understand pataphysics. To define it is merely to indicate a possible meaning, which will always be the opposite of another equally possible meaning, which, when diurnally interpolated with the first meaning, will point toward a third meaning which will in turn elude definition because of the fourth element that is missing. What we see of pataphysics in the so-called real world is what has been created

to provide the *evidence* of pataphysics. It seems to connect with the paradoxes and uncertainties of quantum mechanics, yet it does so through a very different kind of mathematics, a purely imaginary science. The Large Hadron Collider, near Geneva, is an enormous circular underground particle accelerator designed to reveal truths about the Big Bang. But only an infinitely *spiriform* accelerator, one in which the subatomic collisions never take place, would be able to fail to detect the elementary particles of the pataphysical universe.

In the face of such difficulties, any general survey of pataphysics must set its sights on modest goals to be achievable. There are some obvious questions that may be addressed, such as: what is the history of pataphysics? What are its key themes and ideas? How have these evolved? Who are its leading lights? What relevance or influence does it have today? There are also some more detailed questions to consider, for example: what is the nature of pataphysical humor? To what extent can pataphysics be separated from Jarry? How is it distinctive? Is it really a philosophy? What is its role in French culture? How best may it be translated? and even (for the enthusiast): how may I become a pataphysician? But the main contribution that a book such as this can give is to make accessible some of the key texts and ideas that constitute pataphysics insofar as we understand it in the quotidian world. Although pataphysics is at root a literary phenomenon, it has, as we shall see, had an impact on music, cinema, the visual arts, theater, performance, and, more recently, digital media. It has also informed aspects of business, economics, politics and, increasingly, science itself, especially computer science.

What distinguishes pataphysics from other artistic/philosophical movements that developed in the period from the 1890s through to the mid-twentieth century, such as symbolism, Dadaism, futurism, surrealism, situationism, and the rest, is that it is not so much a movement as a collection of ideas. Since these ideas stand in counterpoint to science, rather than art, pataphysics has managed to sustain itself most effectively, finding fertile ground in any mind that thinks the objective truths of empiricism at least demand a little playful tweaking, if not wholesale reevaluation. Which is not to say that pataphysics is simply antiscientific, or even antirational. As always, the relationship between the parodistic aspects of pataphysics and the thing it parodies is complex: ironic, or even, as Marcel Duchamp would have said, meta-ironic. But we can say that pataphysics is *subjective*, privileging the particular above the general, the imaginary above the real, the exceptional above the ordinary, the contradictory above the axiomatic.

Not that there is any choice in such matters: in pataphysics this is just the way things are.

DEFINITIONS

It will already be apparent that definitions of pataphysics are to be treated with caution. This is because the very notion of a "definition," which is a cluster of words that gives the specific sense of a term that holds true in all (or as nearly all as makes no difference) situations, is itself unpataphysical. How can a definition be exceptional, or contain its own contradiction? Nevertheless, there have been useful attempts at a definition of pataphysics, especially those of Jarry himself, which is where we must start. In book II, chapter 8, "Elements of Pataphysics," of the *Exploits and Opinions of Doctor Faustroll, Pataphysician* (published posthumously in 1911, and hereinafter called simply *Faustroll*), he offers the following:

An epiphenomenon is that which is superimposed[2] upon a phenomenon.

Pataphysics, whose etymological spelling should be ἔπι (μετὰ τὰ φυσικά) and actual orthography '*pataphysics*, preceded by an apostrophe so as to avoid a simple pun, is the science of that which is superimposed upon metaphysics, whether within or beyond the latter's limitations, extending as far beyond metaphysics as the latter extends beyond physics. Ex: an epiphenomenon being often accidental, Pataphysics will be, above all, the science of the particular, despite the common opinion that the only science is that of the general. Pataphysics will examine the laws which govern exceptions, and will explain the universe supplementary to this one; or, less ambitiously, will describe a universe which can be—and perhaps should be—envisaged in the place of the traditional one, since the laws which are supposed to have been discovered in the traditional universe are also correlations of exceptions, albeit more frequent ones, but in any case accidental data which, reduced to the status of unexceptional exceptions, possess no longer even the virtue of originality.

DEFINITION. *Pataphysics is the science of imaginary solutions, which symbolically attributes the properties of objects, described by their virtuality, to their lineaments.* (Jarry 1965a [1911], 145)

Let us unpick some of the detail in this rich text. The notes to the Collège de 'Pataphysique's annotated *Faustroll* point out that the Greek etymology implies both mathematical factorizing, since the latter part is in brackets, and a collapsing of the words into the phrase ep[i ta met]a ta fusika. This in turn suggests that the preceding apostrophe elides the letter *e*, as in *épataphysique*. *Épater les bourgeois* (to shock the bourgeoisie) was an avowed aim of the Decadent poets.

Probably the most difficult part of the definition is the phrase *"which symbolically attributes the properties of objects, described by their virtuality, to their lineaments."* Its purpose is, of course, precisely to lead the mind to a state of heightened pataphysical awareness. Ruy Launoir makes some enlightening observations:

We represent the real according to our usage of it or according to our very anthropomorphic perceptions of it. The lineaments could therefore be either the outline of these practices, or, which amounts to the same thing in the end, a sort of elementary structure—we know not what—of what is made manifest. All our ideation bears its mark, and no doubt always in exactly the same way, even though circumstances, and indeed individuals, may vary.

We cannot suppress these lineaments [. . .] but we can at least divert our habits and free up our thinking.

We must, by considering the possible ways in which we can imaginatively extend all the aspects of an object, be able to combine them in order to obtain a new representation of a linear "something"; pataphysical freedom will be attained at the moment when we can think of objects at once as ordinary and in many other ways, being conscious only of the differences in ingenuity between these representations.

This does not exclude other interpretations: one could also say, more simply, that the pataphysician proposes to decorate with new solutions our representations of the poverty-stricken, linear, "world." (Launoir 2005, 22–23)

In most popular variations, the definitions usually get reduced to the following bullet points which, while having the merit of being both relatively easy to understand and indicative of the nature of pataphysics, are scarcely adequate to do justice to the subject:

• Pataphysics is the science of imaginary solutions
• Pataphysics is to metaphysics as metaphysics is to physics
• Pataphysics is the science of the particular and the laws governing exceptions
• Pataphysics describes a universe supplementary to this one.

To which is sometimes added the last line of *Faustroll*, whose meaning is somewhat ambiguous. "La Pataphysique est la science . . ." could be the beginning of a new sentence, or a simple statement (Pataphysics is science), or, as is most usually rendered, an assertion of the particular (Pataphysics is *the* science).

Since Jarry, there have been various additions and developments to the definitions. The Collège de 'Pataphysique, founded in 1948, has used as its motto: *"La pataphysique est la fin des fins.* (Pataphysics is the end of ends)." Punning variations on that phrase have been used elsewhere in Collège publications, as follows: *"La pataphysique est la fin des faims.* (Pataphysics is

the end of hunger.) *La pataphysique est la faim des fins*. (Patapl
ger for ends.) *La pataphysique est le fin du fin*. (Pataphysics is th
fine.)" (Brotchie et al. 2003, 23).

It is often declared that pataphysics is, in aspect, imperturbable.
Vice-Curator of the Collège de 'Pataphysique, Dr. Irénée-Louis Sandomir,
further asserted in the Statutes that 'Pataphysics is "inexhaustible," "illimit-
able," and "totally serious," indeed it is "the most serious of all the sciences."

Various other leading pataphysicians have added their own definitions
over the years. Raymond Queneau sharpened up Jarry by declaring that pat-
aphysics "rests on the truth of contradictions and exceptions." Boris Vian
emphasized the idea of Equivalence, declaring: "One of the fundamentals
of 'Pataphysics is that of Equivalence, which may explain to you this obsti-
nacy we have with regard to what is serious and what is not; for us there is
no distinction: it is 'Pataphysics. Whether it suits us or not, everything we
do is 'Pataphysics" (Bernard and Vian 1959).

René Daumal observed that that pataphysics is "the opposite of physics"
because it comprises "knowledge of the specific and irreducible" (Daumal
1929), whereas Jean Dubuffet and Eugène Ionesco preferred to stress its
anarchic qualities: "The pataphysical position seems to me to be essentially
explosive, implying a mixture of radically incompatible fluids, so why not
proclaim Permanent Detonation?"; "'Pataphysics is a huge and elaborately
constructed hoax, just as Zen is an exercise in hoaxing" (Brotchie et al.
2003, 30–32).

Roger Shattuck adapted Jarry and the Collège de 'Pataphysique: "All
things are pataphysical; yet few men practice 'Pataphysics consciously.
[. . .] Beyond 'Pataphysics lies nothing; 'Pataphysics is the ultimate defense"
(Shattuck 1960, 103–107).

Fernando Arrabal, whose vigorous Panic Movement was formed in 1962,
breathing renewed life into surrealism, seized upon its startling and all-
embracing aspects: "'Pataphysics is a machine for exploring the world. [It
is] a perpetual present: a permanent Gift, Faustian or otherwise; a divine
surprise. 'Pataphysics is daily bread. Imperturbable 'pataphysics remains
immobile amidst eternal change. 'Pataphysics: Mother of the infinite with-
out reference to space (aerial or dead), and Mother of Ethernity without
science of time (rotten weather or past glories)" (Stas 2008, 102).

Jean Baudrillard relished its transcendence: "For pataphysics there's no
longer any singularity. The *grande Gidouille* is no longer a singularity, it is a
transcendent ventriloquism, to use Lichtenberg's expression. We're all *Palo-
tins* in a gaseous world from which the great pataphysical fart is released"
(Baudrillard 2001, 8).

SYMBOLOGY

The *grande Gidouille* is the spiral on the belly of Jarry's Ubu, or rather, "Monsieuye Ubu, Comte de Sandomir, Roi de Pologne & d'Aragon" (Mistah Ubu, Count of Sandomir, King of Poland and Aragon), by which he swears: "cornegidouille!" Translation of pataphysical words is a subdiscipline all of its own, so there are many variations on this one, but "crumboodle" or "hornstrumpot" (the latter credited to Cyril Connolly) are the most common. In the Ubu texts, it serves to emphasize his grossly distorted paunch, bulbous as an alembic (*cornue*) or a pumpkin (*citrouille*). Paul Edwards, and before him Michel Arrivé, also noted "the Rabelaisian *"guedofle"* which also gives *"guedouille"* (*"Les couilles comme une guedofle"* [balls like a fat little bottle]: *Gargantua and Pantagruel,* Book IV, chapter 31) and remarks that *-ouille* is still a popular spicy addition to any word (Edwards 1995, 43).

Following Ubu, the *gidouille* has become a general symbol of pataphysics, not least because drawing the spiral in fact creates *two* spirals: the one that is drawn and the one that is described by what is drawn. This echoes the plus-minus, or that which is and that which is not, in simultaneous existence. In pataphysics, mutually exclusive opposites can and do coexist. At a more subtle level, it also refers to the Mallarméan idea of "ptyx." Stéphane Mallarmé (1842–1898) was the leading French symbolist poet, greatly admired by Jarry and his contemporaries. His *Sonnet en '-yx'* (1887) was an attempt to create a poem that was an allegory of itself. The complex rhyme scheme and the underlying concept necessitated the creation of a new word, or rather the investment of new meaning into a previously existing word. "Ptyx," therefore, referred not to a thing or a place, but to something whose absence is its presence, as in the folds (*pli*) of a fan or a conch shell, or, as Mallarmé described it:

A window opened at night, two fastened shutters; a room with no one inside, in spite of the still appearance presented by the fastened shutters, and in a night made of absence and questioning, without furniture, if not for the likely outline of what might be sideboards, a quarrelsome and agonizing frame, of a mirror hung up in the back, with its reflection, stellar and incomprehensible, of the Ursa Major, which connects to heaven alone this dwelling abandoned by the world. (Mallarmé 1868)

The spiral is the primary symbol of pataphysics and has become a badge of the Collège de 'Pataphysique, with a complicated hierarchy of colors and sizes designating rank within that organization. Beyond that, it is frequently rendered in yellow on a green background, reflecting another of Ubu's symbols, the green candle. Unsurprisingly, the Collège de 'Pataphysique has

made a special study of the forms of spirals, and has adopted as its most recent motto the inscription on the gravestone of the Swiss mathematician Jakob Bernoulli (1654–1705): "Eadem Mutata Resurgo" (I arise the same though changed).

This is a reference to Bernoulli's observations of the appearances of the logarithmic spiral in nature, in particular in the shell of the nautilus. Ironically enough, the stonemasons carved an Archimedean spiral on his tombstone by mistake, the difference being that whereas an Archimedean spiral has a constant distance between its turnings, the logarithmic spiral (Bernoulli called it *spira mirabilis*, the marvelous spiral) executes a curve that seems to continuously increase.

Spiral motion runs seamlike through pataphysics, evoking its energy, timelessness, headiness, absurdity, and self-contradictions. It describes the nearly repetitive flow of history from a pataphysical perspective: endlessly passing again, yet distant from, the same point.

Other symbols similarly derive from *Ubu Roi* and are typically phallic and scatological: the toilet brush scepter (*sabre à merdre*); the physickstick (*bâton à physique*); the phynancial wand (*croc à phynances*); and the aforementioned green candle (*chandelle verte*). Perhaps a more substantial Ubuesque symbol is the *machine à décerveler* or disembraining machine, which in *Ubu cocu* Act 1 Scene 2 occasions the magnificent "Chanson du décervelage" (Debraining Song), sung by the Palotins, those conscience-free executors of the tyrannical will of Ubu. This song, originally with music by Charles Pourny,[3] has become the pataphysical anthem.

Animal symbols include the owl (Jarry kept both live and stuffed owls), the chameleon (changing color constantly, spiral-tailed, and with eyes looking in two directions at once),[4] the archaeopteryx (Ma Ubu gives birth to an archaeopteryx in *Ubu cocu*, a fact which is commemorated in the pataphysical calendar on 25 Sable, or 25 December), and the crocodile (as Jarry remarked: "the work of art is a stuffed crocodile"). The current Vice-Curator of the Collège de 'Pataphysique, Lutembi, is in fact a crocodile.

ABOUT THE APOSTROPHE

The greatest symbol of pataphysics is both the word itself and its curious spelling. In fact, Jarry himself only ever used the apostrophe on a single occasion, in the definition in *Faustroll* which states that the word is "preceded by an apostrophe so as to avoid a simple pun." The point is that we will never know exactly what the "simple pun" might be. The omission of

an initial *é* proposed by the Collège de 'Pataphysique in its annotated *Faustroll* gives *épate à physique*, a shocking or ironically impressive kind of physics. Alternatively, the elision itself could produce a pun-to-be-avoided, such as *patte à physique*, evoking a physics on all fours (*à quatre pattes*). Other suggestions have included *pas ta physique*, which means "not *your* physics," or *pâte à physique* (physics dough). So the "simple pun" is itself something of an imaginary solution, indicated by the apostrophe which implies a further missing word that creates the pataphysical meaning, and renders all the given definitions pataphysical (that is to say, imaginary solutions to the question of the meaning of the word pataphysics). The apostrophe resembles a hiccup before the loud belch that is the word.

Given the significance of this bizarre use of punctuation, debate has raged hotly among pataphysicians about "correct" usage. The matter was ruled upon by His Late Magnificence the Vice-Curator-Founder of the Collège de 'Pataphysique, in a text written in 1955 and first published in 1965:

> Only the word Pataphysics referring substantially and in conformity with the texts of Jarry, to the Science of Imaginary Solutions as such, is entitled to the apostrophe. It is merely tolerated that in certain cases it be granted, *ad conventientiam*, that the substantive used *in genere* take the apostrophe; in most cases, it is better to refrain. The adjective does not take the apostrophe. (Sandomir 1993 [1965], 87)

That is only one interpretation, of course, and other usages are always possible. Nevertheless, this book will follow the Collège conventions that 'pataphysics given with the apostrophe is conscious or, better expressed, *voluntary* (and refers to Jarry's science and the activities of the Collège), whereas pataphysics *sans apostrophe* is *involuntary*. The words *pataphysician* and *pataphysical* will always be given without the apostrophe.

THEMES OF PATAPHYSICS

> Contemporary science is founded upon the principle of induction: most people have seen a certain phenomenon precede or follow some other phenomenon most often, and conclude that it will ever be thus. Apart from other considerations, this is true only in the majority of cases, depends upon the point of view, and is codified only for convenience—if that! (Jarry 1965a [1911], 145)

It is essential to pataphysics that the basis of empirical physics, the repeatable experiment which produces an outcome that may be generalized into a law or axiom, is challenged by the science of the particular. Each experimental occurrence is, in pataphysical terms, a unique event that follows its own singular laws. Interestingly, quantum mechanics has in recent times

begun to approach this same idea, beginning with Heisenberg's Uncertainty Principle and Quantum Indeterminacy and leading on to the "multiverse" that contains all possible universes, including our own.

This apparent convergence of pataphysics with theoretical physics, however, should not lead to any confusion, since pataphysics views the theories of quantum mechanics in precisely the same way as it views every other theoretical, and indeed nontheoretical, understanding: as an imaginary solution. A universe comprised of exceptions implies an *equivalence* between imaginary solutions. This applies in physics, metaphysics, and pataphysics. As the Regent Marie-Louise Aulard observed:

> For the Collège, Jarry is neither a prophet, nor a Messiah, but just the first Pataphysician: a title which it is difficult to contest, for while there have been others, and perhaps "greater" than Jarry, he had the distinction of being the first to introduce the idea of pataphysics and to assign it to its rightful place in the world. However, questions of "greatness" have no meaning for us, by virtue of the postulate of Equivalence. A page of the telephone directory has the same VALUE for us as a page of The Exploits and Opinions of Dr. Faustroll. (Collège de 'Pataphysique 1965, 9)

Does this really mean that there are no contradictions, no exceptions, possible in pataphysics? As usual, the answer is pataphysically complex and relies upon acceptance of the simultaneous existence of mutually exclusive opposites. The nature of pataphysical exceptions may be best (mis)understood by examining some key concepts such as Anomaly, *Clinamen*, Syzygy, and Plus-Minus, or, to speak more philosophically, Antinomy.

ANTINOMY, OR THE PLUS-MINUS

This originates in Jarry's *Caesar-Antichrist* (1895), where the plus-minus is embodied in the physick-stick, a revolving stick which turns across the "stage" (the play is imaginary) creating as it does so both the – and the + and describing, through its rotation, a circle. The Templar and the Fess incarnate the opposition, with the Templar representing God (the symbol of the Knights Templar was the cross) and the Fess the Antichrist (in heraldry, the fess is a horizontal band running across the center of a shield). In a reference to the Comte de Lautréamont's *Les Chants de Maldoror*,[5] the Templar cries: "Uprooted Phallus, DON'T LEAP ABOUT SO!" (Jarry 1972, 105).

Jarry had introduced the idea of opposition in the "Prologal Act" to *Caesar-Antichrist* included in the earlier text *Les Minutes du sable mémorial* (1894) (Black Minutes of Memorial Sand). Here the figure of Caesar-Antichrist triumphantly arises with a long speech, including the following:

Death is egoism in its purest state, the only true egoism . . . [. . .] Christ who came before me, I contradict you as the swinging back of the pendulum wipes out the swinging forth. Diastole and systole, we are each other's Rest. [. . .] Nothingness is opposed to Being, then following an error growing like an avalanche, Nothingness to Life. These are the opposites: Non-Being and Being, arms of the beam on the fulcrum of Nothingness; Being and Life or Life and Death. (Jarry 2001b, 114)

Jarry was also influenced by the "double aspect" philosophy of Gustav Theodor Fechner, or "Doctor Mises," to whom he referred in his preliminary address at the first performance of *Ubu Roi* (Jarry 1965a [1911], 75). Fechner asserted that there is a mathematically demonstrable relationship between physical and psychical events, a theory which he developed in his book *Elemente der Psychophysik* (Elements of Psychophysics, 1860), whose title strangely prefigures Jarry's *Elements of Pataphysics* (eventually Book II of *Faustroll*). Jarry evidently relished Fechner's dual character, having encountered a satirical text by Doctor Mises, *The Comparative Anatomy of Angels*, in 1894 in the classes of Henri Bergson (Brotchie 2011, 30). The simultaneous opposition of seriousness and humor contained within a single individual is an idea that recurs throughout pataphysics.

This is not as simple as it might at first appear. Jarry's opposition was intertwined with a symbology derived from events in his own life. In *Haldernablou*, which is included in the *Black Minutes of Memorial Sand* collection, Jarry himself appears as Haldern (the Breton word for "Alfred") and his lover Léon-Paul Fargue as Ablou. By collapsing the two names into a single word, Jarry intended to symbolize their mirror-like union. This was a technique he was to employ frequently and most notably in the name "Faustroll," which combines two aspects of Jarry himself: the magus in league with the devil in return for absolute knowledge, and the mischievous Nordic creatures of legend that feature in Ibsen's *Peer Gynt*. The idea is developed much further in Book II, chapter 1, of *Days and Nights* (1897), entitled "Adelphism and Nostalgia,"[6] in which Jarry and another lover, François-Benoît Claudius-Jaquet, have mutated into Sengle and Valens:

Sengle discovered the true metaphysical cause of the joy of loving: not the communion of two beings become one, like the two halves of a man's heart which, in the foetus, is double and separate; but, rather, the enjoyment of anachronism and of conversing with his own past (Valens doubtless loved his own future, which was perhaps why he loved with a more tentative violence, not having yet lived his future and being unable to understand it completely). It is fine to live two different moments of time as one: that alone allows one to live authentically a single moment of eternity, indeed all eternity since it has no moments. [. . .] The present, possessing its past in the heart of another, lives at the same time as its Self and its Self plus some-

thing. If a moment of the past or a moment of the present existed separately at one point in time, it would not perceive this Plus something which is quite simply the Act of Perception. This act is, for the sentient being, the most profound enjoyment conceivable, one that is different from the sexual acts of brutes like you and me. — Not me, thought Sengle, correcting himself. (Jarry 1965a [1911], 140–141)

It finds its apogee in the repeated "ha ha" of Bosse-de-Nage, the dog-faced baboon who accompanies Dr. Faustroll on his travels from Paris to Paris by sea:

It is more judicious to use the orthography AA, for the aspiration *h* was never written in ancient language of the world. [. . .] Pronounced slowly, it is the idea of duality, of echo, of distance, of symmetry, of greatness and duration, of the two principles of good and evil. (Ibid., 228–229)

The Kantian antinomy states that "the antinomy of pure understanding exhibits the conflict between freedom and physical necessity. It was solved by showing that there is no real contradiction when the physical events are regarded [. . .] as necessitated but the intelligible noumena as free" (Stockhammer 1972, 18).[7]

The conflict to which Kant refers is that between pure and empirical reason. This conflict has been the death of many a system of formal logic. Kant's solution to most antinomies was to transcend them by finding the conflict itself unreal. The pataphysical solution, being imaginary, is beyond such metaphysics. In *Caesar-Antichrist*, the figure of Ubu appears in an "Earthly Act," declaring: "When I have taken all the Phynance, I will kill everyone in the world and go away" (*The Prolegomena to Caesar-Antichrist*, II) (Jarry 2001b, 104). He proceeds to *become* the plus-minus, embodying the idea of opposites as equivalent.

This theme crops up time and again throughout the pataphysical literature and beyond, extending as far as the fictions of Borges, or to Calvino's half-knight who fights against himself in a kind of ultimate subjective opposition, or to Perec's "W," which formally opposes the two halves of that letter—VV. However, it was perhaps most profoundly and pataphysically explored by Marcel Duchamp, whose mirror-image work *La Mariée mise à nu par ses célibataires, même* (The Bride Stripped Bare by Her Bachelors, Even), hereinafter known by its more familiar title *The Large Glass* (1915–1923), depicts an erotic antinomy divided by a hinge (Duchamp described *The Large Glass* as "a hinged picture"). The hinge subsequently became the symbol of such opposition, appearing repeatedly both as a physical and a conceptual division in his work, and finding fulfillment in the book on chess *L'opposition et les cases conjuguées sont réconciliées* (Opposition and

Sister Squares Are Reconciled), co-written with Vitaly Halberstadt in 1932, in which a hinge divides the board in a unique endgame position. Indeed, the whole of Duchamp's output might be read as an antinomy between the Ubuesque equivalence of the readymades and the Faustrollian preciosity of pieces such as *The Large Glass*.

In a more general sense, the tendency (nay, compulsion) of pataphysics to contrariness may be seen as an example of this theme too. What else is to be expected from a science which rests on the truth of contradictions and exceptions? Duchamp recalled how much he enjoyed his friend Picabia's oft-repeated "yes, but . . .". This may be taken as a standard pataphysical response to any proposition (including this one).

ANOMALY

"It is the exception that proves the rule," runs the cliché. However, as Christian Bök observes: "*the rule itself is the exception* in a pataphysical science that rules out the rule" (Bök 2002, 39).

Anomaly is probably the most generally familiar of the themes of pataphysics (although not as a "theme of pataphysics," of course), not least because it has been the subject of continuous and thorough popular documentation. Nothing, it seems, is so fascinating as the thing that does not fit. For example, *The Sourcebook Project* of William R. Corliss (b. 1926), begun in 1974 and continuing to accumulate examples (over 40,000 to date), sets out to catalog in a nonsensationalized way "unexplained phenomena" in science, archaeology, geophysics, geology, astronomy, and other areas. Corliss in turn was influenced by the work of Charles Fort (1874–1932), who was driven by an extreme skepticism and dislike of the pomposities of scientific positivism. Fort's interests in things such as unidentified flying objects, strange fallings from the sky of animals or matter, mysterious disappearances and alien abductions, levitation and teleportation (a word he coined), ball lightning and spontaneous human combustion, and the whole range of what today would be called the *paranormal*, have given rise to the modern science of "anomalistics," which entails the use of scientific method to evaluate anomalies, and includes such areas as ufology and cryptozoology.

All this finds an echo in Jarry, who would have come across the first French edition of Volume 1 of the *Popular Lectures and Addresses* by the Scottish physicist Lord Kelvin (Sir William Thomson) sometime after its publication in 1893. This contained the following pompous admonition:

In physical science the first essential step in the direction of learning any subject is to find principles of numerical reckoning and practicable methods for measuring

some quality connected with it. I often say that when you can measure what you are speaking about, and express it in numbers, you know something about it; but when you cannot measure it, when you cannot express it in numbers, your knowledge is of a meagre and unsatisfactory kind; it may be the beginning of knowledge, but you have scarcely in your thoughts advanced to the state of Science, whatever the matter may be. (Thomson 1889 [1883], 73–74)

To which Doctor Faustroll replies, in a telepathic letter:

It is a long time since I have sent you news of myself. I do not think you will have imagined that I was dead. Death is only for common people. It is a fact, nevertheless, that I am no longer on earth. [. . .] We are both of the opinion that, if one can measure what one is talking about and express it in numbers, which constitute the sole reality, then one has some knowledge of one's subject. Now, up to the present moment I know myself to be *elsewhere* than on earth, in the same way that I know that quartz is situated elsewhere, in the realm of hardness, and less honourably so than the ruby; the ruby elsewhere than the diamond; the diamond than the posterior callosities of Bosse-de-Nage. [. . .] But was I elsewhere in terms of date or of position, before or to the side, after or nearer? I was in that place where one finds oneself after having left time and space: the infinite eternal, Sir. (Jarry 1965a [1911], 246–247)

The subtleties of this imaginary exchange show that we must resist the crude conclusion: pataphysics = anomaly = the paranormal. Pataphysical anomaly comes more from "in here" than "out there," and follows its own contradictory logic. In the pataphysical universe, there should in theory be no possibility of anomaly, since everything is equally exceptional. The pataphysical anomaly, therefore, exists *within* the rules that it apparently contradicts. Georges Perec summed it up in this short quasi-syllogism: "If physics proposes: 'you have a brother and he likes cheese,' then metaphysics replies: 'If you have a brother, he likes cheese.' But 'Pataphysics says: 'You don't have a brother and he likes cheese'" (Collège de 'Pataphysique 1968, 52).

While the pataphysical universe itself may be anomalous—"Faustroll defined the universe as *that which is the exception to oneself*" (Jarry 1965a [1911], 245)—the pataphysical anomaly is best embodied in the figure of Ubu, whose reign is certainly terrible, but who ultimately leaves the world unchanged. The pataphysical anomaly is as absurd as the thing it contradicts, yet it represents the will to disruption which is one of the principal sources of pataphysical energy.

SYZYGY

This univocalic word has its origins in astronomy, where it denotes a moment of alignment of three or more celestial bodies, such as in an

eclipse. Unexpectedness or surprise is a feature of syzygy, probably because of its origins in a time before such events became predictable. At any rate, this is *not* the same as the more typically bourgeois notion of "serendipity" which, while it contains the idea of a chance encounter, lacks the sense of scientific exactitude of syzygy. Here we see a parting of the ways between pataphysics and surrealism, for while both embrace Chance as a productive principle, pataphysical chance is neither irrational nor subconscious. There are laws that lie behind pataphysical chance, but they are the laws of pataphysics: contradictions, exceptions, and so on.

The term *syzygy* has been taken up in many fields. In Gnosticism it describes the union of male and female (active and passive) aeons, which finds some echoes in pataphysics although, as usual, Jarry's ironies leave the concept somewhat compromised. It is also found as a technical term in medicine, philosophy, mathematics, poetry, psychology, zoology and more, always denoting some kind of conjunction.

In pataphysics, the "syzygy of words" provides the path to pataphysical humor, which is "born out of the discovery of the contradictory." In a letter from God, Faustroll notes "a small fragment of the Beautiful that he knew, [. . .] and a small fragment of the True"; from which "one could have constructed [. . .] all art and all science" (Jarry 1965a [1911], 245). The universe, in its syzygistic movements and crystalline form, produces, as if by chance, unexpected alignments of fragments of meaning which, in pataphysics, are generally in opposition. It is the recognition of this that produces laughter. In its most common form, this describes the pun. As Fr. Leonard Feeney observed:

> Humor consists of seeing an incongruity between fact and an imitation of the fact. [. . .] The incongruity observed is not complete, but only partial; because a likeness as well as an unlikeness must exist in the bogus. [. . .] The mind half accepts, half rejects what is being offered to it for recognition. At one and the same moment, it sees a darkness and a light, a nothingness and a somethingness; it becomes simultaneously aware of its own madness and its own sanity. (Feeney 1943, 169)

Syzygy of this kind can be traced through Raymond Roussel and Jean-Pierre Brisset to the constraint-based literature of the Oulipo and, indeed, to the critical theories of Jacques Derrida or Michel Serres. However, syzygy also had a wider resonance for the uprooted intellectuals and artists of Europe during two World Wars. Driven from their homelands by war, often heading to America, the big names in European art would often encounter one another in surprising new ways and contexts. Although they would doubtless not have used the word "syzygy" to describe these encounters, the happy accident, the use of chance and a delight in unexpected alignments,

became hallmarks of artistic practice as well as personal development. Being open to the possibilities this offers is more or less a prerequisite for the modern artist, and indeed is generally encouraged by creative thinkers in all areas of activity, including business, advertising, even engineering. Spotting a "syzygy" may be a mark of flair, or even genius. For pataphysicians, however, it may help them make (non)sense of their lives.

CLINAMEN

Few of the actual writings of Epicurus (341–270 BC) have survived, so our understanding of his philosophy depends on secondhand accounts, most notably those of Lucretius (ca. 99 BC–ca. 55 BC) in his didactic poem *De rerum natura*, variously translated as "The Way Things Are" or "Of the Nature of Things."

The idea of *clinamen* is a fine example of an imaginary solution, since Epicurus had little or no experimental evidence on which to base his theorizing. The Epicurean universe consists of atoms in continuous descent from an absolute high to an absolute low. During their descent, for reasons we cannot know or understand, some of the atoms happen to make a slight swerve or bias (the *clinamen*) in their trajectory, causing them to collide with other atoms. These chain reactions create matter:

The atoms, as their own weight bears them down
Plumb through the void, at scarce determined times,
In scarce determined places, from their course
Decline a little—call it, so to speak,
Mere changed trend. For were it not their wont
Thuswise to swerve, down would they fall, each one,
Like drops of rain, through the unbottomed void;
And then collisions ne'er could be nor blows
Among the primal elements; and thus
Nature would never have created aught. (Lucretius 2007, 50)

Human freedom, according to Epicurus, is a direct result of these indeterminate motions of atoms:

Again, if ev'r all motions are co-linked,
And from the old ever arise the new
In fixed order, and primordial seeds
Produce not by their swerving some new start
Of motion to sunder the covenants of fate,
That cause succeed not cause from everlasting,
Whence this free will for creatures o'er the lands,

Whence is it wrested from the fates,—this will
Whereby we step right forward where desire
Leads each man on, whereby the same we swerve
In motions, not as at some fixed time,
Nor at some fixed line of space, but where
The mind itself has urged? (Ibid., 51)

So, from an imaginary solution to a physical problem, Epicurus constructed an entire philosophy which eschewed received wisdom and superstition (he was scathing about the gods, for example), rejected the idea of a purposeful universe, and placed chance and human happiness at the center of existence. These ideas continue to resonate in the modern era.

In *Faustroll* the Painting Machine, a mechanical device controlled by Henri Rousseau, creates a series of tableaux:

The Painting Machine, animated inside by a system of weightless springs, revolved in azimuth in the iron hall of the Palace of Machines, the only monument standing in a deserted and razed Paris [. . .] . In the sealed palace which alone ruffled this dead smoothness, this modern deluge of the universal Seine, the unforeseen beast *Clinamen* ejaculated onto the walls of its universe. (Jarry 1965a [1911], 238)

The deviations of the *clinamen* may be observed throughout pataphysics. They are present in the Oulipo's verbal games and in the small alterations that make Duchamp's "rectified" readymades. They give rise to the situationists' *détournement*, in which a work is altered or recontextualized to create a meaning that opposes its original intention. They are the moments of distraction when one is engaged on a task, the sudden shifts of attention to something apparently irrelevant or disconnected. They are the final acknowledgment the pataphysician makes that the universe is governed by chance, so the words we speak, the things we do, our exploits and opinions, are the products of an inexplicable swerve. The words we speak and the things we do merely serve to demonstrate the existence of the *clinamen*, so "merde" (shit) becomes "merdre" (pschit),[8] as its meaning swerves toward something else.

THE ABSOLUTE

"Clichés are the armour of the Absolute," declared Jarry, and his entire project may be seen as an effort to reinvent the concept of a transcendent reality, to restore some originality to an idea which had become banal thanks to religion, to art, and to bourgeois convention. The concept of the Absolute had been reintroduced into philosophy by Hegel, whose unifying system resolved grand contradictions between subject and object, self and

other, mind and spirit, and so on, by synthesizing such oppositions into an uplifted higher knowledge. Jarry would have encountered these ideas during the classes of Henri Bergson, which he attended during his early years (1891–1893) at the Lycée Henri IV in Paris.

While Jarry was studiously attentive to Bergson's lectures, taking "more than 700 pages" of notes (Brotchie 2011, 29), he also had "an inability to approach any subject other than in a spirit of irony" (Gens d'Armes 1922), and consequently took from the classes only what interested or amused him. Thus, for example, he enthusiastically embraced and repurposed epiphenomenalism, "a theory which proposed that consciousness was no more than an accidental side effect of the state of the brain" (Brotchie 2011, 31), despite Bergson's dismissal of the idea. Brotchie links Jarry's definition of pataphysics, and in particular the idea of virtuality, with Bergson's concept of duration, a pure condition in which time (unlike space) is indivisible and "scientifically unknowable." This duration consists of "a wholly qualitative multiplicity, an absolute heterogeneity of elements which pass over into one another." This is a version of the absolute that aspires to freedom, since each moment is in itself unique or exceptional, and privileges subjective experience over objective reality. Bergson himself was no Hegelian, as J. Alexander Gunn points out: "While in Hegel, Mind is the only truth of Nature, in Bergson, Life is the only truth of Matter, or we may express it— whereas for Hegel the truth of Reality is its ideality, for Bergson the truth of Reality is its vitality" (Gunn 2008).

As early as 1884, Bergson had begun his investigation into the meaning of comedy that was to lead to the essay *Le rire. Essai sur la signification du comique* (Laughter: An Essay on the Meaning of the Comic). In his consideration of the comic and the human imagination, Bergson was to note that humor arises when the inflexibility of a mechanism, such as the behavior of a human body under certain conditions, is revealed in the context of the flexibility of life. The comedy is created by our imaginations working on the contrast between the two states. It is not surprising that Jarry, whose short stature and homosexuality figured in many a humorous situation, should have enjoyed this kind of thinking, which rather deflates any notion of a transcendent reality while at the same time allowing for personal transcendence through the imagination, through an admixture with the "ha ha."

The emergence of pataphysics from these ideas begins with Jarry's most personal text, the "novel"[9] *L'Amour absolu* (Absolute Love) of 1899, whose main character, Emmanuel Dieu, is a sublimation of every aspect of love— filial, sexual, religious—into a single universal entity of many facets. The

novel proclaims: "Human Truth is what man wishes: a *desire*. The Truth of God, that which he *creates*. When one is neither one nor the other—Emmanuel—, *his* Truth is *the creation of his desire*" (Beaumont 1984, 170).

By 1901, Emmanuel Dieu had metamorphosed into André Marcueil, the hero of *The Supermale*, a novel which denies any distinction between psyche (the spirit) and soma (the body). The opening sentence declares that "the act of love is of no importance, since it can be performed indefinitely," and the story sets about demonstrating the truth of this proposition through tales of inexhaustible sexual activity fueled by "Perpetual-Motion-Food" and, most famously, a race between an express train and a six-man bicycle team which is won by the latter when one of their number dies and goes into a kind of mechanical *rigor mortis* while strapped to the pedals. In the final climax, Marcueil is tied to a love-machine:

Within this antiphysical circuit connecting the nervous system of the Supermale to the eleven thousand volts, transformed perhaps into something that was no longer electricity, [. . .] it was the man who was influencing the machine-to-inspire-love. Thus, as might mathematically have been foreseen, if the machine really did produce love, it was THE MACHINE THAT FELL IN LOVE WITH THE MAN. (Jarry 1968a [1902], 120)

The final sections of *Faustroll* echo and extend this idea beyond the merely mechano-sexual into a mathematical definition of God, which states: "God is the tangential point between zero and infinity." But it is typical of Jarry that this comes in the context of an idea of the Absolute that is deeply buried in his own subjective experience. In his telepathic letter to Lord Kelvin, who had propounded a "luminiferous aether,"[10] Faustroll writes:

Eternity appears to me the image of an immobile ether, which consequently is not luminiferous. I would describe luminiferous ether as *circularly* mobile and perishable. And I deduce from Aristotle (*Treatise on the Heavens*) that it is appropriate to write ETHERNITY.[11]

Jarry's alcoholism combined with poverty had led him in his later years to drink ether, in order to perpetuate a state of inebriation which by all accounts rarely left him. In such a condition, a sense of connection with the Absolute may easily be attained.

This discussion has focused mainly upon Jarry, because the concept of the Absolute is one which has not survived particularly well. Its nineteenth-century character and its embedding in Roman Catholicism in particular has seen it outmoded by other, similar, concepts that have less obvious

resonances, such as "ultimate reality" or even, simply, "infinity." Nevertheless it is true to say that the Absolute remains central to a certain more spiritually oriented tendency within pataphysics.

PATAPHYSICAL HUMOR

This book as a whole may be taken as an investigation into pataphysical humor. It contains all shades, ranging from the absurd (Ionesco) to the farcical (the Marx Brothers), from the intellectualized (Duchamp) to the all-too-serious (Jorn), from the inadvertent (Brisset) to the knowing (Borges), from the apparently pointless (the Oulipo) to the apparently pointed (Cravan), and so on. Luc Étienne's question—"should pataphysics be taken seriously?"—will never really be answered, or at least, if it is ever satisfactorily answered, that will be an end to pataphysics. For every emphatic "no!" there will always be an equally emphatic "yes!" We may ask, incredulously: "but how *can* you take pataphysics seriously?," to which the reply will come: "but how can you *not* take pataphysics seriously?" It is the very model of literal eccentricity: never calling itself "eccentric" yet always moving away from the center, spiral fashion. Yet eccentricity is not necessarily pataphysical. Nor are spirals. Ha ha.

In order to misunderstand this better, it is necessary to trace the evolution of the pataphysical spiral through time. Strangely, this does not simply begin with Jarry, not even with Epicurus, whose name just happens to be the first on the list, but whose philosophy is not a blueprint for pataphysics. Since pataphysics is an imaginary solution, so its practitioners have not always realized the extent to which their ideas may be pataphysical. The Oulipo has a phrase for such pataphysics *avant la lettre*: plagiarism by anticipation. This is in itself an excellent illustration of pataphysical humor.

PATAPHYSICAL TIME

The twenty-first century has seen a rapidly growing awareness of the presence of pataphysics in the world. This has resulted to a great extent from the disoccultation of the Collège de 'Pataphysique in the year 2000 AD, an event which at the time seemed to be of almost negligible significance, except to a few (mainly French) intellectuals, but whose wider impact is only now beginning to be perceived. The Collège de 'Pataphysique itself was founded in the years immediately following World War II, as a somewhat humorous antidote to the prevailing philosophical orthodoxies in

Paris: existentialism, late surrealism, Marxism-Leninism, and so on. The Collège was driven by the energies of certain movements in art and philosophy between the wars, such as Dada or surrealism, and founded on the ideas and writings, exploits and opinions, of Alfred Jarry. He in turn was influenced by a host of contemporaries and predecessors. Through this lineage, the ideas of pataphysics may be traced back to Epicurus and, in an entirely imaginary way, to Ibicrates[12] and his teacher, Sophrotatos the Armenian, a mysterious figure whose entire output seems to have consisted of some fragments of writing about pataphysics found in the archives of Dr. Faustroll and Alfred Jarry.[13] Jarry may have proselytized the term "pataphysics," but he realized that its spirit has always been present in human (and animal) history.

The rest of this book charts a spiral history of pataphysics, using the reverse chronology of the preceding paragraph. In doing so, it aims both to demonstrate the continuing relevancy of pataphysics and to reveal its origins. It will consider its presence in fields other than literature. It will swerve and digress at times, in the interests of pursuing an interesting idea, rather than delivering a straightforward chronology, in the belief that this will do more to create a sense of the stuff of *the* science than a mere recitation of facts could hope to achieve. Alfred Jarry, who at first glance may appear to be relegated to the final chapter, will be treated as exceptional, and will appear and disappear throughout the book as appropriate, or inappropriate.

The pataphysical conception of Time does not necessarily recognize a conventional chronological succession. As Jarry clarified:

The Explorer in his [Time] Machine beholds Time as a curve, or better as a closed curved surface analogous to Aristotle's Ether. For much these same reasons in another text (*Exploits and Opinions of Doctor Faustroll*, Book VIII) we make the use of the term *Ethernity*. (Jarry 1965a [1911], 121)

Pataphysical time is made up of a collection of unique moments that extend, in much the same way as Space extends, in three dimensions. Thus, said Jarry, "if we could *remain immobile in absolute Space* while Time elapses, [. . .] all future and past instances could be explored successively" (ibid., 115).

Since pataphysicians do not die, but *make the gesture of dying*, or suffer an "apparent" death, it should be possible without qualms to explore selected moments from history in a nonsequential order that might please a pataphysical time traveler. However, a concession has to be made both to the reader of this book (who may well not feel ready to take such a journey) and to the requirements of scholarship, both of which demand at least the

semblance of a succession of events. This spiriform backward retelling of history is the compromise that should convey a sense of the relationship between events, by passing again and again at a slight distance the same staging posts, and by the reversal of time itself.

In following this somewhat curious retrograde motion, we will observe the conventional system of dating imposed by the Gregorian calendar. However, it should be noted that the Collège de 'Pataphysique, inspired by Jarry himself, created in 1949 a *Perpetual 'Pataphysical Calendar* which sets out an alternative system. Copies of this calendar may readily be found through an Internet search. It dates the *Ère 'Pataphysique* ('Pataphysical Era) from the birth of Jarry, rather than the birth of Christ, so "E.P." replaces "A.D." The appendage (vulg.) clarifies when the vulgate is being used. The Pataphysical Era therefore commenced on 8 September 1873 vulg., which is the 1st of the month of *Absolu*, Year I E.P. The pataphysical year is divided into thirteen months, twelve of 28 days and one, *Gidouille*, of 29, as follows (the full significance of these names will emerge later in this book):

- *Absolu* (Absolute)
- *Haha* (Ha ha)
- *As* (Skiff)
- *Sable* (Sand [sandglass], heraldic black, time)
- *Décervelage* (Debraining)
- *Gueules* (Heraldic red, gob)
- *Pédale* (Bicycle pedal, also slang for homosexual)
- *Clinamen* (Swerve)
- *Palotin* (Ubu's henchmen)
- *Merdre* (Pshit)
- *Gidouille* (Spiral)
- *Tatane* (Slang for shoe, or being worn out)
- *Phalle* (Phallus)

Each month contains an imaginary day, or *hunyadi* (named after a Hungarian laxative water), which may be freely inserted anywhere, and the 13th day of each month falls on a Friday. Every day of the calendar is associated with the feast of a particular pataphysical saint, in the manner of the Catholic Church. The preface to the fourth edition of the calendar notes: "For those who might still consider the futility of the vulgar Calendar to be of some import to themselves, a Concordance has been drawn up giving quick reference to every possible Calendar: Roman, Aztec, Revolutionary, Positivist, Chinese, Ponukelean, etc. etc."

A typical pataphysical date might look like this: 22 Palotin 75 (11 May 1948 vulg.). During the occultation of the Collège de 'Pataphysique the calendar itself was hidden from public view, so the dates adopted the following format: (11 May 1948 vulg.). Today, the use of the standard pataphysical dating system has been revived. To calculate the current pataphysical year, the following conversion table is helpful:

- Year 99 E.P. = 8.9.1971
- Year 100 = 8.9.1972
- Year 101 = 8.9.1973
- Year 102 = 8.9.1974
- Year 103 = 8.9.1975
- Year 123 = 8.9.1995
- Year 128 = 8.9.2000.

--

In the year 2000 AD, the Collège de 'Pataphysique disocculted and resumed its public activities.[1] This apparently obscure event has had a large ripple effect that has legitimized a renewed interest in pataphysics in the digital age. An Internet search on the word "Pataphysics" reveals something of the extent of its reach in the first decade of the twenty-first century. If one adds the words "Ubu" and Faustroll," the picture becomes rapidly richer and more diffuse. As with all Internet searches, of course, this also reveals the limitations of Internet searches themselves, since the presence of pataphysics is not necessarily indicated by the use of the word, and "Ubu," in particular, has rather followed his own trajectory through history, developing a meaning that, while not exactly *un*-pataphysical, has sometimes only a tangential relationship to the main thrust of pataphysics. Nevertheless, it is illuminating to observe that there are: dozens of social media groups devoted to pataphysics, with many hundreds of members; innumerable blogs on the subject; a host of variously "wacky" Web pages that trumpet a pataphysical view of subjects as diverse as sociology, psychology, computer programing, calculus, meditation, metallurgy, and cuisine; several online pataphysical Institutes, Collectives, and other groupings; extensive academic research into and using pataphysics; and many collections or museums that have explicitly pataphysical content or which are pataphysical apparently without realizing the fact.

It is important to understand that the pataphysical idea of Equivalence means that all manifestations are, in one sense only, of equal status. An "institute" that has taken no more than a few mouse clicks to create may be as "pataphysical" as the venerable Collège de 'Pataphysique. Yet the ephemeral nature of the digital culture means that in many cases pataphysics is present more as a "cultural meme" than a deep and coordinated effort in pataphysical science. In the account that follows, it will rapidly become clear which are the more or less substantial developments.

Much of this flourishing digital culture has been informed by critical theory, and especially by Gilles Deleuze, Michel Foucault, Umberto Eco, and Jean Baudrillard, all of whom have written about pataphysics. As leading members of the Collège, Eco and Baudrillard have had a particular influence. Eco's writings perhaps show most evidence of his pataphysical thinking in the collections of essays *Pastiches et Postiches* (Eco 2005) and *How to Travel with a Salmon and other essays* (Eco 1994). Paul Gayot points out (Gayot 2008, 97) that these (in particular the second) contain the elements of Eco's project for a "cacopedia" that represents "a negative sum of knowledge or a sum of negative knowledge" which "deduces an exact premiss from false conclusions" or "deduces irrefutable conclusions from an erroneous premiss." Evidence of this inverted knowledge may be observed everywhere.

Baudrillard summed up his view of pataphysics in an interview:

Pataphysics is both a science of imaginary solutions and a myth of imaginary solutions. It's the imaginary solution to the kind of final solution that the current state of affairs might be said to constitute. If there is a return to pataphysics, it's not in terms of argument or solutions, but a return that is itself imaginary, a kind of singular horizon. (Baudrillard 2001, 8)

The "current state of affairs" to which Baudrillard refers has been brought about by the shift from a mass-mediated, virtualized, culture to a "fourth order" of radical uncertainty in the information age. His vision of the digital culture makes hypercritics of us all, as we sift through the vast amounts of *merdre* that flood the Internet. Although Baudrillard himself saw little hope for art in that context, consigning it to perpetual reaction, the reintroduction of pataphysics at least offers a "transcendent ventriloquism." As he put it: "As hypercritical or ultra-critical thought—much more critical than critical thought—there's nothing better [than Pataphysics]" (ibid., 9).

PATAPHYSICS ON THE WEB

The Collège de 'Pataphysique has its own Web site,[2] as do most of the offshoot organizations, such as the OuLiPo, the London Institute of

'Pataphysics, the Italian Istituto di Patafisica Partenopeo, the Netherlands Academy of 'Pataphysics (De Nederlandse Academie voor 'Patafysica), and so on. These Web sites in their various ways reflect the respective institutes as fundamentally paper-based entities. Some are almost exclusively textual, with minimal Web design, whereas others have a more lively appearance, but all are clearly referencing a certain literary tradition. They provide either a gateway to an offline library or bookshop, or an opportunity to display public information about activities that are taking place elsewhere. These sites are for the most part self-contained, and have relatively few links to online resources or the sites of other such organizations.

To find an active digital culture one must turn to social networking sites, and here the picture is both more haphazard and more lively. What these groups have in common is a sense of excited engagement with the literature and traditions of pataphysics and a certain respect for its precepts that is expressed, often enough, through a meaningful disrespect. What they collectively manifest is precisely that "crying need" for pataphysics first identified by Ubu himself. The use of the word "pataphysics" in these manifestations varies between the precisely knowledgable and the vaguely evocative. It is sometimes hard to judge to what extent the artists in question really know the background to the science of pataphysics. However, as many have found, once having entered the pataphysical spiral, it can be impossible to get out again, and sooner or later one will be sucked down the pataphysical vortex into its depths like spiders down plugholes. Pataphysics has a way of carrying you along to places you do not recognize.

The many Facebook groups have titles such as "Pataphysical Enthusiasts" or "Practical Pataphysics," and reflect the internationalization of the science. Each group typically contains hundreds of members, some of whom are evidently experienced pataphysicians and many more of whom are seeking fresh information. There are also many video and photographic sites containing user-generated content that is tagged as pataphysical. There are pataphysical wikis, pataphysical Twitter feeds, and so on, exhibiting varying degrees of wackiness and all quite transitory. Pataphysical "flash mobs" appear, such as the "School of Fish" event organized by the Melbourne Institute of Pataphysics in 2008, in which a group of people clad in wet suits performed with large (dead) fish in various public locations in Melbourne, Australia. There are online pataphysical quizzes, and innumerable blogs and personal Web sites that include the term. Some of these have a classic ring of Internet strangeness about them, ranging from the use of pataphysics as an aid to meditation and therapy, to impassioned statements by supposed authors about impending events or books that do not exist.

Among the blogs, we have: Brian Reffin Smith's *Zombie 'Pataphysics* (begun 2006), which is described as "an excursion into certain areas of art, computers, philosophy, text, zombies, alchemy, metallurgy, music, food, creativity, pataphysics, politics" (Reffin Smith is a Regent of the Collège de 'Pataphysique); Sam Renseiw's *Space-Two PataLab* (begun 2005), a video blog which explores "the fine art of 'pataphysics in daily life" through "condensed poetic voodles"; Dr. Faustroll's blog (begun 2009), written by "a mime leading the blind" to "write the wrongs"; the *Clinamen* blog by Borsky (begun 2005), which "chases the snark into the fnords"; or the *Only Maybe* blog begun by Robert Anton Wilson and continued by a group of his students following his death in 2007; and many, many more in similar vein. It is possible to convey only a superficial impression of the liveliness of this online culture, but its scale is large; nor is it necessarily misinformed about pataphysics. In fact it is interesting to note how many of these sources show considerable erudition and knowledge of their subject.

Part of the root of this erudition lies in the increased availability of pataphysical resources. Indeed, this is an aspect of twenty-first-century culture that has been irrevocably transformed by the arrival of the Internet. What was once obscure has become not just accessible, but *equivalent*. The doctrine of equivalence is, as has already been discussed, a key idea in pataphysics, and the very nature of the Internet makes this a reality. Part of the appeal of pataphysics in the predigital era lay in its marginal existence. Its texts were difficult to find, and, when found, even more difficult to comprehend. The few moments of relative emergence (e.g., the publication of the *Evergreen Review* issue 13, "What Is 'Pataphysics?") led to a corresponding withdrawal, in the manner of a hermit crab poking out of and retreating into its shell. But today this has changed: the *Evergreen Review* is just one of many .pdf files available for download. The Collège de 'Pataphysique accepts subscriptions through Paypal. Jarry is available at Project Gutenberg. Roussel's writings exist in hypertext translations. Large quantities of previously unavailable content is being made available through resources such as *UbuWeb*, whose name indicates its origins, and which "embodies an unstable community, neither vertical nor horizontal but rather a Deleuzian nomadic model: a 4-dimensional space simultaneously expanding and contracting in every direction, growing 'rhizomatically' with ever-increasing unpredictability and uncanniness" (UbuWeb 1996).

PATAPHYSICS AND DIGITAL CULTURE

The pataphysical presence in digital culture is not solely a matter of historical and literary documentation. User-generated content is abundant, and

much explicitly pataphysical production is shared online. What follows are but a few illustrative examples of this activity. Some of these are one-off productions that do not necessarily exhibit great pataphysical depth, but serve to create the impression of a lively culture that has a spiral drawn across its belly.

In filmmaking, movies such as *Terra Incognita* by Peter Volkart (2005), or the "PXL THIS" toy camera festival in New Zealand, exploit the capabilities of new technologies to make short pataphysical films that can readily be shared.

In digital music or electronica, pataphysics has become a byword for experimentation and left-of-field work.[3]

The influential experimental German electronica band Farmer's Manual have called their work "pataphysical," in particular their 1998 album *Explorers_We*, with a title borrowed from Philip K. Dick.

Tomoroh Hidari's notes for the 2009 album *And Music Became Its Own Grandma . . .* state: "Even though originating from times before the private 'pataphysical turn of Nemo von Nirgends, this was compiled and remastered at The Delusory 'Pataphysical Institute of Whateverism."

Paul D. Miller, better known as DJ Spooky, includes in his album *Optometry* a "Variation Cybernétique: Rhythmic Pataphysic" in two parts, a drone-based track which features temple bowls, crotales, and improvised violin. The album is a kind of hip-hop jazz fusion that is typical of Spooky's intelligent approach to genre.

American musician Faustroll makes ambient experimental music.

Australian-Sri Lankan rapper Pataphysics began rapping in Singhalese, and increasingly concentrates on politics and philosophy in his raps.

There are many more such examples in music. In the visual arts, the picture is no less varied.

Paintlust is a Seoul-based "group of international artists and curators whose practices explore the possibilities of contemporary painting, in a time when location and nationality do not necessarily go hand in hand." In 2009, they staged a group exhibition called "The Truth of Contradictions and Exceptions" which "reinterpreted the concept of antinomy" (Paintlust 2009).

Another artists' collective, calling itself Pataphysical Longing Productions, was established in New York in 2006 and aims to promote the works of artists who join the group (Pataphysical Longing Productions 2006).

The Fun With 'Pataphysics Laboratory, created by Sharon Harris, "gives definitive answers to your unanswerable poetic questions and offers all the unsolicited writing advice you will never follow" (Harris 2005).

The Patafisic Design Studio in Florence, Italy, has created distinctive fashion collections since 2009 (Patafisic Design Studio 2009).

The *Patachromo* light installation was created in a Paris street in 2008 by Superbien, and based on "notions of Chromotherapy seen through the prism of Pataphysics" (Patachromo 2008).

The Australian video artist Shaun Gladwell's installation *Pataphysical Man* was part of the Saatchi & Saatchi New Director Showcase in 2006. The title was taken from a 1984 painting by Imants Tillers, and the video "re-presents the dynamics of a break-dancer in the tradition of Da Vinci's Vitruvian man and Le Corbusier's modular man."

"Pataphysics with Pickled Pictures" was the title of an exhibition of photographs by Gail Thacker in the Safe-T Gallery in Brooklyn, New York, in 2008.

Frank Turek's Ubu Studio was established in 2004 in Maine to house the boxed assemblages of this artist, who has been active in the avant-garde music and art scenes since the 1980s (Turek 2004).

A 2008 Master of Fine Arts graduate from Edinburgh College of Arts, Veronica Lussier, writes on her Web site: "My current research explores stories and pataphysics. Stories and their characters are not bound by real world constraints or everyday convention. Pataphysicians see the world in similar light. [Pataphysics] allows for anything and everything, including the factor of wind in equations, and the consequent falling over of numbers" (Lussier 2008).

WOMEN AND PATAPHYSICS

The Laboratory of Feminist Pataphysics is based at Alberta College of Art and Design, Canada. This comprises three Institutes—The Institute for Confounding Pretension, The Institute for Cosmic Procrastination, and The Institute for Corporate Pudding—along with several Emergency Mobile Units, which are "a series of social experiments that masquerade as works of art." There are EMUs for Anatomy, Identity, Transgenetics, Incorporation, and Toxicology. As the LFP documentation observes: "Each mobile unit can easily be set up wherever there is an urgent need for feminist interventions." The LFP founder, Mireille Perron, writes:

At the beginning of the 20th century, Alfred Jarry invented and described the indiscipline of 'pataphysics as the science of imaginary solutions. Like its companion— real physics—'pataphysics remains a predominantly male domain. To remedy this evident lack, LFP members like to think of their work as the reinvention of gendered science through fictive narratives. (Perron 2007)

The readers of the present book can scarcely fail to notice the predominantly male population of the story that follows, and will doubtless draw

their own conclusions. This is partly a historical issue, derived from the fact that *Ubu Roi* was created by schoolboys, and Jarry himself displayed a negative attitude to women that was probably fairly typical of male writers of the late nineteenth century, but with the additional twist of an almost obsessive phallocentrism coupled with a scarcely concealed homosexuality. The true extent of Jarry's misogyny has been the subject of some disagreement. Beaumont (Beaumont 1984, 50–52ff.) and Brotchie (Brotchie 2011, 115–122), for example, have no hesitation in labeling him a misogynist, whereas Brian Parshall (calling himself "Dr. Faustroll") argues in *Pataphysica* 4 (261–262) that the very idea reveals more about our own attitudes than any truth about Jarry, and that "misanthropist" might be a more appropriate label.

The same writer points out that two of Jarry's most important relationships were with women (his mother and the novelist Rachilde), and that he also collaborated with Berthe Danville (alias Berthe Blocq, alias Karl Rosenval) on an opéra-bouffe called *Léda*. Brotchie discusses in as much detail as possible his very close friendship with Fanny Zaessinger, of whom little is known (Brotchie 2011, 103). But there is no escaping the fact that some of his written remarks about women are shocking. To take but one example of many, *Haldernablou* opens with a scathing attack in which the Duke Haldern (a thinly disguised self-portrait) declares: "What I like in women— blight and dross which God extracted from the grid of their [men's] ribs—is their servility, but I want them silent." Nor did many of Jarry's personal statements differ greatly from this general sentiment.

After Jarry, the continuation of the pataphysical idea rested mainly in male hands until the formation of the Collège de 'Pataphysique when, gradually, women began to make a significant contribution. This included some tendency to a feminist reading that echoed Jarry in its assertiveness. Annie LeBrun is probably the foremost exponent of this line and, although a surrealist rather than a pataphysician, she has written extensively about Jarry, Roussel, and Sade. Interestingly, she argues against the idea of Jarry as a misogynist:

I wonder about the one-track-mindedness of certain thoughts on love, which are supposed to give an account of the movements of *two* parties but which, instead of developing our understanding, suddenly become fixated on a single perspective in their system of representation.

And I understand better the incredible fortune of the myth of "bachelor machines" which, through modernist and antilyrical allusions, and lacking the rigor of Duchamp, continue to hide what one might well call a deficiency of occidental thought.

Opposed to this, *alone*, there was Jarry, with the astonishing proposition of *The Supermale*, in which, for the first time, a man and a woman seem to stand *equally* (and I am careful not to say together) before their own enigma. (LeBrun 1990)

LeBrun's writings, including *Lâchez tout* (Leave everything) written in 1977, and *Vagit-prop* from 1990, develop this position with a fervor and lyricism that would have inspired Jarry (LeBrun 2010). However, they do not display particularly *pataphysical* traits, and consequently do not feature much in the historical literature. The women involved in pataphysics, many of whom will be encountered in these pages, have generally concentrated, like their male counterparts, on the evolution of a set of ideas that seem to transcend gender politics. The female presence in this process has steadily increased, and it is certainly true that in the twenty-first century, the gender balance within pataphysical circles has come to reflect much better that of the wider world.

PATAPHYSICAL MUSEUMS

Alongside its digital developments, the twenty-first century has seen a profusion of pataphysical museums. Somehow the very concept of a museum seems particularly fertile for pataphysics. Perhaps this is because museum visitors so often have to create imaginary solutions to the questions of the meaning or origins of the objects that they view. Or perhaps it is because we question the given explanations of those objects, which can often seem strange or even downright ridiculous. Sometimes we may have the impression that the curators and experts of these museums are inventing stories to explain their collections. At least, as uninformed visitors, we have no way of knowing whether or not that is the case. Part of the pleasure in attending museums lies in this secretive perception: that the objective truthfulness of what we are told is beside the point. The glass cases, the explanatory plaques, the interactive installations, the illustrated catalogs, even the public lectures by experts, serve to provide us with enough fragmentary evidence to piece together in our minds the lives and activities of those long gone. These are inevitably mysterious.

The *Musée Patamécanique*, created by Neil Salley, exists at a secret location in Bristol, Rhode Island, USA, and may be visited by appointment only. In an email to the author on 7 August 2010, Salley explained:

Patamechanics may be thought of as a method of manifesting artifacts, (i.e. objects or effects with physical properties—such as dimension, compositional detail, mass, motion, luminosity etc.) that shed light upon the laws governing exceptions. In

short, while 'Pataphysics theoretically explores the laws governing exceptions, Pata-mechanics is the study of physical objects that relay these concepts. Musée Patamé-canique is the first product of this field of inquiry. It is a half imaginary, half physi-cal, research and educational institution that has been developed as both a vehicle and a foundation, for studying the Science and Art of Patamechanics.

The Museum contains various strange mechanical exhibits. The "Pharus Foeti-dus Viscera," or "Olfactory Lighthouse," by Maxine Edison, is a cylindrical pedestal topped by a bell jar and surrounded by metal octopus arms. Inside the jar, a unicorn horn slowly rotates, causing it to secrete green goop that resembles shampoo gel. This lighthouse emits not photons but a random scattering of molecular oscilla-tions as a curious set of bouquets lift and amuse the olfactory organ to the illusory delights of pomegranate, honeydew melon, eucalyptus, citrus, as well as Christmas tree, papaya, the essence of wood, and sugar cookie. The *Auricular-lyrae*, or *Earolin*, by Hans Spinnermen, is a cylindrical glass chamber housing a floating apparition of a giant ear which plays the violin. The *Insecto Reanamus*, also by Hans Spinnermen, is a device which extracts the dreams of bees and displays them in glass jars.

The centerpiece of Le Musée is *Time Machine* by Dr. Ezekiel Borges Plateau. A spinning disc nearly eight feet across that sounds like a train thundering down the tracks, and when it reaches full-speed a visual treat is revealed that cannot be de-scribed except to say that it would make Jules Verne cry.

Each tour concludes with a visit to *The Laboratory for the Study of Advanced Fourth Dimensional Mechanics*. The visitors are told that this is an interactive exhibit and that they are invited to explore it for as long as they remain curious. *"It is a place where thoughts are as real and important as objects, and every object on display is an end-less source of wonder,"* Salley says as he gently ushers his guests ahead. The passage to this realm is a modest doorway marked "EXIT."

The Pataphysical Museum at the London Institute of 'Pataphysics (LIP) houses an archive, a collection of subliminal images, and an exhibition of wands, including: a Golden Dawn Fire wand, Dr. Faustroll's poker, Potas-sonic wands, tickling sticks, a disobedient wand, Great Aunt B's Cursing stick, Toast wand, Givenchy wand, a Russian Military Policeman's Illumi-nated Traffic-Directing Baton, and even a Long-Screw-with-a-Plastic-Knob wand.

In 2002, the Department of Reconstructive Archaeology (DoRA) of the LIP staged an exhibition of the paintings and sculptures of Anthony (bet-ter known as Tony) Hancock, the British comic whose 1960 film *The Rebel* satirized the modern art world, and contained many works of supposedly poorly executed art by the apparently deluded protagonist. The Depart-mental Papers of the DoRA note:

The Department has undertaken to re-create the entirety of Hancock's known picto-rial output, as well as his most important sculpture (the magnificent and imposing

Aphrodite at the Waterhole). The resulting exhibition, at The Foundry gallery, Old St, will allow for a complete re-assessment of Hancock's contribution to the art of his time. And, although the loss of the actual works precluded their having any signifi- cant art historical influence, we shall at last be able to appreciate their remarkable prescience (Hancock's theories of *Infantilism and Shapeism* self-evidently share many similarities with Dubuffet's conception of "Art Brut" for example). (Gilchrist and Joelson 2002)

In a similar vein to the LIP, the *Last Tuesday Society*, which "is a 'Pata- physical organization founded by William James at Harvard in the 1870s and presently run by The Chancellor, Mr. Viktor Wynd and the Tribune, Suzette Field, with the aid of The Fellows of The Society" (Wynd 2010), has a curiosity shop in London which "is perhaps best seen as an attempt to recreate or reinterpret, within 21st century sensibilities, a 17th century Wunderkabinett; a collection of objects assembled at a whim on the basis of their aesthetic or historical appeal. There is no attempt at creating or explaining, meta-narratives or educating anyone. It is merely a display of Naturalia and Artificialia designed to give pleasure to the creators of the Museum, who hope that you too will enjoy it" (ibid.). The Society stages parties, lectures, and other events that deal with the gothic, the subterra- nean, the marvelous, the mysterious, and the unexplained.

The Coney Island Amateur Psychoanalytic Society plays host to a Museum dedicated to Coney Island, "home of the world's first enclosed amuse- ment parks and an epicenter of American culture." Once again, this is essentially a reinvented nineteenth-century cabinet of curiosities, but here reminiscent of the great heyday of such parks that included P. T. Barnum's Museum. The Coney Island Museum rewinds history to a time when the separation between art and science was not as marked as it is today, by inviting artists to exhibit works that explore areas such as biotechnology, anthropology, and psychology. The fact that Sigmund Freud visited Coney Island in 1909, viewing the exhibits "Hell Gate" and "Creation" (and pos- sibly "Dreamland") (Klein 2009), provides the pretext for a show featuring "dream films" made by members of the society, and "a working model of an amusement park designed to illustrate Freud's theories by Albert Grass, the visionary founder of the society, as well as drawings, letters and many unusual artifacts" (Beebe et al. 2009).

Some pataphysical collections are part of larger, more "serious," archives. A good example is the Massachusetts Institute of Technology's "Archive of Useless Research." This contains "the original research papers of some of the most eminent scientists, past and present" (Kossy 1994, 56). These include the rather-less-than-eminent George F. Gillette's 1929 anti-Einsteinian

postulate of a "Spiral Universe" in which "all motions ever strive to go straight—until they bump . . . nothing else ever happens at all. That's all there is. . . . In all the cosmos there is naught but straight-flying bumping, caroming and again straight flying. Phenomena are but lumps, jumps, and bumps. A mass unit's career is but lumping, jumping, bumping, rejumping, rebumping, and finally unlumping" (Gardner 1957, 86).

PATAPHYSICS AND THE ACADEMY

Pataphysics pervades the Academy (or, more appropriately, the ubuniversity). This is controversial on two counts: first, some pataphysicians regard academia as rather incompatible with pataphysics. This has its roots in Jarry's skepticism about science, and a more general perception that the Academy is both useful and unimaginative. Second, academics themselves are often inhibited from revealing the true extent of their knowledge of pataphysics. This is partly out of respect for the conventions of pataphysics, which demand a certain discretion, but a more significant inhibitor is the perception that pataphysics is, purely and simply, a joke. To add a pataphysical reference to an academic *résumé* is to invite peer ridicule.

Both of these positions ignore the reality of pataphysics. Jarry devoured Bergson in a way that was entirely consistent with good student practice: questioning yet engaged. A significant part of the Collège de 'Pataphysique itself emerged from a university environment, and much of its work is rooted in academic research practices. The books and journals of the Collège themselves represent a significant corpus of work documenting aspects of mainly French literature and culture. They have been responsible for authoritative publications of primary sources including Jarry, Roussel, Queneau, and many others.

It is the present author's experience, moving in academic circles around the world, that pataphysics is an open secret among university staff. These academics represent a cross-section, from senior managers to junior lecturers, from the humanities to the sciences. The involvement of luminaries such as Umberto Eco and the late Jean Baudrillard has helped to establish this as a legitimate area of interest in the field of critical and cultural theory. Yet for most, the mere mention of the word is generally accompanied by a knowing smile or even a wink. Even so, some of the most hallowed groves of academia have actively encouraged pataphysical speculation, from the Oxonian cells of the 1970s to the Canadian conferences of the twenty-first century.

Christian Bök leads a flourishing Canadian academic scene. His book *'Pataphysics: The Poetics of an Imaginary Science* includes a survey of Canadian pataphysics, which he sees as a *clinamen* swerve from the European tradition, citing "irrational institutes" such as the Toronto Research Group, whose "faint hope" is that "others will follow and in following lead to the collection of the neglected and (who knows, as a poetic corollary, the neglect of the collected) those whom we have failed to remember or were forced to ignore, the already passed and the yet to come" (Bök 2002, 96–97). Bök's own position as a leading academic has done much to ensure that such marginal figures have been drawn firmly into the center.

Bök's creative writings include *Chrystallography* (1994), which is a simultaneous exploration of language and geology, using various constraints and devices such as word squares and charts to produce concrete verse. This Oulipian tendency is brought to full fruition in *Eunoia* (2001), in which each chapter is written using only a single vowel. The writing is witty and inventive. Here is a typical example from "Chapter U":

Ubu gulps up brunch: duck, hummus, nuts, fugu, bulgur, buns (crusts plus crumbs), blutwurst, brühwurst, spuds, Kurds, plums: *munch munch.* Ubu sups. Ubu slurps rum punch. Ubu chugs full cups (plus mugs), full tubs (plus tuns): *glug, glug.* Ubu gluts up grub; thus Ubu's plump gut hurts. Ubu grunts: *ugh, ugh.* Ubu burps up mucus sputum. Ubu upchucks lunch. Ubu slumps. Ubu sulks. Ubu shrugs. (Bök 2001, 80)

PATAPHYSICAL SCIENCE

In the USA, pataphysics is similarly spiraling throughout academia. To give a few recent examples: the Slought Foundation has staged academic conferences about pataphysics inspired by the work of William Anastasi; at Minnesota State University, Lee Garth Vigilant has created The New College of Sociological Pataphysics; and in 2002 the University of Buffalo staged a symposium on Canadian pataphysics featuring Christian Bök and Darren Wershler-Henry.

The full extent of its penetration may be gauged from the following excerpt from the Minutes of the Bibliographic Standards Committee American Library Association Annual Conference, held on Saturday, 23 June 2007, 8:00 a.m.–12:30 p.m., Washington Plaza—Franklin, Washington, D.C.:

ITEM 6A. THESAURUS TERMS [. . .] PATAPHYSICAL LITERATURE

The Subcommittee proposed adding this new Genre Term. Final version approved:

Thesaurus Genre Terms
Term Pataphysical literature

Hierarchy [Literary forms]
SN Use for works based on the principles of pataphysics (intricate and whimsical
nonsense intended as a parody of science).
UF Pataphysics
BT [Literary forms] (Brotchie et al. 2003)
HN Candidate terms, 6/2007
Warrant "The worst crime you can commit against a joke is to analyse it, which is
why the 'pataphysical literature is a double-helix of obfuscatory reflections, and
why the only way to get it is to get it."
"The apostrophe at the start of the word ''pataphysics' indicates that a prefix,
perhaps the pataphysical prefix, is missing. The word is frequently seen these
days without the apostrophe, and in this sense is generally understood to signify
unconscious pataphysics."
Comments Proposed by Steven R. Young, 9/2006. Apostrophe not included in term
or cross-references, according to ANSI/NISO Z39.19-2005 6.7.2.3.

The University of Virginia's *SpecLab* proposes a pataphysical approach
to the digital humanities that uses "speculative computing" (Drucker 2009)
to privilege ludic subjectivity over supposed analytical objectivity. This has
implications both for computer science and for digital aesthetics, leading
toward a semantic web approach to the former and a networked approach
to the latter. To achieve these, Drucker identifies a technique of "Temporal
Modeling":

Speculative computing is an experiment designed to explore alternative approaches.
On a technical level, the challenge is to change the sequence of events through
which the process of "dis-ambiguation" occurs. Interpretation of subjective activity
can be formalized concurrent with its production—at least, that is the design prin-
ciple we have used as the basis of *Temporal Modeling*.

By creating a constrained visual interface, Temporal Modeling puts subjective in-
terpretation within the system, rather than outside it. The subjective, intuitive inter-
pretation is captured and then formalized into a structured data scheme, rather than
the other way around. The interface gives rise to XML exported in a form that can be
used to design a document type definition (DTD) or to be transformed through use
of Extensible Stylesheet Language Transformation (XSLT) or other manipulations.

[. . .] Our path into the "speculative" has been charted by means of aesthetic
exploration, emphasizing visual means of interpretation. These are informed by
the history of aesthetics in descriptive and generative approaches, as well as by the
anomalous principles of 'pataphysics, that invention of the late nineteenth-century
French poet-philosopher Alfred Jarry. (Drucker and Nowviskie 2004, 433)

Practical applications of speculative computing include the collection of
projects from the ARP (Applied Research in Patacriticism) workshop founded
in 2003, which includes the NINES (Networked Infrastructure for Nine-
teenth-century Electronic Scholarship) and the Collex "name browser."

The present author's own work with the leading scientist James Hendler[4] on the semantic web elaborates a concept of patadata (patadata is to metadata as metadata is to data) in an attempt to reintroduce a serendipitous element to the process of search. The aim is to provide users with a "breadcrumb trail" of unique navigations through tagged content of all types: text, images, sounds, and media. These navigations provide creative stimulation and offer new insights into relationships between information that are not based simply on chance or even oppositional encounters, but rather on a more poetic sense of unity. To achieve this kind of result, the project interrogates the way in which current search algorithms distinguish between "positive" and "negative" information. The model for the project lies in the classification system outlined by Jorge-Luis Borges in a celebrated passage in "The Analytical Language of John Wilkins":

These ambiguities, redundancies, and deficiencies recall those attributed by Dr. Franz Kuhn to a certain Chinese encyclopedia called the Heavenly Emporium of Benevolent Knowledge. In its distant pages it is written that animals are divided into (a) those that belong to the emperor; (b) embalmed ones; (c) those that are trained; (d) suckling pigs; (e) mermaids; (f) fabulous ones; (g) stray dogs; (h) those that are included in this classification; (i) those that tremble as if they were mad; (j) innumerable ones; (k) those drawn with a very fine camel's-hair brush; (l) etcetera; (m) those that have just broken the flower vase; (n) those that at a distance resemble flies. (Borges 1964 [1942])

Patadata and pataobjects are also mentioned by "Darko Svitek" and a collective called Ill.posed Software, who elaborate "The Principals (*sic*) of 'Pataphysical Programming" which see "software as writing. In writing, as in software, the end result is something abstract, a product purely of the mind. Though programming is undeniably a distinct discipline, we think that software can learn quite a bit from certain writing movements" (Svitek 2006). Their project seems in abeyance, however, and their promised manifesto has yet to appear.

Another academic idea which similarly links pataphysics with breaking out from disciplinary constraints is "Jootsy Calculus," a branch of metamathematics. "Jootsy" stands for Jump Out Of The SYstem, and uses several alphanumeric systems at once to arrive at some unexpected results. In Jootsy Calculus, for example, "two plus two not only can equal five, but an infinite number of other correct answers, depending on pov [point of view] even including infinities. One, in fact, can use any mathematical representation included in the set of Generalized Orthographic Denotations, as 'All things are possible with GOD'" (Hierogamous Enterprises 1978).

There are many Jootsy examples of the answer to 2 + 2, from the linguistic (2 teacups + 2 teacups = 40 cups) to the graphical (9 − 8 + 9 − 8 (read it upside down)) to Gnomonics, in which square roots and cube roots are not the only roots, any more than base ten is the only number system. The triangular root, for example, is the length of the side of an equilateral triangle formed by successive gnomons as shown in the "pile of bricks" illustration below.

So, 2 + 2 = the triangular root of 10, the dodecagonal root of 64, the octodecagonal root of 100, and so on.

PATAPHYSICAL JOURNALS

There are thousands of references to pataphysics in peer-reviewed academic journals. Many of these emerge from critical theory, with Lacan, Baudrillard, and Deleuze providing key jumping-off points. There are also several academic journals that are themselves explicitly pataphysical. A typical example is *Semiophagy: A Journal of Pataphysics and Existential Semiotics*, whose editorial policy includes the following statement:

Semiophagy aims to trace the being of signs from their phenomenological emergence to their existential significance, asserting that insofar as all signs must be interpreted, the search for every sign's meaning is a creative urge expressed as art. This includes but is not restricted to philosophical and critical inquiries, visual works, pataphysical experiments, manifestos, comics, spoof ads and articles, Dada, ethical treatises, as well as the history and myth of semiotics itself. (*Semiophagy* 2008)

Pataphysica, edited by Cal Clements, is an example of a journal that straddles the private press tradition of pataphysical publication and peer-reviewed academic publication. It includes critical essays on aspects of literature, music, art history, and so on, alongside more hermetic writings on alchemy, philosophy, and mysticism, and translations of works by Jarry.

The *Ludic Society* journal emerges from the Zurich University of the Arts, and "exists to provoke a new research discipline: ludics." Focusing mainly on creative technologies, the journal investigates areas such as computer games through a pataphysical lens:

Similar to a 'pataphysical bike, ludics is a levitation model for a thinking machine, providing the salvation, that is embedded in the danger and joy of in-game tech-

nologies. Behind the books of physics and science, the methods and practices of 'pataphysika and pata-science fiction vanquish the physics of the rules of play. (Ludic Society 2005)

There are many more such journals that tread an imagined borderland between pataphysics and academia (the journals of the Collège de 'Pataphysique itself and its offshoots could be listed among their number). They present themselves as marginal while at the same time containing much solid research. They perhaps represent the fusion of Sherlock Holmes, the gentlemanly amateur, with Doctor Watson, the academic professional. Given its nature, it is highly unlikely that pataphysics would ever become an accepted academic discipline in its own right. On the other hand, given its content, it is equally unlikely that academia will lose its fascination with all things pataphysical. This book is an example of exactly that paradox.

THE FOURTH MAGISTRALITY (LUTEMBI)

For the Collège de 'Pataphysique, the disoccultation in 2000 signaled a reemergence of its familiar structures and hierarchies. The ranks of the Satraps were swelled by several new promotions, including Umberto Eco, Dario Fo, Edoardo Sanguineti, Barry Flanagan, Barbara Wright, Roland Topor (posthumously), Henri Bouché, and Jean Baudrillard. A new series of periodicals, the *Carnets Trimestriels*, appeared, to be followed in 2007 after twenty-eight issues by the *Correspondanciers*. It continues to flourish, under the leadership of its fourth Vice-Curator, His Magnificence Lutembi, who had effectively been chosen by his predecessor Opach in 1978, when he stipulated in a message to the Serenissimus Opitulator-General that his successor should be "neither a human being, nor French." Lutembi is in fact an African crocodile, and it is more correct to say *Her* Magnificence since it has recently been reported in a Collège *Carnet Trimestriel* that she is in fact female.

The history of the Collège de 'Pataphysique has been well documented both through its own reviews and, under the direction of Thieri Foulc, in *Les très riches heures du Collège de 'Pataphysique* (The Very Rich Hours of the College of 'Pataphysics) (Foulc et al. 2000). Ruy Launoir's *Clefs pour la 'Pataphysique* (Keys to 'Pataphysics) first appeared in 1969, and recent editions have continued to bring the story up to date (Launoir 2005). *Le Cercle des pataphysiciens* (The Circle of Pataphysicians) (Foulc 2008) gives insights into the leading pataphysicians, and thereby the history of the Collège. An account in English, entitled *A True History of the College of 'Pataphysics*, was published in a limited edition of 300 copies (Brotchie 1995). Other accounts exist online and in numerous references in other sources.

Given the nature of the Collège, which is pataphysical at every level, it is not surprising that all these accounts can become somewhat contradictory, and even obfuscatory, especially when discussing the more secretive internal activities of the organization. Since the Collège is itself an imaginary solution to the problem of organizing pataphysics in the world, it may readily be concluded that trying to get to some notion of the "truth" of certain events is in fact both hopeless and misguided. As the Collège put it: "the veils that surround the mystery *are* the mystery." During the occultation, and indeed before, the Collège could appear to be a kind of secret society, along the lines of the Freemasons. While it is certainly true that there were internal publications and a discourse between members that was unlike any public discourse, the secrecy of this secret society was as much an imaginary solution as anything else in pataphysics.

JEAN BAUDRILLARD

Baudrillard produced two influential texts about pataphysics. The first, published in 1992, was entitled *L'Illusion de la fin: ou La grève des événements* (literally: The illusion of the end: or Events go on strike). The English translation of this piece was entitled "Pataphysics of the Year 2000." This caused a certain stir at the time, and was made freely available on the Internet, where it duly circulated widely. The text rides the wave of millennialism that was gathering pace in the 1990s to advance a typically Baudrillardian thesis in which the information age gives way to a disappearance of the object in favor of a mediated subjectivity, a consequence of which is the loss of history. While the body of text does not directly mention pataphysics, the ideas it contains develop its familiar tropes in a particular direction.

At the heart of information one finds history haunted by its own disappearance. At the hub of hi-fi, music is haunted by its disappearance. At the core of experimentation, science is haunted by the disappearance of its object. Pivotal to pornography is a sexuality haunted by its own disappearance. Everywhere it is the same stereophonic effect, the absolute proximity of the real: the same effect of simulation.

This side of the vanishing-point—where there was still history, there was still music—remains irreparable. Where should one stop the perfecting of the stereo? Its bounds or limits are constantly pushed back or forced to retreat in the face of technical obsessions. Where should information stop? Confronted with such a fascination with "real time," with high fidelity, one can only resort to moral objections, and that does not carry much meaning/weight.

Once one has passed beyond this point, the process becomes irreversible. [. . .]

The possibility to move out of history in order to enter into simulation is but the consequence of the fact that, basically, history itself was none other than an immense model of simulation. (Baudrillard 1992)

It ends with the line "the year 2000 may well not take place [. . .]," playing on the title of his famously controversial book *The Gulf War Did Not Take Place* (1991), itself an example of a pataphysical statement. The second text, entitled simply *Pataphysique* (Pataphysics), is much more explicit:

Pataphysics is the highest temptation of the spirit. The horror of ridicule and necessity lead to an enormous infatuation, the enormous flatulence of Ubu.

The pataphysical spirit is the nail in the tire—the world, a wolf's mouth. The *gidouille* is also a hot-air balloon, a nebulous or even a perfect sphere of knowledge. The intestinal sphere of the sun. There is nothing to take away from death. Does a tire die? It gives up its tire soul. Flatulence is the origin of breath.

[. . .] Pataphysics: philosophy of the gaseous state. It can only be defined in a new undiscovered language, because its tautology is too obvious. Better: it can only define itself in its own terms, because: it doesn't exist. It turns in on itself and, with an empty smile, rehashes the same half-baked incongruences from *girolles* and imputrescible dreams.

The rules of the pataphysical game are far more terrible than any other. It is a narcissism of death, a mortal eccentricity. The world is an inane protuberance, a dry jack-off, a delirium of stucco and cardboard, but Artaud, for all that he thinks thus, believes that from this brandished empty sex a true sperm will one day spring, that a caricatural existence can make a theater of cruelty, that is to say a real virulence, surge forth. But pataphysics believes in neither sex nor theater. There is only a façade with nothing behind it. The ventriloquicity of the bladder and lanterns is absolute. All things are born infatuated, imaginary, an edema, crab meat, dirge. There is not even a means to be born or to die. This is reserved for the rock, meat, blood, for all which has weight. For pataphysics, all phenomena are absolutely gaseous. Even the recognition of this state, even the knowledge of farting and purity, and coitus, because nothing is serious . . . and the conscience of this conscience etc. Without goal, without soul, without sentences, and itself imaginary but necessary all the same, the pataphysical paradox is, quite simply, to die. (Baudrillard 2002, 11–23)

The text goes on to discuss in detail the divergence between Jarry's pataphysics and the version fashioned by Antonin Artaud after Jarry's death. Artaud's vision of madness and a theater of cruelty, while superficially resembling some of Jarry's exploits and certainly reflecting his theatrical influence, nevertheless leads to a subtly yet importantly different idea. As Baudrillard puts it: "Artaud wants the revalorization of creation and wants to put it into the world," whereas "pataphysics is *ex-sangue* and doesn't get itself wet." He ends with the line: "such is the unique imaginary solution to

the absence of problems," which echoes and extends Duchamp's "there is no solution because there is no problem."

Baudrillard's ideas of pataphysics have been further developed by a number of theorists. Two examples will suffice to illustrate the point.

Seth Giddings "plays a game" with Baudrillard's hyperreality of the contemporary world, by examining the interconnection of theories of play, waste, technology, and multiple realities in twentieth-century French thought and practice. Giddings invokes Ubu as an embodiment of Integral Reality, and cites Baudrillard:

Ubu is the very symbol of this plethoric reality and, at the same time, the only response to this Integral Reality, the only solution that is truly imaginary and its fierce irony, its grotesque fullness. The great spiral belly of Pa Ubu is the profile of our world and its umbilical entombment. (Giddings 2007, 44–45)

Giddings argues that "this collapsing of Ubu and plethoric reality should not be reduced to questions of the systemic appropriation of radical, unsettling alternatives. [. . .] Hyperreality is not so much a substitute for a lost reality as a distension of reality as it is commonly understood, its runaway production in a monstrous spiral of positive feedback" (ibid., 400).

Damian P. O'Doherty applies similar thoughts in a different sphere, writing from a business perspective on theories of organizations in crisis, which are producing "a cacophony of voices, a 'dada' of incoherence and contradiction" (O'Doherty 2007). Here, Baudrillardian pataphysics emerges as a "context within which we can cast new light on the location and understanding of our assumptions, procedures or theoretical study, and methods of orthodox sense-making" (ibid., 855).

When organization and science is responsible for some of the most fantastical and improbable inventions and curiosities, from the hydro-heated "two-in-one couples foot slipper™," advertised recently in the US South-West airlines in-flight magazine, to the pornographic interactive holograms modeled on real-life Hollywood stars, the absurdist fictions of the pataphysicians begin to appear more sane and credible. (Ibid., 856)

O'Doherty calls this the organizational "stuplime," derived from Sianne Ngai's ideas of the "stuplimity" that arises from the postmodern conditions of boredom, anxiety, stupefaction, envy, and other such "ugly feelings" (Ngai 2005). He remarks that "by deflecting the mundane order with their apostrophes and interruptions that make us look twice, 'pataphysicians help us see the boundaries and limitations of what we routinely accept as organizational reality" (O'Doherty 2007, 856).

3 (1975-2000) OCCULTATION

The occultation of the Collège de 'Pataphysique took place on the *hunyadi*, or imaginary day, between 19 and 20 April 1975. It had the immediate effect of ceasing all public manifestations, including the publication of college reviews. As the warning note to members explained:

> The occultation of the Collegial Institute does not in the least imply some form of "disappearance of pataphysics." Obviously 'Pataphysics, as his late Magnificence the Vice-Curator-Founder was already saying in 84, "does not even need to exist in order to exist." Even more so can it do without a college. . . . (Brotchie 1995, 108)

In fact, pataphysical reviews in French did continue to appear throughout the occultation, under the auspices of the Cymbalum Pataphysicum. In keeping with the pattern established in previous series, there were twenty-eight *Organographes*. These were followed by a series of forty-one *Monitoires*, the last of which began a retrograde subseries entitled *L'Expectateur* which counted down from number 16 to number 1 (in which the disocculation is finally announced).

The reasons for the occultation are mysterious. Ruy Launoir cites the deaths of a whole generation of Transcendental Satraps of the Collège around this time, including: Max Ernst (1976), Man Ray (1976), Raymond Queneau (1976), Jacques Prévert (1977), Pascal Pia (1979), René Clair (1981), and Joan Miró (1983). He also mentions a possible numerological reason:

Various esoterico-numerological interpretations have also been put forward, based on the quasi-coincidence of the Occultation with the year 100 (E.P.) and that of the disoccultation with the year 2000 (vulg.). (Launoir 2005, 146)

Ultimately, though, it was the decision of His Magnificence Opach, the third Vice-Curator of the Collège. As he explained in a message to the Regent, Thieri Foulc, the occultation was at once "un geste, une geste, une gestion et une gestation" (a gesture, an epic, a management, and a gestation) (ibid., 148).

During his time as Vice-Curator, it is true to say that Opach presided over a gradual withdrawal of the Collège from public view. Indeed, he himself was a mysterious individual, and little is known about his activities. He died in 1993 (his death was announced on a special card in *Monitoire* 27 and his obituary appeared in *Monitoire* 29), and the disoccultation of the Collège followed on the date he had preordained.

There was, however, a significant exception built into the announcement of the occultation. Item 4 declared: "The Institutes of Pataphysical Studies established abroad, and which have always benefited from a large degree of autonomy, are in no way affected by the measures of the Occultation" (Brotchie 1995, 108).

This decision, which effectively removed only *French* pataphysics from the public eye, did much to create the environment in which the current international interest described in chapter 2 could grow. Those pataphysicians who were familiar with the French Collège tended to be rather cautious in their response to the occultation, perhaps out of a sense of loyalty to the general direction in which it seemed to be going. Non-French newcomers to pataphysics, on the other hand, had no such inhibitions, and it soon became clear that the exceptional item 4 did more than simply allow for a situation over which the Collège had little control in any case. Numerous offshoots of the Collège de 'Pataphysique, and indeed independent pataphysical groups and organizations, began to spring up across the world.

OFFSHOOTS OF THE COLLÈGE DE 'PATAPHYSIQUE

The following survey is by no means comprehensive, but should give a flavor of the international spread of pataphysics, and covers most of the better-known groups. It does not consider those groups emerging from the subcommissions of the French Collège itself, such as the Oulipo, which will be discussed later. The sources for the list include the Collège's own publications, in particular two recent *Correspondanciers* (9 and 11) and various

Web sites including the *Clinamen* blog by Borsky. These are "offshoots" of the Collège in the sense that they seem to recognize its authority and it, in turn, recognizes them. This would not necessarily imply any superiority or inferiority in pataphysical terms to those others which are not so linked.

The earliest offshoots of the Collège were formed before the occultation. The first was the Instituto de Altos Estudios Patafísicos de Buenos Aires (Buenos Aires Institute of Higher Studies in 'Pataphysics), whose leaders were Juan Esteban Fassio and Albano-Emilio Rodríguez. This was officially recognized in 1957, occasioning the following congratulatory message from Vice-Curator-Founder Sandomir:

Is there any need to wish pataphysics well in Buenos Aires? It was there, as it was everywhere, before we came into existence and it can do without the lot of us. It will always exist and will do without us altogether. It can even do without existing, for it does not even need to exist in order to exist. (Brotchie 1995, 75)

In 2003, the Novísimo Instituto de Altos Estudios Patafísicos de Buenos Aires revived this venerable Institute, under the direction of Eva Garcia, with Vladimir Andralis, Ná Kar Elliff cé, Ignacio Vázquez, Rónex, and Rafael Cippolini.

The Institutum Pataphysicum Mediolanense, or Institut Milanais de Hautes Études Pataphysiques, was founded in Milan, Italy, in 1963, initiating a long and flourishing lineage of Italian pataphysics, which continues unabated to the present day. The Institutum was founded by the Transcendental Satrap Farfa, with the Regents Enrico Baj and Arturo Schwarz (Tristan Sauvage), and has included such names as Renato Mucci, Dario Fo, and Leonardo Sinisgalli. The first public exhibition of the Institute took place on 3–13 March 1964, at the Galleria Schwarz in Milan, and included artworks by: Arman, Baj, Dubuffet, Duchamp, Ernst, Farfa, Fontana, Jorn, Miró, Picabia, Prévert, Man Ray, and Spoerri.

More recent Italian Institutes have included: the Institutum Pataphysicum Parthenopeium founded in Naples by Lucio Del Pezzo, Luigi Castellano (LUCA), and Enrico Baj; the Turin Institute of Pataphysics, started by Ugo Nespolo in Turin in 1979; the Simposio Permanente Ventilati Patafisici Benacensi, started in 1987 in Riva del Garda; the Istituto Patafisico Ticinese in Locarno; the Collage de Pataphysique, founded in 1991 by Tania Lorandi; the Istituto Patafisico Vitellianense, founded in 1994 in Viadana by Afro Somenzari, with Enrico Baj and Ugo Nespolo; the Dipartimento Etrusco di 'Patafysica in Rosignano Solvay, founded in 2001 by Yari Spadoni, which publishes the bulletin *Soluzioni Immaginarie*; and the Autoclave di Estrazioni Patafisiche, founded in Milan in 2008.

Italian pataphysics is thoroughly documented at the Ubuland Web site, and produces such a range of journals, exhibitions, events, performances, and other manifestations that it has really become a significant cultural force in that country.

A Pataphysical Society was founded in Stockholm in 1964 by Michael Meschke, at the time he created his famous *Kung Ubu* with Franciszka Themerson. This was followed by the Vestrogotiska Patafysica Institutet (Vestrogothic Institute of Pataphysics), founded in 1984 by Leon Viktor Krutzsinger. Elis Ernst Eriksson was the third Rektor Magnifikus of this Institute, elected in 2003 at the age of 96. He died in 2006 aged 99 and was succeeded by Sven Nyström. Their journal, *Vestrogotiska Patafysica Institutet Talar* (The Vestrogothic Institute of Pataphysics Speaks), includes an issue in which the word *patafysik* is translated into many languages including runic scripts, Morse code, and ancient Peruvian.

The Centre de Recherches Périphériscopiques is a Swiss Institute based in Oleyres, a municipality in the canton of Vaud in the Avenches district, which sits on the peripheries in every sense: geographically, linguistically, spiritually, pataphysically. Its journal, *Le Périphériscope*, is edited by the Regents of Practical Debraining, Blablabla and Gibberish, and Punning and the Dialectic of Useless Sciences, and focuses mainly on word games and puns.

The President of the Nederlandse Academie voor 'Patafysica (Netherlands Academy of Pataphysics) is Woudagemaal, an enormous steam pump constructed in the 1920s to protect Friesland from flooding. Although it is a recent creation (founded in 2004), the NAP emerges from a long tradition of Dutch involvement in pataphysics. Probably the most notable figure in its history was the artist M. C. Escher, who became a Transcendental Satrap of the Collège in 1970. The NAP includes the Regents Matthijs van Boxsel (Chair of Morosophy) and Bastiaan D. van de Velden (Chair of Epigean (or Terrestrial) Nautics), editor of the journal *L'Ymagier de Curaçao*.

The Institut Limbourgeois de Hautes Études Pataphysiques was created in Liège, Belgium, in 1965 by André Blavier and others. More recently, the Observatoire Bruxellois du Clinamen (Brussels Observatory of Clinamen), itself an offshoot of the OuPolPot (Ouvroir de Politique Potentielle, or Workshop of Potential Politics), has imagined various solutions to the problems of separation and regionalism which occupy the collective minds of Belgians, including a massive expansion of Brussels to cover the whole country, a series of arbitrary divisions based on various kinds of line, and a submersion of Belgium by the North Sea, thereby rendering it "like the South Pole, a land that belongs to nobody" (Collège de 'Pataphysique 2009, 58). Brussels also plays host to the Pataphysical Institute of United Europe.

The London Institute of Pataphysics, founded in 2000, is closely asso-
ciated with Atlas Press, which has been publishing pataphysical texts in
English translation since the early 1980s. The LIP's president was, until his
death in 2009, Stanley Chapman (he has recently been succeeded by Peter
Blegvad). The LIP is organized into several divisions: the Bureau of Sublimi-
nal Images, the Committee for Hirsutism and Pogonotrophy, the Depart-
ment of Dogma and Theory, the Department of Potassons, the Department
of Reconstructive Archaeology, the Office of Patentry, and the Pataphysical
Museum and Archive described above. The Central Committee of the LIP
includes Alastair Brotchie, a Regent who has overseen Atlas Press since the
beginning.

The LIP was not the first pataphysical organization in the UK. The
Annexe de la Rogation et de l'Organon à Londres-en-Middlesex (Annex
of the Rogation and the Organon in London-in-Middlesex) was set up by
the Collège de 'Pataphysique on 11 May 1959, under the directorship of
Stanley Chapman. Both the 'Pataphysical Society of Edinburgh (based in
Yorkshire) and the Cellule Oxonienne de 'Pataphysique became active after
that date.

Another Cellule which was once very active, and has shown signs of
revivification in 2011 with Péter Tillinger's publications of Hungarian
editions of *Faustroll* and the Ubu cycle, is the Cellule Pataphysique de
Ubudapest.

In Germany, the Deutsche Institut für Pataphysische Studien (founded
in 1982) has given way to the Berliner Institut für Pataphysik, whose Pata-
panoptikum includes performance events, Web publications, conferences,
and other manifestations.

Spain has several Institutes: the Independent Institute of Pataphysical
Studies in Valencia; the Institutum Pataphysicum Granatensis in Granada
(founded in 1995 by Ángel Olgoso), whose work has covered many top-
ics, including a Spanish ludo-pataphysical dictionary and a pataphysical
demonstration of Goldbach's conjecture; and the Pataphysical Institute of
Saragossa, founded in 1997 by Grasso Toro, which has been replaced by the
Altissimo Instituto de Altos Estudios Pataphysicos de La Candelaria estab-
lished in Chodes, near Saragossa (formerly also in Bogotá) and ruled by the
same Regent. The Otro Ilustre Colegio Oficial de la Pataphysica (Another
Official College of Pataphysics) seems to be the name of a rock band.

In South America, there is an Instituto Patafísico de Chile based in San-
tiago; an Akademia de Patafísica Avanzada of places bordering the Laguna
de Chapala in Mexico; the Décollage de 'Pataphysique in São Paulo, Brazil;
an Escola Horizontal de Patafísica in Belo Horizonte; a Templo 'Patafísico

de Mar del Plata in Argentina; and, at 2,640 meters above sea level, an Altissimo Instituto de Estudios 'Pataphysicos de La Candelaria in Bogotá, Colombia (linked with the one in Saragossa).

In 2001, His Emphyteosis Timo Pekkanen, a bicycle maker, founded the Suomalais-Ugrilainen Patafysinen Keittöseura—Finno-Ugriska Patapfysiska Kökssällskapet, in Lapland. In 2007, the pataphysical presence in Lapland was further extended by the founding of an Institute of Pataphysical Studies of the Offshore Islands.

The Institut Pataphysique Mongol (Mongolian Institute of Pataphysics) was founded in 1997 by the Itinerant President Galbaatar and the "Midnight Chauffeur" Tumul. An Institut Chinois de Hautes Études Pataphysiques (Chinese Institute of High Pataphysical Studies) was founded in Shanghai in 1997, and more developments are under way in China. A translation of the Ubu plays with commentary was published in Beijing in 2006 by a group who also produced theatrical performances and films explicitly inspired by Ubu and pataphysics.

Finally, it should be noted that a small group of pataphysicians in Czechoslovakia, inspired by productions of *Ubu*, started a Patafyzické Kollegium and a journal called *PAKO* (*jobbernowl* or *josser*) during the Communist era.

PATAPHYSICS BEYOND THE COLLÈGE

The Collège de 'Pataphysique may have been the most recognizable center of pataphysics, but its stewardship has not been uncontroversial, especially beyond the Francophone world. Something of the strength of feeling on this matter may be deduced from the following piece of invective in an American periodical:

It is one of the great ironies of Western culture that the legacy of Jarry's genius has been left in the hands of this self-proclaimed "do-nothing" assembly of "conscious" and "unconscious" obscurantists. (Parshall 2007a, 214)

During the occultation years, much evidence of the pataphysical presence in the wider world continued to appear. In some cases, however, these appearances only indirectly, if at all, acknowledge the source. This is either a reflection of the extent to which pataphysical ideas have permeated culture, or a reflection of the natural discretion of those who reference the ideas. Either way, without going to too much trouble, we can discover examples of pataphysics, with or without the apostrophe, across the entire spectrum of human activity. A judicious selection of examples should convey an impression of the extent of these manifestations.

FILM

In her study of the films of Tim Burton, Alison McMahan generalizes pataphysics into an entire tradition within cinema:

Pataphysical films have several common characteristics, including some or all of the following. Pataphysical films

1. make fun of established systems of knowledge, especially academic and scientific
2. follow an alternative narrative logic
3. use special effects in a "gee whiz," that is, a blatant, visible way (as compared to "invisible" effects that simulate live action, but without real harm to the actors)
4. feature thin plots and thinly drawn characters, because the narrative relies more on intertextual, non-diegetic references to be understood. (McMahan 2006, 3)

Thus, a movie such as *Donnie Darko* (2001) seems to flirt with pataphysical imagery and concepts: the bicycle climbing a hill at the start; the "Philosophy of Time Travel"; the dialog between Fear and Love (directly echoing the dialog "Fear Visits Love" in Jarry's *Visits of Love*); the depiction of a universe parallel to this one; and the overall emphasis on the subjectivity of the title character. The film also fits McMahan's profile which, while presenting only the most superficial account of pataphysics itself, does make a convincing case for how its fundamentally useless ideas can be and have been applied in moviemaking.

LITERATURE

It is perhaps inevitable that science fiction, which practically demands imaginary solutions to things and maintains a somewhat tangential relationship with conventional science, should offer fertile ground for pataphysical speculation. If a single literary genre could be considered to be inherently pataphysical, then this would be the one. Jarry's own writings, such as *The Supermale* and *How to Construct a Time Machine*, offer some kind of starting point for this tendency although, of course, H. G. Wells and Jules Verne, both admired by Jarry, have much greater claims to being the fathers of science fiction.

Nevertheless, many science fiction writers have made reference to pataphysics. In the short stories of Brian Aldiss, for example, "The Man and a Man with His Mule" (published in 2002 by *Pataphysics* magazine in its "Psychomilitary Issue") features a narrator who tries to escape into the fictional world of a novel while being constantly brought back to reality by the interruptions of a stranger on a train; and in the 2005 story "The

National Heritage," a man attempts to document his own silliness as a matter of national importance.

Pat Murphy has included pataphysical characters such as Gyro Renacus throughout her work. This dialog between Gyro and the character called Bailey in *There and Back Again* (1999) summarizes her approach:

"I've heard people say that 'pataphysicians think everything's a kind of a joke."

Gyro shook his head. "Now that's not true at all. In fact, only a 'pataphysician is capable of complete seriousness. You see, we take everything seriously. Absolutely everything." He sipped his whiskey.

"According to the Principle of Universal Equivalence, everything is just as serious as everything else. A battle to the death with Resurrectionists, a game of Scrabble, a love affair—all are equally serious."

"But people say . . ."

"People don't always understand," Gyro said gently. "You see, people confuse playing with not being serious. We are very serious about our play."

Bailey frowned. "I guess I see. You play—but you take it seriously so that you can win, and . . ."

"Ha ha, no. Playing to win—that's not it at all. When you are playing to win, you are in a finite game, a game with boundaries. I was speaking of the infinite game, where one plays simply in order to continue to play."

"So you don't take winning seriously?"

"We take it just as seriously as we take everything else." (Murphy 1999, 56)

Where "serious" fiction crosses science fiction we may find writers such as Angela Carter, whose 1972 novel *The Infernal Desire Machines of Doctor Hoffman* includes a quotation from *Faustroll* at the start, and imagines the diabolical eponymous hero and his attempts to destroy reason and the reality principle.

In 1985, Julian Barnes contributed a story called "Gnossienne" to *Granta: 50*. The story was later published as part of a collection entitled *Cross Channel*. Barnes had already hinted at aspects of pataphysics in his breakthrough novel *Flaubert's Parrot* (1984) and this story, whose title was taken from a collection of pieces by Erik Satie, played with the ambiguities of the Collège de 'Pataphysique (especially in its occulted form) and the Oulipo. "Gnossienne" is written in such a way as to convince the reader that the narrator is Barnes himself. Invited to a literary conference, he overcomes his reluctance to attend out of a sense of curiosity sparked by the instructions to meet at a small village called *Marrant* in the Massif Central on a particular day on a particular train.

There was something familiar about it, which I eventually located, as I did the insouciance and cheeky familiarity of the invitation, in a particular French literary tradi-

tion: Jarry, pataphysics, Queneau, Perec, the OULIPO group and so on. The official unofficials, the honoured rebels: [. . .] What was that definition of pataphysics? "The science of imagining solutions." And the point of the conference consisted in being met at the station. (Barnes 1996, 117)

His host is "Jean-Luc Cazes, one of those old-fashioned, Left-Bank, anarcho-rock characters (tired leather blouson, pipe wedged in the corner of mouth), the sort of genial zinc-bar philosopher you suspect has an alarming success rate among women."

The story plays out into a charming dissolution of its mystery in a mixture of cheese and red wine. It concludes by revealing that "Jean-Luc Cazes [. . .] was a writer invented by the OULIPO group and used as a front for various promotional and provocation or enterprises. *Marrant* is the French for funny, which of course I had known before I set off: where else would you expect a pataphysical encounter to take place? I have not seen any of my fellow participants since that day, which isn't surprising. And I have still never been to a literary conference."[1]

The American writer Pablo Lopez has coined the term 'pataphor to describe "a figure of speech that exists as far from metaphor as metaphor exists from non-figurative language. Whereas a metaphor is the comparison of a real object or event with a seemingly unrelated subject in order to emphasize the similarities between the two, the 'pataphor uses the newly created metaphorical similarity as a reality with which to base itself. In going beyond mere ornamentation of the original idea, the 'pataphor seeks to describe a new and separate world, in which an idea or aspect has taken on a life of its own." Lopez provides the following example:

NON-FIGURATIVE
Tom and Alice stood side by side in the lunch line.

METAPHOR
Tom and Alice stood side by side in the lunch line, two pieces on a chessboard.

'PATAPHOR
Tom took a step closer to Alice and made a date for Friday night, checkmating. Rudy was furious at losing to Margaret so easily and dumped the board on the rose-colored quilt, stomping downstairs. (Lopez 2007)

MUSIC

A particular line of experimental music in Britain and the USA emerged from the work of John Cage, whose close friendship with Marcel Duchamp

and involvement in the Fluxus group connected him with the pataphysical tradition. Cage was not a fan of Jarry, declaring:

I have an allergy, you might call it, against the kind of expression that was Jarry's, but it's clear that Duchamp did not. But I agree with the view that everyone was influenced by Jarry. I myself think that Duchamp and Joyce having used Jarry is far more interesting than anything Jarry himself did. (Anastasi 2000)

Cage's "silent" piece, *4'33"*, composed in 1952, was presaged by Alphonse Allais's silent composition *Marche funèbre composée pour les funérailles d'un grand homme sourd* (Funeral March for the Obsequies of a Large Deaf Man, 1884). Both are examples of an imaginary solution in music but, as the two titles illustrate, the nature of their humor is very different. In Cage's case, the piece has Zen Buddhist overtones, with an encouragement to open one's ears to environmental sounds. Even so, Cage seems to have enjoyed the more anarchic aspects of the composition.

Several other experimental composers have been influenced by pataphysics. In 1972, Gavin Bryars composed *The Sinking of the Titanic*, which explicitly set out to give a pataphysical account of the tragedy. The piece included fragments of interviews with a survivor, Morse signals played on woodblocks, references to the different bagpipe players on the ship (one Irish, one Scottish), miscellaneous sound effects relating to descriptions given by survivors of the sound of the iceberg's impact, and other "found materials." The "imaginary solution" that provided the most overtly pataphysical aspect of the piece, however, was the prolongation of the hymn tune "Autumn" that was famously played by the ship's band, recorded underwater. In Bryars's version, the band plays for eternity:

The prolongation of the music into eternity, however, comes about from another "scientific" point of view. Marconi had developed the principles of wireless telegraphy over great distances and this was the first extensive use of wireless in ocean rescue. In fact, when Bride arrived in New York on the *Carpathia*, Marconi rushed on board to shake his hand. Towards the end of his life, Marconi became convinced that sounds once generated never die, they simply become fainter and fainter until we can no longer perceive them. Curiously enough, one of the rescue ships, the *Birma*, received radio signals from the *Titanic* 1 hour and 28 minutes after the *Titanic* had finally gone beneath the waves. To hear these past, faint sounds we need, according to Marconi, to develop sufficiently sensitive equipment, and one supposes filters, to pick up these sounds. Ultimately he hoped to be able to hear Christ delivering the Sermon on the Mount. (Bryars 1990)

Bryars has continued to make both overt and covert references to pataphysics in his work. Many of the early experimental pieces are conceptual

in nature, pieces that exist in the imagination as much as in reality. Concert works of the period also show the pataphysical presence, so *Ponukélian Melody* (1975), for example, is directly inspired by Roussel's *Impressions of Africa*. Such ideas remain as programmatic themes in the more recent pieces.

The veteran maverick John White continues to produce pataphysical music, most recently for the London Institute of Pataphysics, of which he has become something of a composer in residence. White's output is vast, extending to nearly 200 piano sonatas, over 20 symphonies, more than 30 ballet scores, a body of electronic music, and a very large amount of incidental music for the stage. It is generally characterized by the kind of ironical humor and references to found material that typify a certain kind of pataphysical art. One recent work, a homage to Jacques Prévert which processes the sounds of a poem through various electronic devices, sums up the approach by being both strangely evocative and yet apparently meaningless.

Jazz has been a stronghold of the pataphysical infuence, in particular in its more "anarchic" forms of free improvisation. *Raudelunas 'Pataphysical Revue* is the title of a 2002 album by the Rev. Dr. Fred Lane (alias of Tim Reed), an enigmatic character who has been creating pataphysically inspired music and wind sculptures since the 1980s. Norbert Stein's *Pata-Music* is a record label that features recordings of his own influential improvisations. More recently, artists such as Karen Mantler have shown signs of a pataphysical influence.

Popular music continued the Ubu fetish, through bands such as the *avant-garage* Père Ubu, formed in 1975 and still going strong. *The Sisters of Pataphysics* was a 1989 album by the avant-garde band Nurse with Wound led by Steve Stapleton. Pataphonie were a French prog-rock outfit active in the 1970s. There has even been a musical: *Ubu Rock* (1995) by Rusty Magee.

The major figure, at least in spirit, was Frank Zappa, most of whose recorded output may be viewed as a pataphysical legacy, albeit not explicitly labeled as such. Zappa seems to have picked up on the interest in pataphysics generated on the West Coast by the celebrated issue 13 of the *Evergreen Review*, published in 1960, Roger Shattuck's *The Banquet Years*, and the English translations of Jarry, who was seen as a precursor of figures such as William Burroughs and Hunter S. Thompson. This became part of the *Zeitgeist* of hippiedom and a byword for all that was "far out" or zany, a tradition that continues to this day. Bands such as The Residents and musicians such as Captain Beefheart were clearly aware of pataphysics and worked it into their output, but in a freewheeling sort of way that was inspired more by its spirit of nonconformity than by the letter of the written words.

NORTH AMERICAN CULTURE

The strongest evidence for Zappa's interest in all this, apart from his recorded legacy, is provided by Nigey Lennon's biographies of both him (*Being Frank: My Time with Frank Zappa*) and Alfred Jarry. Lennon was closely associated with Zappa for a time in the 1970s. The introduction to *Alfred Jarry: The Man with the Axe* (1984) discusses the profound impact the life and works of Jarry had on her as an adolescent. Although lacking in biographical detail (it owes a great deal to Shattuck), the book gives an account of how pataphysics as a concept translated into US culture and became intertwined with the left-of-field vibe of the time.

The Man with the Axe was illustrated by Bill Griffith, whose *Zippy the Pinhead* comic strip, which started in the 1970s, is clearly inspired by Ubu. Zippy wears a yellow muu-muu (Hawaiian shirt or clown suit) covered in large red polka dots, and is a microcephalic philosopher with an Ubu-shaped head, whose blind pursuit of a kind of knowingness produced the famous catchphrase "Are we having fun yet?" Griffith explains that Zippy is really his own inner child, or represents the "natural spirit" within us all, and the strip is to be read as a constant dialog between Zippy and his assistant Griffy, who is Griffith himself. "Zippy does not 'rave,' nor does he speak 'gibberish' . . . there is sense in 'nonsense,' logic in 'illogic,' if you'll allow it in . . ." (Griffith 2002).

This brand of pataphysics also made its way into the minds of some of the early computer visionaries. Figures such as Ted Nelson, who coined the word "hypertext" in 1963, or Howard Rheingold, who was one of the first to describe a Virtual Community and in 1991 published *Virtual Reality: Exploring the Brave New Technologies of Artificial Experience and Interactive Worlds from Cyberspace to Teledildonics*, have long acknowledged the importance of pataphysics in their work. Rheingold declared in a recent tweet: "I was one of the readers of the Evergreen Review issue on pataphysics at age 16, got into Jarry, Ubu & Satie because of it." With some friends he has recently created a Pataphysical Slot Machine.

Peter Schickele, the inventor of P. D. Q. Bach, and Tex Avery, the legendary animator, both showed pataphysical tendencies, which also exist in many more examples of American humor. In Canada, the idea was extended into an entire political party, The Rhinoceros Party, who contested a number of elections on their platform of "a promise to keep none of our promises." They then promised outlandishly impossible schemes designed to amuse and entertain the voting public, such as repealing the

law of gravity, putting the national debt on Visa, and declaring war on Belgium because Tintin killed a rhinoceros during one of his adventures.

ART

The pervasive influence of Marcel Duchamp has effectively pataphysical-ized the visual arts. It may be detected throughout conceptual art, such as in the work of Turner Prize winners Martin Creed (*Work No. 227, the lights going on and off*, 2001) and Simon Starling, whose *Tabernas Desert Run* of 2004, with its improvised electric bicycle, seems to evoke both Jarry and Duchamp. It could be argued that conceptual art itself is an imaginary solu-tion, relying as it does on the subjectivity of the viewer. As Duchamp put it, in a lecture entitled "The Creative Act," delivered at a meeting of the American Federation of Arts in 1957:

The creative act is not performed by the artist alone; the spectator brings the work in contact with the external world by deciphering and interpreting its inner qualifica-tions and thus adds his own contribution to the creative act. (Duchamp 1975, 140)

Most of the art that has proved so controversial and so popular in the past few decades acknowledges Duchamp as a primary source. Given the depths to which pataphysics penetrated Duchamp's life and work (which will be discussed later), it is not surprising to find hints of it popping up in the work of many of today's leading artists.

Pataphysics is also a discernable presence in the work of many other artists throughout this period. To give but a few examples: the useless machines of Jean Tinguely and Niki de Saint Phalle have playful echoes both of Duchamp's bachelor machines and Jarry's impossible mechanics; the work of Louise Bourgeois is full of pataphysical spirit, a fact which was recognized in 2009 when the Transcendental Satrap Fernando Arrabal pre-sented her with the Ordre de la Grande Gidouille (Commandeur Exquis); and Barry Flanagan's interest in pataphysics began in 1963 and continued up until his death in 2009. The pataphysical spirals that are symbols of liberty in his early work evolved into the hares for which he is best known:

Throughout world mythology trickster figures transgress frameworks of right and wrong, delighting in breaking the rules, boasting and playing tricks on both humans and gods. They may also act as messengers between human and divine worlds, and most tricksters are shape changers, often appearing as animals, including, of course, the hare. (Wallis 2011, 19)

One artist who paid overt homage to pataphysics was Thomas Chimes (1921–2009). Chimes was profoundly influenced by issue 13 of the *Evergreen*

Review and later texts by Roger Shattuck, including *The Banquet Years* with its accounts of the lives of Apollinaire, Jarry, Rousseau, and Satie. Up to that point, Chimes's painting had shown a number of influences, such as Van Gogh, Picasso, and Matisse. In 1965, he produced some book jacket illustrations that revealed a deep interest in alchemy and mysticism, most notably for the hermetic text *Cymbalum Mundi* (1538) by Bonaventure des Périers. He also became fascinated by the figure of Antonin Artaud, who had cofounded the Théâtre Alfred Jarry in Paris in 1926 with Robert Aron and Roger Vitrac. Marcel Duchamp and Man Ray too were key figures, along with Joseph Cornell, whose boxes provided a sense of peeking into a mysterious hidden world. The result of all these influences was a memorable series of panel paintings begun in 1973 which comprise portraits of figures such as Edgar Allan Poe, Michael Faraday, Aubrey Beardsley, Oscar Wilde, Ludwig Wittgenstein, Alfred Jarry, and the first Vice-Curator of the Collège de 'Pataphysique, Dr. I.-L. Sandomir. It was Jarry himself who left the most lasting impression, gradually merging into Chimes's own dreams. He recalled:

Later on somehow this impish little figure of Jarry as I observed it in the photographs, and in the writings and the kind of things he had to say in his work, I connected with a dream I had when I was five years old that had really frightened me. Five years old, this was in South Georgia where we were living at the time. The dream is simply this. It's my earliest dream, but it terrified me. I see a desert. There is a mound, a dune in that desert, a single dune. And standing on that dune, there is this tiny little black figure with staring eyes looking directly at me and whose mouth is puckered in a shrill whistle, which just terrified me. I can still see the dream. Now, how I connected Jarry to that dream I don't know, except through my studies in psychology I had dreamed of an archetypal form and the connection was made. (Taylor 2007b, 135)

This self-identification with Jarry developed further in the 1980s, when Chimes's style changed and he produced a series of larger canvases that depict hazy forms dimly perceived through a blanket of whiteness that resembles thick snow or dense fog. One of these, entitled *Faustroll/Square* (1988), reproduces the head of Jarry wearing a porkpie hat, from a well-known photograph of him riding his bicycle, taken in 1898. By reproducing only Jarry's head, Chimes emphasizes a certain physical similarity with himself (he took to wearing a porkpie hat during this period too), but the haziness suggests another deeper layer beyond the panel portraits which Chimes called "emerging consciousness." In an interview with Marian Locks in 1990 he explained: "What lies hidden and mysterious in the metal boxes and the panel portraits seems to show forth in the whiteness" (Locks 1990, 104).

CULT AND OCCULT

While the influence of pataphysics has often unobtrusively suffused culture, the cult of Ubu (and hence of Jarry) has remained very much more obviously alive. The Ubu plays have been produced and adapted thousands of times, ranging from Peter Brook's *Ubu aux Bouffes* (1977) to Jane Taylor's *Ubu and the Truth Commission*, performed in South Africa in 1997, to Veggie Vaudeville's 1992 version featuring a cast of fruit and vegetables. Versions of Ubu have appeared in film and on TV, from Geoff Dunbar's cartoon movie to the Ubuesque work of the Brothers Quay. There have been several Ubu musicals, and a succession of Ubu operas including those of Krzysztof Penderecki (1991), Andrew Toovey (1991–1992), and Donald Dinicola (2002). The Ubu plays have been constant and popular favorites for student productions, and it is really true to say that the figure of Ubu has become an archetype that has entered the public consciousness. There is Ubu beer, Ubu production companies, Ubu comic strips, Ubu design, and Ubu jewelry. The computer game *Broken Sword: The Shadow of the Templars* is stuffed with references to Ubu and Jarry. The list goes on.

Meanwhile, a more hidden aspect of pataphysics has entered the public domain through an occult route. The series of speculations surrounding the mysteries of Rennes-le-Château, the Knights Templar, and the rest, which provided the materials for Dan Brown's bestselling mystery novel *The Da Vinci Code* (2003), began around 1982, during the occultation. The source for Brown's novel was *The Holy Blood and the Holy Grail*, by Michael Baigent, Richard Leigh, and Henry Lincoln, which describes a mysterious individual named Pierre Plantard who supplies the authors with certain information regarding the sudden accumulated wealth of a parish priest, and an organization called the Prieuré de Sion (Priory of Sion). The heart of the mystery is the delineation of a direct line of descent from Christ and Mary Magdalene to Plantard himself. The Holy Grail, *Saint Graal*, is in fact a bloodline, *sang réal*, upon which (rather pataphysical) pun the whole story rests.

Pierre Plantard's evidence relied heavily on a collection of "medieval" documents, which were in fact created by his colleague Philippe de Chérisey. The latter was a contributor (under the name Amédée, for which he was better known as a radio humorist) to an issue of the *AA Revue* which made a study of circumflexes and diereses. The name of this journal has led to some speculation that it is the continuation of a seventeenth- and eighteenth-century secret society: *L'AA Cléricale* (Douzet 2004), and hence to a whole series of speculations designed, of course, to support the central thesis of a Christ-line. To pataphysicians, on the other hand, the meaning

is immediately clear: AA is simply the pronunciation specified by Jarry of Bosse-de-Nage's repeated "ha ha"s: "In the first instance, it is more judicious to use the orthography AA, for the aspiration *h* was never written in the ancient language of the world" (Jarry 1965a [1911], 228). The *AA Revue* was published and edited in Liège, Belgium, by Richard Tialans and may be considered to have existed in parallel to the Collège de 'Pataphysique's own publications.

Philippe de Chérisey's writings are full of mischievous touches. The parchments supplied to Plantard, and planted in the Bibliothèque Nationale, contained many errors in Latin translation, but were nevertheless good enough to fool the somewhat gullible journalists. The full extent of the pataphysical involvement in an occult story which still seems to grip the popular imagination has never been documented.

OULIPIAN WRITINGS

The period of the occultation saw the flowering of Oulipian writing. The Oulipo had been founded in 1960 by Raymond Queneau, François Le Lionnais, and others, initially as a subcommission of the Collège de 'Pataphysique. Oulipo—or, more correctly, OuLiPo—is short for *Ouvroir de la Littérature Potentielle*. This is usually translated as "workshop for potential literature," although *ouvroir* is a slightly odd word, meaning a sewing circle or Dorcas Circle (presumably chosen as a way of diminishing its activities). There were 14 founding members, all of whom were French, including not only writers but also mathematicians, engineers, and computer scientists. The group still meets monthly to investigate potential literature or new structures and patterns that could be used by writers. This emphasis on *potential* rather than actual literature meant that the Oulipo felt no obligation to produce creative writing as such. Instead, many of the early publications were simply elaborations of method or manifestos. These will be explored later in this book. However, the group did contain writers, and it is no surprise to find them applying Oulipian constraints, such as algorithms, lipograms, wordplay, and systems and processes of all kinds, in their work.

The Oulipo continues to flourish today and membership stands at 36, which includes all the deceased members, since once you have joined the group you may never leave. The group has in many respects filled the gap created by the temporary absence of the Collège de 'Pataphysique, at least in the public mind. However, although it retains the ludic approach to language that characterizes much pataphysical literature, it has a distinctly different flavor to the anarchic and iconoclastic tendencies of Jarry-based

pataphysics. Its influence, both in literature and in academic circles, is considerable, not least because of a series of works by Oulipian writers that may be considered to be among the genuine masterpieces of twentieth-century literature. Identifying the extent to which pataphysics forms part of that influence is not straightforward. Pataphysics was in the soil from which the Oulipo grew, and so in some senses permeates all aspects of Oulipian writing, but there are other things that could also make that claim. It is probably accurate to say that the amount of pataphysics varies from writer to writer, but its presence is constant throughout the Oulipo. The only way to get to the bottom of this question is to consider some leading examples.

GEORGES PEREC (1936–1982)

Subsidia Pataphysica 6 of the publications of the Collège de 'Pataphysique includes the following notice:

Within the (ever-increasing) scope of the labors of the Ouvroir de la Littérature Potentielle, M. Georges Perec, one of the new members recently admitted into the ranks of the Co-Commission, has set about (and, what is more, seen through!) the writing of a lipogrammatic novel entitled, appropriately enough, *La Disparition*. (Collège de 'Pataphysique 1968, 73)

A footnote further explains that a lipogrammatic novel is one in which the author is constrained to omit a letter or letters. The record for undertaking such an exercise had, up to this point, belonged to an English writer, Ernest Vincent Wright, whose 267-page novel *Gadsby* (1939) entirely omitted the letter *e*.

According to the Collège article, Perec's novel attempted a similar feat in the interests of bringing the record to France.[2] While there may well be an element of truth in this claim, the full reasons behind Perec's extraordinarily virtuosic and, some might say, masochistic enterprise were quite complex and, indeed, personal. There is no doubt that *La Disparition* is an anomalous work, but not in ways the critics always understood. One reviewer, René-Marill Albérès, wrote in *Les Nouvelles littéraires* on 22 May 1969:

La Disparition is a raw, violent and facile fiction. A man disappears . . . Another man disappears . . . and—you must have guessed this—Georges Perec is too crafty to supply any conclusion. . . . The mystery remains entire, but the novel is finished; that is the contemporary form of "literary" detective fiction.

Perec loved this review, because it failed to notice the absence of the *e*. Achieving an elegant and convincing story in spite of the rigors of the constraint was highly important to him. *Gadsby* stood as an example of

how a lipogrammatic novel could be no more than a redundant technical exercise. The challenge was not just to write without the letter *e*, but to make the result readable.

To create the novel Perec was obliged to assemble a lexicon of *e*-less words, and indeed to think and talk in lipograms. David Bellos recounts how Perec drew friends and visitors into the creative process:

For much of 1968 no one came to stay at the Moulin d'Andé without being tackled by a grinning imp of a man intent on extracting a least a sentence or two without an *e*. Perec had never really allowed himself to develop his talents as a seducer or manipulator of others, but now he learnt how to make himself irresistible in the service of words. (Bellos 1993, 399)

Perec's enjoyment of the creative process and the technical challenge made him apparently oblivious to the riots of May '68 in Paris. Yet the very existence of this novel conceals a deep engagement with earlier events in Europe. In French, the letter *e* is pronounced *eux*, which means *them*, a letter used as a stamp by French administrations after the war to indicate a person missing presumed dead. This is a novel about the "disappeared," and in Perec's case it had a particular resonance, since members of his family had been deported to concentration camps and presumably gassed during the war. Bellos states:

In his drawer at rue du Bac, Perec still had the certificate issued in 1947 by the Ministry of War veterans in re Perec Cyrla née Szulewicz, last seen alive at Drancy on the 11th February 1943, a document headed ACTE DE DISPARITION. (Ibid., 400)

Perec Cyrla née Szulewicz, better known as Cécile, was Georges Perec's mother.

The novel itself makes no mention of this hidden autobiographical subtext. Instead it is a multiple whodunit whose virtuosity lies not just in the use of the constraint but also in the way in which Perec plays within the rules. Characters disappear at the moment at which they are about to utter a word containing the letter *e*! Everything in the book tends toward disappearance. There is a constant sense of the absence of something, the elision of precisely that element which might provide some meaning, but which, at the same time, one senses probably will not. Just like the pataphysical apostrophe, present "to avoid an obvious pun" which one will never understand, the reasons for the missing letter are as much a part of the mystery of the book as the series of murders it describes. As if to ram home the point, Perec wrote a second lipogrammatic story in 1972, a vaguely raunchy tale entitled *Les Revenentes* (which has been translated as *The Exeter Text: Jewels, Secrets, Sex*) which uses *e* as its only vowel. It is as if he wanted to use up

all the *e*'s that had been eliminated from *La Disparition*. Jacques Roubaud, another Oulipian, observed that these two novels are made from disjoint sets. Formally, two sets A and B are disjoint if their intersection is the empty set, i.e., if $A \cap B = \varnothing$. This means that a third novel is theoretically possible, made from the words not used so far (those containing both "e" and a vowel other than "e").

Perec's other achievements in the field of extreme literary constraints included a palindrome of more than one thousand words and, to be precise, 5,566 letters, composed in 1969. This in fact comprises two texts, each around 500 words, which give two different readings, thanks to word divisions and punctuation, of the same sequence of letters. Bellos comments:

> The Great Palindrome must have been the very hardest of texts to write, and it is undeniably difficult to read. Knowledge of the constraint disarms critical faculties; when you know that it is a monster palindrome, you tend to see nothing but its palindromic design. At Manchester, in 1989, doctored photocopies and unsigned handwritten versions were given to students and teachers of French who were to mark it as an essay. Perec's palindrome barely made sense to the readers. Some teachers took it for the work of an incompetent student, while others suspected that they had been treated to a surrealist text produced by "automatic writing." Those with psychiatric interests identified the author as an adolescent in a dangerously paranoid state; those who had not forgotten the swinging sixties wondered whether it was LSD or marijuana that had generated the disconnected images of the text. Readers seem to project their own positive and negative fantasies onto Perec's palindrome, as they do onto other difficult, obscure and unattributed works. But it is perhaps not now simply a matter of projection if we glimpse anger, cruelty, and self-mutilation in some of the jagged images of Perec's reversible text. (Bellos 1993, 429)

The richest application of Oulipian constraints, however, occurs in Perec's masterpiece *La Vie mode d'emploi* (Life: A User's Manual, 1978). This book describes the lives of the inhabitants of a fictitious Parisian apartment block, 11 rue Simon-Crubellier. The novel takes place at the moment the central character, Bartlebooth, fails to complete a bizarre self-imposed task. Having spent 10 years learning to paint watercolors, he then tours the world for 20 years, painting a picture of a different port every two weeks or so. He sends each painting back to France, where the paper is glued to a support board, and made into a jigsaw puzzle. When he returns to Paris, Bartlebooth spends the rest of his life solving each jigsaw. When he completes a jigsaw, the support board is removed and the pieces are glued back together again, with the resulting image being sent back to the port where it was painted. Exactly 20 years to the day after it was painted, it is placed in a detergent solution until the colors dissolve, and the paper,

now completely blank, is returned to Bartlebooth. The aim is to leave no mark upon the world whatsoever, but Bartlebooth's plan is foiled by the increasing difficulty of the jigsaws and by the attempts of an admirer to prevent the destruction of his paintings. Bartlebooth dies in 1975, 16 months behind schedule, and while working on the 439th puzzle.

Many of the characters who assist Bartlebooth in his self-defeating task are also residents of the same apartment block. This narrative is only a central thread, however, and there are many more tales which unfold both backward and forward in time, as Perec describes in meticulous detail every single room and individual, complete with their imagined histories.

In 1981 Perec himself wrote a detailed account of the novel's underlying structure and his compositional approach, entitled *Quatre figures pour 'La Vie mode d'emploi'* (Four Figures for 'Life: A User's Manual') (Perec 1981), which explained that the underlying constraint of the novel was the application of a 10 x 10 Greco-Latin bi-square as a structuring device. This is a mathematical square of order n over two sets S and T, each consisting of n symbols (in Perec's case, $n = 2$). There is a 10 x 10 arrangement of cells, each cell containing an ordered pair of numbers, such that every row and every column contains each number exactly once, and that no two cells contain the same ordered pair of symbols. This is then applied to the façade of an imagined Parisian apartment block, so as to cover every room within.

The Knight's tour of the chessboard, in which the Knight travels around the board landing on each square once and only once, provided the chapter sequence. The division of the book into six parts was derived from the same principle: each time the knight has finished touching all four sides of the square, a new section begins.

Perec explains how the narrative is then constructed, using these constraints:

Imagine a story 3 chapters long involving 3 characters named Jones, Smith, and Wolkowski. Supply the 3 individuals with 2 sets of attributes: first, headgear—a cap (C), a bowler hat (H), and a beret (B); second, something handheld—a dog (D), a suitcase (S), and a bouquet of roses (R). Assume the problem to be that of telling a story in which these 6 items will be ascribed to the 3 characters in turn without their ever having the same 2. The following formula:

	JONES	SMITH	WOLKOWSKI
CHAPTER 1	CS	BR	HD
CHAPTER 2	BD	HS	CR
CHAPTER 3	HR	CD	BS

—which is nothing more than a very simple 3 x 3 Greco-Latin bi-square—provides the solution. In the first chapter, Jones has a cap and a suitcase, Smith a beret and a bouquet of roses, Wolkowski a bowler hat and a dog. In the second, Jones has a beret and a dog, Smith a bowler hat and a suitcase, Wolkowski a cap and a bouquet of roses. In the third, Jones has a bowler hat and a bouquet, Smith with his cap will be walking a dog, and Wolkowski, wearing a beret, will be lugging a suitcase. All that remains to be done is to invent situations to justify these successive transformations.

In *Life: A User's Manual*, instead of 2 series of 3 items, 21 times 2 series of 10 items are permutated in this fashion to determine the material of each chapter. (Mathews and Brotchie 1998, 172)

Just as the novel itself describes a puzzle which is never completed, so Perec creates deliberate single errors or missing elements in his complex puzzle. Some groups of constraints contain a gap (something missing) and some contain an error (something false). This even applies at the highest level: one of the rooms is never described. Perec's system allows him to apply "gap" or "wrong" to lists that themselves contain "gaps" or "wrongs." Bellos explains:

Perec's impish machine thus allows him to apply "gap" in such cases by *not* missing out any other constraint in the group ("gapping the gap") or by missing out a constraint in a group *not* determined by the bi-square number ("wronging the gap") or by *not* getting anything wrong at all ("gapping the wrong"). An odd machine, by any standards, and one that would have tickled the College of Pataphysics by taking *clinamen* to a mind-boggling, recursive extreme. (Bellos 1993, 600–601)

This is not to say that the use of constraints is an inherently pataphysical activity. However, we do see here the introduction of a pataphysical rule that, in Christian Bök's words, "rules out the rule" (Bök 2002, 39). Perec's pataphysics is so deeply ingrained as to remove the need for an apostrophe. In *Life: A User's Manual* we can see a self-conscious adoption of a scientific approach to the kind of chance-based deviations in material reality implied by the *clinamen* that never loses a sense of its own irony and hence, at a deep and pataphysical level, humor.

ITALO CALVINO (1923-1985)

Italo Calvino joined the Oulipo in the early 1970s, having moved to Paris from Italy in 1967. He was already familiar with the work of Raymond Queneau, having translated *Les Fleurs bleues* (The Blue Flowers, 1965) in the same year. His earlier works, such as *Il visconte dimezzato* (The Cloven Viscount, 1952), *Il barone rampante* (The Baron in the Trees, 1957), and *Il cavaliere inesistente* (The Nonexistent Knight, 1958), had demonstrated an

extraordinary willingness to submit to the remorseless demands of an imag-
ined and self-imposed logic, within the context of allegorical fantasy. His
membership of the Oulipo was to result in a series of works underpinned by
constraints, which nevertheless retained Calvino's characteristic style and
elegance in storytelling.

Cosmicomiche (Cosmicomics, 1965) and *t con zero* (t zero, 1967) her-
ald this approach, both narrated by a character with the palindromic and
unpronounceable name Qfwfq, who stands outside time. Both books apply
scientific "facts" as a rigorous premise for the unfolding of an imaginative
story. The facts may be definitely true (such as the fact that the moon was
once closer to the earth than it is today) or more speculative (such as that
there was no color before the universe began); it matters not, since they
serve merely to provide a pretext for the magical stories.

Il castello dei destini incrociati (The Castle of Crossed Destinies, 1973)
describes a Chaucerian encounter between a group of travelers who, wish-
ing to tell one another their stories, are inexplicably struck dumb and so
obliged to communicate using only a set of tarot cards. A second part, *The
Tavern of Crossed Destinies*, employs the same constraint but using the Tarot
of Marseille. In an essay on these stories Calvino stated:

> I shared with the Oulipo several ideas and predilections: the importance of constraints
> in literary works, the meticulous application of very strict rules of the game, the use
> of combinatory procedures, the creation of new works using pre-existing materials.
> The Oulipo would only allow operations conducted with rigor, convinced that poetic
> value can arise from extremely constraining structures. (Calvino 1981, 384)

Probably the most Oulipian of all Calvino's works is the extraordinary *If
on a Winter's Night a Traveller*, which manages to pull off the feat of making
the reader into a character in the novel. It does this by writing every odd-
numbered chapter in the second person, and explaining to the reader how
he/she is preparing to read the next chapter. Each even-numbered chapter
is an excerpt from the book that the reader is trying to read, which seems
to be a novel by Italo Calvino called *If on a Winter's Night a Traveller*. How-
ever, each time the reader begins a chapter, his/her endeavors to read are
frustrated by a series of problems, including misprints, missing pages, blank
sections, and so on. Since each new chapter is in fact another book, and
each of these books is in its own way engrossing, the reader feels the frustra-
tion and is then readily drawn into a central detective story that emerges
from the odd-numbered chapters and involves two protagonists on the
track of an international book fraud conspiracy, a mischievous translator,
a reclusive novelist, a collapsing publishing house, and several repressive

governments. Calvino wrote an explanation of the book's compositional process for the Oulipo, entitled "How I Wrote One of My Books" (1984), an obvious nod to Raymond Roussel's *Comment j'ai écrit certains de mes livres* (How I Wrote Certain of My Books), and adopts a very similar explicatory manner which nevertheless fails completely to explain the novel.

So where, exactly, is the pataphysics in Calvino's work? To trace a direct line of influence from Jarry through Queneau to Calvino is not entirely straightforward. Beno Weiss, citing Linda Klieger Stillman, observes:

> Jarry's influence on Calvino's evolving artistic formation is due primarily to Jarry's demonstration that reality resides not only in observable, physical laws, but in exceptions to these laws. He is important too not only for showing Calvino the combinatory potentials of language and text, and that 'pataphysics is the "science of imaginary solutions," but also for being among the first "to reject chronological time sequence" in favor of the "spatialization of time," and for dismantling "standards of perception generally presumed adequate to measure and represent reality." (Weiss 1993, 89–90)

Weiss also observes that the rigorous methods of science were applied by Jarry in order to create his worlds. To this we may add that Jarry's willful use of anachronism, greatly in evidence in text such as *Messalina*, and his ideas of equivalence, expressed in *Faustroll*, combined with an elaborate and fantastical narrative style that is most prominent in some of the denser symbolist works such as *The Other Alcestis*, are the admixture from which Calvino, rather more than Queneau, springs. In particular, the theme of Time is one which the Oulipo, with its mathematical obsessions, tends to underplay. Calvino, like Borges, on the other hand, explores the ways in which our perceptions of time passing affect our thought and change our understanding. The pataphysical notion of time, it will be recalled, does not recognize a conventional succession of events, and culminates in Jarry's *ethernity*. This is something which reading Calvino leads us toward, whether through the narrations of Qfwfq, or indeed by becoming fictionalized ourselves.

OTHER OULIPIANS

Space does not permit a detailed examination of the pataphysical presence in the writings of every single member of the Oulipo. For the record, the members are, currently († = deceased):

Noël Arnaud †
Valérie Beaudouin

Marcel Bénabou
Jacques Bens †
Claude Berge †
André Blavier †
Paul Braffort
Italo Calvino †
François Caradec †
Bernard Cerquiglini
Ross Chambers
Stanley Chapman †
Marcel Duchamp †
Jacques Duchateau
Luc Étienne †
Frédéric Forte
Paul Fournel
Anne F. Garréta
Michelle Grangaud
Jacques Jouet
Latis †
François Le Lionnais †
Hervé Le Tellier
Jean Lescure †
Harry Mathews
Michèle Métail
Ian Monk
Oskar Pastior †
Georges Perec †
Raymond Queneau †
Jean Quéval †
Pierre Rosenstiehl
Jacques Roubaud
Olivier Salon
Albert-Marie Schmidt †

Suffice to say that pataphysics may be detected in many of these, even if not all of them are members of the Collège de 'Pataphysique. André Blavier contributed a vast study of literary madmen (Blavier 1982). François Caradec wrote an important biography of Raymond Roussel (Caradec 1997) as well as wonderful accounts of the less orthodox aspects of French theater, including *Le Pétomane 1857–1945* (Caradec and Nohain 1967), the story of

the celebrated "fartist" Jean Pujol, which was in 1979 made into a film starring Leonard Rossiter, directed by Ian MacNaughton, and was the subject of many other references in fiction and movies (in his 1974 film *Blazing Saddles*, for example, Mel Brooks plays the part of "Governor William J. LePetomane"). Paul Fournel's writings include "Suburbia" (Fournel 1995), a highly pataphysical tale whose text is entirely imaginary, leaving the reader to piece together the story from a collection of footnotes, preface, introduction, and other marginalia. Marcel Bénabou's work includes the Rousselian *Pourquoi je n'ai écrit aucun de mes livres* (Why I did not write any of my books), which describes his anguished struggle with the act of creative writing, and imagines a Book. "There would commence a long sentence in the conditional," he says at the beginning of a long sentence in the conditional, that ends after the promised twists and turns in "a clausula that concludes nothing" (Bénabou 1986).

Of the Anglophone Oulipians, Harry Mathews has achieved the greatest literary reputation. His early novels, such as *The Conversions* (1962) and *Tlooth* (1966), anticipate Oulipian techniques, whereas his later works explicitly adopt them. In particular, he contributed "Mathews's algorithm," which shifts letters, or blocks of text, in a given passage, in a fixed pattern which delivers surprising combinations. Mathews's texts that show a more obviously pataphysical sense of humor include *Country Cooking from Central France* (1980) (Mathews 1989, 9–22), a hilarious description of a seemingly endless imaginary ritual associated with the preparation of the perfect roast boned rolled stuffed shoulder of lamb (*farce double*), and the memorable *Singular Pleasures* (Mathews 1988), which comprises 66 brief descriptions of people masturbating, delivered with a mixture of humor and poignancy that is voyeuristic while not pornographic.

The Anglophone Oulipian who may have best captured the spirit of 'pataphysics was the late Stanley Chapman. He joined the Oulipo in 1960, yet never attended a single one of their meetings, and is barely mentioned in any of their publications, which is testament to the fact that he saw the pataphysical life as one to be lived, and lived with a sense of fun. Despite his voluminous writings, which included hundreds of poems and prose texts, mostly sent as letters or postcards to friends, he showed little interest in establishing a serious literary reputation. He is still best known today as the translator of Boris Vian and Raymond Queneau, and the freewheeling style of these translations conveys much about his attitude to life. He worked variously as an architect, designer, and unofficial theater critic, documenting in letters every performance he attended. His letter to Yves Simon giving incisive accounts of almost all the productions of *Ubu Roi* that

took place in the UK during his lifetime was published by The Printed Head as *Letter Concerning Productions of UBU in the UK* (Chapman 1993). He also contributed many designs to Collège publications, including the covers for the *Subsidia Pataphysica*. In 1991, he founded the OuTraPo (Ouvroir de Tragicomédie Potentielle) to work on potential theater, which is still active today and whose membership includes Milie von Bariter, Cosima Schmetterling, Jean-Pierre Poisson, Anne Feillet, Félix Pruvost, and Tom Stoppard, whose own works, such as *Travesties* (1974) and *Hapgood* (1988), exhibit both pataphysical and Oulipian tendencies. *Travesties* creates an imaginary encounter between James Joyce, Tristan Tzara, and Lenin in Zurich in 1917, while *Hapgood* is underpinned by the topological problem of the bridges of Königsberg (also used by Queneau), and quantum mechanics. In 2000, Chapman became the founding President of the London Institute of 'Pataphysics, a role which he dispensed with vigor right up to his death in 2009. He was a Regent of the Collège de 'Pataphysique and a member of the Lewis Carroll Society.

OU-X-POS (1973–)

The Oulipopo (Ouvroir de la littérature potentielle policière) was the first of the spinoff Ou-x-pos to be formed. It was created in 1973 by François Le Lionnais and others, with a mission to investigate potential detective fiction, recognizing that this genre was already an example of constraint-based literature with certain fixed requirements. Le Lionnais had anticipated the group with his publication "Les Structures du Roman Policier: Qui est le coupable?" (The Structures of Detective Fiction: Who is Guilty?) in *Subsidia Pataphysica* 15 (Le Lionnais 1972, 16–18), which sets out to classify "whodunit" into a workable system for combinatorial mathematical purposes. As well as such analytical work, the Oulipopo identifies constraints that might prove useful to writers of detective fiction, and indeed some original work (mostly pastiche) of its own. A typical example of its work is the 1975 text "Towards the definition of the perfect crime" (Collège de 'Pataphysique 1975, 41–45), which divides perfect crimes according to their legal and aesthetic perfection, and sets out a typology of the resulting subcategories.
 Other Ou-x-pos include:

- Ouarchpo—architecture
- Oubapo (Ouvroir de bande dessinée potentielle)—comic strips
- Oucipo (Ouvroir de cinématographie potentielle)—cinema
- Oucuipo (Ouvroir de cuisine potentielle)—cooking

- Ougrapo—graphic design
- Ouhispo—history
- Ou'inpo (Ouvroir d'informatique potentielle)—information technology
- Oumapo (Ouvroir de marionettes potentielles)—marionettes
- Oumathpo—mathematics
- Oumupo—music
- Oupeinpo (Ouvroir de peinture potentielle)—painting
- Ouphopo (Ouvroir de photographie potentielle)—photography
- Oupolpot—politics
- Oupornpo (Ouvroir de pornographie potentielle)—pornography

There are some which relate to social media, including an Oumypo for Myspace, and Ouwikipo, and the Oublogpo, which describes itself simply as an "Ouvroir de 'Pataphysique" (La Lumière 2006). This proliferation of Ou-x-Pos reflects a certain fascination with formula, but it should be noted that their levels of activity, and indeed reality, vary enormously. There are also various parody Ou-x-Pos in existence of which the same may even more emphatically be said.

LUC ÉTIENNE: SHOULD 'PATAPHYSICS BE TAKEN SERIOUSLY? (1984)

To conclude this chapter, and to act as a salutary reminder of the true role of pataphysics in all the above, here is a short text by Luc Étienne, or, more vulgarly, Luc Étienne Périn (1908–1984), who had been a fellow pupil with René Daumal in Charleville and became first a member of the Collège de 'Pataphysique and then, in 1970, of the Oulipo. He was an expert on word games, including spoonerisms, on which he wrote a book (Étienne 1956), palindromes, charades, and many more. His wonderful text *La Méthode à Mimile* (Boudard and Étienne 1970) is a kind of easy primer in the understanding and speaking of French street slang, or *argot*. He was also a musician, and composed several works using a decimal system which divided the octave into ten, rather than twelve, equal steps. Probably his most significant contribution was the creation of *phonetic palindromes*. These relied upon the tape recorder and the observation that the written palindrome is purely orthographic and does not reflect the sounds of the words. By reversing tape, he was able to create words and phrases that *sounded* similar backward as well as forward. These included those which produced the same words both ways, such as "une slave valse nue," and those which produced different words, such as "la femme joue, elle a chaud, Jeanne en

virage." The peculiar sound of these reversed tapes seems to prefigure the speech of the dwarf in David Lynch's television series *Twin Peaks*, and other similar experiments.

At one time or another in his life, even if only dimly aware or not formulated clearly, the true pataphysician is confronted in his most intimate being by the following two propositions:

PROPOSITION A
The true pataphysician takes nothing seriously, apart from 'Pataphysics . . . which consists of taking nothing seriously.

PROPOSITION B
Since 'Pataphysics consists of taking nothing seriously, the true pataphysician can take nothing seriously, not even 'Pataphysics.

[. . .]

The true pataphysician must not take himself seriously. Thereby he will protect himself from a temptation to which, alas, so many of contemporaries surrender! (Étienne 1984)

4 (1964-1975) PATAPHYSICS, 'PATAPHYSICS

This decade was marked by two distinct trends. On the one hand, pataphysics was increasingly publicly exposed in ways which surprised many of the people involved. It entered, or rather tried not to enter, the political arena through the events of May 1968 in Paris. It became part of the counterculture, which harvested its riches very effectively through poetry, music, and fiction. It even achieved widespread popular recognition, of a sort, when the word was used in a Beatles song. Many of these developments took place in the Anglophone world.

On the other hand, the Collège de 'Pataphysique, under its Third Vice-Curator, Opach, led a gradual withdrawal of French 'pataphysics from public view, culminating in the occultation of 1975. The general tenor of Collège publications during this period, from the definitive *Subsidium* 0 onward, was toward a more carefully elaborated doctrinal position, with the Oulipo and other Ou-x-Pos increasingly dominating public manifestations. The imperturbability of pataphysics found itself frequently challenged by its engagements with the quotidian world.

A PATAPHYSICAL HARVEST

The Great Sower is a symbol of France found on coins, but also the symbol of the Larousse dictionary, where she is depicted blowing at a dandelion

head. By a syzygy, she also became a symbol of the sowing of the seeds from which the pataphysical harvest might be gathered in. The seeds were scattered far and wide, words falling on various different soils and growing into crops that provided many forms of nourishment.

POETRY AND SCIENCE FICTION

In literature, the traditions of pataphysics opened up paths to experimentation, encouraged in part by Harold Bloom, for whom "the study of Poetic Influence is necessarily a branch of 'Pataphysics, and gladly confesses its indebtedness to '. . . *the* Science, of imaginary Solutions'" (Bloom 1972, 389).

The poet Kenneth Koch, for example, discovered Raymond Roussel, and introduced his work to John Ashbery. The pair named their influential literary magazine, founded in 1961, after one of his novels: *Locus Solus*. In the poem "The Instruction Manual," Ashbery imagines someone required to write an instruction manual on the uses of new metal who then, in Rousselian fashion, imagines Guadalajara, a place he has never visited. The poem ends (Ashbery 1956):

How limited, but how complete withal, has been our experience of Guadalajara!
We have seen young love, married love, and the love of an aged mother for her son.
We have heard the music, tasted the drinks, and looked at colored houses.
What more is there to do, except stay? And that we cannot do.
And as a last breeze freshens the top of the weathered old tower, I turn my gaze
Back to the instruction manual which has made me dream of Guadalajara.

By the mid-1960s, this influence had blossomed into Ashbery's mature style, and Koch subsequently translated a Canto from the *Nouvelles Impressions d'Afrique*. Ashbery traces his own work on Roussel in *Other Traditions* (Ashbery 2000, 45–48). He also contributed a foreword to Mark Ford's *Raymond Roussel and the Republic of Dreams*, in which he says of the *New Impressions*: "It seemed impossible that I would ever be able to read it with any understanding, but for a long time it was the thing I most wanted to do. So I learned French with the primary aim of reading Roussel" (Ford 2000, xii). This sums up the sense of urgent curiosity that filled many people confronted not just with Roussel, but with the entire pataphysical harvest.

Pataphysical ideas had also found a whole potential genre in science fiction, which had steadily blossomed, largely through the distribution of pulp magazines, into a thriving subculture that continues vibrantly to this day. Jarry's painstaking accuracy regarding mathematical and engineering

detail in texts such as *How to Construct a Time Machine*, and the rampant futurism of novels such as *The Supermale*, to say nothing of the highly intellectualized yet populist stance of *Ubu* and the various puppet theater works, made him a potential first point of reference for many science fiction writers. However, the main obstacles to their adoption of him as a literary hero had been the polysemic obscurity of his work, which invariably includes more layers than the simple quasi-scientific homilies of Wells or the narrative romps of Verne, and the simple fact that he wrote in French. His presence really began to be felt in sci-fi circles when the English translations of his work started to appear in the 1960s.

We must, therefore, be somewhat cautious when claiming science fiction for pataphysics. While it is tempting to see the whole genre as an extension of pataphysical principles (which in the unconscious sense, of course, it could be), this is really to overstate the case. Instead, the presence of pataphysics should be noted where it is acknowledged as such, or at least so evidently strong as to be deduced without fear of contradiction. The Collège de 'Pataphysique is helpful in this endeavor. In *Subsidia Pataphysica 22*, Paul Gayot first cites an earlier article by Marie-Louise Aulard, noting that she "identifies a certain distance [between pataphysics] and this genre," then sets out instead to map their intersections:

• The uncertainty of the frontier between the imaginary and the real treated for example and in an exemplary fashion by Daniel Galouye (*Simulacron 3*), an uncertainty which is also present in almost all the works of Philip K. Dick.
• The apprehension and description of the strange, which many science fiction writers stumble upon and in which Stanislav Lem (*Solaris, The Invincible*) has noticeably succeeded. [. . .]
• The theme of parallel universes which is perhaps the connecting thread in this quest for a relationship. Did not *Faustroll* define the Science of Imaginary Solutions as describing a world which one cannot see yet which perhaps one could see in place of this world? [. . .]
• Finally, might not humor (!) be a key? Are not certain authors normally categorized as "humorists" (Swift, Rabelais, Vaché, Boris Vian, and indeed Jarry himself), pataphysicians whose intrinsic seriousness, following the well-known formula, does not take itself seriously? [. . .]

By these counts, the most consciously pataphysical science fiction author will be one who ties together all these strings: serious to the nth degree, able to make strangeness and aberration palpable, and to make the real perceptible as just one possible flower in the bouquet of imaginary solutions. (Gayot 1973, 45–46)

Gayot goes on to discuss Robert Sheckley as an example of such an artist, mentioning also Fredric Brown and Raphael Lafferty.

Philip K. Dick certainly provides several hints at a pataphysical connection. In *Do Androids Dream of Electric Sheep?* (1968, later reissued as *Blade Runner*), Wilbur Mercer is the messianic figure of Mercerism, a religion that encourages fusion with other humans in order to share in suffering and persecution. At the dénouement, it turns out that Mercerism is a sham and Wilbur Mercer was in fact a character played by an alcoholic B-movie actor named "Al Jarry" from Indiana. Both the title and some of the content of his 1969 novel *Ubik* also seem to reference pataphysics. It describes a mysterious "ubiq"itous substance that preserves (both materials and people in half-life or suspended animation) in a world that is rapidly and disturbingly decomposing, brought from the future by semirobots. As Linda Klieger Stillman points out: "This novel deconstructs the anthropomorphic presuppositions of science and science fiction. The inorganic Other is capable, in most cases, of thinking and speaking—artificially?—and surpassing us in many domains, such as speed, calculating facility and strength" (Stillman 1985, 107–116). Stillman draws a direct parallel with the machines that both integrate and surpass humanity in Jarry, from the debraining machine to the machine to inspire love.

Stanislav Lem shares a similar sympathetic resonance with pataphysics. The planet in *Solaris* is about as great an example of an imaginary solution as it is possible to get. Its total-surface-covering ocean is able to enter the imaginations of the orbiting human scientists, exposing their flaws and the futility of an attempted dialog with an alien intelligence that is simply *too* alien for human communication. In many respects it is a description of ethernity.

J. G. Ballard (1930–2009) picked up the pataphysical influence in several of his dystopian science fiction short stories, such as those in the collection *The Four-Dimensional Nightmare* (Ballard 2001) which imagine a world in which art has declined to what Ballard called a "visionary present." The notorious novel *Crash* (Ballard 1973b) seems to connect strongly with the sexualized mechanomorphic themes in Jarry's *The Supermale*. The characters in *Crash* are able to become sexually aroused only when confronted by a real car crash, a form of fetishism known as symphorophilia. A sentence such as this—"The crushed body of the sportscar had turned her into a being of free and perverse sexuality, releasing, within its dying chromium and leaking engine-parts, all the deviant possibilities of her sex"—is highly reminiscent of the description of the way the "machine that inspires love" and the Supermale himself, André Marcueil, fuse into one orgasmic and technological entity at the end of Jarry's novel: "André Marcueil's body, stark naked, and gilded in spots with reddish gold, remained wrapped

around the bars—or the bars remained wrapped around it. . . . There the Supermale died, twisted into the ironwork."

Jarry's influence on Ballard is most explicitly expressed in "The Assassination of John Fitzgerald Kennedy as a Downhill Motor Race," written in 1967 and published in the *Evergreen Review* in 1973, more than a decade after its seminal issue on 'Pataphysics. Here, Ballard rewrites Jarry's blasphemous text *The Passion Considered as an Uphill Bicycle Race* (1903), which had been published in a translation by Roger Shattuck in the *Selected Works of Alfred Jarry* in 1965. Ballard notes: "The assassination of President Kennedy on November 22, 1963, raised many questions, not all of which were answered by the Report of the Warren Commission. It is suggested that a less conventional view of the events of that grim day may provide a more satisfactory explanation." Here is the opening, set against Jarry's original.

BALLARD:
Oswald was the starter.

From his window above the track he opened the race by firing the starting gun. It is believed that the first shot was not properly heard by all the drivers. In the following confusion, Oswald fired the gun two more times, but the race was already underway.

Kennedy got off to a bad start.

There was a governor in his car and its speed remained constant at about fifteen miles an hour. However, shortly afterwards, when the governor had been put out of action, the car accelerated rapidly, and continued at high speed along the remainder of the course.

JARRY:
Barabbas, slated to race, was scratched.

Pilate, the starter, pulling out his clepsydra or water clock, an operation which wet his hands unless he had merely spit on them—Pilate gave the sendoff.

Jesus got away to a good start.

In those days, according to the excellent sports commentator St. Matthew, it was customary to flagellate the sprinters at the start the way a coachman whips his horses. The whip both stimulates and gives a hygienic massage. Jesus, then, got off in good form, but he had a flat right away. A bed of thorns punctured the whole circumference of his front tire.

ROCK AND POP MUSIC

The most prominent aspect of the popularization of pataphysics was the way in which the musical counterculture of the 1960s and 1970s picked it up. A succession of bands made either direct or oblique references to it in their works. Probably the most influential was the progressive rock group

Soft Machine (Elton Dean, Hugh Hopper, Mike Ratledge, Robert Wyatt) who became, somewhat to their surprise, the "official orchestra of the College of Pataphysics" in the late 1960s. The *Volume Two* album of 1969 contains a "Pataphysical Introduction Parts I and II," with lyrics that begin as follows:

Good evening—or morning
And now we have a choice selection
Of rivmic melodies from the Official Orchestra of the College of Pataphysics.
But first is our great pleasure—and indeed we hope yours
To present in its entire and manifold entiretity
Ladies and Gentlemen
—the British Alphabet!

The following song duly recites the alphabet, as a prelude to an extended riff-based instrumental track. The jazz fusion style of the music was to set down a marker for the prog-rock of the future, but at this stage it lacked the bombast that came to characterize that movement.

Another prog-rock band that picked up pataphysics was Hawkwind, who included the science fiction writer Michael Moorcock as an honorary member.[1] The lyrics for their 1972 hit "Silver Machine" were written by Robert Calvert, who explained:

I read this essay by Alfred Jarry called, "How to Construct a Time Machine," and I noticed something which I don't think anyone else has thought of because I've never seen any criticism of the piece to suggest this. I seemed to suss out immediately that what he was describing was his bicycle. He did have that turn of mind. He was the kind of bloke who'd think it was a good joke to write this very informed sounding piece, full of really good physics (and it has got some proper physics in it), describing how to build a time machine, which is actually about how to build a bicycle, buried under this smoke-screen of physics that sounds authentic. Jarry got into doing this thing called "Pataphysics," which is a sort of French joke science. (Wall 1999)

The tip of the pataphysical iceberg in popular music may be found in The Beatles' song "Maxwell's Silver Hammer," which contains probably the best-known reference to an obscure avant-garde French literary concept in the whole of music (The Beatles 1969):

Joan was quizzical
studied pataphysical
science in the home.

Barry Miles recounts that Paul McCartney's interest in pataphysics began when he heard a radio broadcast of Jarry's play *Ubu cocu* (Ubu Cuckolded) on the BBC Third Programme in 1966. Paul said: "It was the best radio play I had ever heard in my life, and the best production, and Ubu was so

brilliantly played. It was just a sensation. That was one of the big things of the period for me" (Miles 1997, 229).

"Maxwell's Silver Hammer" seems to be modeled on the "Chanson du décervelage" (Debraining song) from *Ubu cocu*. The schoolboy Maxwell Edison's silver hammer repeatedly comes down "bang, bang" upon the heads of those who, in their normality, have offended him in various ways, and "makes sure that they are dead." Just like the "Chanson du décervelage," the Beatles' tune is reminiscent of music-hall: childishly simple and ironically joyous.

Meanwhile, *Sergeant Pepper's Lonely Hearts Club Band* (1967) offered a pataphysical solution to the problem of fame. An imaginary band delivers a "live" performance that is entirely synthetic to a nonexistent audience that is itself part of the recording. The celebrated album cover by Peter Blake seems to echo Dr. Faustroll's Library of Equivalent Books, with its impervious juxtapositions of unlikely bedfellows, such as Karlheinz Stockhausen, Bobby Breen, and Diana Dors. There are also some figures known to Jarry (Wilde, Beardsley) and others who were referenced in his writings (Poe, Wells). John Lennon's politics and Paul McCartney's interest in pataphysics combined in a way which typified their entire collaboration. As Paul commented, referring to John's involvement with avant-gardism: "That was the big difference between me and John: whereas John shouted it from the rooftops, I often just whispered it in the drawing room, thinking that was enough" (Miles 1997, 230).

Paul's interest in pataphysics, or at least Ubu, has continued, and in 1995 he produced a six-part radio show entitled *Oobu Joobu*, which aired on the American network Westwood One.

OTHER CROPS

Rock and pop were not the only forms of music to have picked up pataphysical ideas. They also featured in many musical theater and contemporary classical works of the period that referenced Jarry and Ubu in particular. A typical example was Bernd Alois Zimmerman's *Musique pour les soupers du Roi Ubu* (Music for King Ubu's Suppers, 1966), a work which consists entirely of quotations from other composers, many of them contemporaries, with an overtly satirical political message.

Mention should also be made of Jacques Carelman's delightful drawings of impossible objects, published as the *Catalogue d'objets introuvables* (Catalog of Unobtainable Objects, 1969). These included such witty designs as: an upside-down brassière for female trapeze artists, a collection of tandem

bicycles with seats facing toward one another (for lovers) or away from one another (for divorcées), and a hieroglyphic typewriter for Ancient Egyptian. This seems to connect with the imaginary solutions depicted in the drawings of William Heath Robinson (1872–1944), whose strange machines exhibit pataphysical traits. The tradition of graphic arts and cartoons in pataphysics has continued unabated, and Carelman himself was responsible for refounding the Oupeinpo in 1980.

PATAPHYSICS, SITUATIONISM, AND MAY 1968

The sequence of events that led to the student riots in Paris in May 1968 could in some respects be seen as a natural evolution from the anarchic tendency that pataphysics represented in Left Bank culture. At the same time, some of its most fundamental tenets seemed incompatible with the kind of serious political engagement that fueled the riots. This conflict of interests found its crucible in the Situationist International, whose ideas and motivations underpinned the riots, and whose attitude to pataphysics tells us a great deal about the factionalism of Parisian intellectual life, and at least something about the nature of pataphysics itself.

The facts of the May '68 riots are simply told. The story began at the Paris University at Nanterre, where in March 1968 around 150 students, poets, and musicians occupied university buildings in protest at class discrimination in French society. The university authorities called the police and subsequently shut down the University, threatening to expel the students involved. On 3 May, students at the Sorbonne University protested against these actions. This was followed by a march involving more than 20,000 protesters which was met by a violent police reaction. As negotiations between the students and the authorities broke down, more protests took place and barricades were erected in the streets. The heavy-handed way in which the police tried to suppress the rioters caused a wave of sympathy that extended around the Western world. Leading workers' unions in France called a one-day general strike on 13 May. Around a million people marched through Paris in protest. The Sorbonne was occupied and declared to be an autonomous "People's University." Workers began occupying factories and conducting wildcat sit-down strikes. It rapidly became clear that there was far more at stake here than just the rights of some students. The government, under President Charles de Gaulle, was under threat and the protests forced the dissolution of the National Assembly. For a few weeks, it really seemed as though a left-wing revolution was taking place in France.

However, in June and July, around the beginning of the traditional holiday season in France, the revolutionary fervor began to dissipate. Various leftist groups were banned, and workers were driven out of their factories by the police. The Sorbonne was retaken by the authorities, and President de Gaulle won victory in the legislative elections held in June. Matters came to a final head on Bastille Day (14 July), when a mixture of leftist and anarchist students mounted another street protest that was brutally suppressed by police. Although generally seen as a failure of the Left that has led to the demise of Marxism as a serious political force in the West, the events of May '68 nevertheless did achieve a sea change in French society. In general, it replaced the prevailing repressive conservative values with a more liberal attitude that embraced sexual freedom and human rights.

At the political heart of the protests was a surprisingly small group of intellectuals grouped together under the banner of the Situationist International. They were predominantly Marxists who were nevertheless influenced by European artistic avant-garde movements such as Dada, surrealism, and lettrism. The mission of situationism was to oppose capitalism through the fulfillment of underlying human passions. In order to enable this revolutionary activity, it would be necessary to construct *situations* or environments that provided suitable conditions. The situation created by capitalism, through the spectacles of mass media, advertising, and the built environment, was, according to the Situationist International, degrading to human existence and deliberately designed to suppress creative freedom. The central arguments are set out in the influential book *The Society of the Spectacle* (1967) by Guy Debord, and the *Internationale Situationniste* and other journals and pamphlets.[2]

Situationism deployed a number of strategies to try to overturn the spectacles of capitalism in favor of individual ownership and personal freedom. These included the *dérive*, or drift, which is: "a technique of rapid passage through varied ambiances. *Dérives* involve playful-constructive behavior and awareness of psychogeographical effects, and are thus quite different from the classic notions of journey or stroll" (Debord 1981 [1958], 50). Psychogeography was a technique for reimaging a landscape (usually urban). Walking through Paris using a map of Berlin was a classic example. It is still active today through the work of the London Psychogeographical Association and other groups.

Another situationist technique was the *détournement*, in which a work of art or media is varied or altered in order to create a new meaning that is opposite to the original intention. Debord identified two types, minor and deceptive:

Minor *détournement* is the *détournement* of an element which has no importance in it-self and which thus draws all its meaning from the new context in which it has been placed. For example, a press clipping, a neutral phrase, a commonplace photograph.

Deceptive *détournement*, also termed premonitory-proposition *détournement*, is in contrast the *détournement* of an intrinsically significant element, which derives a different scope from the new context. A slogan of Saint-Just, for example, or a film sequence from Eisenstein. (Debord and Wolman 1981 [1956], 8)

These strategies have distinct echoes of pataphysics: the *détournements* of Jarry's treatments of Shakespeare in the *Ubu* plays or the scientific theories of Lord Kelvin in *Faustroll*; the imaginary solutions of psychogeography which imply a removal from reality familiar from *Days and Nights* or *Faustroll*; the imaginary journey through Paris, and the use of bicycles so common in *dérives* that are reminiscent of *How to Construct a Time Machine* or of Jarry himself.

While Debord was the leading philosopher of the Situationist International (SI), a small number of other individuals from various backgrounds combined to form the group, representing lettrism, the London Psychogeographical Association, and COBRA, a counter-surrealist group whose name was derived from the initials of the home cities of its members: Copenhagen, Brussels, and Amsterdam.

One member of this group, Asger Jorn (1914–1973), became effectively the second-in-command of the SI, and a crucial figure in the dissemination and communication of its ideas to the wider public and other interested rival political groups who were active on the Left Bank at that time. Jorn was a Danish artist who had studied with Kandinsky in Paris in the 1930s. With Debord, he founded the SI in 1957. Although not a member of the Collège, he was a Commandeur Exquis of the Ordre de la Grande Gidouille. Nor was he the only pataphysician involved: Noël Arnaud, for example, was the coeditor of the *Situationist Times*, which ran for six issues between 1962 and 1964. Nevertheless, the Collège was always cautious about both Jorn and the SI.

All the events of May '68 took place in streets of the Left Bank where, twenty years earlier, the Collège had been founded. Ralph Rumney, one of the early members of the SI, recalled:

The College of 'Pataphysics was an influence on the Situationists. Debord hated anything which could be seen as having influenced him. He saw the College of 'Pataphysics as a wretched little coterie. I declined to become a member of the College because of the Situationists. I liked their publications, they had a coherence and a persistent line of thought running through them which, if you look at the twelve issues of "Internationale Situationniste," is not there. Now then, that may actually be in favour of the IS and say something rather good about it, because where I would

criticise Debord is that he wanted to be in charge of the group, he wanted to set up a party line and he wanted everyone to toe it. In fact he never really achieved this and consequently you get this amalgam of divergent ideas which did amalgamate in the first three days of May '68 and in the punk movement. It's not every little group of twelve that can lay claim thirty years later to having had any influence on two events as important as that. (Home 1996, 137)

The extent of the Collège de 'Pataphysique's involvement in situationism may be gauged not just through the participation of Jorn and others, but also in its publications. This was unusual, because in general they made little comment on any aspect of current affairs. But in *Dossier* 20, for example, there are essays on Jorn, Enrico Baj, and the Nuclear Art group, another small group to join the SI. However, the ideas of pataphysics itself needed some significant and well-nigh impossible tweaking if it was to become capable of political application. In short, they had to become something you could *believe in*. Jorn himself set out this rather anti-pataphysical position in an essay published in 1961 in the *Internationale Situationniste* journal.

ASGER JORN, "LA PATAPHYSIQUE: UNE RELIGION EN FORMATION" (PATAPHYSICS: A RELIGION IN THE MAKING) (1961)

The history of religion seems to be made up of three stages: so-called materialist or natural religion, which reached its maturity in the Bronze Age; metaphysical religion, beginning with Zoroastrianism and developing through Judaism, Christianity, and Islam to the Reformation of the sixteenth century; and finally, Jarry's ideology from the turn of the century, which has ended up laying the foundations of a new religion, a third kind of religion that could very well become the most widespread in the world by the twenty-second century: pataphysical religion.

Until recently, the pataphysical enterprise has been attributed no religious significance, quite simply because, outside the tiny circle of believers who publish the long-running private newsletter *Cahiers du Collège de 'Pataphysique*, pataphysics has had no significance at all.

The honor of having introduced pataphysics to the world goes to the Americans, with the publication of a special issue of *Evergreen Review* that lets the great pataphysical satraps speak for themselves. While the word "religion" is obviously never openly mentioned in this issue, the enormous success that it has enjoyed for the past year with the American intelligentsia has brought about a period of objective analysis of this new phenomenon, and it won't be long before they realize what's really at stake.

Natural religion was a spiritual confirmation of material life. Metaphysical religion represented the establishment of an ever-widening opposition between material life and spiritual life. The various degrees of this polarization were represented by various metaphysical beliefs, and were intensified and made all the more backward by an attachment to natural rites and cults that were more or less successfully transformed into metaphysical rites, cults and myths. The absurdity of this cultural my-

thology's persistence at a time when scientific metaphysics have already triumphed was demonstrated clearly by Kierkegaard's choice of confirming Christianity: one must believe in absurdity. The next question was: why? And the obvious response was that secular political and social authorities need to maintain a spiritual justification for their power. This, of course, is a purely material, antimetaphysical argument from a time when the radical critique of all traditional mythologies was beginning.

All sides, however, are calling for a new mythology capable of responding to the new social conditions. It is up this old sidetrack that surrealism, existentialism, and also lettrism have disappeared. The classical lettrists who persevered with this effort have gone even further—further backward—by carefully assembling all the elements that have actually grown incompatible with a modern and universal belief: the revival of the idea of the Messiah, and even of the resurrection of the dead; everything that guarantees the didactic character of belief. Now that politicians possess the means to bring about the end of the world in an instant, anything that has to do with the Last Judgment has become governmental, perfectly secularized. Metaphysical opposition to the physical world has been permanently defeated. The fight has ended in a knockout.

The only winner in this debate is the scientific criterion of truth. A religion can no longer be considered as the truth if it conflicts with what is known as scientific truth; and a religion that does not represent the truth is not a religion. This is the conflict that is about to be overcome by pataphysical religion, which has placed one of most fundamental concepts of modern science at the level of the absolute: the idea that equivalents are constant.

Suitable ground for the theory of equivalents was already prepared with Christianity's introduction of the idea that all men are equal before God. But it was only with the development of science and industry that the principle was imposed in every area of life, culminating, with scientific socialism, in the social equivalence of all individuals.

The fact that the principle of equivalence could no longer be restricted to the spiritual world gave rise to the project of scientific surrealism, already sketched out in the theories of Alfred Jarry. To the Kierkegaardian concept of absurdity, all that was added was the principle of the equivalence of absurdities (the equivalence of gods among themselves; and among gods, men and objects). Thus, the future religion was founded, the religion that cannot be beaten on its own ground: the pataphysical religion that encompasses all possible and impossible religions of the past, present and future indifferently.

If it were possible for this religion to go into the world completely unnoticed, if pataphysical beliefs were anonymously taught and never criticized, a seemingly irresolvable paradox would not be presented: the problem of pataphysical authority, the consecration of the inconsecrable (that is to say, its appearance in social life in the same role as earlier religions). Indeed, this particular religion cannot become a social authority without becoming antipataphysical at the same time, and everything that seeks social recognition finds itself surrounded by this singular fact of social authority. Thus, pataphysical religion could very well be the unconscious victim of its own

superiority over every common metaphysical religion, as there is certainly no pos-
sible reconciliation between superiority and equivalence.

To its credit, pataphysics has confirmed that there is no metaphysical justifica-
tion for forcing everyone to believe in the same absurdity. The possibilities of art and
the absurd are many. The logical conclusion to this principle could be an anarchist
thesis: to each his own absurdity. The opposite is expressed by the legal power that
forces every member of society to submit completely to the political absurdity of
the State.

But it should be said that the acceptance of a pataphysical authority, such as the
one currently being instituted, becomes a demagogic new weapon against the spirit
of pataphysics. It is the pataphysical program itself that prevents the existence of a
pataphysical program, making a Pataphysical Church impossible.

The impossibility of creating a pataphysical situation in social life also prevents
the creation of a social situation in the name of pataphysics. The reasons have al-
ready been given. Equivalence is the complete elimination of any notion of situa-
tion, of event.

At this time, when pataphysics is, on the outside, very much placed in a certain
cultural position, the inevitable consequences of this basic definition necessarily lead
to the creation of a schism within the followers of pataphysics between pure anti-situ-
ationists and those who, on the basis of pataphysical equivalences, are nevertheless all
in favor of the development of those organized absurdities known as games.

The game is the opening of pataphysics onto the world, and the realization of
such games is the creation of situations. There is therefore a crisis caused by the cru-
cial problem encountered by every adept of pataphysics: whether they should apply
the situological method of becoming socially active, or flatly refuse to act in any
situation whatsoever. It is in this instance that pataphysics well and truly becomes
the religion most perfectly suited to the modern society of the spectacle: a religion
of passivity, of pure absence.

There is also another problem that is no less serious, which demands a choice
from the organization of the antiorganizers, the Situationist International. The SI
is capable of completely adapting the pataphysical principle as antimetaphysical
method: this occurs directly in the establishment of new games. The absurdity of
superiority and absurd superiority are the very key to the game, and authority is its
essential object. By using the principle of equivalents as its point of departure, the
game is free: the situation can completely construct itself, in a pure appearance of
superiority and authority. But if, on the contrary, a metaphysical basis is chosen,
whatever it may be, situology will automatically fall to the level of an authoritarily
directed method of popular distraction, a reprise of the old formula of slavery: bread
and circuses.

After a long period of maturation in largely ignored circles, the basic elements
of a new game are now appearing. Whether these elements are complementary or
hostile, only time will tell. (Jorn 1961, 29–32)

To this text was added the following editorial comment, probably penned by Guy Debord, which effectively exhorted the "less ecclesiastical" pataphysicians to leave the Collège and join the SI:

Before his resignation from the SI, Asger Jorn was concerned, through this text and through various other interventions, to warn situationists against the religious ambitions of pataphysical ideology, which have been massively disseminated in the United States following the conversion of the editors of the *Evergreen Review*.

Pataphysical ideology, which emanates from certain aged participants in various enterprises in modern art, is itself the product of the aging of this "modern art" from the first half of the century. It conserves its frozen principles in a state of static amusement that is noncreative in the extreme. It accepts the world as it is and thereby takes on board all the usual religious despairs. "The pataphysician," B. Vian declared on the radio (cf. *Dossier* 12 of the Collège), "who has in truth no reason to be moral, also has no reason not to be so. That's how he is uniquely able, without a conformist's come-down, to remain honest."

It goes without saying that the contingent possibilities envisaged by Jorn can only be understood through his perspective of a schism, an apostasy of the less ecclesiastical pataphysicians. The SI reckons that one religion is as risible as another; and guarantees an equivalent hostility toward all religions, even science fiction.

The Collège de 'Pataphysique responded to this provocation in the following article, which first appeared in *Dossier* 17 and subsequently in the definitive *Subsidium* 0:

'PATAPHYSICS AS APOSTASY
The College alone takes no measures to save anyone. Since conscious 'Pataphysics simultaneously negates and affirms itself, Pataphysicians have at their disposal a convenience unique in the modern world—they do not even have to apostasize in order to satisfy that little need to excrete which tithes us all at one time or another. 'PATAPHYSICS IS "APOSTASY" FROM ITSELF, as article 11 of the Statutes so admirably suggests. We might add, of course, that it is the only apostasy—and that an apostasy in the profane or situationist sense is simply one more affirmation-negation as total as ever (even if unconscious) of 'Pataphysics, which as we know does without affirmations, negations, or other operations, as His late Magnificence so lucidly expounded in the preamble to his *Testament* and his message to the *Instituto de Altos Estudios Patafísicos* of Ubuenos Aires. (College of 'Pataphysics 1993 [1961], 5)

The events of May '68 had significant consequences both for the Situationist International, which disbanded in 1972, and for the Collège de 'Pataphysique, which occulted, as we know. The survival of pataphysics as an idea is testament to its resistance to the notion of becoming a religion, or even a way of life, even though many of its adherents find that it does indeed change the way they live and what they believe. The very internal

contradictions that characterize the pataphysical tropes, and are signaled throughout Jorn's essay, guarantee its longevity. Perhaps the best epitaphs for the pataphysical presence in the events of May '68 are left in some of the graffiti from the time, which have certain resonances: "Je suis Marxiste, tendance Groucho. [I'm a Groucho Marxist.] Manquer d'imagination, c'est ne pas imaginer le manque. [Those who lack imagination cannot imagine what is lacking.] L'imagination prend le pouvoir! (Imagination takes power!) Réforme mon cul. [Reform my arse.]"

THE THIRD MAGISTRALITY (OPACH)

Given the pattern of events described above, it is perhaps not surprising that the Collège de 'Pataphysique felt the need to publish a defiant statement summarizing its achievements. The following text appeared in 1970 as the introduction to the *Promptuary*, a complete listing of the publications of the Collège undertaken by the Co-Commission of Inferences, assisted by the Sub-Commission of Storage & Provisions, & by the Sub-Commission of Revisions:

WHAT IS THE COLLEGE OF 'PATAPHYSICS? (1970)
'PATAPHYSICS
Vast and most profound of the Sciences, encompassing them all, whether they will it or no, 'Pataphysics or the science of imaginary solutions was illustrated by Alfred Jarry in the admirable person of Doctor Faustroll. *The Exploits and Opinions of Doctor Faustroll, pataphysician*, written in 1898 and published in 1911 (after Jarry's death), contains both the Principles and the Ends of 'Pataphysics, science of the particular, science of the exception (it being understood that there are only exceptions in the world, and that a "rule" is merely an exception to an exception; as for the universe, Faustroll defined it as "that which is the exception to oneself").

This Science, to which Jarry had devoted his life, is practised by all men, without their knowing it. They would find it easier to leave off breathing. We can observe 'Pataphysics in the Exact and Inexact Sciences (which no one dare admit), in the Fine Arts and Foul Arts, in Literary Activities and Inactivities of every kind. Open the newspaper, listen to the Radio, look at the Television, open your mouth: 'Pataphysics! 'Pataphysics is the very substance of the world.

THE COLLEGE
The College of 'Pataphysics was created to study these problems, the most important and the most serious of all: the only ones of importance, the only serious ones. Certain jejune individuals, who take Jarry for a satirist, imagine that it is all a question of denouncing human activity and cosmic reality; let there be no misunderstanding, there was never any question of affecting a mocking pessimism or a corrosive nihilism. On the contrary, the aim of the College is to discover the perfect harmony of

all things and the profound accord of minds withal (or the ersatz there instead, it is of little consequence). Some must do consciously what all others do unconsciously.

The College of 'Pataphysics addresses itself, and can only address itself, to a minority.

Its work is ambiguous in character. The superficial observer finds it amusing, sometimes heartily rejoices: he thinks he has found a collection of prize howlers and titillating curiosities, bad jokes and good laughs, subtle humour and pitiless piss-takes. . . . Is he wrong?

Anyone who takes a closer look, and pursues this work for any length of time, will gradually realise that it corresponds to an overall view and a totally new psychology. Beyond laughter and maybe even smiles. Jarry was imperturbable.

[There follows a summary of the publications of the Collège.]

For twenty years, then, indefatigable, the great Sower, swinging her arm in an august arc, has been steadily striding over the vast field of future pataphysical harvests. [. . .]

In the present opuscule, all the Publications of the College that can be mentioned have been carefully listed and succinctly described. Let Faustroll ever fly to our aid.

For the Cocommission and the two Sub-Commissions

Sylain d'Y, Regent (d'Y 1995, 101–104)

His Magnificence Opach had been a teacher at the Lycée de Charleville in 1938–1939, when P. Lié was a student. He had also been one of the first Satraps of the Collège de 'Pataphysique. However, he played very little active part in the life of the Collège until his elevation to the status of Vice-Curator in 1965 by the Unique Elector, Jean Dubuffet (whose next action was to break permanently with the Collège). Opach maintained a somewhat enigmatic presence, the most obvious manifestation of which was the occultation itself, throughout his Magistrality.

The next series of Collège publications were probably the most substantial products of Opach's Magistrality. The arrival of the new series of *Subsidia Pataphysica* had been heralded in the *Third Manifesto of the College of 'Pataphysics*, published in 1965, which had set out carefully the scope of the reviews:

Let it be clear to everyone that the miraculous survival of our Review is due to its nuclear SINGULARITY: "know how to be different" (Nietzsche). Its singular nature is its strength. It would be misguided to think that by diluting this singularity we would interest a wider public: on the contrary, it is our essential strength that would evanesce. Besides, this enviable singularity is not something to limit us, for: "*'Pataphysics is illimitation.*" (Bullin 1995, 94)

According to the Co-Commissioner of Inferences, the title of the *Subsidia Pataphysica* was more international and more modest but also clearer, since they aimed to become a help, a resource, and a reinforcement for

pataphysicians. Each of the *Subsidia* divides into three sections: the Syntaxic (covering Collège life); the Operatory (covering Works in the widest possible sense); and the Ideotomic (speculations on conscious and unconscious pataphysics). Issue 1 was a set of guidelines bound within a paper band which declared: "a new series is starting: the era of preparatory works is over." The series of *Subsidia* covered the following themes:

Subsidium 0 (10 August 1965). "Chrestomathie élémentaire." The full title is "Du Vrai Du Beau Du Bien: Chrestomathie Élémentaire de 'Pataphysique" (The True, The Beautiful, The Good: An Elementary Chrestomathy of 'Pataphysics).
Subsidium 1 (28 December 1965). "Gouvernements pour les Subsidia" (Rules governing the *Subsidia*). This includes a special Message from His Magnificence Opach.
Subsidium 2 (10 August 1966). "Applications de ces Gouvernements." Begins the application of the rules identified in *Subsidium* 1, and includes two of the most significant papers published in the review: one on the vocabulary of Cactology, and the other on the way of life of ancient stylites.
Subsidium 3–4 (8 December 1967). "Guide des Environs de Vrigny-à-la Montagne" (A guide to Vrigny and its environs).
Subsidium 5 (6 July 1968). "Les événements de mai." The events of May '68 which, according to the introduction, "have troubled some people," are in fact barely mentioned in this volume except pataphysically as a series of disquisitions on the nature of moral education.
Subsidium 6 (10 December 1968). "Varia." Includes a homage to Marcel Duchamp (three blank pages) and part of Perec's *La Disparition*.
Subsidium 7 (15 June 1969). "Fanzines et Crambophyllologie" (mainly concerned with worldly perceptions of the Collège).
Subsidium 8 (22 December 1969). "Patanalyse de Jules Verne" (Patanalysis of Jules Verne). Includes a fascinating study of motion in Jules Verne.
Subsidia 9–10 (6 July 1970). "Anthologie pataphysique de Poésie" (An anthology of pataphysical poetry).
Subsidium 11 (2 February 1971). "Les bons auteurs." Covers a variety of topics, including "Borges, Ménard, Lautréamont, and plagiarism" (Alain Calame).
Subsidia 12–13 (8 June 1971). "La poésie politique" (Political poetry).
Subsidium 14 (8 December 1971). "Exégèse" (Exegesis). Includes studies of M. C. Escher.
Subsidium 15 (22 February 1972). "Oulipo et Chaval" (Chaval, the Oulipo).
Subsidium 16–17 (14 July 1972). "Petite fierte des reliques" (On relics).

Subsidium 18 (27 October 1972). "Célébration de l'An Cent" (Celebrating the 100th Year of the Pataphysical Era).

Subsidium 19 (25 February 1973). "La course des Dix Mille Milles" (The Ten Thousand Mile Race (in *The Supermale*)).

Subsidia 20–21 (2 July 1973). "Études sur le Surmâle" (Studies of *The Supermale*).

Subsidium 22 (22 December 1973). "Varia". Essays on 'pataphysics and science fiction, the surface of God as described in *Faustroll*, and other matters.

Subsidium 23 (2 May 1974). "La Chine imaginaire" (Imaginary China).

Subsidium 24–25 (7 October 1974). "Croisade pour l'énigme et le roman d'énigme" (Crusade for mystery and mystery novels). OuLiPoPo.

Subsidium 26 (22 March 1975). "Variation sur le Ha ha" (Variation on Ha ha). Concerns the consequences of the occultation, and nominations to the Order of the Grande Gidouille, including the writers Octavio Paz, Stefan Themerson, and Fernando Arrabal, along with Christian Heidsieck, head of a famous brand of champagne.

Subsidia 27–28 (19 April 1975). "Répertoire" (a very useful index to all the previous *Cahiers*, *Dossiers*, and *Subsidia*).

This period was also notable for the publication of Jean Ferry's magisterial study of Raymond Roussel's *Impressions of Africa*, entitled *L'Afrique des Impressions* (Ferry 1967), and various documents clarifying the organizational structures of the Collège and subsequently the Cymbalum Pataphysicum, as well as the fourth version of the pataphysical calendar, which is still the standard edition today.

The decade before the occultation saw several significant deaths within the Collège: Duchamp; Escher; Pierre Mac Orlan; Georges Limbour; Jean Ferry; and, in 1973, probably most significantly of all, Latis, P. Lié, Jean-Hugues Sainmont, Mélanie Le Plumet, Oktav Votka, etc., of whom more anon . . .

SUBSIDIUM 0 (1965)

The pre-first volume in the series, *Subsidium* 0, or the "Elementary Chrestomathy of 'Pataphysics," contains a selection of some of the finest examples of pataphysical speculation published in the previous series, and did much to summarize the state that pataphysics had reached by this stage in its evolution. The following excerpt will have to suffice to convey the flavor:

INGEST: ANOREXIA, DYSOREXIA, APLESTIA

Insere, nunc, Meliboee, piros (Virgil, *Bucolics* I)

An eminent journalist (the qualities of journalist and *eminent* cannot be combined without a certain insouciance), an eminent journalist merrily confided to one of the Great and Good Organs of the Press his fears concerning the College of 'Pataphysics: with affectionate concern he wondered whether by the XXIst *Cahier*, pataphysical language (which he inaccurately called *jargon*)[3] might not have lost the power to "*shock*" it had shown at the "*beginning.*"

There is no need to point out for the benefit of Members of the College the magnificent ignorance revealed by such IMPRUDENT AND SIGNIFICANT appreciations.

IMPRUDENT? Well, did the College ever try to produce shocks, even in the manner of psychiatrists when treating "cases"? We do not undertake treatments. We have no desire either to correct or to "save" anything. Not by means of scandal, nor indignation, nor orgasm, nor effusions. We are not lyrical or surrealist exhibitionists. We are modest scholars working away at an enormous task, whose dimensions are in fact difficult to discern; our means are decidedly limited; a fact of which we are well aware, but do not complain about; we are "*armed with ardent patience*" and besides have no "*mission to achieve*" in the sense that the expression is usually understood (with quite unwitting 'pataphysics). Our methods, and mind—or whatever we have in its place—are those of "science": we observe, we record, we avoid value judgments whether aesthetic or moral: indeed we ethnographize the latter scientifically. And we study "science" in this way as well. And Pataphysics itself is posited only as pataphysical (cf. *Statutes of the College*, 1, § 1).

To link ourselves with those who stand up for the Clichés of revolution and revolt would be an obvious mistake: The College is didactic, administrative, solidly monolithic and ritualized. There is no question of its being, as some halfwits have believed, a parody; it is a reality which only we have grasped in this little world of the XXth century, and which we call Pataphysical Ontogeny. To us, the complex, precise formality of the College Hierarchy is as suitable and valid as—one cannot say the social hierarchy which even in the eyes of the laity is radically inferior—but as suitable and valid as *Nature, Life, Humanity*, or *Dasein*, not to mention literary values and their classification by MM. André Breton and Émile Henriot of the Académie Française.

SIGNIFICANT? Journalists naturally go for what is "sensational": to their tired eyes the College looked, six years ago, like something rather new and original, maybe somewhat fantastic, and therefore good "copy." Journalists and their clientele thought the College was an overdelicate diversion, a hyperintellectual clownery, and that numbers of the Cahiers were more like Music Hall numbers, fancy sketches aimed at provoking a house full of "highbrow" suckers. That is, after all, the postulate of written things: from the Koran to Marx, from Sappho to Rimbaud, the EFFECT is what is aimed for:—edifying, arousing, soothing, upsetting, etc., according to the fashion of this same deep-seated gullibility. Science alone, amid the vast mass of printed paper, sets out to escape, and indeed in spite of Pasteur and other heartwringing Benefactors of Humanity and Beetroot, sometimes has escaped this subjection to effect. But our College does better, and unfailingly so; it neither seeks effects, nor seeks to have any effect. It is an end in itself. (J. Mauvoisin 1995 [1956], 10–12)

--

This was the period during which pataphysics was injected into the cultural bloodstream through a variety of routes. Philosophy increasingly acknowledged its presence. Literature was transformed by the appearance of the Oulipo. The Anglophone world woke up to its own pataphysics thanks to the publication of the "What Is 'Pataphysics?" issue of the *Evergreen Review* and various translations of Jarry. Administration of all this treatment was overseen by the Collège de 'Pataphysique and its new Vice-Curator, the benign and indulgent Baron Mollet.

THE SECOND MAGISTRALITY (MOLLET)

The "Baron" Jean Mollet (1877–1964) was neither a baron nor, as was repeatedly claimed, the secretary of Guillaume Apollinaire. He was in fact a self-confessed dilettante who spent much time hanging out with the artists in Paris around the turn of the twentieth century. His attitude to life was summed up in his memoirs:

J'ai toujours vécu sur le présent, rarement sur le passé, mais jamais sur l'avenir. Vivre sur l'avenir, c'est, je pense, la chose la plus ridicule qui puisse exister. Dire de quelqu'un: "Il a beaucoup d'avenir," cela l'avance bien; il finira quand même comme tout le monde. [I have always lived in the present, rarely in the past, and never in the future. Living in the future, I think, is the most ridiculous way to exist. You can say

that someone "has their future ahead of them" all you like, but it'll come to an end one day just the same]. (Mollet 2008 [1963], 21)

As Raymond Queneau remarked in his preface to the memoirs: "Mais, au fait, qu'est-ce qu'il a donc fait ce Baron Mollet? Eh bien! voilà: rien. Il n'était ni peintre, ni poète, ni graveur, ni acteur, ni sculpteur, ni pianiste." (But what, in fact, did he actually do, this Baron Mollet? Absolutely nothing! He was neither painter, nor poet, nor engraver, nor actor, nor sculptor, nor pianist.)

However, let it be quickly stated, Mollet did have many qualities which made him admirably suited to become the Vice-Curator of the Collège de 'Pataphysique. He had known Alfred Jarry personally, which none of the other members at the time could claim. He had also been close friends with Apollinaire and many other artists in his circle, so had real insights into the *fin-de-siècle* culture of Montparnasse in particular. It also suited the Collège very well that he was by nature a *bon viveur* dedicated to the café culture, since the various pataphysical doctrines were by now well established, and the time was ripe for fruitfulness and expansiveness. Most photographs of Mollet show him in restaurants surrounded by the leading 'pataphysicans of the period (Ernst, Queneau, Vian, Prévert, Leiris, Ferry, Clair, etc.), and as many bottles of wine. It was somewhat in this spirit, therefore, that Mollet's Magistrality began with a "Message to the World, Civilized or Not":

Let the College of 'Pataphysics continue. Its world task is hardly begun. Faithful to its already decennial tradition, with Members as far as the antipodes and under every latitude, let it accomplish its learning labors for the delectation of all. In expressing our gratitude to all those who have participated in the election of a Vice-Curator in the way they have, it is through Them that we give thanks for Universal and Total 'Pataphysics. (Mollet 1995 [1959], 91)

Under Mollet, *the* science was to become predominantly a question of administration. A first step was to reform the Rogation (administrative organization). The Pro-Administration which had existed up to this point was transformed into an Organon Exécutif (Executive Organon) with responsibility for "autonomous administration and operational initiative." The Aristotelian echoes of the word "Organon" were in due course to provoke a Baconian reaction[1] with the creation of a *Novum Organum* following the disoccultation in 2000 AD.

Another important development was to clarify the collection of Commissions and Sub-Commissions that formed the Collège. The functions of these were set out in detail in *Dossier* 7, which reproduced a table listing more than 90 different entities. A similar table in *Dossier* 28 included the

Oulipo, which was soon to disappear again as it became a separate organization (it ceased to be linked with the Collège following the occultation). *Dossier* 28 also included maps of pataphysics in France showing the distribution of individuals and groups around the regions, then a statistical survey of pataphysical activities, followed by a complete history of the first and second Magistralities and, grandest of all, a Planisphere showing the spread of the Collège de 'Pataphysique around the world.

The series of *Dossiers* had begun in 1957, during the Interregnum between the First and Second Magistralities, and was to end in 1965. It included the following titles:

Dossier 1–2 (17 November 1957). "Le Tableau" (play by Ionesco).

Dossier 3 (6 April 1957). "Le Temps dans l'art" and other unpublished texts by Jarry.

Dossier 4 (14 July 1957). "Adam" (play by Jean Marvier).

Dossier 5 (17 November 1958). Jarry's "XII Arguments on Theater" and his unusual translation of "Olalla" by R. L. Stevenson.

Dossier 6 (23 February 1959). "Les Bâtisseurs d'empire" (*The Empire-Builders* was a play by Boris Vian; this *Dossier* also included works by Max Ernst).

Dossier 7 (25 June 1959). Election of His Magnificence Baron Mollet, marking the start of the Second Magistrality. It also includes a first summary of the reorganizations of the Collège structures, and an obituary for the recently deceased Boris Vian.

Dossier 8 (1 September 1959). "Être et vivre" (To Be and to Live) by Jarry.

Dossier 9 (22 December 1959). "Traité des queues" (Treatise on Tails) by Lichtenberg, and writings on Verne by Ferry.

Dossier 10–11 (30 March 1960). "Cosmorama de Dubuffet" (entirely devoted to the life and work of Jean Dubuffet).

Dossier 12 (23 June 1960). "Hommage à Boris Vian" (Homage to Boris Vian).

Dossier 13 (25 December 1960). "Gyroscopie de la gidouille" (cartoons by Philippe Dumarçay).

Dossier 14 (31 March 1961). "La Trichomonase" (dedicated to a parasitic organism that lives inside human vaginas, and the infections it causes).

Dossier 15 (29 June 1961). "G. Albert Aurier" (Noël Arnaud discusses the work of a little-known symbolist poet and art critic).

Dossier 16 (1 September 1961). "Centenaire de la découverte du Pôle Nord par le Capitaine Hatteras" (the North Pole from a Vernian perspective; includes texts by Queneau, Ionesco, Ferry, and others, including Eskimos).

Dossier 17 (22 December 1961). "Exercices de littérature potentielle" (the first publication of the Oulipo).

Dossier 18–19 (29 March 1962). "Le Goûter des généraux" (*The Generals' Tea-Party*, a play by Boris Vian).

Dossier 20 (6 July 1962). "Études sur les œuvres de Raymond Queneau" (studies on Queneau).

Dossier 21 (1 November 1962). "Inédits de Julien Torma" (unpublished writings of Torma).

Dossier 22–24 (7 September 1963). "Belles lettres" (letters from Jarry, Torma, and others).

Dossier 25 (3 March 1964). "Institutum Pataphysicum Mediolanense."

Dossier 26 (8 June 1964). "Album de l'Antlium" (early play by Jarry).

Dossier 27 (18 January 1965). "La Dragonne" (Jarry's final unfinished work).

Dossier 28 (8 June 1965). "Géographie et histoire du Collège de 'Pataphysique."

The emphasis on administration had one immediate consequence for the Collège: that of putting a great deal of pressure on the Dataries (*Dataires*) who, as Ruy Launoir explains, "constitute [. . .] a powerful social grouping at the heart of the Collège de 'Pataphysique" (Launoir 2005, 85). The Dataries are administrators who are responsible for liaisons between the Regents, the Body of the Collège, and the wider Membership. As with most Collège roles, the Dataries are organized hierarchically, in order of seniority, into: Protodataries; Vice-Protodataries; Deutérodataries; Dataries (many of whom are assigned overseas); and sub-Dataries. The insignificant administrative tasks they perform are, in pataphysical terms, no less significant than the apparently grander work of the Regents and others. In the years 1961–1963 the truth of this assertion became painfully clear as the Dataries, complaining of the pressures of work, initiated a temporary split within the Collège. A small group of them formed a syndicate entitled Syndicat des Dataires de l'Organon, and published a review, *Réveil des Dataires* (The Dataries' Awakening), which criticized the whole power structure of the Collège and its hierarchies. They proposed a less centralized organization, something which the Collège itself opposed by forming a larger rival group of Dataries, the ACACADOOR (Association Corporative Amicale et Culturelle des Amis des Dataires de l'Oulipo, de l'Organon et de la Rogation). Their review, *Le Petit Moniteur de l'ACACADOOR*, then engaged in a series of disputes with the SDO which lasted a couple of years until finally the two merged and the problem was resolved broadly in favor of the majority.

Mollet's Magistrality was marked at the start by the untimely death of Boris Vian in 1959, which was an enormous blow. However, many of the big figures of the Collège experienced a flowering of their pataphysical

potential during this period. Man Ray and Françoise Gilot both joined the Collège as Transcendental Satraps. Pablo Picasso and Asger Jorn became Exquisite Commanders of the Ordre de la Grande Gidouille. Simon Watson Taylor, whose translations of Jarry set the standard for the Anglophone world, became Proveditor-Delegatory, and Stanley Chapman established the first Annex of the Rogation at London-in-Middlesex. Other leading pataphysicians in the UK included Barbara Wright, who translated Queneau, and the artists-cum-writers-cum-filmmakers-cum-publishers Franciszka and Stefan Themerson, who published many key texts including the first English version of *Ubu Roi*, and works by Apollinaire and Queneau. No less significantly for the future of the Collège, Paul Gayot became a Datary of the Organon and was to be central to its internal operations for many subsequent decades.

The cartoonist Siné was particularly prominent at this time, during which he illustrated Jarry, Allais, Artaud, and others, and published a magazine called *Siné Massacre* (1962–1963). An attempt in 1966 to publish a volume of Siné's cartoons under that title in the UK by Penguin Books met with an outcry from, among others, the satirical British magazine *Private Eye*. The founder of Penguin, Sir Allen Lane, actually stole the entire print run of the book from his own company (he was subject to a boardroom *coup* at the time) and burnt it, on the grounds that it was both obscene and offensive to Christians. The few volumes that survived are much sought after by bibliophiles.

This was also the period of Jean Dubuffet's finite relationship with the Collège. He joined in 1954, was made a Grand Officieux OGG in 1958 and a Satrap in 1960, only to be "decommissioned" in 1966, evidently by mutual agreement: the only person ever to have achieved that position. He described his understanding of pataphysics as follows: "I have never managed to grasp what exactly 'pataphysics' consisted of; but in short what I have always seen in it is a desire to disconnect philosophy from the discipline of logic, and to admit incoherence as a legitimate component of it" (Dubuffet 1986, 19).

Dubuffet's creation of *Art Brut* ("raw" art) seemed to have much in common with Jarry's illustrations for *Ubu*, and indeed the kind of "outsider art" created not just by Jarry but also by "naïfs" such as Henri Rousseau or Jean-Pierre Brisset. It certainly connected with the drawings and works of Antonin Artaud, whose "instinct, passion, caprice, violence, insanity" Dubuffet contrasted with the "official art" of museums and galleries. Georges Limbour, writing in the *Dossiers* 10–11 of the Collège de 'Pataphysique devoted to the work of Dubuffet, elaborated:

On the face of it the main aim of a painting by Dubuffet is to evoke a world of real, nameable objects and people. But what is the nature of this reality? First we must find out what it is or where it is. In front of pataphysicians I do not need to develop this idea. I would just say that the work of the Satrap seems to me a great game of contradictory movements, alternating, without regularity, movements of exterior-ization and interiorization; it evokes by turns an exterior reality, then an interior reality, and more often than not the object we see exists somewhere on an uncertain frontier between the two. (Limbour 1959, 21)

Dubuffet also worked with Jorn on some musical experiments in the early 1960s which were similarly characterized by an attempt to find an authentic voice at the expense of traditional technique. Dubuffet recounted: "Neither Asger Jorn nor myself were *au fait* with the output of contemporary composers and weren't even familiar with the instigators of serialism, dodecaphony, electronic music and musique concrète. Indeed I only learned these terms recently. My own musical experience was limited to fairly cursory study of classical music on the piano, which I played a lot as a child and teenager and gave up when about 20" (Dubuffet 1961).

Dubuffet's relationship with the Collège seems to have come to an end somewhat acrimoniously; at any rate, neither he nor the Collège seems to have been particularly keen on retaining any kind of association.

PHILOSOPHY AND PSEUDOPHILOSOPHY

Meanwhile, the wider French intellectual culture was busy integrating pata-physics into its own theoretical narrative. The two prevailing strands of this integration were linguistics and psychoanalysis. The pataphysical interest in wordplay provided the basis for much of the theorizing. On the one hand it exhibited a certain delight in the discovery of meaning beyond the surface of the text. On the other hand it pointed to a delirium or inco-herence that arises from the deconstruction of meaning. Neither of these was unique to pataphysics, of course, but its influence on the evolution of French culture in particular made it a useful staging post in the develop-ment of postwar philosophy. Both Jacques Derrida and Jacques Lacan have been linked to pataphysics,[2] in particular with regard to their ideas about the nature of the Real. Writing about Artaud's "theater of cruelty," Derrida remarked: "The theater of cruelty is not a *representation*. It is life itself, in the extent to which life is unrepresentable" (Derrida 1997 [1978], 42).

For Lacan, the Real was one of the three Orders which, unlike the Sym-bolic and the Imaginary, is literally *impossible* since it stands outside lan-guage and signification. The Lacanian Real is not exactly the same thing as

"reality," but rather a state of nature from which language cuts us off at an early age. Despite its impossibility, its presence is felt in all our subsequent lives, usually in a traumatic way since our failure to reach it brings us face to face with the realities of our own existences.

The connection between these ideas finds an extreme realization in Jarry's conflict with his own material existence, in the monstrous figure of Ubu, and the cries of "ha ha" of Bosse-de-Nage in *Faustroll*. It is present in the repeated phallic references to "green candles" and "physick-sticks" and "hornstrumpots," as a form of pleasure—or, to use the Lacanian term, *jouissance*—that transgresses conventional limitations and leads ultimately to suffering. It is the "merdre," the stuff of life, in which we revel and by which we are disgusted. Hence, by extension, it is beyond the science of physics, and beyond metaphysics.

GILLES DELEUZE

The early work of Gilles Deleuze (1925–1995) concerned metaphysics and, in particular, pointed to a transcendental empiricism that owes something to both Kant and Bergson. In a 1964 essay entitled "How Jarry's Pataphysics Opened the Way to Phenomenology," he elaborated the extent to which pataphysics informed his thinking:

Major modern authors often surprise us with a thought that seems both a remark and a prophecy: metaphysics is and must be surpassed. In so far as its fate is conceived as metaphysics, philosophy makes room and must make room for other forms of thought, other forms of thinking.

This modern idea is seized on in various contexts, which dramatize it:

1.) *God is dead* (it would be interesting to do an anthology of all the versions of the dead God, all the dramatizations of this death. For example, Jarry's bicycle race. In Nietzsche alone, we could find a dozen versions, the first of which is not at all found in *The Gay Science*, but in *The Wanderer and His Shadow*, in the admirable text on the death of the prison-guard. But whatever the case, the death of God for philosophy means the abolition of the cosmological distinction between two worlds, the metaphysical distinction between essence and appearance, the logical distinction between the true and the false. The death of God thus demands a new form of thought, a transmutation of values.

2.) *The Human dies also* (finished is the belief in the substitution of humanity for God, the belief in the Human–God who would replace God–the Human. For in changing places, nothing has changed, the old values remain in place. Nihilism must go all the way, to the end of itself, in the human being who wants to perish, the last human, the men and women of the atomic age foretold by Nietzsche.

3.) This something "other" is conceived as a force already at work in human sub-
jectivity, but hiding in it, and also destroying it (cf. Rimbaud's "Something thinks
me."). The action of this force follows two paths: the path of actual history and the
development of technology, and the path of poetry and the poetic creation of fan-
tastic imaginary machines. This conception demands a new thinker (a new subject
of thought, "death to the Cogito"), new concepts (a new object to be thought), and
new forms of thought (which integrate the old poetic unconscious and today's pow-
erful machines, e.g. Heraclitus and cybernetics).

In a certain way, this attempt to surpass metaphysics is already well known. We find
it in different degrees in Nietzsche, Marx, and Heidegger. The only general name
that befits it was coined by Jarry: *pataphysics*. (Deleuze 2004, 74–76)

Having thus identified Jarry's relationship to Nietzschean metaphysics,
Deleuze turned his attention to technology, and in particular to Heidegger's
idea of technology as a mode of being, rather than a set of tools. Once
again, he connects the pataphysical technologies of *The Supermale* or *Faus-
troll* with the "desiring-machines" he later identified in *Anti-Oedipus* (1983)
and with Duchamp's bachelor machines.

GILLES DELEUZE, "AN UNRECOGNIZED PRECURSOR TO HEIDEGGER: ALFRED JARRY"

Pataphysics (*epi meta ta phusika*) has as its exact and explicit object the great Turn-
ing, the overcoming of metaphysics, the rising up beyond or before, "the science of
that which is superimposed upon metaphysics, whether in itself or outside of itself,
extending as far beyond metaphysics as the latter extends beyond physics. We can
thus consider Heidegger's work as a development of pataphysics in conformity with
the principles of Sophrotates the Armenian, and of his first disciple, Alfred Jarry. The
great resemblances, memorial or historical, concern the *Being of phenomena, planetary
technology,* and the *treatment of language.* [. . .]

II. Because it confuses Being with beings, metaphysics in its entirety stands in the
withdrawal of Being, or forgetfulness. Technology as the effective mastery of Being
is the heir to metaphysics: it completes metaphysics, it realizes it. Action and life
"have killed thought, therefore let us Live, and in so doing we will become Masters."
In this sense, it is Ubu who represents the fat being, the outcome of metaphysics as
planetary technology and a completely mechanized science, the science of machines
in all its sinister frenzy. Anarchy is the bomb, or the comprehension of technology.
Jarry puts forward a curious conception of anarchism: "Anarchy Is," but it makes Be-
ing lower itself to the being of science and technology (Ubu himself will become an
anarchist in order to better ensure that he is obeyed). More generally, Jarry's entire
œuvre ceaselessly invokes science and technology; it is populated with machines and
places itself under the sign of the *Bicycle.* The bicycle is not a simple machine, but
the simple model of a Machine appropriate to the times. And it is the Bicycle that
transforms the Passion, as the Christian metaphysics of the death of God, into an

eminently technical relay race. The Bicycle, with its chain and its gears, is the essence of technology: it envelops and develops, it brings about the great Turning of the earth. The bicycle is the frame, like Heidegger's "fourfold."

If the problem is a complex one, however, it is because technology and technologized science, for both Jarry and Heidegger, do not simply entail the withdrawal or forgetting of Being. Being also shows itself in technology by the very fact that it withdraws from it, insofar as it withdraws. But *this* can only be comprehended pataphysically (ontologically), and not metaphysically. This is why Ubu invents pataphysics at the same time as he promotes planetary technology: he comprehends the essence of technology—the comprehension Heidegger imprudently credited to National Socialism. What Heidegger finds in Nazism (a populist tendency), Jarry finds in anarchism (a right-wing tendency). In both authors, technology seems to be the site of a combat in which Being is sometimes lost in forgetting or in withdrawal, while at other times, on the contrary, it shows itself or unveils itself in it. It is not enough to oppose Being to its forgetting or withdrawal, since what defines the loss of Being is rather the forgetting of forgetting, the withdrawal of the withdrawal, whereas withdrawal and forgetting are the manner by which Being shows itself, or is *able* to show itself. The essence of technology is not technology, and "must harbor in itself the growth of the saving power." Thus, it is the culmination of metaphysics in technology that makes possible the overcoming of metaphysics, that is, pataphysics. Hence the importance of the theory of science and the experimentations with machines as integral parts of pataphysics: planetary technology is not simply the loss of Being, but the possibility of its salvation. [. . .]

Undertakings like those of Heidegger or Jarry should not be compared with linguistics, but rather with the analogous undertakings of Roussel, Brisset, or Wolfson. The difference consists in this: Wolfson maintains the Tower of Babel, and makes use of every language minus *one* to constitute the language of the future in which this *one* must disappear; Roussel on the contrary makes use of only one language, but he carves out from it, as the equivalent of another language, homophonous series, which say something else entirely with similar sounds; and Brisset makes use of one language in order to pull out syllabic or phonic elements that may be present in other languages, but that say the same thing, and that in turn form the secret language of the Origin or the Future. Jarry and Heidegger have yet another procedure: they work in principle with two languages, activating a dead language within a living language, in such a way that the living language is transformed and transmuted. [. . .] (Deleuze 1997, 91–98)

ANGLOPHONE 'PATAPHYSICS

As French critical theory increasingly took notice of pataphysics and moved it toward a central position in the narrative of cultural evolution, so the Anglophone world also began to become aware of its importance. Three crucial publications during this period did more to cement its reputation

than any others. The first was *The Banquet Years: The Origins of the Avant-Garde in France, 1885 to World War I* by Roger Shattuck (1923–2005), originally published in 1958, which included not only a life of Jarry but also a discussion of pataphysics. This was followed in 1960 by issue 13 of the *Evergreen Review* entitled "What is 'Pataphysics?" which was, once again, edited by Shattuck. Finally, 1965 saw the publication of the *Selected Works of Alfred Jarry*, which he coedited and translated with Simon Watson Taylor.

The Banquet Years had the great merit of being both engagingly written and thoroughly researched. It also took an unusual approach, examining the lives and works of four figures—Guillaume Apollinaire, Henri Rousseau, Erik Satie, and Alfred Jarry—to illustrate the period. Emphasizing Jarry's acceptance of the simultaneous existence of opposites, Shattuck wrote: "Freudians, Surrealists, and semanticists have claimed various significance of ambiguity; Jarry treated ambiguity as the stylistic manifestation of a universal principle of convertibility. Text means all things equivocally; anything may be(come) its opposite; not literature, but living is the supreme pun; writing is a slip of the tongue. Such total literary promiscuity is bound to yield the monstrous" (Shattuck 1968 [1958], 241). With this in mind, he discussed pataphysics:

[Jarry] never did much more than name it and sketch in its outlines. Yet it stands as the final expression of all his attitudes, for it subsumes the principles of innocence and blasphemy, ambiguity and the absurd, and universal convertibility. They constitute the world within which he violated his own identity and exceeded the limits of literature. The disciplines of drink and 'Pataphysics, however, were finally not enough to sustain his total hallucination. Unlike Rousseau and Satie, who could live to a ripe old age in a world of devotion and candor, Jarry had to die in order to find the beauties of "a universe supplementary to this one." His death at thirty-four put an end to a deliberately monstrous life which, having transformed everything else, had no recalls that transport itself elsewhere. (Ibid., 243)

For Shattuck, Jarry committed "suicide by hallucination," and it was this combination of literature and lifestyle that was the essence of pataphysics. Such a reading proved attractive to an emerging counterculture devoted to self-discovery, sometimes with the aid of drink or drugs. Subsequent scholars, including Michel Arrivé and Alastair Brotchie, have argued that it is nevertheless partial: "Jarry's myth should not be substituted either for his writings or for his life; rather, it should be seen as their inevitable epiphenomenon, since it proceeded from identical impulses on his part" (Brotchie 2011, 306).

Shattuck had joined the Collège de 'Pataphysique in 1952, and the publication of *The Banquet Years* began his rapid promotion through the ranks;

he became Regent of Applied Mateology in the same year, and eventually Proveditor-General Propagator for the Islands and the Americas (the most senior position in the Anglophone world). His "Superliminal Note" (Shattuck 1960b) was subsequently translated into French as *Au seuil de la 'pataphysique* (literally, "On the threshold of pataphysics," referencing Jarry's early text "Lintel"). This text did more than any other to excite interest in pataphysics in the USA, and continues to be the most cited discussion of the subject in English.

The Collège responded to this interest initially by publishing a version of the text translated into nine different languages in 1962. However, it fairly soon became apparent that this was a rather controversial move, and objections to Shattuck's account of the subject began to appear. The nature of the objections may be gauged by this excerpt from the introductory article to *Subsidium* 0:

Certain fundamentalists—or rather those who see themselves as such, for it is not easy to be a fundamentalist Pataphysician—have reproached the text by the S^{mus} Roger Shattuck for giving the impression, in spite of the precautions with which he surrounds it, that 'Pataphysics might resemble however distantly a "philosophy," a "point of view," a "Weltanschauung," or even, what's worse, a philosophy, a point of view, or a Weltanschauung just like any other! However, it should be remembered (as was given at the top of each translation) that this text was simply an introduction to the remarkable collection of pataphysical works collected in Number 13 of the *Evergreen Review*: thereby, anything in those prolegomena that might resemble (albeit distantly!) a systematic dissertation would have been compensated and balanced by that ensemble of choice morsels. Was it a mistake to publish it separately, even with a warning to the reader? There was a material necessity: when one thinks of the difficulties involved in producing this work in nine languages, one would hardly expect or even imagine the one hundred and sixty pages that accompanied it also being translated into all nine languages! And the title itself, repeated nine times: *On the Threshold*, was already an eloquent restriction. (Senninger 1964, 6)

In exceeding the definitions of pataphysics originally given by Jarry, and in developing his theme of the relationship between pataphysics and life, Shattuck had run counter to some of the established doctrines within the Collège; he consequently suffered both disapprobation and a certain loss of status within its imaginary walls. However, his article woke the wider world up to its own pataphysics in ways which were discussed in chapter 4. His notions of, for example, 'pataphysics as a form of defense against the world, or of the pataphysician's imperturbability when faced with modern bureaucracy, were indeed precisely those aspects that many people found inspiring, when compared with the relatively impenetrable texts that they

introduced. The publication of *Evergreen Review* 13 was a key tipping point in the emergence of pataphysics into the Anglophone world, and has somewhat set the tone ever since. For some, its popularization introduced some concepts that were a distortion of *the* science. On the other hand, it provided exactly what it intended to provide: a threshold over which many people crossed into the pataphysical universe, becoming familiar with literature which would otherwise have remained marginal.

ROGER SHATTUCK, "SUPERLIMINAL NOTE" (1960)

The world is ready for 'Pataphysics—about as ready as it is for outer space. Occupying an inner space where we are at the same time most and least ourselves, 'Pataphysics has always been there. It will remain; unlike other spaces, it will never be conquered. Yet the Science of Sciences has had a name and a place on earth for only sixty odd years, and recently it has begun to lurk almost too visibly in certain prominent forms of human activity. So the time has come to talk of 'Pataphysics.

Just recall a few of last year's major happenings. A British newspaper organized a race between a marble arch in London and a limestone arch in Paris, and all Europe gaped in delight as a roller-skater in a derby, several playboys unoccupied since the Twenties, three aircraft corporations, and finally the Royal Air Force itself jumped into the fray. Western technology achieved the supreme demonstration of free enterprise (at great expense) in an air-borne hop-skip-and-jump relay race that was more tastefully staged than a hot war, and as productive of newspaper copy. May our leaders ponder the lesson. A few months earlier, a diplomat inadvertently revealed that he and his peers of several nations daily risk their reputations and their countries' future on their capacity to introduce naturally into the proceedings of a conference a word like "unicorn" or "hermaphrodite"—any outlandish word agreed upon beforehand among the players. The point is to say it first and without it sounding forced. One admires these poor men of state trying to brighten a bleak life of cultural exchange and disarmament. But the cat is out of the bag: diplomacy is finally unmasked as an international word game.

It was last year also that a physicist advanced the theory that every charged particle in the universe is balanced not only by an oppositely charged particle in the same atom but also by an oppositely charged particle in a totally different "phantom" universe, which haunts this one like a ghost. Alice's looking-glass world is right here around us if we could simply change all the signs of our thinking or being.

Reflect on these events for a moment. The ultimate manifestations of competitive industrial society, of international statesmanship, and of science are sheer 'Pataphysics. No other single perspective could assemble them as anything more meaningful than symptoms of collective hysteria or boredom. In reality (a word I shall henceforth have to dismiss), they manifest the final stage of 'Pataphysics practiced unconsciously before it mutates into the higher, conscious stage. Such events as these reveal the desperate measures of men starved for a new science; they need no longer go hungry.

With the majestic and millennial timing of a comet, a handsomely printed book appeared privately last year in France amid all this pathetic fumbling and points the way toward the higher level of thought: *Opus Pataphysicum, the Testament of his Late Magnificence, Dr. I. L. Sandomir, Vice-Curator and Founder of the College of 'Pataphysics, Preceded by his Writings in 'Pataphysics.*

At this point it is probably necessary for me to make a gratuitous comment: I am quite serious. Seriously.

What then is 'Pataphysics? This is no new literary-philosophical school spawned in Paris and proffered now to the voracious American public. 'Pataphysics, I reiterate, has always existed, ever since a man first scratched his head to quell the itch of reflective thought, ever since Socrates demonstrated to Meno that his slave boy had known the Pythagorean theorem all along,[3] ever since the day Panurge defeated *the* English scholar in a disputation by signs, ever since Lewis Carroll established the equivalence of cabbages and kings. Not until the end of the nineteenth century, however, at a time when science, art, and religion were coming very close to bumping into one another in the dark, did 'Pataphysics drop its disguises and disclose its intentions. Its chosen vessel was Alfred Jarry, who achieved notoriety by assuming paternity of a raucous schoolboy farce, *Ubu Roi*, performed in Paris in 1896. Jarry appropriated from Père Ubu his "science of 'Pataphysics" and attributed it to a new personage, Dr. Faustroll. In a book that remained unpublished until after his death (*Exploits and Opinions of Dr. Faustroll, Pataphysician*, 1911), and in a variety of novels, poems, and speculative texts, Jarry elaborated and applied the science of sciences. Both Jarry and 'Pataphysics have remained controversial subjects in French literature through the periods of Symbolism, Dada, Surrealism, and even Existentialism.[4] Highly contradictory praise has come from such sources as Apollinaire, Max Jacob, André Breton, André Gide, Antonin Artaud, and Raymond Queneau. 'Pataphysics had occasional difficulty preserving its identity until after the Second World War, when the Collège de 'Pataphysique was founded. With its proliferation have come a set of statutes, a complex hierarchy, commissions and subcommissions, quarrels and settlements, a quarterly review, publishing house, world-wide representation and occasional public manifestations. In all its internal and external activities, the College has cultivated the pataphysical sense of life, until it is possible to say very simply with Père Ubu: "'Pataphysics is a branch of science we have invented and for which a crying need is generally experienced." Faustroll wasted less words when he took over: "*La 'Pataphysique est la science . . .*[5]

But what, once again, is 'Pataphysics? The real yet half legendary figure of Jarry provides the readiest access to it. Born in 1873 and celebrated at twenty-two for his precocious talents and deliberate eccentricity, Jarry *lived* fully exposed to his era. He belonged to the bohemian world of Montmartre cabarets and was at home with the great tradition of embittered humor and honesty that came out of this squalid exoticism. He was befriended and published by the symbolists and shared their sense of the musicality and suggestiveness of language as reflecting the hidden relations between all existing beings. He had felt the lure of occultism, the wave of

Rosicrucianism and Satanism and esoteric knowledge that had been gaining popu-
larity throughout the century. And, without inner conflict, he had become absorbed
in the transformation taking place in science—not in the expiring positivism of his
own country but in the highly imaginative investigations of a generation of British
thinkers such as Lord Kelvin (on relativity and units of measurement) and C. V. Boys
(his amazing volume, *Soap Bubbles and the Forces Which Mould Them*, was republished
just last fall in the Science Study Series) and inevitably H. G. Wells. Finally, Jarry
welcomed the fearless dynamism of the anarchists, who set out, like Ubu, to destroy
in order to construct upon the ruins. Leaving the greater part of the society intact,
these several forces were rarely related and spent themselves in divergent directions.
It was Jarry's particular talent to have transformed them into the single science of
'Pataphysics. It can be seen as a method, a discipline, a faith, a cult, a point of view,
a hoax. It is all of those and none of them.

We have now reached the point where it is necessary to undertake the self-con-
tradictory task of defining 'Pataphysics in non-pataphysical terms.

1. 'Pataphysics is the science of the realm beyond metaphysics; or, 'Pataphysics lies
as far beyond metaphysics as metaphysics lies beyond physics—in one direction or
another.

Now, metaphysics is a word which can mean exactly what one wants it to mean,
whence its continuing popularity. To Aristotle it meant merely the field of specula-
tion he took up after physics. The pataphysician beholds the entire created universe,
and all others with it, and sees that they are neither good nor bad but pataphysical.
René Daumal, writing in the twentieth century, said that he proposed to do for
metaphysics what Jules Verne had done for physics. 'Pataphysics, then, entering the
great beyond in whatever direction it may lie, offers us a voyage of discovery and
adventure into what Jarry called "ethernity." That, of course, is where we all live.

2. 'Pataphysics is the science of the particular, of laws governing exceptions.

The realm beyond metaphysics will not be reached by vaster and vaster gener-
alities; this has been the error of contemporary thought. A return to the particular
shows that every event determines a law, a particular law. 'Pataphysics relates each
thing and each event not to any generality (a mere plastering over of exceptions)
but to the singularity that makes it an exception. Thus the science of 'Pataphysics at-
tempts no cures, envisages no progress, distrusts all claims of "improvement" in the
state of things, and remains innocent of any message. 'Pataphysics is pure science,
lawless and therefore impossible to outlaw.

3. 'Pataphysics is the science of imaginary solutions.

In the realm of the particular, every event arises from an infinite number of
causes. All solutions, therefore, to particular problems, all attributions of cause and
effect, are based on arbitrary choice, another term for scientific imagination. Gravity
as curvature of space or as electro-magnetic attraction—does it make any difference
which solution we accept? Understanding either of them entails a large exercise of
scientific imagination. Science must elect the solution that fits the facts—travel of
light or fall of an apple. 'Pataphysics welcomes all scientific theories (they are get-

ting better and better) and treats each one not as a generality but as an attempt, sometimes heroic and sometimes pathetic, to pin down one point of view as "real." Students of philosophy may remember the German Hans Vaihinger with his philosophy of *Als ob*. Ponderously yet persistently he declared that we construct our own system of thought and value, and then live "as if" reality conformed to it. The idea of "truth" is the most imaginary of all solutions.

4. For 'Pataphysics, all things are equal.

The pataphysician not only accepts no final scientific explanation of the universe, he also rejects all values, moral, aesthetic, and otherwise. The principle of universal equivalence and the conversion of opposites reduces the world in its pataphysical reality to particular cases only. All the more reason, indeed, that the pataphysician should enjoy "working," and in the most diverse ways, should respond to all the normal (and "abnormal") appetites of the flesh and the spirit, should sometimes behave with considerateness toward his neighbor and even fulfill a "responsible" role in society. 'Pataphysics preaches no rebellion and no acquiescence, no new morality nor immorality, no political reform nor reaction and certainly no promise of happiness nor unhappiness. What would be the use, all things being equal?

5. 'Pataphysics is, in aspect, imperturbable.

Jarry was regarded by most of his contemporaries as a joker or a lunatic. Here lie the first errors of incomprehension. 'Pataphysics has nothing to do with humor or with the kind of tame insanity psychoanalysis has drummed into fashion. Life is, of course, absurd, *and* it is ludicrous to take it seriously. Only the comic is serious. The pataphysician, therefore, remains entirely serious, attentive, imperturbable. He does not burst out laughing or curse when asked to fill out in quadruplicate a questionnaire on his political affiliations or sexual habits: on the contrary, he details a different and equally valid activity on each of the four sheets. His imperturbability gives him anonymity and the possibility of savoring the full pataphysical richness of life.[6]

6. All things are pataphysical; yet few men practice 'Pataphysics consciously.

No difference in value, only in state, exists between ordinary men and those who are consciously aware of the pataphysical nature of the world, including themselves. The College of 'Pataphysics is no better and no worse than the French Academy or than the Hilldale Garden Club Men's Auxiliary Committee of Three on Poison Ivy Extermination. The College, however, being aware of its own nature, can enjoy the spectacle of its own pataphysical behavior. And what science but 'Pataphysics can cope with consciousness, "self"-consciousness perpetually twisting out of itself into the reaches of ethernity? Père Ubu's monstrous *gidouille* or belly is represented by a spiral, which Dr. Faustroll's 'Pataphysics transposes into a symbol of ethernal consciousness circling forever around itself. Symbol? By now all words are pataphysical, being equal.

7. Beyond 'Pataphysics lies nothing; 'Pataphysics is the ultimate defense.

Like the sorcerer's apprentice, we have become victims of our own knowledge— principally of our scientific and technological knowledge. In 'Pataphysics resides our only defense against ourselves. Not that 'Pataphysics will change history: that great

improvisation of the past already belongs to the Science of Sciences. But 'Pataphysics allows a few individuals, beneath their imperturbability, to live up to their particular selves: Ubu or Faustroll, you or I. Outwardly one may conform meticulously to the rituals and conventions of civilized life, but inwardly one watches this conformity with the care and enjoyment of a painter choosing his colors—or perhaps of a chameleon. 'Pataphysics, then, is an inner attitude, a discipline, a science, and an art, which allows each man to live his life as an exception, proving no law but his own. [. . .]

15 *Clinamen* 87 E.P., Feast of the Invention of 'Pataphysics (Shattuck 1960b, 24–33)

THE OULIPO

The Oulipo has been extensively discussed in several excellent critical studies, most notably in English: *Oulipo: A Primer of Potential Literature* (Motte 1986), the *Oulipo Compendium* (Mathews and Brotchie 1998), and the *Oulipo Laboratory* (Queneau et al. 1995) and, in French, in the publications of the group itself, such as *La Littérature potentielle* (1973), the *Bibliothèque oulipienne* (1974, 1987), the *Atlas de littérature potentielle* (1981, 1988), and Jacques Bens's *OuLiPo 1960–1963* (1980), later reissued as *Genèse de l'Oulipo 1960–1963* (2005).

What characterizes the Oulipian approach is constraint. This has led to a common assumption that any constraint-based literature may be called "Oulipian," something that is a mark of the success of the group. Unlike the Collège de 'Pataphysique, the Oulipo is taken seriously in literary and critical circles. This is paradoxical, because of course it is possible to use constraints in writing without being Oulipian and, more significantly, the initial impulse that launched the Oulipo was essentially ludic, albeit in a rather more mathematical than literary spirit. Many of the Oulipian experiments are extremely funny and explore the same pataphysical humor that Jarry identified as emerging from the syzygy of words. The more literary products of the group, such as the works of Perec, Calvino, Mathews, Queneau, and the rest, manage to retain a sense of delight and play, however fierce the constraints may be. Therein lies their success: the delivery of an elegant, witty, and sophisticated text while behind the scenes, as the reader may or may not perceive, a monumental struggle with the exigencies of a self-imposed set of rules is taking place. In some cases, this tension between aesthetic surface and compositional reality may produce art that is genuinely sublime. At this point, a reader who is less engaged with questions of the processes of the Oulipo might conclude that the potential has been realized.

The Oulipo was founded in 1960 by François Le Lionnais and Raymond Queneau. It held its first meeting on 24 November, initially calling itself the SLE (Séminaire de littérature expérimentale). The name "Oulipo" was agreed at the second meeting a month later and was recorded as such by the Private General Secretary to Baron Mollet, Latis. As Jean Lescure recounts in his brief history of the Oulipo, the first definition of the group was: "Oulipo: group which proposes to examine in what manner and by what means, given a scientific theory ultimately concerning language (therefore anthropology), one can introduce aesthetic pleasure (affectivity and fancy) therein" (Lescure 1973, 32–39).

A second definition quickly followed: "Oulipians: rats who must build the labyrinth from which they propose to escape."

The scientific analogy was significant. Both Queneau and Le Lionnais were not only writers but mathematicians, and admirers of "Nicolas Bourbaki," the collective pseudonym of an influential group of French mathematicians who advanced their discipline through the rigorous application of set theory. The way the Bourbaki group was constituted and operated, in a collaborative spirit with a pervasive anonymity and a highly determined sense of purpose, clearly provided a model for the Oulipo. What distinguished Queneau and Le Lionnais was their interdisciplinarity, their ability to work equally well in both literature and mathematics. This was also true of several other early members of the Oulipo, such as Claude Berge, whose area of focus has been combinatorics; Paul Braffort, who is a computer scientist and musician; or Jacques Roubaud, who is both a poet and a professor of mathematics. Other key figures in the early years included the aforementioned Latis, who was also highly influential in the Collège de 'Pataphysique; Jacques Bens, a writer and scientist who also became the first Provisional Definitive Secretary of the Oulipo; Jacques Duchateau, a journalist and writer; Albert-Marie Schmidt, an expert on the history of constraints in literature; Jean Queval, a writer and translator; and two contacts of Boris Vian—Stanley Chapman and Noël Arnaud, a Regent of General Pataphysics and the Clinic of Rhetoriconosis and President of the Association des Amis d'Alfred Jarry and the Association des Amis de Valentin Brû.[7]

FRANÇOIS LE LIONNAIS (1901-1984)

Le Lionnais was the perfect example of a transdisciplinary pataphysican. He was, on the one hand, a chemical engineer and mathematician, who ran the Forges d'Aquiny, a large industrial enterprise, from the age of 26. He was also a Dada poet and man of letters, who was active in the French

Resistance during World War II. After the war, he became a professor at the École de Guerre, and subsequently Head of the Division of Teaching and Diffusion of Sciences at UNESCO. The sheer breadth of his knowledge and abilities, and his powerful influence, made him indispensable to the formation of the Oulipo. He was responsible for the major theorizing of the group in its early stages, and continued to be a driving force behind its subsequent publications.

LIPO:The first manifesto was first written in 1962, and set out the aims, objectives, and strategies of the group, with a distinct echo of its pataphysical roots:

[. . .] In the research which the Oulipo proposes to undertake, one may distinguish two principal tendencies, oriented respectively towards Analysis and Synthesis. The analytic tendency investigates works from the past in order to find possibilities that often exceed those their authors had anticipated. This, for example, is the case of the cento, which might be reinvigorated, it seems to me, by a few considerations taken from Markov's chain theory.

The synthetic tendency is more ambitious: it constitutes the essential vocation of the Oulipo. It's a question of developing new possibilities unknown to our predecessors. This is the case, for example, of the *100,000,000,000,000 Poems* or the Boolean haikus. [. . .]

When they are the work of poets, entertainments, pranks, and hoaxes still fall within the domain of poetry. Potential literature remains therefore the most serious thing in the world. Q.E.D. (Le Lionnais 1973, 21)

The Oulipo published *La Littérature potentielle* in 1973, followed in 1981 by the *Atlas de littérature potentielle*. These books contain descriptions of many of the Oulipian methods, with examples of actual literature produced using them. *La Littérature potentielle* also contained historical information, including both the First Manifesto and a Second Manifesto, which sets out the context for the group's work, along with Jean Lescure's *Petite histoire de l'Oulipo* (Brief History of the Oulipo).

La Littérature potentielle is divided into several sections, dealing with clusters of methods, that included: *anoulipisms* (analytical oulipisms, such as combinatorial literature); *use of preexisting structures* such as lipograms (omitting a letter or letters), palindromes and snowballs (in which each successive word adds or subtracts a letter), homophonic translation, tautogram, and definitional literature; *lexical, syntactic, or prosodic manipulations* (such as the celebrated S+7, in which each substantive is replaced by the seventh word after it in a standard dictionary; *lexicographical or prosodic synthoulipisms* (early algorithmic methods); and perimathematical

synthoulipisms (including Boolean poetry, branching literature, and an analysis of Queneau's 10^{14} *Poems*.

RAYMOND QUENEAU (1903-1976)

In his brief text "Jarry inconnu" (The Unknown Jarry, 1962), Baron Mollet set out to debunk the myth that Jarry was nothing more than an eccentric poet. He pointed out:

His predilection was chiefly for mathematics, in which he was excessively gifted. Indeed, he kept up a long correspondence with foremost mathematicians. I remember one day when I was to fetch him for lunch, I found him barefoot, in his underpants, shirtless, his eternal bowler hat upon his head, tracing numbers with a piece of chalk on the wall of his flat. As I was hurrying him along, for we were late, he said: "What! I'm ready and I was waiting to you; look, I have my hat on." (Brotchie 1995, 92)

The entry of Raymond Queneau into the Collège de 'Pataphysique in 1950 was a powerful symbol of the value of such transdisciplinary approaches. It also signaled a definitive break with surrealism, in which Queneau had been an active participant but with which he had certain fundamental disagreements. The surrealist emphasis on chance and the subconscious, expressed through automatic writing and dream narratives, did not sit well with Queneau's intensely logical and formalized outlook. Queneau had satirized surrealism in his novel *Odile* (1937), in which André Breton appears as the manipulative character Anglarès, leading a ragtag collection of literary types in a doomed pursuit of spiritualism and communism. He later explained: "I had a kind of gut reaction, a passionate detestation. I had not begun to shake it off when I wrote a novel called *Odile*, [. . .] it showed a total rejection of the whole surrealist spirit" (Queneau 1965, 37–38).

Following this rupture, Queneau embarked on a study of literary madmen (*les fous littéraires*), which turned into an enormous *Encyclopedia of Inexact Sciences*. This tome included writers who claimed to have discovered some fundamental truth, but eliminated mystics, occultists, socialists, and others with an obvious "mission." Although the text remained unpublished, parts of it found their way into his novel *Les enfants du limon* (Children of Clay, 1938), and it inaugurated a tradition which continues to the present day through the efforts of, among others, the Institut International de Recherches sur les Fous Littéraires.

In 1938, Queneau joined the publishing house Éditions Gallimard, where he was first a reader and translator and then General Secretary, a position

of great influence that allowed him to coordinate readers' committees, contact the authors, and generally manage the company. He was director of the Encyclopédie de la Pléiade, through which he published many volumes on topics ranging from history (including the history of religions) to astronomy, zoology, and so on, with major scientists and scholars of the time. Queneau's writings of this period included the novels *Le Chiendent* (The Bark Tree, 1933) and *Pierrot mon ami* (My Friend Pierrot, 1942), which was his first popular success.

In 1947, he published *Exercices de style* (Exercises in Style), which was the first book directly to anticipate the working methods of the Oulipo. It consists of 99 descriptions of a minor incident on a bus, each told in a different style. While many of the styles are literary in nature, quite a few concentrate on word games, permutations, and quasi-mathematical operations. These include: synchysis (an interlocked word order, A-B-A-B, in which the pairs contrast); anagrams; apheresis, syncope and apocope (omitting the beginning, middle and ends of words respectively); spoonerisms; and permutations by groups of letters or words. This is one of those books where an excerpt simply will not do to convey the richness and indeed playfulness of the whole. The curious Anglophone reader is directed to the brilliant translation by Barbara Wright.

The complementary nature of Queneau's interests may be gauged from his activities in the immediate postwar years. He wrote poems that became the lyrics for popular songs in the bars and cabarets of the boulevard Saint-Germain area of Paris (*Si tu t'imagines*, for example, was a hit for Juliette Gréco), as well as popular theater. In 1948, he joined the Société mathématique de France, and began publishing texts inspired by science and mathematics. Meanwhile his novels and other writings continued to influence French literary life, and in 1951 he was elected to the Académie Goncourt. And, of course, he joined the Collège de 'Pataphysique in 1950 as a Transcendental Satrap. The novel *Le Dimanche de la vie* (The Sunday of Life, 1952) reflects this curious mixture, borrowing its title from Hegel, yet describing a charming narrative of the suburbs featuring an utterly likeable hero, the second-class soldier Valentin Brû, whose romantic entanglements are underpinned by an obsession with the passage of time.

The idea of a story that can be read on several levels at once is carried off most explicitly and brilliantly in Queneau's classic novel *Zazie dans le métro* (Zazie in the Metro), published in 1959 and subsequently made into a film directed by Louis Malle. On the face of it, *Zazie* is a simple story of a mischievous little girl who visits her cross-dressing uncle in Paris for a holiday and is horrified to discover that the Metro is on strike. Since riding

on the Metro was to be the highlight of her trip, she takes revenge for her frustration on the collection of strange adults who surround her. The novel consists of a series of playful escapades, written in a delightful comic style peppered with mild obscenities and cheerful bar-room banter. However, this story conceals a much deeper meditation on the nature and function of language. Many years earlier, in 1932, Queneau had observed a difference between classical and demotic Greek: the former effectively dead; the latter very much alive and evolving. He wrote: "It was then that I saw it was obvious that modern French must now finally free itself from the conventions that still hemmed it in; the conventions of style, spelling and vocabulary that date from the grammarians of the sixteenth century and the poets of the seventeenth" (Wright 2001).

This peculiarly French problem, which still persists to some extent today, derives from the fact that formal "dictionary" French differs from spoken French, especially the kind of French that one would hear spoken in the bars and streets of Paris. This formality allows many of the wordplays and puns that characterize a great deal of pataphysical humor. The language itself divided society into a class of academic *cognoscenti* and an underclass of the street. The *argot* of Paris was therefore as much a matter of zinc-bar mumblings as of the language of the philosophers. These spoken words, inflected with alcohol, replace their sibilant sounds with lazy z's, and elide whole phrases into neologisms that Queneau captures in the novel. *Zazie* is therefore a book about what happens when this underground language is forced to the surface. The Metro is a metaphor that echoes *Alice's Adventures Underground*, a wonderland of possibilities that are here denied to the eponymous heroine. Given Lewis Carroll's playful use of mathematics, the parallel with Queneau is complete. The first word of *Zazie* is "Doukipudonktan," a phonetic transcription of *D'où qu'il pue donc tant?* (translated as "Holifart watastink"), which nicely illustrates the point.

The easy, freewheeling style of *Zazie* and all his other books belies the painstaking craftsmanship of Queneau's writing. He declared: "I have always thought that a literary work should have a structure and a form, and in the first novel I wrote I took great pains to see that the structure was extremely strict, and furthermore, that it was a multiple structure. . . . Since at the time I was, let's say, rather arithmomaniac, I built this construction on combinations of numbers, some more or less arbitrary, others according to my personal preferences" (Wright 2001).

Barbara Wright commented: "This structure [. . .] was like a scaffolding, which is removed when the construction is finished. He added that he

hoped it wasn't obvious. It certainly wasn't: no one even suspected it until he wrote about it much later" (ibid.).

In 1961, Queneau created the first great Oulipian text, *Cent mille milliards de poèmes* (One hundred thousand billion poems). He wrote in the preface: "This little work allows everyone to compose at will one hundred thousand billion sonnets, all following the strict rules. This amounts a sort of machine for making poems, but limited in number: however this number, although limited, will provide reading material for nearly two hundred million years (reading 24 hours a day)" (Queneau 1961, 1).

Each line of ten sonnets is printed on its own strip of paper, and so may be substituted for any other of the lines, giving a theoretical total of 10^{14} combinations. It is therefore simultaneously a work of both literature and *potential* literature. It also somewhat anticipates hypertext, as indeed do many of the Oulipo's early products, in its use of substitution to "link" to a new "page."

There have been several English translations, including a limited-edition version by John Crombie from 1983 that follows the original format, and a hypertext version by Beverley Charles Rowe. A version by Stanley Chapman lay unpublished for many years, appearing first in a journal called *Prospice*, before being reprinted in the *Oulipo Compendium* published by Atlas Press (Mathews and Brotchie 1998, 14–33). Chapman noted:

The OuLiPo, which has managed to get itself taken as seriously as its patron saint Marcel Duchamp, neither of them having done as much for—or *against*—art and literature as, say, the *Listener* crossword or the *Statesman* competition, claims these poems as its foundation stone, although they must have been intended simply as an amiably acceptable alliance between Science (Mathematics) and Art (Literature), being minor works summarising—in the basic form in which they are printed here— the major themes and preoccupations of their author's main achievements, and the only work so far inspired by them being my own ONZE MILLE VERBES, CENT VIRGULES which was composed for the Apollinaire centenary. [. . .]

To get the most out of these poems, copy them out carefully on one side of each page of the notebook, cut carefully between each line to make equal strips so that the alternative equivalent of lines of the other sonnets can be read when individual strips are lifted, and then give up all other ambitions and start to make your own hundreds and thousands of billions of poems, just as children used to create fantastic monsters and mutations out of little books of heads, bodies and legs, or as André Breton and his temporary friends used to play exquisitely boring games of consequences. (Chapman 1978, 57–66)

6 (1948-1959) LE COLLÈGE DE 'PATAPHYSIQUE

Adrienne Monnier opened her celebrated bookstore La Maison des Amis des Livres in the rue de l'Odéon in the Latin Quarter of Paris in 1915. When Sylvia Beach decided to open her own bookstore, Shakespeare and Company, in 1919, Monnier provided advice and support, and the two stores rapidly became important meeting places for the literary avant-garde, attracting French, British, and American writers.[1] Unlike Shakespeare and Company, La Maison des Amis des Livres managed to remain open during the German occupation and continued for a further decade after the end of World War II. The idea of a Collège de 'Pataphysique was first discussed there, on 11 May 1948, by Oktav Votka and Maurice Saillet, witnessed by Mélanie Le Plumet and Jean-Hugues Sainmont.

The Collège de 'Pataphysique was formally founded in the winter of 1948, and right from the start set out its organizational structures. The fictional head of the Collège, its "Inamovable Curator," is Dr. Faustroll himself, assisted by his "Starosta" Bosse-de-Nage, the dog-faced baboon who accompanies him on his travels from Paris to Paris by sea, and who only ever says "ha ha." The first and most senior apparently living entity in the hierarchy is therefore the Vice-Curator, who, at the foundation of the College, was His Magnificence Irénée-Louis Sandomir (1864–1957).[2] Sandomir was a lifelong Roman Catholic who had studied at the Angelicum,

or Pontifical University of Saint Thomas Aquinas, in Rome before returning to Paris and becoming interested in Jarry in 1906. His writings, and indeed the way in which the Collège itself was organized during his magistrality, show the influence of both Catholicism and pataphysical humor. As Gilles Firmin puts it:

[. . .] Unlike other dignitaries of the Collège, whose aggressive tendencies could sometimes lead to anticlericalism, [. . .] Doctor Sandomir never gave in to "bitter words." He was content to observe that, while 'pataphysics has an imperturbable aspect, it also has a jubilatory essence." (Firmin 2008, 57)

His Magnificence was ably supported by the Proveditor General, Janvier J. Mauvoisin, and the Adjoint and Rogatory Proveditor, Jean-Hugues Sainmont. Mauvoisin succeeded in this role Mélanie Le Plumet, who was the first member of the Collège to die, a matter of months after the foundation. Her funeral oration, delivered by the Vice-Curator, became the first publication of the Collège.

Another version of the same story concerns a Professor of Letters and Philosophy who taught at the Lycée in Reims (Baudrillard, among others, was a pupil) and then at the Lycées Michelet in Vanves and Louis-le-Grand in Paris. According to the essayist Jean-Louis Curtis, his teaching "focused on emancipation, on rupture: one must always be liberating oneself from something" (Jacob 1997). He also published, with his pupils, a clandestine edition of the poems of Jacques Prévert during the war. He was a man of many identities, including P. Lié, Lathis, Anne de Latis, Jean-Hugues Sainmont, Dr. Sandomir, Mélanie Le Plumet,[3] Oktav Votka, and certain other luminaries of the Collège de 'Pataphysique.[4]

FIRST MAGISTRALITY (SANDOMIR)

Sandomir's magistrality focused on three main activities: establishing the principal doctrines of the Collège de 'Pataphysique; making its presence in the world evident through the production of many high-quality publications; and building up the membership. Among the founders were: Georges Petitfaux, who oversaw the phynances; Henri Robillot, who edited the Collège publications; Maurice Saillet; Maurice Bazy; and two who were later to become Vice-Curators, Opach and Lutembi. The tortoise Mata-Mata was soon to be elevated to the rank of Transcendant Satrap. The founding Regents included: François Laloux, Luc Étienne, Julien Apolon, Nicolas Cromorne, Marcel Maigret; and the first Datary was Henri Bouché (Launoir 2005, 115).

In the first few years, many of the most celebrated members joined the Collège, including: Raymond Queneau, François Caradec, Jean Ferry (1950); Pascal Pia, Jacques Prévert, Max Ernst, Eugène Ionesco, Baron Mollet, Zhang Zemin (Tchang Tsö-min) (1951); Joan Miró, Roger Grenier, Roger Shattuck, Boris Vian, Noël Arnaud, Juan-Esteban Fassio, Marcel Duchamp, Barbara Wright (1952); the Marx Brothers, Ergé (1953); Jean Dubuffet (1954); René Clair (1955) (The Printed Head 1995, 11–14). On 2 June 1953 the Collège held one of its first manifestations outside France: a celebration of the anniversary of the birth of the Marquis de Sade, with the Archbishop of Canterbury and Her Majesty the Queen presiding over a "coronation" ceremony in Westminster Abbey, London.

Given that the list of members contains some of the most ruggedly individualistic names in the arts, cinema, and literature, it is clear that the Collège offered something to its adherents that other groups could not. There is much evidence that Paris in the postwar years was desperately seeking to rediscover its artistic, literary, and philosophical soul. This understandable fervor resulted in a proliferation of variously earnest groups. Their seriousness and intensity was partly a response to the horrors of World War II, the realities of occupation and Nazi atrocities. The reinvention of a Dada spirit of nihilism, which had so well captured the sense of futility of World War I, seemed dangerously trivial at this time. Likewise, the séances and dream-inspired doodlings of surrealism ran the risk of self-indulgence or irrelevancy. What was apparently needed was what the existentialists called "engagement," a practical commitment to the world that—somewhat paradoxically, given the futility of existence—provides some kind of meaning. This engagement is to be found only in a political struggle, theorized Jean-Paul Sartre and others, in which the individual can find an authentic relationship with a social reality. Literature, Sartre eventually concluded, is a bourgeois substitute for real engagement with the world. For many existentialists, "engagement" offered an alternative to suicide, which could have been (and indeed frequently was) an equally authentic response for intelligent individuals.

The fierceness with which the various politicized groups of intellectuals disputed their positions did much to foment the grim atmosphere in Paris. There were many right-wing groups, including Gaullist factions, ranging from anti-Communists such as the "Rally of the French People" (led by de Gaulle himself) through to "left-wing" Gaullists such as André Malraux. The former surrealists had split, with Louis Aragon, now political head of the National Committee of Writers, leaning ever more toward Stalin, and André Breton, still rather loyal to Trotsky, leading a surrealist group in

condemning the French Communist Party's support for colonialism. Sartre and his colleagues meanwhile pioneered the role of public intellectual, espousing a kind of radical individualism that pulled people away from the French Communist Party. Many of these groups based themselves in rival cafés on the Left Bank: Les Deux Magots and the Café de Flore on the boulevard Saint-Germain, and the Dôme in Montparnasse, for example. For the curious visitor, it was possible to make a tour of intellectual Paris by visiting the cafés.

In this context the Collège de 'Pataphysique offered a refreshingly transcendent alternative. Its posture as a nonpartisan home of quiet scholarship and reflection nuanced with pataphysical humor gave it a pleasingly subversive flavor: heretical within a heretical position. As Alastair Brotchie points out: "The College could never be a polemical organization, a science of *exceptions, equivalence* and *imaginary solutions* being irreconcilable with concepts of progress" (The Printed Head 1995, 7).

It even had its own venue, the Restaurant Polidor, originally founded as a *crèmerie* in the mid-nineteenth century (Rimbaud, Nouveau, and others had dinner there in the 1870s). Polidor still flourishes today, and is located in rue Monsieur Le Prince, a little way off the boulevard Saint-Germain, a stone's throw from Jarry's former apartment on the second-and-a-half floor of 7, rue Cassette. It is somewhat different in style from the intellectual cafés with its artisan cooking, murals (dating from 1977), and back room in which the Collège held regular meetings. Noël Arnaud recounted:

Polidor is full of history. [. . .] As soon as the first number of its Cahiers appeared in 1950, the Collège de 'Pataphysique made the Polidor the special venue for its feasts, at once studious and joyous, which it called "scientific banquets." I met there René Clair, Max Ernst, Jean Ferry, Boris Vian, Georges Limbour, Prince Mario Ruspoli, who has since disappeared. I met Ionesco and Paul-Émile Victor there, and pretty soon a big book was necessary to list all the people who came. In the big room at the back, banquets of twenty, thirty, forty covers were organized, with tables added in T, L, even Z formation. The Cymbalum Pataphysicum—which kept the seats warm for the Collège during the occultation through to 2000—kept up this noble tradition at Polidor.

It was Stefan Themerson, English writer and publisher, who one day in 1955, while we were honoring Barbara Wright, the translator of Queneau and Jarry, at the tables in Polidor, informed me that James Joyce was a regular at the restaurant. [. . .] To a generation or more, for its influence continues to this day, Polidor was fundamentally the birthplace of the Collège de 'Pataphysique, because it saw the coming-together of those illustrious people of the 50s and above all Jean-Hugues Sainmont, whom his old friend Henri Thomas, with poetic license, called sometimes Latis, sometimes Emmanuel Peillet. Sainmont was indissociable from Polidor. He added himself to—and for a while led—the long list of those who, down the ages,

wove the legend of this establishment, who came to find what they were looking for, some kind of tangible reality. This is how marvels are born. (Arnaud 2002)

Now, pataphysics at this time had little of the desire for universal adoption that was characteristic of existentialism, communism, and the rest. It was content rather to observe that pataphysics is everywhere, whether or not people realize the fact. In reestablishing a tradition inaugurated by Jarry, it affirmed that Ubu's "merdre" both ended a nineteenth-century culture and foreshadowed all that was to follow. That this insight was quintessentially French, indeed Parisian, made the Collège de 'Pataphysique a perfect example of a certain defiant attitude consistently maintained in the face of continued opposition. To commit to what many others were calling absurdism with such scholarly dedication, and indeed elegance, was the hallmark of a philosophical—or, let us say, *scientific*—tradition that had truly come of age. The following doctrinal documents give some indication of the extent of this dedication. They are to some extent a re-creation of things envisaged by Jarry himself in the two illustrated *Almanachs of Père Ubu*, published in 1899 and 1901, which include a heretical calendar, a Grand Ordre de la Gidouille awarded to chosen contemporaries, and many other ideas that become enshrined in the Statutes and Organization of the Collège.[5] These are still to this day the foundations upon which the Collège de 'Pataphysique stands.

IRÉNÉE-LOUIS SANDOMIR, "INAUGURAL HARANGUE" (1948)

pronounced on 1 Décervelage 76 P.E.

by *His Magnificence* Dr. I. L. Sandomir, Vice-Curator-Founder of the College, on the occasion of the College's first meeting, which brought together almost all those who were Optimates or Members at that time.

Beloved Proveditors,

Beloved Satraps,

Beloved Regents,

and you all, beloved Auditors of the College of 'Pataphysics,

Seeing before us such a closely packed Assembly, gathered together for these solemn and inaugural Assizes, we nevertheless cannot ignore altogether certain doubts (*sensation*) which might cloud the general sense of enthusiasm.

That the College of 'Pataphysics, after a long gestation, should at last have presented itself to the World and that the World should have presented itself to the College (*applause*), does that not in itself represent a fall from grace and a kind of dilution of its pataphysical excellence? (*new sensation*). We do not fear to say aloud, as you can hear (*bravo, bravo!*) what some people may perhaps be thinking surreptitiously. And since for a College such as ours existence can evidently be little more than a barely necessary evil, we would not be reluctant to share their opinion if

precisely this necessary evil—especially by virtue of the contradictions which it implies—did not appear capable of perfecting in depth the pataphysical character of this College: for it still would be an unwarrantable limitation of 'Pataphysics if one should wish to confine it within the domain of nonexistence under the pretext of withdrawing it to the very frontiers of existence (*applause*).

'Pataphysics transcends both equally, and, as our Statutes affirm, the existence of a College could have no authority to restrain or cramp it in any manner, since it is illimitation itself. (*The audience rises and applauds the Vice-Curator-Founder.*)

It was not necessary for the College to be born in order that 'Pataphysics should exist. Ontologically, if I may use such a vulgar adverb, 'Pataphysics precedes Existence. A priori, this is obvious because Existence has no more reason to exist than reason has to exist. A posteriori, it is equally obvious because the manifestations of existence are aberrant and their necessity entirely contingent.

In the infinite glittering of pataphysical light, existence is a mere ray of light, and by no means the brightest, among all those which emerge from this inexhaustible sun. And he whom human infirmity calls the Creator was only, as our Unremovable Curator Doctor Faustroll (*ovation*) has made clear, the first in time or in ethernity of all pataphysicians. When the Scriptures depict first-born Wisdom proclaiming: *Nondum erant abyssi et jam concepta eram*, there is no doubt that it is 'Pataphysics which is being referred to, save in the one particular that Wisdom was not created by God *ante secula*, but on the contrary, as everything tends to show, it created him *ipsum et secula*, among other pataphysical objects. The World is but one of these objects and human beings—since custom demands that we mention them—are pataphysical concretions. (*Murmurs of agreement.*)

The present era has had the privilege of recalling this fact to us with brilliant clarity. Since the apparent death of Alfred Jarry, it seems that humanity has unconsciously taken upon itself the task of incarnating—not indeed more really for that would be impossible, but more openly and more fulguratingly—the explosive fullness and undefinable profusion of 'Pataphysics. (*Profound silence revealing complete attentiveness.*) Our first World Unbraining and the peace which followed it, our prosperities and our crises, our combined overproductions and famines, our morale and our defeatism, a vivificatory spirit and an assinatory literature, our scientific mythologies and our mystics, our civic or military virtues and our revolutionary faiths, our platonic and other despairs, our fascist and democratic furies, our occupation and our liberation, our collaboration, just as much as our resistance (*the audience remains motionless*), our triumphs and our immolations, the translucency of our emaciations like the blackness of our markets, then, again, the imperturbable and inevitable resumption of ranting from the forum, our radios, our newspapers, our national and international organisms, our court orders and disorders, our pedagogies of all complexions, our illnesses and our manias, everything written, everything sung, everything said and everything done, this whole mass of priceless seriousness, this whole inexorable buffoonery, this Coliseum of blablabla seems to have been planned with an admirable application so that no false note may intrude to mar this universal and impeccable Pataphysical Harmony. (*Thunderous applause.*)

It is for this reason that, turning toward you, my dear young listeners, we say to you: Open your eyes and you shall see (*signs of approval*). More fortunate than St. Paul, who could envisage the deity only in terms of an enigma and through a glass darkly, you are privileged to regard 'Pataphysics face to face. Thus the teaching of these learned Regents, the example of these incorruptible Satraps, the counsel of these most serene Proveditors cannot instruct you any more effectively than can the spectacle now spread before your eyes. And we feel it appropriate to recall at this juncture the words uttered by a great pataphysician who was unfortunately unaware of the fact—we refer to Dr. Pangloss: Pataphysically one can say that all is for the best in the most pataphysical of all possible worlds. There could not be more 'Pataphysics in this World than there is because already it is the sole ingredient. The World in all its dimensions is the true College of 'Pataphysics. (*Bursts of applause. Choruses of approval.*)

In any case, the role of this College here assembled will be far more modest. And at this point I can appropriately examine a fresh doubt (*some movement among the audience*) which I divined in your thoughts. Have you not, in short, even if only momentarily and despite the inestimable guarantees which the pataphysically unsuspectable personality of these Optimates assured you, have you not experienced almost a hesitation at the threshold of the College (*hesitation*)? Does not the word College imply teaching? Does not the word teaching imply usefulness or pretensions to usefulness? Does not the word usefulness imply seriousness? Does not the word seriousness imply antipataphysics? All these terms are equivalent (*profound sensation*). And it would be too simple to retort that nothing could be antipataphysics, since all and even those things beyond all are pataphysical. This is pataphysically evident but by no means prevents this Antipataphysics from existing. For it exists: it exists fully; it exists formally; it exists aggressively. And in what does it consist? Ah! this is where the argument runs full circle (*general sigh of relief*): it is precisely ignorance of its own pataphysical nature and it is this ignorance which is its pugnacity, its power, its plenitude and the root of its being. The seriousness of God and of mankind, the usefulness of services and works, the gravity and weight of teachings and systems are only antipataphysical because they will not and cannot proclaim themselves to be pataphysical; for as far as being is concerned they cannot be otherwise than they are (*general approval*). Ducunt volentem fata (*i.e. pataphysica*) nolentem trahunt. (*bravo!*) And so the College is pataphysically founded (*acclamations*).

For it is within the College that the unique and fundamental distinction is made between 'Pataphysics as the substance, if one may say so, of being and nonbeing, and 'Pataphysics as the science of this substance: or in other terms, between the Pataphysics that one is and the 'Pataphysics that one does. For this reason there are, as our Statutes announce, two sorts of pataphysicians: on one hand, those who are pataphysicians without wanting to be and without knowing and, above all, without wanting to know—which is, must necessarily be, will always be the immense mass of our contemporaries; on the other hand, those who recognize themselves to be pataphysicians, affirm themselves as such, demand to be considered as such, and in

whom Pataphysics is superabundant. In them resides the true Pataphysical Privilege, for "'Pataphysics is the only science." (*Prolonged cheering.*)

It is these then whom our College reunites in its useless Ark which drifts and plunges upon the flood of usefulness. Should we regret that it can never have a democratic nature, nor address itself to all? In a flood, are not the waves of the many necessary to bear up the Noetic skiff? Can you believe that an enterprise which takes neither seriousness nor laughter—that shameful seriousness—seriously, an enterprise that refuses to be lyrically lyrical, to serve any kind of purpose, indeed that refuses to save mankind or, what is even more unusual, the World, could possibly have ecumenical pretensions? (*Cries of: no, no!*) The College is not a Church. It is not concerned with winning as many "souls" as possible. In addition, the majority could gain no satisfaction in its ranks, for, in their pataphysically naïve misunderstanding of Pataphysics (which they incarnate nevertheless) they find a sort of mediocre stimulant which they could never do without. (*Disapproving murmurs.*)

Minority members by vocation (*approving murmurs*), we are so much the more alert and ready to undertake our epigean navigation in this new appropriately paraffined skiff which is the College of 'Pataphysics. (*Applause, cheers and acclamations. The Assembly rises and sings the Palotins' Hymn.*)

[stenographic record] (Sandomir 1960a [1948], 169–173)

STATUTES (1948)

TITLE I: CANONS

ARTICLE I—§unique. The Statutes of the College of 'Pataphysics are pataphysical.

ARTICLE 2—§I. "'Pataphysics is *the* science" (Alfred Jarry).

§2. 'Pataphysics is inexhaustible.

ARTICLE 3—§I. The human species being composed only of pataphysicians, the *College of 'Pataphysics* selects those who know they are pataphysicians from those who do not know.

§2. The *College of 'Pataphysics* encourages 'Pataphysics in this world and in all the others.

TITLE II: OF THE HIERARCHY OF THE OPTIMATES

ARTICLE 4—§I. An *Inamovable Curator*, situated in the elementary ethernity of non-being yet supereminently more real than all reality including the divine, presides as much over the essence as the existence of the College which he moves by the attraction of his Pataphysical Perfection. He institutes himself indefinitely at the same time that he perpetuates his Infallible Magisterium, one and the other operation producing themselves by the effect of a Science no less gratuitous than apodictic: which factors make it evident that he is and could only be Doctor Faustroll, *Pataphysician*.

§2. We deduce, by the concatenation of several primary evidences, that he is, on the level of the said ethernity, assisted by the Great Monkey Bosse-de-Nage Cynocephalus Papio [dog-faced baboon], who assumes the title of Starosta.

§3. He is assisted secondly, and on the phenomenal plane, by a Vice-Curator, elected as outlined below, and who directs the College of 'Pataphysics in spiritual as much

as in temporal affairs, ensuring that the said College keep from utility and that 'Pataphysics maintain a Faustrollian excellence.

ARTICLE 5—§I. A *Corps of Proveditors* administers the imaginary and real goods of the *College of 'Pataphysics*; it organizes its Publications and Manifestations; it creates the chairs of the Regents with the adnutation [nod of approval] of the *Vice-Curator*, it proposes to the arbitrium [judgment] of the *Vice-Curator* the recommendation of *Regents* and the investiture of the new *Proveditors*; it pataphysically admonishes the Regents and the members of the College.

. . .

ARTICLE 6—§I. In the image and likeness of the Inamovable Curator, a *Corps of Satraps* is active in the *College of 'Pataphysics* by its mere presence, and even—far surpassing the power of catalysts by its absence. This venerable Synod is bound by no rules and gives itself none. Its assemblies are private, and no one is obliged to be indispensable. No teaching is demanded of it, nor activity of any kind. Each and every one of its members cultivates 'Pataphysics only for its own sake and for himself.

. . .

ARTICLE 7—§I. *Regents* are chosen by the *Proveditors* and approved by the *Vice-Curator*. They are eminent pataphysical personalities whose works, whose antecedents, and even whose accidents qualify them to pataphysically occupy the chairs of the *College*. It is also stated that their lessons may be given in any medium, including the oral medium.

. . .

ARTICLE 8—§unique. The Fundamental Chairs of the College of 'Pataphysics are:

a. General 'Pataphysics and Dialectics of the Useless Sciences.

b. Applied 'Pataphysics, Blablabla and Mataeology.

c. History of 'Pataphysics and Exegesis.

d. Catachemistry and 'Pataphysics of the Inexact Sciences (Merdicine, History, Social Sciences, Home Economics, etc.).—Complementary Classes in Magirosophy.

e. Mythography of the Exact Sciences and of the Absurd Sciences. Complementary Classes in Alogonomy.

f. Military and Strategic Eristics.

g. Epigean and Hypogean Nautics.

h. Halieutics and Ichthyballistics.

i. Velocipedology, Ocypodonomy and Siderodromany.

j. Photosophistics.

k. Cinematographology and Oneirocriticism.

l. Erotica and Pornosophy.

m. The Gay Science and Adelphism.

n. Crocodilology.

o. Pompagogy, Pomponerism and Lollipoposophy.

p. Lyricopathology and Clinical Lectures in Rhetoriconosis.

q. Aesthetic Mechanics and Comparative Graphology.

r. Spoonerisms.

s. Heraldry, Celtics, Fencing, Tarot, Experimental Cybeutics (Practical Work).

t. Matrimonial and Maieutical 'Pataphysics (Practical Work).

u. Mental Alienation and Psychiatry (Practical Work).—Complementary Classes in Occultism, Demonology and Astrology.

v. Moral and Political Sciences and Comparative Atrocities (Practical Work).

w. Painting Machine (Practical Work).

x. Belgian (Practical Work).

y. Alcoholism and Applied Cephalorgics (Practical Work).

z. Experimental Necrobiosis (Practical Work).

aa. Debraining Machine (Practical Work).

Nota Bene. This list is not restrictive. The accumulation and the fractioning of chairs may be authorized by the Vice-Curator.

. . .

ARTICLE 12—§I. The *pataphysical emblem* is Ubu's *umbilicus*.

§2. The Pataphysical Era commences on the *8 September 1873*, which thereinafter is denominated 1st of the *month of Absolu, Year 1* P.E (Pataphysical Era), and following which the order of the thirteen months (twelve of 28 days and one of 29) of the Pataphysical Calendar is fixed, and follows thus: *Absolu, Haha, As, Sable, Décervelage, Gueules, Pédale, Clinamen, Palotin, Merdre, Gidouille* (29 days), *Tatane, Phalle.*

ARTICLE 13—§unique. "**Ha, ha**" (Bosse-de-Nage).

So let the Statutes of the College of 'Pataphysics be reinstated.

From Circasia, on the 1st of the month of Décervelage Year LXXVI, P.E.

The Vice-Curator-Founder Sandomir

In collusion with and for the countersigning:

The Proveditoress General: *Mélanie Le Plumet.*

The Proveditor General Adjuvant and Rogatory: *J. Hugues Sainmont.*

The Amovable Moderator (provisional) of the Corps of Satraps: *Oktav Votka.* (Sandomir 1995 [1948], 39–44)

The other major outcomes of the First Magistrality were its publications: the beautifully produced *Viridis Candela* and other internal volumes. These included texts, many of them previously unpublished, by writers such as: Alphonse Allais; Guillaume Apollinaire; Antonin Artaud; Arthur Cravan; Charles Cros; René Daumal; Marceline Desbordes-Valmore; Léon-Paul Fargue; André Gide; Max Jacob; James Joyce; Pierre Louÿs; Jacques Prévert; Raymond Queneau; Arthur Rimbaud; Jacques Rigaut; Erik Satie; Julien Torma; Paul Valéry; and Boris Vian.

These publications helped to introduce the notion of the *patacessor*: someone who was, consciously or unconsciously, pataphysical *avant la lettre* (although the word "patacessor" itself took some time to pass into general usage). They also contained both historical accounts and critical analyses of works or writers that were important to Jarry, although it should

be stressed that the Collège has never been a "Jarry Society." La Société des Amis d'Alfred Jarry exists as a separate organization although, to be sure, it counts several leading pataphysicians among its members. It was founded in 1979 and is still publishing its periodical *L'Étoile-Absinthe* to this day. The internal publications of the Collège were distributed in a range of formats and typographies, such as: Collection Q (pronounced *cul* in French, which means "arse"), of which each volume was shaped differently (trapezoid, parallelogram, etc.); *Petit Théâtre* by René Daumal and Roger Gilbert-Lecomte, to be opened only when wearing pigskin gloves; and the *Monolo* by Jean Ferry, typeset to be read while lying down.

Viridis Candela is the general name given to the Collège journals, grouped into series of *Cahiers, Dossiers, Subsidia*, and so on. Each of the initial series of *Cahiers* was organized around a central theme, but also included a section on Collège activities and announcements. At times they feel like parish magazines in their intimacy and exhortations, at others they seem to transcend the parochial and acquire the status of the best philosophy. Taken as a whole, they represent an indispensable collection of literary and critical documents.

Cahier 1 (6 April 1950). "Présentation du Collège et de sa tâche" (The College and its Tasks). Includes the Inaugural Harangue and part of Sainmont's "Jarry and 'Pataphysics."

Cahier 2 (22 September 1950). "Commentaire pour servir à la construction pratique de la Machine à explorer le Temps" (Commentary on How to Construct a Time Machine). This important text by Jarry had been omitted from the published edition of the *Œuvres Complètes*, so this was its first publication since his lifetime.

Cahier 3–4 (27 October 1950). "Le problème d'Ubu" (The Problem of Ubu). Secondary sources on Ubu.

Cahier 5–6 (13 April 1952). "La 'Pataphysique à l'Époque symboliste" ('Pataphysics in the symbolist period). Rare texts by contemporaries of Jarry, preceded by an outline of an imaginary exhibition of symbolism by Mélanie Le Plumet.

Cahier 7 (4 September 1952). "Hommage à Julien Torma" (Homage to Julien Torma). Also contained the first publication of Ionesco's *The Bald Primadonna* and "a page of *Finnegans Wake*."

Cahier 8–9 (25 December 1952). "Sur la pensée mystique" (On Mystical Thought). Texts by Jarry, Torma, Daumal, Max Jacob, Ionesco and others, preceded by a Digression by His Magnificence the Vice-Curator Founder.

Cahier 10 (6 April 1953). "Cahier Jarry." Catalogue to the "Expojarrysition" exhibition held at the Galerie Jean Loize.

Cahier 11 (11 June 1953). "Sur la sagesse des nations" (On the Wisdom of Nations). Letter from Boris Vian to His Magnificence Sandomir, with texts by Prévert and others.

Cahier 12 (29 September 1953). "Devoir de vacances" (Holiday Duties). Previously unpublished texts by Allais, Jarry, and others.

Cahier 13–14 (15 January 1954). "Rabelais pataphysicien" (Rabelais, pataphysician). Writings about Rabelais by Collège members.

Cahier 15 (14 April 1954). "Jarry pantagruéliste" (Jarry pantagruelist). Rabelais in Jarry's work.

Cahier 16 (8 September 1954). "Traité des Patagrammes de René Daumal" (Treatise on Patagrams by René Daumal). This *Cahier* also includes mocking anagrams of the name "André Breton" by members of the Collège.

Cahier 17–18 (20 October 1954). "Centenaire Allais-Rimbaud" (Allais-Rimbaud Centenary). The fact that the two writers were born on the same day occasioned this collection of writings.

Cahier 19 (25 March 1955). "L'avenir futur ou non" (The Future Coming or Not). A review of the work of the Collège up to that point. Membership now stood at over 300.

Cahier 20 (29 June 1955). "Complément au Cahier Ubu" (Ubu Cahier Complement). Includes several studies on *Ubu* and an unpublished text by Jarry: *Onésime*.

Cahier 21 (22 December 1955). "Sur la morale" (On Morality). Texts on such topics as: casuistry; surrealist honesty; sincerity; and other moral epiphanies.

Cahier 22–23 (12 May 1956). "Navigation de Faustroll" (Navigation of Faustroll). A critical commentary on *Faustroll*.

Cahier 24 (7 September 1956). "Marceline Desbordes-Valmore" An edition of *Le Serment des Petits Polonais*. This moralizing text by Marceline Desbordes-Valmore is one of the "Equivalent Books" in *Faustroll*, reprinted here because it was completely unavailable.

Cahier 25 (31 December 1956). "Sur l'être «On» et le langage" (On the entity ONE and language). On language as the departure (and arrival) point for all aberrations (Collège de 'Pataphysique 1950–1956).

Mention should also be made of the important "Expojarrysition" staged in 1953 at the Galerie Jean Loize, an enormous scholarly exibition of some 533 separate pieces of work, including manuscripts, letters, first editions, and many texts by Jarry and others.

Sandomir died on 10 May 1957 (his last words were "Qu'est-ce qui fait du bruit?" (What is that making a noise?)), an event whose sorrow was,

according to Jean Paulhan, editor of the *Nouvelle Revue Française*, "tempered by the suspicion that probably Dr. Sandomir had never existed." Outraged, the Collège declared in return that "Jean Paulhan does not exist" and distributed postcards worldwide to that effect, which were then sent to the (rueful?) Paulhan from Rome, London, Brussels, Geneva, Frankfurt, Moscow, Baghdad, Calcutta, Pondicherry, Austin (Texas), Singapore, Hong Kong, Brisbane, Chicago, San Francisco, Caracas, Bogotá, Rio de Janeiro, Buenos Aires, Senegal, Konakry, Addis Ababa, and across France. In the same year, the Collège de 'Pataphysique launched a campaign to have itself formally recognized as a Public Inutility.

The remaining two *Cahiers* were published after the death of Sandomir, preceded by a volume in the Collection Q series by Jean-Hugues Sainmont, entitled *Bouquet*. This seems to chart his descent into madness, including ravings about Martians, the national lottery, and insects. Sainmont resigned from the Collège soon afterward and was subsequently confined to a lunatic asylum.

Cahier 26–27 "Cinquantenaire de Jarry" (26 May 1957) included a celebration of the 50th anniversary of the death of Jarry. This was a 128-page volume evoking each year of the writer's life, with texts by François Laloux, Franc-Nohain, Prévert, Torma, Balzac, René Crevel, Jean Ferry, Stefan Themerson, Michel Leiris, Sully-Prudhomme, and photos by Arthur Cravan. It was assembled by Sainmont, Maurice Saillet, Henri Bouché, Pascal Pia, François Caradec, Georges Petitfaux, Nikolaj Kamenev, Claude Ernoult, Luc Étienne, and Marie-Louise Aulard.

Cahier 28 "Blanchissage" (8 September 1957) consisted of a laundry note of Jarry's and a brief announcement: "In Order to Celebrate fully the 50th Anniversary of the Occultation of Alfred Jarry the College of 'Pataphysics Hereby Terminates all its Public Activities." This dramatic announcement was the culmination of a mysterious episode of conflict which is usually referred to as "the Plomb Affair." There seems to have been a move by a certain faction, led by the aforementioned Datary Vivien Plomb, to take over the Collège. The attempted *coup* was apparently prompted by the death of the Satrap P. Lié, and other deaths around this time, as well as the deteriorating state of mind of Sainmont. In any event, the result was the sudden resignation of Plomb, Mauvoisin, and several others, and the subsequent appointment (by Sandomir on his deathbed) of a new cohort of Proveditors, Satraps, and Regents.

In the two years following the Plomb affair and the death of Sandomir, usually called the First Magisterial Interregnum, the Collège was forced to

reorganize itself. The first step in this direction was a *Report to the Corps of Proveditors* produced by Nikolaj Nikolaïevitch Kamenev, which addressed "Certain Historical Problems Concerning 'Pataphysical Activity Posed by the 50th Anniversary of the Death of Jarry." This was essentially a Marxist (Karl, rather than the brothers) analysis of the Collège, which attacked "Sainmontism" as an example of a "cult of personality." The recommendations were that "the College becomes increasingly an institution resting upon collective responsibilities," and that it should avoid "reactionary subjectivism and unconscious 'Pataphysics as much in the economico-directional infrastructure as in the consequent ideology which would necessarily result therefrom."

1959 saw the publication of Sandomir's collected writings, the *Opus Pataphysicum*, plus the appearance of Roger Shattuck's *The Banquet Years*. A Committee of Ten was formed to oversee the appointment of a new Vice-Curator, and Raymond Queneau was elected "Unique Elector"; he in turn, and after a secret ballot, was responsible for the appointment of Baron Mollet. Whether or not the "cult of personality" was eradicated through this process, there was nevertheless a clear sense of transition and a change of tone in both the publications and the way in which the Collège operated. The following excerpt from the *Last Will and Testament* of Sandomir therefore in some senses marks an end to the original vision of the Collège, although many of its ideas persisted in what was to follow.

IRÉNÉE-LOUIS SANDOMIR, "EXTRACT FROM THE *TESTAMENT* OF DR. I. L. SANDOMIR" (1956)

[. . .] The World is a gigantic aberrance, which, additionally and universally, is based upon an infinity of other aberrances. Whatever we may say about it is a fiction of a fiction. The naïvety of mankind (another evagation) has named Reason what is only one possibility (among several others) of making apparent the incommensurability of this super-aberration and of discovering that it is neither one, nor multiple, but ambiguously iridescent and coruscating. The least of its innumerable reflections, the most simplistic of myths or the most genial of intuitions, once they become possible, have every right to be placed on the same level as this supreme and hyperstatic super-aberration. Pataphysics contains all infinites.

There is thus no difference whatsoever, either of nature or degree, between different minds, any more than there is any difference between their products, or indeed between one thing and another. For the Complete Pataphysician the most banal graffito equals in value the most consummate book, even the *Exploits and Opinions of Doctor Faustroll* themselves, and the humblest mass-produced saucepan equals the Nativity of Altdorfer. Who among us would dare to consider himself as having reached such a point of extralucidity? Such is nevertheless the postulate of Pataphys-

ical Equivalence, upon which the worlds of worlds and the ersatz spiritual residues find indiscernably their revolving base, just like the hippoxylic cycle upon its pivot. Thus, although democracy or demophily are for him only one fiction among others, the pataphysician is without doubt the undisputed holder of the absolute record of democracy: without even making an effort he beats the egalitarians at their own game. The fact is that he denies nothing; he exsuperates. In this as in everything. He is not there to do away with things but to subsume them.

Such an attitude may seem scandalous to those who are enamored of past or present dogmas, inscient of their nature as they are. It will doubtless appear negative—and negatory of "Science" and "Art." Nevertheless this, as in everything else, is only an appearance. No one is more positive than the pataphysician: determined to place everything and to extract everything with the same amiability. "*All is fruit which your seasons, Nature, offer me.*" He has not the slightest feeling of hostility. He has nothing against what the vulgar call delirium or insanity, nor does he deprecate what clever people term stupidity. He sees precisely as much in stupidity as he does in cleverness or wisdom: for, in life, such folly is for many a very sufficient basis for existence and, more particularly, an appropriate garniture for their thought processes. He does not even distinguish his own attitude from that of the masses: he calls it 'Pataphysics, giving himself only the benefit of that humble apostrophe recommended by Jarry,[6] the significance and use of which has been so eruditely defined by our College.

And if anyone asserts the efficacity of "Science"—the term generally used for its technical "achievements"—the pataphysician will certainly not deny this claim. But he will apply definite tests to it, tests so important that once again the part equals the whole. You can often see that so-called "objective Science" does in fact affect (or has some effect on) so-called "reality." Nevertheless the facts that this "reality" is intrinsically aberrant and that the successes of "Science" hardly ever cling to its initial justification (the reactions of thirty years later, for instance) are revealing. It is no less true to say that imaginary solutions are just as efficacious as supposedly real solutions. These imaginary solutions influence events. They influence people. And sometimes far more powerfully. Above all, they influence the very ideas of so-called objective Science, which draw their power from this motivation. An average observer could quickly establish the fact that the scholars of our time, the moment that they approach generalities, merely copy—usually by way of mathematics—the theories of ancient metaphysics: and the wilder theories at that. And if our average observer leaves such panoramatory theoristics, and proceeds to the detailed establishment of facts, it will be to discover that the identification on an astrophotograph of the millimetric trace of a spiral nebula involves such a lavish abundance of the most staggering metaphysical assertions that, without 'Pataphysics, it would be demoralizing to hear "Science" proclaiming itself positive and objective. It is clear, in fact, that its capacity for self-inflation and its ability to provide furniture for the mind depends solely on the pullulation of Imaginary Solutions.

But we are wrong to hypnotize ourselves with "Science" in concession to contemporary myths. For this supposed "Science" is not Science, if it is so ignorant

and assiduously self-deluded about itself. It is neither the science of a "real," being incapable of *"distinguishing"* it in *any* sense, nor is it the science of self-awareness. It could become these things only through a participation in 'Pataphysics, which, because of its illimitation and autocritical faculty alone, has the right to assume the name of Science. [. . .]

15 As 84 (17 November 1956 vulg.) on the Supreme Feast of the Navigation of Doctor Faustroll (Sandomir 1960b [1956], 178–180)

PATAPHYSICAL ART AND PATAPHYSICAL LIFE

Many of the leading European figures in pataphysics in the postwar years were visual artists: painters, sculptors, cartoonists, photographers, and cinematographers. For the majority, pataphysics offered a way out of the surrealist impasse. Following the fascination of painters since Bonnard, Rouault, and Picasso with the monstrous figure of Ubu, many of them had been drawn to surrealism in the 1920s and 1930s. The antibourgeois, scandalous nature of Ubu became a rallying point for the surrealist revolution. However, the full horror of the prophetic nature of Jarry's vision of an ultimate dictator had become all too *real* during World War II. From 1945 onward, Ubu seemed to reaffirm the essential truth of an absurd irrationality at whose whim many European citizens lived or died. This was something which artists such as Max Ernst, Joan Miró, Marcel Duchamp, and Man Ray had directly experienced in their own lives. André Breton's increasingly dictatorial role as the "Pope" of surrealism unfortunately seemed to have become itself rather Ubuesque. The efforts of surrealism to overturn bourgeois society had plainly failed. This, combined with the surrealists' interest in Stalin and/or their drift into mysticism, tended to drive many former adherents toward the Collège de 'Pataphysique.

At the same time, a new generation of artists in Paris began to pick up on the pataphysical spirit. Overseas visitors, such as the American Ellsworth Kelly, the Italian Enrico Baj, the Chilean Roberto Matta, the Pole/naturalized Briton Franciszka Themerson, and many others became to a greater or lesser extent interested in and influenced by it. In Kelly's case, it was part of the formative process of development that led to his mature style. For Baj, it was a lifelong commitment that led him into direct conflict with the Italian government. For Matta, it was a refuge from the surrealist group from which he had been expelled, and a source of imaginative stimulation. For Themerson, it led to a collection of paintings, book illustrations, and set designs for productions of Ubu, and the establishment, with her husband Stefan Themerson, of the Gaberbocchus Press.

JACQUES PRÉVERT (1900-1977)

Some of the most productive partnerships in French cinema were those between Jacques Prévert, as screenwriter, and various leading directors of the day, including: Marcel Carné (*Drôle de drame* (Bizarre, Bizarre), 1937; *Quai des brumes* (Port of Shadows), 1938; *Le Jour se lève* (Daybreak), 1939; *Les Visiteurs du soir* (The Night Visitors), 1942; and *Les Enfants du paradis* (The Children of Paradise), 1945); Jean Renoir (*Le Crime de Monsieur Lange* (Monsieur Lange's Crime), 1936); and Jean Grémillon (*Lumière d'été* (Summer Light), 1943).

Prévert's 'pataphysics was always a matter of a light touch, but none the less present for that. He joined the Collège de 'Pataphysique in 1951, and rapidly became (as did his dog, Ergé) a Transcendental Satrap, but his work had anticipated this involvement as early as 1938 when a group of socialist students, which included the future founders of the Collège, published his poem *Le Paysage changeur* (The Changing Landscape).[7] He was also part of the rue du Château group, which included Raymond Queneau and Marcel Duhamel, and very active in a prewar agitprop theater group, Groupe Octobre, for which he wrote several anticapitalist plays that are much admired by pataphysicians, such as *La Bataille de Fontenoy* (The Battle of Fontenoy). Later poems included *Les Petits Plats dans les grands* (Dust off your best china), which depicts the Holy Eucharist as cannibalism, with Ubu doubling for God.

In the postwar years, Prévert's juicy writing style, filled with wordplay, neologisms, and baroque invention, came to epitomize the very character of Paris, and he is still much studied in French schools. His most famous poem, "Les Feuilles mortes" (Autumn Leaves, 1945), has been sung by many leading vocalists, including Juliette Gréco, Yves Montand, Édith Piaf, Joan Baez, Frank Sinatra, and many more, and has become a jazz standard in the musical setting by Joseph Kosma.

Prévert's collection of writings entitled *Paroles* (Prévert 1990) probably best encapsulated the spirit of French culture at this time. It was published in 1946 by Les Éditions du Point du Jour. The book consisted of fragmentary cabaret songs, poems, and other writings scribbled on the backs of envelopes and café tablecloths. The collection sold in large numbers, and was subsequently picked up by the Beat Generation as a kind of model of a freewheeling approach to life. Lawrence Ferlinghetti, who led the jazz-poetry movement, became one of Prévert's most influential translators.

The spirit of the volume may be felt in the poem *Pater Noster*, with its opening cry "Our Father who art in heaven / Stay there / And we'll stay

here on earth" (which echoes Jarry's antireligious stance) and its rapturous yet bitter celebration of the beauties and the horrors of the modern world.

BORIS VIAN (1920–1959)

Boris Vian was another of those figures who seemed to epitomize a pataphysical way of life: full of liberty, experimentation, antiestablishment attitudes, artistic mastery, and *joie de vivre*. For some years, Vian was the most identifiable French pataphysician, and his infectious spirit permeated the Collège de 'Pataphysique. The eulogy on his untimely death in 1959, published in *Dossier 7*, conveys something of the depth of feeling in pataphysical circles, and also serves as a good introduction:

"It's not a friendship, it's love," replied Boris Vian to one of the Proveditors General who, in recognition of services rendered, thanked him for his friendship with the Collège. [. . .]

This hyperbole is a euphemism, which simultaneously conceals and reveals both enthusiasm and generosity. Irony here permits a truth, more true than the truth. The casualness is both aristocratic and subtle. And right on the verge of bad taste is this perfect expression of delicacy and refinement. [. . .]

Nobody lived the doctrine of Imaginary Solutions in the *here and now* more than Boris Vian. With a stupefying fecundity and renewing energy, he was capable of improvising a plurality of unexpected solutions, on any subject, that were always marked with his genius. [. . .]

Two years ago, the Satrap Boris Vian, *Promoteur insigne* de l'Ordre de la Grande Gidouille, wrote: "It is no longer possible that the Collège de 'Pataphysique could cease to exist: if it were to cease, it would continue of its own accord and without any members." It is no less evident to us that the Satrap Boris Vian could cease to exist: at least we know through irrefutable science that his admirable role and presence in the Collège will continue.

LATIS, S.-P.G. de S.M. (Latis 1959, i–iv)

Vian did much to draw people's attention to the Collège, both generally through his high public profile and through specific activities such as a radio interview about pataphysics with the popular singer Henri Salvador (Salvador, Arnac, and Vian 1959). The Collège published the plays *Les Bâtisseurs d'empire* (The Empire Builders) in 1959, and *Le Goûter des généraux* (The Generals' Tea Party), an antimilitarist piece, in 1962. Vian's involvement in jazz (he joined the "Hot Club" in Paris, was the contact for Hoagy Carmichael, Duke Ellington, and Miles Davis, and wrote the best reviews in journals such as *Jazz Hot* and *Jazz News*) is reflected in his writing, which constantly invents while playing with words and ideas in a quasi-improvisatory style.

His most famous book was *L'Écume des jours* (Froth on the Daydream, 1946). His other novels include the psychoanalytically influenced *L'Arrache-cœur* (Heartsnatcher, 1953) and *L'Herbe rouge* (The Red Grass, 1950), which tells the story of an inventor, Wolf, who creates a machine that allows him to relive past anxieties in order to be able to forget them.

The following brief plot summary and excerpt from *Froth on the Daydream* will give some idea of Vian's style, and of how lightly the pataphysics appears in his writing (note the satirical appearance of Jean-Paul Sartre). The translation is by Stanley Chapman, who delighted in deliberate anachronisms, such as the references to Sam E. Phray (Sami Frey) and Jacques Goon Luddard (Jean-Luc Godard). (The French text at this point reads: "le blond qui joue le rôle de Slim dans Hollywood Canteen.")

The protagonist, Colin, is a wealthy young man with a resourceful and stylish manservant, Nicolas, and a healthy supply of doublezoons. With dizzying speed, Colin meets and weds Chloë in a grand ceremony. Generously, Colin bequeaths a quarter of his fortune to his friends Chick and Alise so they too may marry. Happiness should await both couples, but Chloë falls ill upon her honeymoon with a water lily in the lung, a painful and rare condition that can be treated only by surrounding her with flowers. The expense is prohibitive, and Colin soon exhausts his funds. Meanwhile, Chick's obsession with the philosopher Jean-Sol Partre causes him to spend all his money, effort and attention upon collecting Partre's literature. Alise hopes to save Chick financially and renew his interest in her by persuading Partre to stop publishing books. She kills him when he refuses, and seeks revenge upon the booksellers. Colin struggles to provide flowers for Chloë, to no avail, and his grief at her death is so strong his pet mouse commits suicide to escape the gloom.

Colin finished his bath. He got out and wrapped himself in a thick woolly towel with his legs coming out at the bottom and his top coming out at the top. He took the hair-oil from the glass shelf and sprayed its pulverized perfume on to his yellow hair. His golden comb separated the silky mop into long honeyed strands like the furrows that a happy farmer's fork ploughs through apricot jam. Colin put back his comb and, seizing the nail-clippers, beveled the corners of his eggshell eyelids, adding a touch of mystery to his appearance. He often had to do this because they grew again so quickly. He put on the little light over the magnifying mirror and went up close to it to examine the condition of his epidermis. A few blackheads were sprouting at the sides of his nose near his nostrils. When they saw themselves in the magnifying mirror and realized how ugly they were, they immediately jumped back under the skin. Colin put out the light and sighed with relief. He took the towel from his middle and slipped a corner of it between his toes to dry away the last signs of dampness. In the glass it was obvious that he was exactly like a fair-headed Sam E. Phray in a film by Jacques Goon Luddard. His face was smooth, his ears small, his nose straight and his complexion radiant. He was always smiling, as innocently as a baby, and through having done it so often a dimple had grown into his chin He was reasonably tall and slim-hipped; he had long legs and was very, very nice. The name

Colin suited him almost perfectly. He talked to girls with charm and to boys with pleasure. He was nearly always in a good mood—and the rest of the time he slept.

He emptied his bath by boring a hole in the bottom of the tub. The light yellow ceramic clay tiles of the bathroom floor sloped in such a way that the water was orientated into an orifice placed directly over the study of the tenant in the flat below. But only a few days previously, without saying a word to Colin, the position of the study had been changed. Now the water went straight into the larder underneath. (Vian 1988a [1946], 9–10)

All of Vian's work has an underlying subversive tendency, and in some cases this expressed itself more directly. His notorious antimilitary song "The Deserter" was released on 7 May 1954, during the Battle of Điện Biên Phủ in French Indochina, and later was sung as a protest song against the Algerian War. The song was banned for many years by the French authorities, but was revived during the anti-Vietnam protests in America by singers such as Joan Baez and Peter, Paul and Mary. The lyrics simply state one individual's decision to refuse to fight, possibly at the cost of his own life, in the form of a "letter" to the President. The letter urges others to resist military service, and declares: "I am not on this earth to kill poor people." This kind of direct, political statement might seem at first glance to be a long way from the "imaginary solutions" of pataphysics. Yet Jarry's novel *Days and Nights*, which chronicles his experiences in the army, is subtitled "novel of a deserter." The desertion in question is not just from military service but also from reality itself.

Vian's works cannot be seen in isolation from one another, but rather as part of a rich picture which includes everything from engineering to jazz, from political action to a literary life "just beautiful, like literature." He died on 23 June 1959, having just attended a screening of a film version of his notorious novel *I Will Spit on Your Graves*, a version which he detested and publicly disowned. A few minutes after the film began, he cried: "These guys are supposed to be American? My ass!" then had a heart attack (he had suffered from a heart condition throughout his life).

THE THEATER OF THE ABSURD

Jarry's influence on the theater was profound. A direct line may be drawn from *Ubu Roi*, through the plays of Guillaume Apollinaire and Roger Vitrac, and Antonin Artaud's "Theater of Cruelty," to what the critic Martin Esslin called the "Theater of the Absurd," which "strives to express its sense of the senselessness of the human condition and the inadequacy of the rational approach by the open abandonment of rational devices and discursive thought" (Esslin 1961, 23–24).

This obviously overlaps not just with pataphysics, but also with existentialism, Dada, surrealism, and other similar ideas. Nevertheless, the leading "absurdist" playwrights included Vian and Eugène Ionesco, who was probably the most explicit in his acknowledgment of pataphysics. Less often recognized is the debt of Samuel Beckett to Jarry, some of whose works he had translated. Beckett was also influenced by the tradition of cabarets such as the *mirliton*, and the recontextualization of popular music hall performance within the "art house" theater represented by the Théâtre des Pantins and other efforts by Jarry and his circle. Beckett's characters often behave in a puppet-like manner, and are instructed to speak in a way which resembles Jarry's (or Ubu's) flat monotone, with every syllable equally accented. Some of the exchanges in *En attendant Godot* (Waiting for Godot, 1953), for example, echo those between Dr. Faustroll, with his lengthy pataphysical orations, and Bosse-de-Nage, with his perfunctory reply of "ha ha." The figure of Godot himself, on whom the entire play hinges, is an imaginary entity. Of course, Beckett's universalism leaves such characteristics capable of more than a single interpretation, and this is not an argument that somehow Beckett's work is solely an example of concealed pataphysics (except insofar as anything may be so). Still, the traces of its presence are there.

EUGÈNE IONESCO

In the case of Eugène Ionesco (1909–1994), it is far easier to identify the influence, for he was a Transcendental Satrap of the Collège de 'Pataphysique, and he acknowledged the (ir)relevance of pataphysics throughout his career. The following excerpts from an interview conducted in 1980 reveal the extent of his involvement.

LINE MCMURRAY, INTERVIEW WITH EUGÈNE IONESCO (1980)

Can you tell us how you developed your understanding of Pataphysics?
Although the Merging of Opposites is a pataphysical idea, it doesn't belong solely to Pataphysics. It is an ancient theory belonging to many different metaphysical traditions. As you mentioned, I've already been a Pataphysician without being aware of it, although my consciousness of Pataphysics was raised when I started coming into contact with the people running the College of Pataphysics: Boris Vian, Raymond Queneau, and especially Sainmont. It seems that Sainmont underwent a resurrection due to Pataphysics and became "born again" under the name of Latis. But then off he went again, never to return . . .
And has your awareness of Pataphysics influenced either your life or work?
I don't believe that Pataphysics has influenced either my life or my work. I've led a life that is half bourgeois, half pataphysical. A bourgeois life is by nature

a pataphysical one, even if I haven't been too aware of what sort of a life I've been leading. I haven't made a deliberate effort to let Pataphysics influence my work, even though my work has been developing in ways that are consciously or unconsciously related to Pataphysics. This philosophy hasn't influenced me in a way that's either literary or bookish. It's the *spirit* of Pataphysics that's grabbed me, and it's through the spirit of something that one draws inspiration from it the most easily.

. . .

But you say that everything's pataphysical?
Yes, everything's pataphysical. And what's more pataphysical than anything else is absolute indifference and irony; irony on a grand scale. When you say that leading a bourgeois life is also the same as leading a pataphysical one, that's true to an extent, but it's not ultimately true. A bourgeois life is one which is unknowingly pataphysical, because the bourgeoisie think they've got the answers, but in fact they don't have any. And inasmuch as they don't have any, they're Pataphysicians, but only in the sense of being ones gained by accident. Pataphysics is a nihilistic doctrine.

. . .

For the Pataphysician, is there neither hope nor despair?
For the Pataphysician—a real Pataphysician—the issue of hope and no-hope does not arise. That's why I was telling you that Pataphysics is closer to Zen than Christianity, Marxism, or the idealistic philosophies of the centuries which have just passed. (McMurray 1980, 123–136)

With Jarry's observation that "clichés are the armour of the Absolute" in mind, the pataphysical themes in *The Bald Soprano*—and, indeed, other works by Ionesco from this period—become plain. *The Bald Soprano*, Ionesco's first play, was written after he attempted to learn English from a primer (he was a Romanian exile in Paris). The cliché-ridden truisms in the primer produced a series of astonishing syzygies of words and a series of *clinamen* deviations from meaning. Language itself dissolved into a tragic mess of missed meanings. The play is in effect a transcription of these peculiar deviancies. It opened on 11 May 1950, at the Théâtre des Noctambules, Paris, under the direction of Nicolas Bataille, and has played more or less continuously since at the Théâtre de la Huchette, making it one of the most frequently performed plays in Western theater and, by the 1960s, recognized as a modern classic.

The plot of *The Bald Soprano* is circular (TheatreHistory.com 2006). The Smiths are a traditional couple from London, who have invited another couple, the Martins, over for a visit. They are joined later by the Smiths' maid, Mary, and the local fire chief, who is also Mary's lover. The two families engage in meaningless banter, telling stories and relating nonsensical

poems. Mrs. Martin at one point converses with her husband as if he were a stranger she just met. As the fire chief turns to leave, he mentions "the bald soprano" in passing; this has a very unsettling effect on the others. Mrs. Smith replies that "she always wears her hair in the same style."

After the fire chief's exit, the play devolves into a series of complete *non sequiturs*, with no resemblance to normal conversation, for example:

MRS. MARTIN: I can buy a pocketknife for my brother, but you can't buy Ireland for your grandfather.
MR. SMITH: One walks on his feet, but one heats with electricity or coal.
MR. MARTIN: He who sells an ox today, will have an egg tomorrow.
MRS. SMITH: In real life, one must look out of the window.
MRS. MARTIN: One can sit down on a chair, when the chair doesn't have any.
MR. SMITH: One must always think of everything.
MR. MARTIN: The ceiling is above, the floor is below.
MRS. SMITH: When I say yes, it's only a manner of speaking.
MRS. MARTIN: To each his Own.
MR. SMITH: Take a circle, caress it, and it will turn vicious.
MRS. SMITH: A schoolmaster teaches his pupils to read, but the cat suckles her young when they are small.

It ends with the two couples shouting in unison "It's not that way. It's over here!," right before a blackout occurs on stage; when the lights come on, the scene starts from the beginning, with the Smiths reciting the Martins' lines from the beginning of the play for a while before the curtain drops. The Martins become the Smiths and the Smiths become the Martins:

MRS. MARTIN: Silly gobblegobblers, silly gobblegobblers.
MR. MARTIN: Marietta, spot the pot!
MRS. SMITH: Krishnamurti, Krishnamurti, Krishnamurti!
MR. SMITH: The pope elopes! The pope's got no horoscope. The horoscope's bespoke.
MRS. MARTIN: Bazaar, Balzac, bazooka!
MR. MARTIN: Bizarre, beaux-arts, brassieres!
MR. SMITH: A, e, i, o, u, a, e, i, o, u, a, e, i, o, u, i!
MRS. MARTIN: B, c, d, f, g, l, m, n, p, r, s, t, v, w, x, z!
MR. MARTIN: From sage to stooge, from stage to serge!
MRS. SMITH [imitating a train]: Choo, choo, choo, choo, choo, choo, choo, choo, choo, choo, choo!
MR. SMITH: It's!
MRS. MARTIN: Not!
MR. MARTIN: That!
MRS. SMITH: Way!
MR. SMITH: It's!

MRS. MARTIN: O!
MR. MARTIN: Ver!
MRS. SMITH: Here!

[All together, completely infuriated, screaming in each other's ears. The light is extinguished. In the darkness we hear, in an increasingly rapid rhythm:]

ALL TOGETHER: It's not that way, it's over here, it's not that way, it's over here, it's not that way, it's over here, it's not that way, it's over here!

[The words cease abruptly. Again, the lights come on. Mr. and Mrs. Martin are seated like the Smiths at the beginning of the play. The play begins again with the Martins, who say exactly the same lines as the Smiths in the first scene, while the curtain softly falls.] (Ionesco 1994 [1950])

7 (1907-1948) DADA, SURREALISM, AND 'PATAPHYSICS

--

In the years between the death of Jarry and the foundation of the Collège de 'Pataphysique, the dual nature of the *gidouille* became increasingly apparent. On the one hand, the monstrous figure of Ubu, merged with the personality of Jarry himself, cast a long shadow across the theater, literature, and the visual arts. Dada, surrealism, futurism, and the artistic avant-garde in general acknowledged the importance of Jarry's creation, doubtless encouraged by the efforts of the world to confirm the accuracy of his savage vision through its two great wars. On the other hand, a much less visible and generally unacknowledged pataphysics made its presence felt both in the artistic world and, to a certain extent, in the wider society. This pataphysics was the one identified in many of Jarry's other writings, which were little known beyond Parisian literary circles.

It would be tempting in an account such as this to draw a neatly unrolling spiral line conveying both these histories as smooth successions of events in which Jarry's legacy was passed from generation to generation. In truth, of course, just like European history itself, the picture is far more patchy and fragmented. There were pataphysicians who consciously adopted pataphysical ideas and applied them in their work to a greater or lesser extent. However, it should be noted that the word itself was infrequently used even by these individuals. At the same time, there were many

pataphysicians *sans apostrophe*, some of whom were barely aware of Jarry, or even the avant-garde, but whose works have been generally recognized and adopted as pataphysical. In some ways, these individuals were even more important than the avant-gardists, because they demonstrated the existence of pataphysics without the word itself.

Both Paris and the *idea* of Paris were the hubs of pataphysics during this period. The imaginary Paris was particularly important for those artists, thinkers, and pataphysicians who were displaced by war, an idea summed up in Marcel Duchamp's 1920 readymade *Air de Paris*, a glass ampoule containing genuine Paris air, given as a souvenir to Walter Arensberg in New York. Faustroll's journey from Paris to Paris by sea was a parallel voyage of the imagination to the physical voyages undertaken by individuals who then encountered one another again as islands in a Western world uprooted by conflict. At the same time, there were pataphysical manifestations that had nothing whatever to do with Paris, even though subsequent acknowledgment of the fact from the hub would be required to seal their status. Beyond them lay the vast mass of unconscious pataphysics that happened (and continues to happen) whether or not anyone was there to acknowledge it as such.

THE SIGNIFICANCE OF PATAPHYSICS

Jarry's legacy was interpreted in various ways by different groups and individuals, each claiming him as a precursor. This was therefore a period in which the significance of pataphysics was a matter of debate, although discussion of the word itself was relatively infrequent. Instead, the spirit of Ubu provided a great source of energy, so much so that a distorted picture of Jarry's *œuvre* was formed that somewhat persists to this day. Had it not been for a handful of people who carefully tried to balance the rest of pataphysics with the enormous mass of Ubu, Jarry would have survived simply as the creator of that singular character and nothing more.

ANDRÉ BRETON

Chief among these was André Breton (1896–1966), whose perceptive championing of Jarry was of crucial importance, for several reasons. By placing him on the surrealist group's list of approved authors, he made Jarry an indispensable part of the Grand Narrative of Modernism. What is more, he did so while fully recognizing the value of Jarry's works as a whole.

However, in his eagerness to discover the latent surrealism in Jarry, Breton made his own interpretations which ultimately were to prove incompatible with pataphysics itself. In particular, the emphasis on the oneiric and the irrational, while superficially inspired by Jarry's life and work, in fact sat uncomfortably with pataphysics as a science. The surrealists' love of chance and the pataphysical *clinamen*, it turned out, were not the same thing at all.

In the *Anthologie de l'humor noir* (Anthology of Black Humor) (Breton 1997), first published in 1940, and a later article, "Alfred Jarry: initiateur et éclaireur" (Alfred Jarry as Precursor and Initiator: Breton 1995), written in 1951, Breton set out his views of Jarry as a forerunner (alongside Jean-Pierre Brisset) of Salvador Dalí's "paranoiac-critical" method. This arose from what Breton called "a fundamental crisis of the object" and was defined by Dalí as a "spontaneous method of irrational knowledge based on the critical and systematic objectivity of the associations and interpretations of delirious phenomena" (Dalí 1935). Dalí used the example of Millet's *L'Angélus*, in which he saw a female praying mantis overlaid on the figure of the praying woman.

Jill Fell points out that this ability to see two images within a single picture is also "the feature that most distinguishes Jarry's poetry and descriptive prose. A typical example follows the erotic image sequence 'cils' > 'baïonnettes' > 'étoiles' > 'châtaignes' (lashes > bayonets > stars > chestnuts) in the chapter 'Mélusine était souillarde de cuisine, Pertinax eschalleur de noix' (Mélusine was a kitchen soiler, Pertinax a nut sheller) in *L'Amour Absolu*" (Fell 2000, 112). In "Alfred Jarry: initiateur et éclaireur," Breton himself examined *Perhinderion* (meaning "pilgrimage" in the Breton tongue), a luxuriously produced pictorial album, created and written by Jarry and funded from the inheritance from the death of his mother. This was intended to be the first in a series containing the complete works of Albrecht Dürer, with commentaries, and the earliest *images d'Épinal*. In the end, only two volumes appeared, at which point Jarry's inheritance ran out. Volume 2 contains Jarry's commentary on Dürer's engraving *The Martyrdom of St. Catherine of Alexandria* which is, in Breton's view, an attempt to reach the beauty that is *latent* in Dürer's image.

For Jarry, this involved seeing *another picture* in the image, almost entirely disregarding "le contenu manifeste" (the manifest content), instead focusing through wordplay on the "eternal picture" emerging from the knife cuts in the wood. As Jill Fell describes it, Jarry sees "still St Catherine—but larger, lying decapitated and either involuntarily inscribed in the wood by the artist, or *dictated* by the grooves in the wood themselves [. . .]" (Fell 2000, 116).

Breton's reading was essentially Freudian, as he made clear in the intro-
duction to the section on Jarry in the *Anthology of Black Humor*:

We know that humor represents the revenge of the pleasure principle (attached to
the superego) over the reality principle (attached to the ego). The latter being put in
too uncomfortable a position, it is easy to see in the character of Ubu the magisterial
incarnation of the Nietzschean-Freudian id that designates the totality of unknown,
unconscious, repressed energies, of which the ego is but the sanctioned emanation,
dictated by prudence. "The ego," says Freud, "does not completely envelop the id,
but only does so to the extent to which the system Pcpt. [= perception, as opposed
to Cs. = consciousness] forms its surface, more or less as the germinal disk rests upon
the ovum." As it happens, the ovum, or egg, is none other than Ubu, triumph of
the instinct and the instinctive impulse, as he himself proclaims: "Like an egg, a
pumpkin, or a blazing meteor, I roll over this earth doing as I please. Whence are
born these three animals [the pal-contents] whose nearoles are imperturbably di-
rected northward, and whose virgin noses are like trunks that have not yet blared."
Under the name Ubu, the id assumes the right to punish and reprimand what in fact
belongs only to the superego, the psychic final appeal. Raised to supreme power, the
id immediately proceeds to liquidate every noble sentiment ("Push all the Nobles
through the trap!"), every feeling of guilt ("Down the hatch with the judges!"), every
notion of social dependence ("Down the hatch with the financiers!"). The hostility
of the hypermoral superego toward the ego is thus transferred to the utterly amoral
id and gives its destructive tendencies free rein. Humor, the process that allows one
to brush reality aside when it gets too distressing, is exercised here almost exclusively
at others' expense. We are nonetheless, without contradiction, at the very source of
that humor, as witnessed by its continual outpouring. (Breton 1997 [1940], 258–259)

It was this identification of Jarry's "objective humor" that set the pattern
of understanding of pataphysics for decades to come. It was largely due to
Breton that Brisset and Roussel also became identified as pataphysical writ-
ers. By locating pataphysics within the typical surrealist terrain of psycho-
analysis and formative left-wing politics, he (Breton) was obliged somewhat
to traduce its status as the science of the laws governing exceptions. Judging
by the later article, it was also rather against his own judgment to give Ubu
preeminence, but Breton was, as he well knew, writing history. Given the
experience of the Great War and the emergence of the Great Dictators, this
resonated most satisfactorily with the concerns of the surrealist group.

JULIEN TORMA

Julien Torma (1902–1933) represents probably the most extreme example
of a pataphysical life and body of work. This makes him almost as dif-
ficult to discuss as the whole subject of pataphysics itself. The problem is

compounded for the Anglophone reader, since both the writing, and the literary and artistic *milieu* in which he dabbled, were so very French. To omit him, however, would be a grave mistake, because nobody better epitomizes the apostrophe that precedes the word.

The facts of his life are simply told. He was born in Cambrai on 6 April 1902, and the early death of his father led to a troubled childhood in Pontoise and elsewhere, during which he was forced by his stepfather to become involved in some illegal activities. In 1919 he met the poet Max Jacob and the following year published his first book of poetry, *La Lampe obscure* (The Dim Lamp), which shows the influence of his friend. Having then fallen out with Jacob, he became friendly with some members of the surrealist group in Paris (in particular Robert Desnos, Jacques Rigaut, and René Crevel) during the early 1920s and published a second volume of verse, *Le Grand Troche, sorite* (The Great Misery, chain syllogism) in 1925. This was followed by *Lauma Lamer*, a one-act play, and *Coupures* (Cuttings), another play which consisted of lines that were cut up and randomly reordered, in the manner of a Dada poem. In 1926, another friend, Jean Montmort, assembled a collection of fragments by Torma into a book entitled *Euphorisms*, which is the most revealing of all his works. During the late 1920s he met and corresponded with René Daumal, and their disagreements, as well as Torma's refusal to join Le Grand Jeu, the group that Daumal was assembling at the time, were important to the evolution of pataphysics. After that he drifted around France and abroad, producing nothing. In November 1932 he retreated to the Tyrol for the sake of his health. On 17 February 1933, he mysteriously disappeared during a walk in the mountains and was never seen again.

The trajectory of Torma's literary career shows a progression from an initial indifference through aggressive hostility to complete abdication of the very notion of himself as a writer. He began by learning "to love his boredom" (*Euphorisms*), and was then drawn toward a series of increasingly obscure ideas which he rejected in turn. The first was mysticism, in which, encouraged by Max Jacob, he indulged in *La Lampe obscure*. The volume was published in an edition of 200 by a man he met by chance in a café, and sold badly, but did show considerable inventiveness in certain forms of wordplay. Jacob converted to Catholicism, but this was not a path Torma chose to follow, and his increasing nihilism drove him toward a destruction of Dada. As Terry Hale puts it in his essay on Torma, the play *Coupures* was "less a matter of incoherence in the immediate sense, as was frequently the case with Dada, and more to do with the manner in which the assumptions of theatre are systematically undermined or shown to be inadequate" (Hale 1995, 139).

This is typical of Torma's whole position, which challenged not just conventions and anticonventions, but their very underpinnings. *Euphorisms*, as Hale points out, "attacks the very root of reason not by rejecting such notions as truth, knowledge, or intelligibility but by refusing to accept their desirability" (ibid., 141).

THE *IS* ARE CAST

Our ideas about death are ingenuous. Some believe we do not die. That is—obviously—too naïve. Others believe that dying is nothing, that before, one lives, and afterwards one no longer gives it any thought. That is—no less obviously—too well thought out. It seems, should one wish to judge it coldly, that it is the latter who are in the right, because it is they who better express the facts. But this is an illusion: facts here say nothing, if they ever say anything. Death. Death is ironic.

Man is an onion, the noblest there is in nature, but a peeling onion—like any other.

A skin? You don't know how right you are.

But, if you remove it, you'll find another, and another . . . down to the void at the centre (that's not all that large, either).

Let's weep, let's weep, my crocodile brothers. (Conover et al. 1995, 151)

What is left after this assault is pataphysics, which alone survived Torma's utter nihilism.

Euphorisms arose in part from another perceived danger. For Torma, pataphysics should avoid becoming the guiding principle of a group such as Daumal's Le Grand Jeu, with its roots in spiritual philosophy. It is in the exchange of letters between Torma and Daumal that we can perceive perhaps the clearest statement of Torma's position. Daumal's essay "Pataphysics and the Revelation of Laughter" had been published in the second issue of *Bifur*, edited by Georges Ribemont-Dessaignes, who had recently been ejected from the surrealist group by André Breton. Daumal sent a copy to Torma, whose reaction was as follows:

My Dear Daumal,

No apologies needed for sending the issue of *Bifur*. *Bifur* is *Bifur*, and you may daub things on walls if you have a mind to. You were right to send a copy as I would not have got to hear of your article otherwise—and discovered that pataphysics could be married to mysticism. I am still intrigued by that. Of all the reading matter that chance has thrown in my way—and that worthy deity has always done well by me—the various pieces that I have come across by Jarry have always seemed the least tedious to me. I see by way of them. There are those who see by way of H. Bordeaux or Gide. Is there anything wrong with that? As for me, I see through the eyes of Sengle or Emmanuel Dieu. Question of taste and pretensions. Indeed, it is even what makes some books still possible, because I am no longer—despite your past remonstrances—interested in either culture or gnosis. So I am pleased to find you seeing via the same bodies of smoke.

Once again I shirk the issue.

It will come as no surprise to learn that I do not much care for your slaps of the absolute, having little faith in any other kind of absolute except that which slaps. Is there any other? I found your article upsetting because everything in it is true. Except the tone. The word true means precisely nothing here and succumbs under a pataphysical paw-swipe. You are right to speak of chaos. But one gets the feeling that you believe in it as if it were some sort of God. In spite of your subtlety, my dear René, you have too much of the graciousness-of-god about you. You are working at the absolute.

Your pataphysician laughs too much. And that laughter is both too comic and too cosmic. Put metaphysics behind pataphysics and you make it merely the façade for a belief. Now the essence of pataphysics is that it is the façade of a façade, behind which there is nothing.

I do not see Dr. Faustroll laugh. I do not have the book to hand. But I would swear blind—don't you see?—How can you write: "Faustroll grins." You are horribly behind the times. We are no longer at the Méphisto stage. At evil and guilty consciences, or even consciences at all. If Faustroll turns Mephistophelian it can only be part of a pataphysical game. Because Mephistophelianism is something they cooked up, as we were saying. Faustroll is imperturbable. Or not at all. He has the appearance of being natural and of not being natural. Because nature is just one more farce neither more nor less interesting than another. He does not choose, he no longer distinguishes, he no longer prefers. He voyages wrong side up. But his voyage does not even exist. These characters and their adventures are not real. This is clearly seen in the death and the resurrection of Bosse-de-Nage. But neither are they imaginary in the sense of the heroes of novels and stories in the fantastic genre. One supposes, provisionally at least, however extravagant the hypothesis, that it is not totally implausible that those heroes exist. But it is pretty rich of you to say that *all defined existence is a scandal*. With the One and suchlike. But why not say that *undefined existence is a scandal*, though the word scandal is superfluous. Faustroll says: "I am God," and he surely has as much right to say that as does God himself. All the same it is a bit much—or not much enough—to take him seriously.

No writing—either holy or impeeous—No time to. I am doing nothing, just boring jobs, and jobbing boredom. It will go on like zat . . . (or sade) probably till our dying day. So be it—Do not take that as an alluvion (sic).

All the usual . . . best

Torma (Conover et al. 1995, 144–146)

RENÉ DAUMAL

René Daumal (1908–1944) was a spiritualist writer, whose thinking was ultimately deeply influenced by the mystic teacher G. I. Gurdjieff, prime advocate of a path of self-development called "The Work," or the "Fourth

Way," or "esoteric Christianity." Daumal learned Sanskrit in order to study the Tripitaka Buddhist canon, and also translated Zen texts by D. T. Suzuki. However, in 1922, with three fellow schoolboys at the Lycée in Reims, he formed a pataphysics-influenced group called the "Phrères simplistes" (Simplist Brotherrs), which aimed to achieve a childlike spontaneity and sense of freedom. He became involved in surrealism early in his career but rapidly broke away, forming his own group (including Roger Gilbert-Lecomte and Roger Vailland from the Phrères simplistes) and publishing a journal: *Le Grand Jeu* (The Great Game).

The group was highly influenced by Jarry, adopting a doll called "Bubu" as a fetish, and using a spiral design on the cover of the review (Sigoda 2008, 48–49). They explored "experimental metaphysics" in various ways, including drugs. Daumal sampled narcotics apparently in a quest to "possess death," and subsequently died young after contracting tuberculosis. His "Traité de patagrammes" (Treatise on patagrams: Daumal 1954 [1932]) explores the pataphysics of many aspects of real and imaginary existence, from photography to werewolves, from astrology to drilling the well of science. In *La Grande Beuverie* (A Night of Serious Drinking: Daumal 1969 [1938]), Alfred Jarry appears as a character, alongside Rabelais, Léon-Paul Fargue, and many others.

Daumal's great (unfinished) novel *Mount Analogue: A Novel of Symbolically Authentic Non-Euclidean Adventures in Mountain Climbing*, written in 1939–1944 and first published posthumously (Daumal 1981 [1952]), is a strange allegorical account of one man's climb of a nearly imperceptible mountain, whose "summit must be inaccessible, but its base accessible to human beings as nature made them. It must be unique and it must exist geographically. The door to the invisible must be visible."

Here is part of the essay against which Torma had reacted:

RENÉ DAUMAL, "PATAPHYSICS AND THE REVELATION OF LAUGHTER" (1928, REVISED 1929)

"Pataphysics is *the* science . . ."
—Alfred Jarry, *Exploits and Opinions of Dr. Faustroll, Pataphysician*, XLI

For I know and I maintain that pataphysics is not simply a joke. And if laughter often shakes the bones of us other pataphysicians, it is a terrible laughter, faced with the evidence that each thing is (and so arbitrarily!) just what it is and not otherwise; that I *am* without being *everything*, that this is grotesque, and that all defined existence is scandalous.

In bodily terms, the shake of laughter is the jostling of bone and muscle disintegrated by the great wave of anxiety and love-panic as it penetrates the intimate interior of every last atom. And then! under this slap in the face delivered by the

absolute, fragments of the pataphysician leap into the skin of the average guy and rush headlong toward the maddening lies of the infinite roads of space, finally toward chaos. The individual who has known himself in his totality can momentarily believe that he is about to scatter into dust—a dust so homogeneous that it will be no more than dust, precisely filling an absence of dust, in no place, and at no time. This happy earthling explodes, but his all-too-solid elastic bag of skin holds him in, creases only in the supplest parts of his face, pulls back the corners of his mouth, tightens up at the eyelids and, distended to the extreme, suddenly contracts and doubles up with a start, while his lungs alternately fill with air and empty out. Thus is born the rhythm of laughter, thought and felt in itself, or as it is observed in the laughing other. Each time he thinks he will explode once and for all, man is held back by his *skin*, I mean by his *form*; by the bonds of his specific law whose form is external expression; by the absurd formula, the irrational, unresolved equation of his existence. He constantly rebounds off that absolute star that attracts him, never able to reach dead center. Heating up under repeated shocks, he first becomes dark red, then cherry, then white-hot, and spews out boiling globules and explodes once again, this time more violently, and his laughter becomes the fury of mad planets. And this chuckling fellow breaks something, he does.

Pataphysical laughter is the intense awareness of an absurd duality that gouges your eyes out. In this sense it is the only human expression of the identity of opposites (and, amazingly enough, it expresses this in a universal language). Or rather, it signifies the subject's headlong rush toward the opposed object, and at the same time the submission of this act of love to an inconceivable and cruelly felt law of becoming—a law which prevents me from immediately attaining my totality, and according to which laughter is engendered in its dialectical progression:

I am Universal, I explode; I am Specific, I contract;

I *become* Universal, I *laugh*.

And in turn, the act of becoming appears as the most tangible form of the absurd, and again I rebel against it by throwing out another burst of laughter, and so on indefinitely in this dialectical rhythm, which is the same as the panting of laughter in the thorax. I laugh for ever and ever, and this tumble downstairs never ends, for these laughs are my sobs, my hiccups, perpetuated by their own collision: the pataphysician's laugh, whether deep and deaf-mute or harrowing and on the surface, is also the only human expression of despair.

And faced with the faces that most resemble mine—those of other men—this despair folds onto itself in a final spasm; digging my nails into my palm, my fist clenches to crush a phantom egg whose yolk might nourish some hope of teaching, if only I could believe in it. No, I only wanted to say *what it was* for those who already knew, who had already laughed with this laughter, so that now they might know what I'm talking about.

You, who have settled into this mad sun, into this impossible burst of supreme lucidity, can hear Faustroll's great pataphysician's voice, and you can no longer believe that Jarry was a joyful droll, nor that his Rabelaisian verve or Gallic tartness

. . . *"Ho hum! Ho hum!"* replies the profound echo of Marine bishop Mendacious, and this outrageous reply is all such an insinuation deserves.

The metaphysician has wormed his way into the world's pores and into the evolution of phenomena, in the guise of the gnawing dialectic of bodies, which is the motor of revolutions. Now, pataphysics *"is the science of that which is superimposed upon metaphysics, either in itself or beyond itself, reaching as far beyond metaphysics as the latter reaches beyond physics"* (Jarry). Dialectics galvanized matter. Now it is pataphysics' turn to rush onto this living body and consume it in its fire. We must expect the imminent birth of a new age, to see a new force surge from the extreme ramifications of matter. Devouring, gluttonous thought, with respect for nothing, believing in and pledging allegiance to no one, brutal with its own evidence in defiance of all logic. This is the thought of the universal pataphysician who will suddenly awaken in all men, breaking their backs with a sneeze and laughing, and laughing, and disemboweling the all-too-peaceful braincases with bursts of laughter. And what a ruckus in the moldy sarcophagi that house our self-civilization.

I can only give brief indications here of the confusion in which pataphysics will throw the various ways of thinking, acting and feeling characteristic of lettuces—oops! I almost said "men." Soon I hope to unveil, for example, my discovery of the pataphysics of love, and of a graphic method which enabled me to plot the curve of "normal man," which is no mean joke, believe me.

[. . .] The specific is revolting. But if I, who watch you take your revolt seriously, seek refuge beside Doctor Faustroll in his *Skiff* which is a riddle, I can still laugh. Is there nothing to be done, then? There is; for pataphysics is like nothing so much as a sidestepping: leave even that accidental but inevitable fury behind, and take it up again later as an iconoclastic force. It will be still another way of laughing, of negating and rejecting (as the first laugh renounced a part of the self, which was the World). And if, in negating everything, you should break something—hearts, hopes, palaces, statues, churches, intelligences, governments—remember, oh pataphysicians, under pain of turning back into serious boors, that this is not what you were looking for (in that case, it would be truly joyful!): that tears, blood and screams are the necessary effects of a desperate run on an endless track, of a momentum that negates the goal. (Daumal 1991b [1929], 15–22)

Torma's critical view of this was echoed later by the Collège de 'Pataphysique, which asserted that 'pataphysics is "beyond laughter, and even beyond smiling perhaps" (Collège de 'Pataphysique 1958). Anthony Enns gets to the heart of the disagreement:

Daumal [. . .] argues that "pataphysics is not simply a joke," but rather "the only human expression of despair." [. . .] [His] characterization of pataphysics as comic nihilism is precisely the sort of interpretation which the Collège de 'Pataphysique attempted to undo [. . .]. [According to them] Pataphysics does not shatter systems of thought with the abandon of an anarchist, but rather its goal is empowerment and enlightenment, a "profound concordance between men's minds," which is "beyond laughter." (Enns 2002, 42–55)

ANTONIN ARTAUD (1896–1948)

Artaud was one of the first people to reassert Jarry's importance in the years after his death, acknowledging *Ubu Roi* as a seminal moment in the development of theater, and eventually naming his own short-lived venture (1926–1928) the Alfred Jarry Theater. His book of essays *Le Théâtre et son double* (The Theater and Its Double) (Artaud 1958 [1938]) makes a direct allusion in its title to the theme of the "double" or *Doppelgänger* that Jarry uses to symbolize the arrival of death, first in *César-Antichrist*, in which Ubu is the "double" of the Antichrist, and later in *Days and Nights*, when the peculiar relationship between Sengle and Valens is explored in the chapter "Adelphism and Nostalgia." For Artaud, the appearance of the double represented the death of the conventional theater of the day, ultimately to be replaced by his idea of a "theater of cruelty," which would include violence, sexuality, and the breaking of social taboos, in order to achieve a direct action. Inspired both by Jarry's shocking behavior and by his writings, Artaud sought to introduce danger, visceral sensations, and a total commitment into his art. Artists, he declared, should be "condemned men at the stake, signaling through the flames." Theater should recover "the notion of a kind of unique language half-way between gesture and thought." There should be no more masterpieces.

The Theater of Cruelty has been created in order to restore to the theater a passionate and convulsive conception of life, and it is in this sense of violent rigor and extreme condensation of scenic elements that the cruelty on which it is based must be understood. This cruelty, which will be bloody when necessary but not systematically so, can thus be identified with a kind of severe moral purity which is not afraid to pay life the price it must be paid. (Artaud 1958 [1938], 122)

Compared with Jarry's own writings on the theater, which merely called for stylized gestures, antirealistic sets, masks and puppet-like behavior, this is divergent from the spirit of Ubu. Richard Kostelanetz makes this pertinent observation: "Another useful divide within avant-garde consciousness is separating those who treasure Jarry from those who worship Artaud— those valuing invention over madness" (Kostelanetz 2001, 315).

The question of Artaud's 'pataphysics, therefore, barely arises, since he was little concerned with such intellectualized notions except insofar as they were capable of achieving some kind of impact on his intended audience. The Alfred Jarry Theater was pretty much a failure in its own terms, yet Artaud's influence continues to be strongly felt through the idea of the theater of cruelty, and through the work of figures such as Peter Brook, who himself directed an important production of *Ubu Roi*. We can conclude that

it is the wild spirit of Jarry expressed through Ubu that provided a model for Artaud. Insofar as that was pataphysical, then so was Artaud.

A NIGHT AT THE PATAPHYSICAL CINEMA

In his novel *Loin de Rueil* (Queneau 1987 [1944]), Raymond Queneau created a dreamer, Jacques Laumône, who lives an imaginary life. Enraptured by his many trips to the cinema, he invents and reinvents his own genealogy, becoming a King, or Pope, or founder of a dynasty, or ruler of the universe: "it is incredible to think that you were not born a Prince, Duke or Count, and yet, and yet, why not you, why not you?" thinks Jacques. He constantly substitutes dreams for reality: "Sometimes Jacques would follow someone in the street to find out something about this other person and to live his life for a few minutes."

His dreams become ever more fantastical, cosmic, utopian, unbelievable. The alternative English translation of the title, *The Skin of Dreams*, successfully evokes this experience of cinema, so popular during this period. The "skin" here is the screen itself, which conveys its imaginary solutions to a mass audience who willingly surrender themselves, at least for a time, to the alternative reality. Film apparently offered possibilities to pataphysicians which few other media could achieve. The total immersion in a "universe supplementary to this one" and the imaginative distance from an illusory reality (the audience's imagination is to film as film is to reality) suggested a degree of inherent pataphysics embedded in the medium itself. Queneau's novel deploys cinematic techniques in its writing, something that has become a standard feature of much literature today: the jump cut, the flashback, and so on.

Two examples of pataphysical cinema, from René Clair and the Marx Brothers, will illustrate the point most effectively. All of them subsequently became leading members of the Collège de 'Pataphysique, but during this period they were simply making movies that exhibited a pataphysical spirit. One came from the European experimental tradition and the other from American popular entertainment, yet they share many aspects of their respective visions, humor, and cinematic techniques, as we shall see.

RENÉ CLAIR (1898–1981)

René Clair (born René-Lucien Chomette) began his working life as a journalist, then became a screen actor. He worked under director Jacques de Baroncelli, making his first film, *Paris qui dort* (Paris Asleep), in 1924; it is

about a mad doctor who uses a magic ray on citizens that causes them to freeze in strange and often embarrassing positions. People who are unaffected by the ray begin to loot Paris. Other films from this period include *Entr'acte* ("Intermission," 1924), *Sous les toits de Paris* ("Under the Rooftops of Paris,"1930), and the dystopian *À nous la liberté* ("Freedom For Us!", 1931), which explores the dehumanizing effects of technological advances, and reputedly partly inspired Charlie Chaplin's *Modern Times*. These movies are generally regarded as classics, featuring an anticapitalist satire shot through with surrealist comedy, and a light directorial touch that nonetheless pushes the limits of the language of cinema. During the war Clair moved to the USA, where he directed several more movies in Hollywood. *I Married a Witch* (1942), for example, was a successful comic fantasy that inspired the hit TV series *Bewitched*. On his return to France after the war, Clair's filmmaking career went somewhat into decline, but his influence was enormous. In 1962 he was elected to the Académie Française, the first film director to have achieved that honor. Clair became a Satrap of the Collège around the time of the death of Sandomir, and continued to play a leading role in its operations throughout the subsequent decades.

ENTR'ACTE (1924)

The "Instantaneist" ballet *Relâche* was one of the most celebrated events of 1924. The word *relâche* was generally used to indicate that a theater is dark, or a show is canceled, and indeed on the opening night of this Dadaist piece the audience arrived at the Théâtre des Champs-Élysées to find it shut. The scenario was created by Francis Picabia and choreographed by Jean Börlin for the Ballets Suédois, with music by Erik Satie. The piece was designed as a satire on grand spectacles, and consequently challenged as many of the conventions of such occasions as it possibly could, including their formal structures. To that end, the ballet was written "in two acts, one cinematographic intermission (*entr'acte cinématographique*), and the tail of Francis Picabia's dog." Following the typical music hall practice of the period, Picabia gave René Clair a few notes, scribbled in haste on a tablecloth from Maxim's restaurant, which were to provide the basic scenario of the film *Entr'acte*. It was to be an "intermission from our daily imbecilities . . . which will translate those dreams and immaterial events that occur inside our skulls."

The film is generally recognized today as a landmark in the history of cinema—partly because of the accompanying music by Erik Satie, which for the first time was composed to run exactly to the duration of shots, and partly because it represented a lexicon of available cinematic techniques of

the period. These included photomontage, randomization, slow motion, backward motion, speeded-up sequences, very unusual camera angles, rapid jump cutting, and a cast that featured Satie, Picabia, Börlin, Marcel Duchamp, and Man Ray.

The "plot" of *Entr'acte* is usually dismissed as little more than a series of visual jokes, strung together in a way that resembles the surrealist technique of automatic writing. Seen through a pataphysical eye, however, it has perhaps more meaning than might at first be apparent. The opening sequence (which in fact played at the beginning of the ballet, before the main film was shown in the intermission) consists of Satie and Picabia firing a cannon over the roofs of Paris. This, and the other scenes featuring guns (such as the sniper), exhibit that anarchistic and inappropriate use of firearms for which Jarry was famous. A paper boat travels from Paris to Paris by sea, and the presence of leading artists in the film confirms the parallel with *Faustroll*, in which the voyage leads to a series of islands inhabited by Jarry's contemporaries. The celebrated Tyrolean hunter's funeral procession, led by a camel, which begins in slow motion then develops into a crazy chase, during which a "legless" man stands up and runs, and at the end of which the coffin falls open and a conjuror appears and makes all the characters disappear and then himself, seems to echo the race between the bicycle team and the express train in *The Supermale*. Certain other scenes also show a typically pataphysical spirit: a bearded ballerina dances, then is filmed from below a glass table; a chess game between Man Ray and Marcel Duchamp is interrupted by a jet of water; and so on. The general atmosphere and the use of visual puns, with images from one sequence appearing intercut into an earlier sequence, playing with similarities of shapes of objects, or actions, on screen, suggests exactly the kind of "imaginary solution" implied in Picabia's note.

For Clair, the experience of making the film was formative. He was particularly struck by Erik Satie, who arrived for filming dressed in his ironically conformist uniform of bowler hat, rolled-up umbrella, and impeccable suit, looking just like a bank clerk. This look, which also seemed to fascinate Magritte, so impressed Clair that he included a silhouette of Satie (Hitchcock-style) in many of the films he directed after that.

THE MARX BROTHERS (C. 1887–C. 1979)

The Marxist wing of the Collège de 'Pataphysique came to be led, of course, by Groucho, Chico, and Harpo. Groucho's most famous witticism may serve as a guiding principle for any pataphysical organization: "I DON'T

WANT TO BELONG TO ANY CLUB THAT WILL ACCEPT PEOPLE LIKE ME AS A MEMBER."[1]

Although there is little or nothing in the standard Marx Brothers literature that acknowledges their involvement with *the* Science, there is abundant evidence of its importance to them, both in the content of their movies and in the written records of the Collège de 'Pataphysique. These mention, among other things, the attendance at the second wedding of Chico to Mary de Vithas in Paris in August 1958 of a delegation of Collège Satraps, including Boris Vian (Collège de 'Pataphysique 1958, 61).

The Collège literature also explains that the three brothers[2] taken together constitute a single Transcendence, rather than three individual Transcendences. This echoes a recurring theme in critical discussion of the three Marx Brothers: their inseparability. According to Slavoj Žižek's Freudian analysis, the Marx Brothers reveal the workings of the unconscious mind: they are the superego (Groucho), the ego (Chico), and the id (Harpo) (Žižek 2006). This is an attractive thesis, but a pataphysician might well respond with another inseparable trio: Faustroll, Panmuphle, and Bosse-de-Nage. For Groucho preaches 'pataphysics, while Harpo subsitutes "honk honk" for "ha ha," and Chico's endless misunderstandings provide many of the beginnings of the subsequent mayhem, through which he happily travels.

Discussions of the Marx Brothers in the Collège literature do reflect the French love of American comedy (Woody Allen and Jerry Lewis, both in their way directly influenced by the Marx Brothers, remain more popular in France than in their own country),[3] particularly slapstick comedy. Even so, there is much in the Marx Brothers' *œuvre* that connects with the theatrical tradition of writers such as Eugène Ionesco or Antonin Artaud, who attached an enthusiastic "Note on the Marx Brothers" to *The Theater and Its Double* (Artaud 1958 [1938], 144). The Marx Brothers emerged from a vaudeville tradition that shared its roots with European popular theater such as the music hall, or the Parisian cabarets with which Jarry was familiar.

The Marx Brothers movies seem to be peppered with allusions to Jarry and pataphysics. If we consider *Duck Soup*, for example, which seems the most fertile in this respect, we may observe that the story has much in common with *Ubu*. It is set in the imaginary country of Freedonia,[4] which is to be "saved" from financial disaster by Rufus T. Firefly (Groucho), just as *Ubu Roi* is set in an imaginary Poland, which is driven further into disaster by the arrival of Ubu and his phynancial ledger. The Freedonians cheer Firefly's appointment, just as the populace cheer Ubu, unappreciative and indifferent though their ruler may be. The soldiers and attendants, who at

one point are converted into a human xylophone by the Brothers, behave in a rather similarly puppet-like way to the Palcontents, or perhaps the Army of Free Men. Firefly, like Ubu, cuts a swathe through the state officials and representatives of the people, dismissing their opinions and indeed their persons. His song "Just Wait 'til I Get Through with It" is strongly reminiscent of the "Chanson du décervelage," setting out the "laws of his administration" with an extreme penalty for smoking, chewing gum, and other minor offenses, and an Ubuesque promise to raise taxes inordinately, embed corruption, and cuckold husbands. The extreme sanction is expressed by the repeated childlike chorus "Pop goes the weasel." The climax of *Duck Soup* is a war, in which Firefly famously dons various military and not-so-military uniforms in rapid succession, and, just as in *Ubu Roi*, the war ends with an inconclusive "victory" that leaves everything more or less unchanged.

Asked for a light for a cigar, Harpo produces a blowtorch, echoing the excess of the story about Jarry's gesture of pulling a gun when asked for a light in a Paris street. And Harpo's second appearance in the movie, when he arrives at the Sylvanian ambassador's residence, sees him dressed as a typical pataphysician, with spinning *gidouille* spectacles and a long beard. However, it would not be right to overemphasize these parallels. *Duck Soup* has its own originality; it is by no means simply a retelling of *Ubu Roi*, nor is it just a set of overt or covert allusions to pataphysics. Margaret Dumont is no Ma Ubu (despite Firefly's constant jokes about her size), the war scenes are fundamentally pacifist, and so on.

The Marx Brothers' pataphysics lies more importantly at the level of their humor. This has of course influenced a long line of comedy, including *The Goons, Monty Python's Flying Circus*, and many more. An article in *Subsidium* 11 of the Collège de 'Pataphysique examines the subject in some depth (Gayot and Monomaque 1971, 135–140):

If we set the more obviously cinematographic and visual imaginary solutions[5] (like Buster Keaton's in *Sherlock Junior*, for example) against those of the Marx Brothers based on the spoken word, Their Transcendences' films are no less impressive as a gallery of visual gags. We can cite, at least, in *Horse Feathers* the banana embedded in an éclair, the nutcracker telephone and the finger sandwich which we can compare with [W. C.] Fields's sandwich gag. In *Horse Feathers* Harpo, during a football match which was plagiarized by *Mash*, puts the fingers of an opponent between two slices of bread and eats the resulting improvised hot dog. In *It's a Gift*, Fields, whose wife asks him to share his ham sandwich with his son, carefully folds the slice of ham so that it is all in one half of the sandwich, so that what is given to the boy is only dry bread. Fields is here more hypocritical, more social, more human than Harpo. Fur-

thermore, he lacks a sense of meaning, or of logic, whereas Harpo, although illogical and nonsensical, achieves a sort of super-sense (or negative power). Some things are outside satire and beyond comedy: such as when Harpo, as usual, bursts in on a pretty young housewife. There follows a pan shot: the end of a bed with a pair of mules, Harpo's boots, four horseshoes . . . and a quick shot of the bed with the pretty girl, Harpo, and the horse, then a close-up of the horse looking happy and relaxed. Leo McCarey who, before becoming one of the kings of American comedy, directed Laurel and Hardy, Charlie Chase, and the Marx Brothers, found this "completely crazy," denied, quite reasonably, all humor that was not "verbal" in Groucho, and declared that he did not like *Duck Soup* (cf. *Cahiers du Cinéma* no. 163). There was about as much in common between the mashed potato that was *An Affair to Remember* and this *Duck Soup* as between a rock thrown into a duck pond and a typhoon in Nagasaki.

It is, however, indeed true that the "comedy" of the early Marx Brothers was mostly oratorical, Groucho being the specialist of quickfire delivery that left the viewer who lacked sufficiently agile or Anglophile ears to follow the verbal high-wire act, gasping. Which created fewer laughs than the later films when the deluge slowed to a shower. [. . .]

Whatever the pace might be, everyone would agree that some exchanges are beyond laughter, such as:

"Your eyes, your eyes, they shine like the pants of a blue serge suit" (*The Cocoanuts*).

"This school was here before you came and it'll be here before you go" (*Horse Feathers*).

Or this from *Cocoanuts*:

Chico: Right now I'd do anything for money. I'd kill somebody for money. I'd kill *you* for money.
[Harpo looks dejected]
Chico: Ha ha ha. Ah, no. You're my friend. I'd kill you for nothing.
[Harpo smiles]

It is understandable that such lines do not produce quite as many decibels from the laughing crowds as a Michel Audiard[6] witticism, but to use Groucho's remark delivered straight to the audience watching *Horse Feathers*:

"I've got to stay here, but there's no reason you folks shouldn't go out into the lobby till this thing blows over."

There is, however, a category of gags which do not fall under the previous two classes and which, directly and perhaps for the first time in cinema, are part of the Science of Imaginary Solutions as practiced in the writings of Béroalde de Verville or the T. S. Boris Vian: these gags consist of (precisely!) literal interpretations of well-known sayings (or pictures).

In *The Cocoanuts*, Harpo uses a cleaver when he is given cards to cut.

In *Horse Feathers*, a candle is, literally, burnt at both ends.

In *A Night in Casablanca*, the three Marx Brothers pull a cork measuring at least 20 cm. in length from a bottle of champagne: classic gag. Less so is Groucho's reply to Chico, who is surprised to see nothing flowing from the bottle: "It's dry champagne!"

What takes the Marx Brothers beyond mere "zany" comedy and beyond, again, the metaphysics of the hidden layer beneath polite society are the many unique moments such as these, which transcend "laughs" and seem to arrive at a still place unlike any other. One example is the famous "mirror" sequence in *Duck Soup*, the Marx Brothers' take on a classic clown routine, which emphasizes the sense of stillness by cutting the soundtrack. For a while, time is suspended and we enter a small world governed by a self-contradictory internal logic that is funny, certainly, but also points to an ethernity that is shared with Carroll's Alice and is, in its way, serious.

Groucho, in pursuit, hears a loud noise in another room. He doesn't know it, but this is Harpo running into and smashing a large full-length mirror dividing two rooms. Groucho rushes in, and sees what is apparently himself in the "mirror"; in fact it is the hole left by the shattered glass. What he is really seeing is Harpo, standing in the neighboring room, who has dressed identically in white nightshirt and cap, bedsocks, and Groucho's trademark heavy mustache and glasses. Their movements mirror one another: Groucho muses, chin in hand, so does Harpo; Groucho bends down and wiggles his behind, so does Harpo; Groucho nods, so does Harpo; Groucho lowers his glasses and peers around the mirror edge, so does Harpo. Now becoming suspicious, Groucho tries various tricks: he crawls, does funny walks, dances. Somehow, Harpo anticipates and exactly imitates all these moves. Finally, Groucho spins around. We, the audience, see that Harpo does not in fact spin, but we also see that Groucho cannot know that. Now Groucho has the solution: he brings in a white panama hat. Harpo also has a hat, but his is black. Armed with these identifiers, the two circle one another, passing through the mirror and swapping places as they do so. Now they have both entered the looking-glass world. They both know that what has taken place is impossible, and yet they continue as if it is not.

Circling once more, Groucho suddenly dons his hat and points laughingly at Harpo. But Harpo has, from somewhere, found an identical white panama hat. Even though Groucho could not have known that Harpo was concealing a black hat, he appears to know it. Even though Harpo could not have known that Groucho was concealing a white hat, he also appears to know it and, moreover, to know that his black hat is the wrong hat, and, moreover again, to have secreted about his person the correct hat! The

audience is as much the dupe as Groucho at this moment. Harpo's finger-pointing and laughing wins over Groucho's and over us. As it does so, the pair lose their mirroring gestures and become complicit in this pataphysical game. As if in recognition of the fact, they remove their hats and make elaborate bows to one another. Harpo drops his hat and Groucho reaches through the mirror, picks it up, and returns it to him. They bow again to thank one another. The mirroring has really broken down, yet Groucho still seems unconvinced that it has. In a final game with the audience, he turns away, apparently to puzzle it out. Now Chico enters on Harpo's side of the mirror, dressed the same as the others. This really shatters the illusion, because once Groucho sees two people he finally "knows" the truth. The scene breaks down and becomes a chase. Chico is captured and, in the next scene, tried for treason.

"Dreamlike" and "surreal" scarcely do justice as descriptions of this sequence. This is a world that has its own physics based on nonreflective reflection, in which identities (the brothers) at first interchange through the similarities of their lineaments, then decay and dissolve as their particulars emerge. The properties of the brothers (in this case the cigar and mustache of Groucho, and the nightgown he wears) are described by their virtuality in the mirror, and symbolically attributed to their lineaments by the movie itself and our (the audience's) knowledge of who, in reality, is who. If any scene sums up the Marx Brothers' pataphysics, this is the one.

PATAPHYSICS AND THE VISUAL ARTS

Jarry was a visual artist as well as a writer, and his involvement with other visual artists, in particular Maurice Denis, Pierre Bonnard, and Édouard Vuillard, of the Nabis group, did much to elaborate pataphysical ideas, which have always had a strong pictorial and representational dimension. By most accounts Jarry also knew Picasso (although some of Picasso's biographers have cast doubt on this).[7] On the evening of 20 April 1905, as was most famously recounted by Guillaume Apollinaire, Max Jacob, and Maurice Raynal, they met at a wild dinner, during which Jarry fired his revolver several times at a sculptor called Manolo, declaring afterward: "Wasn't that just beautiful, like literature?" Fortunately, he missed, and was disarmed by Apollinaire, who supposedly gave the gun to Pablo Picasso. According to Raynal, the two men were friends, even though they met infrequently. Whatever the truth, there is no doubt that Picasso sketched some portraits of Père Ubu in 1905 and executed a famous drawing of Jarry. Picasso's lover, Dora Maar, produced one of the most celebrated photographic images of

Ubu in 1936 (her *Père Ubu* was in fact a close-up of an armadillo fetus). In 1937, Picasso executed a series of etchings which showed the influence of Jarry, under the title *Sueño y mentira de Franco* (The Dream and Lie of Franco). These depicted General Franco as a kind of deformed Ubu, riding Quixote-style on a mangy horse into battle against the bull of Spain. In 1942 he made another portrait of Ubu, this time in colored crayons and gouache, showing him as a kind of triangle.

The art dealer Ambroise Vollard, too, recounted a story of Jarry's revolver:

He [Jarry] came to Paris by bicycle, which, along with a revolver, was the only item of any value he had left from a modest inheritance which he dissipated very quickly and fastidiously. When a pedestrian failed to hear his approach, Jarry would let off his revolver into the air to gain passage.

"But Jarry," people would say, "what if one day someone takes real offense at that?"

"Oh!—" the author of *Ubu Roi* would explain, "before he had time to recognize me, I would already be well past him and then, anyway, in giving this man the illusion that he had been attacked, I would have provided him with a good story to tell his friends and acquaintances!" (Vollard 2007 [1937])

Vollard was captivated by Ubu, and commissioned Georges Rouault to illustrate with woodcuts his own sequel: *Les Réincarnations de Père Ubu* (The Reincarnations of *Père Ubu*, 1932). Rouault worked on Ubu-related projects for around twenty years, producing many paintings, drawings, woodcuts, etchings, and so on. His deep religious convictions drew out a latent aspect of the iconography that was always present in Jarry's own work, but usually in a somewhat irreligious and scatological vein. In Rouault's style, which was tinged with social comment, the idea of Ubu as a political as well as symbolic icon took root.

JOAN MIRÓ (1893–1983)

In 1920, the Catalan artist Joan Miró arrived in France and became passionate about Ubu, who to him was the very incarnation of General Franco. He made works about Ubu throughout his career, including many sculptures, lithographs, drawings, paintings and puppets, all characterized by his typically childlike style, and a scabrous satirical humor aimed in the early days directly at the Spanish dictator and latterly at other targets. He began work on an illustrated *Ubu Roi* in 1948 which was published in 1966 with thirteen lithographs, and created his own sequel to the Ubu cycle, *Ubu aux Baléares* (Ubu in the Balearics), in 1971. Miró was living in the Balearic Islands by this time, and made the piece as a protest "against all the Ubus

who sprawl on the island beaches during the month of August." In 1975, he created *L'enfance d'Ubu* (Ubu's Childhood), for which he produced twenty-four lithographs, wrote his own texts, using a surrealist style in the manner of automatic writing, and made a monstrous ceramic sculpture of a man-rhinoceros.

MAX ERNST (1891-1976)

Max Ernst, similarly, adopted Ubu as a symbol of dictatorship. His canvas *Ubu Imperator* (1923), one of the earliest examples of surrealist painting, sees Ubu as an enormous redbrick structure rendered as a spinning top, with a hen's beak, human hands and navel, green hair and shawl, with a needle nearby, in a desert landscape. The "Imperator" of the title (Latin for "Emperor") seems to be a reference to Mussolini's self-styled role as a reincarnation of the Roman emperors. But *Ubu Imperator* attacks all dictators. Ernst was driven from Germany by the Nazis, and six of his works were included (and subsequently burnt) by them in the "Entartete Kunst" (Degenerate Art) exhibition in 1937. Apart from this important painting, Ernst produced other smaller works on Ubuesque themes, but it is perhaps his techniques of frottage, grattage, decalcomania, and collage that most evoke the pataphysical spirit in their syzygies of images and materials.

MARCEL DUCHAMP (1887-1968)

In December 2004 a UK newspaper, *The Independent*, polled 500 selected British art world professionals to find out which was the most influential artwork of the twentieth century. Marcel Duchamp's *Fountain*, the famous urinal submitted to the Society of Independent Artists exhibition in 1917, was the winner. In a follow-up article, Philip Hensher commented: "with this single 'readymade' work, Duchamp invented conceptual art and severed for ever the traditional link between the artist's labor and the merit of the work" (Hensher 2008).

The urinal itself, with its signature "R. Mutt," has been the object of much critical analysis. Several commentators have discussed the curious pseudonym, apparently derived from the *Mutt and Jeff* cartoon strip, or perhaps from the German word for "poverty" (*Armut*), with which Duchamp temporarily concealed his identity while the judges contemplated whether to exhibit this controversial piece (in the end, they hid it, prompting Duchamp to resign from the committee and publish a revelatory article). Many more have commented on the urinal's iconoclasm, its origins in

Dada, the fact that it is stood on its back, its whiteness and purity, its sepulchral and feminine qualities, and so on. Paul Renaud and others have noted the close correspondence of the gesture of this work to the scatological opening word of *Ubu Roi* (Renaud 2009). As *Ubu* changed the theater, so *Fountain* changed the visual art world. The use of the letter *R* as Mutt's initial is significant, and recalls Duchamp's maxim in the *1914 Box*: "Arrhe est à art que merdre est à merde" (Arrhe is to art as shitr is to shit: Duchamp 1975, 24). The addition of an *r* was a Jarry-derived formula to which Duchamp returned frequently, not least in the name of his alter ego Rrose Sélavy.

Duchamp himself stated: "Rabelais and Jarry are my gods, evidently" (Tomkins 1998, 73), and references to Jarry abound in his work. For example, the bicycle, which provides the frame for both Jarry's Time Machine and the Cross of Jesus in *The Passion Considered as an Uphill Bicycle Race*, also appears in Duchamp's 1914 drawing *To Have the Apprentice in the Sun* and his first readymade, the *Bicycle Wheel* (1913).[8] The five-man bicycle team of *The Supermale* finds an echo in the "machine with five hearts, the pure child of nickel and platinum" which "dominates the Jura-Paris road" in Duchamp's text of 1912 (Duchamp 1975, 26–27). In *The Supermale*, one of the hearts, belonging to Jewey Jacobs, stops beating, and his subsequent rigor mortis leads to a perpetual motion that enables the team to beat the express train against which they are racing. In Duchamp's text the car's heart, its engine, is a machine which acquires life as the road stretches to the infinite horizon of a line without thickness.

Duchamp's note in *The Green Box* (1934) "The Clock *in profile*" (ibid., 31) directly references the "Elements of Pataphysics" book of *Faustroll*:

Why should anyone claim the shape of a watch is round—a manifestly false proposition—since it appears in profile as a narrow rectangular construction, elliptic on three sides; and why the devil should one only have noticed its shape at the moment of telling the time?—Perhaps under the pretext of utility. But a child who draws the watch as a circle will also draw a house as a square, as a façade, without any justification. . . . (Jarry 1965a [1911], 193)

The list of Duchamp's references to Jarry is extensive, and goes well beyond these few salient examples. Linda Dalrymple Henderson's authoritative study *Duchamp in Context* (Henderson 1998) makes clear the extent to which both Jarry and Duchamp drew on contemporary scientific and not-so-scientific developments. She explores the themes of electromagnetism and electricity that appear in *The Supermale* and *Dr. Faustroll*, and in particular on Jarry's interest in non-Euclidian geometry and the fourth dimension, derived from the contemporary scientific theories of C. V. Boys,

William Crookes, and Lord Kelvin, and expressed most completely in *How to Construct a Time Machine*. Duchamp developed these ideas further, partly inspired by Gaston de Pawlowski's *Voyage au pays de la quatrième dimension* (Journey to the Land of the Fourth Dimension, 1911) (Pawlowski and Jarry knew one another well) and Henri Poincaré's *Science and Method* (1914). So, for example, Jarry's perpetual-motion-food (*Supermale*) and luminiferous ether (*Faustroll*) come to resemble the Water and Illuminating Gas of *The Large Glass* and *Étant donnés: 1° la chute d'eau, 2° le gaz d'éclairage*. But Duchamp goes beyond Jarry in both the nature and the extent of his scientific and technological borrowings. As Henderson shows, *The Large Glass* develops and distorts: meteorology (barometric pressure), incandescence (the Bride as lighthouse), biology (the Wasp), chemistry (especially at the molecular level), thermodynamics (engines and motors), molecular and atomic physics (Brownian motion and the kinetic theory of gases), radioactivity and X-rays (invisibility), and of course mechanics (the Bachelor Apparatus, in particular). This is to say nothing of the later experiments with precision optics, stereoscopy, and so on.

These kinds of scientific allusion also owe much to Raymond Roussel, whose stage production of *Impressions of Africa* was famously attended by Guillaume Apollinaire, Gabrielle Buffet, Francis Picabia, and Duchamp in 1912.[9] As Duchamp said to James Johnson Sweeney: "It was fundamentally Roussel who was responsible for my glass. . . . From his 'Impressions d'Afrique' I got the general approach. . . . I saw at once that I could use Roussel as an influence" (Sweeney 1946, 19).

So much has been written about this influence that too much discussion is really superfluous.[10] There are very many parallels between the characters and machines of Roussel and elements of the *Glass*. However, the more fundamental aspects of Roussel's influence on Duchamp are the ironic use of scientific language, the insistence on Conception over Reality, the "inutilious" nature of the machines themselves, and the "poetic method" that uses underlying puns to lead to their creation. These are indeed essentially the methods of *The Large Glass*.

Whereas Roussel was a pataphysician unawares, Duchamp's 'pataphysics was both knowing and acknowledged. Even so, his version was subtly yet profoundly different from Jarry's. He occupied another part of the *gidouille*. It is hard to sum up this difference, but it rests in the plus-minus distinction between Jarry's project to make life beautiful like literature and Duchamp's desire to remove the concept of "Art" in order to make it "universal, a human factor in anyone's life" (Duchamp 1968). Both men experienced the exquisite exceptions and contradictions this brought about. In Jarry's case, the fusion of his literary creation with his own being placed him at

odds with physical existence itself. Duchamp also professed scant regard for reality, but found himself constantly contradicting the self-contradictory, bemused by his inability to escape the art world he so consistently decried. He even succumbed to repetition, or at least delayed replication, in the end,[11] just as he was working on the unique and highly precious installation *Étant donnés* (Given). The secretive fleshliness of that work seems to echo the hidden presence of Jarry in Duchamp's life, not least because the gender fusion represented by the half-male-half-female central figure conceals a sexual confusion which Jarry lived out, and with which Duchamp played through Rrose and alchemy. What was a reality from which to escape for Jarry, was a door through which Duchamp chose to enter. Perhaps the best metaphor for this is provided by the syzygistic pun that is *Door, 11 rue Larrey* (1926), which opens onto one room when closed to another, thus contradicting the old adage that a door must be either open or closed.

Another key difference between the two was their attitude to religion. This difference was to a great extent a reflection of the times in which they lived. Whereas Jarry, through Ubu, seemed to foresee the horrors of World War I, Duchamp, through Dada, shared in a general sense of the bankruptcy of European culture that it represented. Both men responded with humor to wider events, but Duchamp's response was of a distinctly more secular order than Jarry's. Faustroll's reply to the question "Are you a Christian?" was "I am God." Duchamp's reply to a similar question was very different:

Cabanne: Do you believe in God?
Duchamp: No, not at all. Don't ask that! For me, the question doesn't exist. God is a human invention. Why talk about such a Utopia? When man invents something, there's always someone for it and someone against it. It's mad foolishness to have made up the idea of God. I don't mean that I'm neither atheist nor believer, I don't even want to talk about it. I don't talk to you about the life of bees on Sunday, do I? It's the same thing. (Cabanne 1971, 107)

A note in *The Green Box* states: "Ironism of affirmation: differences from negative ironism dependent solely on Laughter" (Duchamp 1975, 30). Affirmation is something which Duchamp's work generally tries to avoid. It suggests, contradicts, points out, proposes, shrinks from, conceals, pokes fun at, amuses itself by, passes the time with, but does not, on the whole, affirm. Even *Fountain*, which has come to symbolize a certain attitude to Art, if not Life, lacks the affirmative qualities of, say, a *Guernica*. It raises as many questions as it answers. Ever the post-Cartesian, Duchamp dealt in doubt far more than certainty.

Duchamp's 'pataphysics was therefore more than just a collection of nods and homages to literary forebears. It so thoroughly permeated all his

exploits and opinions that it seems to have constituted his entire being. Pick more or less any work or action by Duchamp, however apparently insignificant, and one can trace its pataphysical origins. His *œuvre* is an archaeology which provides evidence of a pataphysical life. The fact that he did not put a name to this life until its last decades is a reflection of the postwar emergence of the Collège de 'Pataphysique and its cautious relationship with the wider world. Given Duchamp's well-known dislike of groups, it is not surprising that he took time to wear the pataphysician's plaque. He would have been suspicious of anything that looked like a literary society. But his "playful physics" shows that these ideas were important to him long before his accession to the Collège.

Duchamp called his humor "meta-irony" which, given that irony is already one step removed from straightforward joking, reaches the pataphysical domain rather quickly. As with all pataphysical humor, there is something both brutal and elegant about it. "Establish a society in which the individual has to pay for the air he breathes," he wrote *in The Green Box*: "in case of nonpayment simple asphyxiation if necessary (cut off the air)" (ibid., 31). Duchamp's 1959 drawing with relief entitled *With My Tongue in My Cheek* sets the tone, as does his statement "every word I tell you is stupid and false," which surely comes from a first-year undergraduate logic textbook. This humor operates at the level of all his work and his public persona, from the *Wanted* poster of 1923 to the public renunciation of art for chess. The readymades, in particular, continue to amuse and outrage in equal measure.

Rrose Sélavy preferred the pun. "My niece is cold because my knees are cold" is the only one in English in *Anemic Cinema* (1926) (ibid., 111). Much of her humor relies upon the same syzygy of words,[12] or "momentary conjunction or opposition of meanings" that obsessed Roussel and Brisset. Duchamp extended the concept to number (e.g. taking "3" as "a refrain"), geometry (e.g. the *3 Standard Stoppages*), and chess, where the opposition of a unique endgame position, described in Duchamp and Halberstadt's *L'Opposition et les cases conjuguées sont réconciliées* (Opposition and Sister Squares Are Reconciled) (Duchamp and Halberstadt 1932), created a dark humor that seems to have inspired Samuel Beckett (Hugill 2000). *The Large Glass* is "a hilarious Picture" that conjoins opposites, and the pun that is *L.H.O.O.Q.* (look/elle a chaud au cul = she's got a hot arse) similarly opposes gender, and makes the schoolboy prank of drawing a mustache and goatee on the *Mona Lisa*. Sex is still the funniest joke of all.

Duchamp's engine was the exceptional or the particular. He frequently stated that he was interested only in creating something new. His suspicion

of repetition derived from this. Thus every individual work had to be unique, and so his collected works represent a study of the science of the laws governing exceptions. For the playful physics of *The Large Glass* to work, Duchamp had to reinvent the laws of gravity, the unit of measure, the passage of time, the means of energy and power, the behavior of light, the rendering of perspective, the actions of machines, and so on. This reinvention continued in *Étant donnés* which, despite appearances, is not a reduction of the *Glass* to a three-dimensional reality but, rather, an attempt to present a three-dimensional shadow of a four-dimensional object, just as the *Glass* itself is a two-dimensional shadow of a three-dimensional object.[13]

In a world of particulars, no one thing is more significant than any other: they are all equivalent. Thus *The Large Glass* itself, with the vast amount of time and effort lavished upon it, is no more significant than a simple readymade that required only a decision. The point is made most forcefully by Duchamp in the *Boîte-en-valise* (Box-in-a-suitcase, 1935–1941), in which the replica of the *Glass* is scaled to the same size as the other works, and the three large reproduced readymades *Air de Paris* (1919), *Travelers Folding Item* (1916), and *Fountain* (1917) are carefully placed alongside the Bride, the horizon or hinge, and the Bachelor Apparatus respectively, to suggest a cruder version of the narrative. The Bride is rarefied and hermetically sealed, while the Bachelors are base, peering up the "skirts" of the Underwood typewriter case and pissing about with a urinal that they stand on its back to see an outline of the Lady above. Duchamp's indifference to the fate of *The Large Glass* when it was shattered is legendary, yet entirely consistent with the doctrine of equivalence.

Duchamp's creation of work that is made possible by "slightly distending the laws of physics and chemistry," as he noted in *The Green Box* (Duchamp 1975, 271), invokes another pataphysical theme which receives a reexamination at his hands: *clinamen*. Molecular swervings are a feature of *The Large Glass*,[14] captured, for example, in the *3 Standard Stoppages* (created by letting a meter-length string fall into paint, then using the resulting line as a ruler) which provide the measure of distance, or in the *Draft Pistons* (created by photographing the heat distortions made in a square of veil suspended above a radiator, and copying the outlines to the upper panel of the glass). Many of his other works, especially the rectified readymades, are examples of small adjustments that change the nature of the object in a way that metaphorically echoes the *clinamen*. Thus *Pharmacie* (Pharmacy, 1914) adds two small colored objects and a title to a found landscape image to transform its meaning; or *In Advance of the Broken Arm* (1915), in which a snow shovel is amusingly retitled.

Clinamen is also developed in Duchamp's concept of the infra-thin. He first coined this term in the surrealist journal *View* (March 1945), declaring that it cannot be defined, but instead "one can only give examples of it." Some examples:

The warmth of a seat (which has just been left) is infra-thin.
Velvet trousers—their whistling sound (in walking) by brushing of the 2 legs is an infra-thin separation signaled by sound.
When the tobacco smoke smells also of the mouth which exhales it, the 2 odors marry by infra-thin (olfactory in thin) (Matisse 1980).

The infra-thin is therefore the infinitely small difference between things, which nevertheless creates something, albeit intangible and invisible. It is the transparent division between the two panes of *The Large Glass*, or even the "interchange between what is put in view and the glacial observation of the public (that sees and immediately forgets)" (ibid.).

The *gidouille* appears in two of the unfinished elements of *The Large Glass*: the Juggler/Handler of Gravity, and the Splash. The Juggler is a springlike ethereal entity whose agitations send waves toward the Bride; the Splash is a slide down which the liquid love gas runs, to be shot into the upper pane. These are the two most important elements of *The Large Glass*, insofar as they control the product of the entire operation, yet they are absent from the unfinished piece, just as pataphysics itself is a largely invisible presence in Duchamp's work. The *Rotative Demi-Sphère* (Rotary Demisphere, 1925) and the *Rotoreliefs* (1935) also animate spirals and are shown in *Anemic Cinema* intercalated with spiriform puns. Less obvious is the spiral passage of the viewer's eye from (or toward) the vaginal opening of the hermaphroditic figure in *Étant donnés*.

André Gervais suggested: "the artist who said 'There is no solution because there is no problem' would not accept Pataphysics—which is, as Jarry said, the 'science of imaginary solutions'—at face value" (de Duve 1991, 409). However, the "science of imaginary solutions" is an incomplete definition. The full definition, of course, reads: "Pataphysics is the science of imaginary solutions, which symbolically attributes the properties of objects, described by their virtuality, to their lineaments."

Now this seems much closer to a description of Duchamp's life and work. The objects he created all have properties which he was at pains to document and explain—indeed, it is a key feature of his work that the objects themselves are inadequate to convey all the meaning they contain. Jarry's definition is deeply rooted in French symbolism, which had also infused Duchamp's early work. In this tradition, the function of a symbol was far more than merely to represent something else; rather, it created a

meaningful obfuscation. As Jean Moréas puts it in his "manifesto" of Symbolism (1886):

Ainsi, dans cet art, les tableaux de la nature, les actions des humains, tous les phénomènes concrets ne sauraient se manifester eux-mêmes; ce sont là des apparences sensibles destinées à représenter leurs affinités ésotériques avec des Idées primordiales. [In this art, scenes from nature, human activities, and all other real-world phenomena could not in themselves be made manifest; here, they are perceptible surfaces created to represent their esoteric affinities with the primordial Ideals.]

Duchamp's "primordial Ideals" were eroticism and humor, which never left him, from the early paintings onward. The symbolic attribution of the properties of his works to their lineaments relies upon a removal of superfluous detail for its effect, something which is represented by the gradual erasing of backgrounds, from the black neutrality of the *Broyeuse de chocolat* (Chocolate Grinder) paintings to the invisibility of *The Large Glass* and, meta-ironically, the apparently banal landscape of *Étant donnés*. Throughout his work we find this triple step: from physics to metaphysics to 'pataphysics, represented by the move from two, to three, to four dimensions, or from ether to eternity to ethernity. As Duchamp commented: "One is unity, two is the double, and three is the rest."[15] Duchamp's imaginary solution is a solution without a problem. It is a solution to art and to life itself.

In later life, Duchamp seemed to become more willing to acknowledge directly the importance of pataphysics. The word itself, and particularly the prefix, began to appear in new formulations. In December 1953, he wrote to André Breton, lamenting the death of his old friend Francis Picabia: "It's a pleasure for me to see that something exists in Paris apart from "arassuxait."[16] Plagiarizing Jarry, we might have opposed "patArt" to contemporary vulgarity" (Gough-Cooper and Caumont 1993, 18–19–20 December).

A few years later, another neologism surfaced in a letter to Jean Mayoux, dated 8 March 1956: "All this twaddle, the existence of God, atheism, determinism, societies, death, etc., are pieces of a chess game called language, and they are amusing only if one does not preoccupy oneself with winning or losing this game of chess. As a good nominalist, I propose the word Patatautologies, which, with frequent repetition, will create the concept of what I am trying to explain in this letter by these execrable means: subject, verb, object, etc." (ibid., 8–9 March).

Duchamp joined the Collège de 'Pataphysique in 1952 and was elevated to Satrap the following year. In 1962 he also joined the OuLiPo. On his death, the internal publication *Subsidia Pataphysica* no. 6 appeared, containing three blank pages entitled "Hommage à Marcel DUCHAMP," and some copies reproduced in facsimile his greeting "Bien 'pataphysic à vous!"

Duchamp was enigmatic, and everyone sees something a little different in his body of work. However, he was a conscious pataphysician. While much of the vast body of Duchamp criticism acknowledges the presence of 'pataphysics in his life and work, not all writers perceive its full extent, which is hardly equivalent to the influence on him of cubism, futurism, or Dada. He was a pataphysical entity.

PATAPHYSICAL LIVES

As Breton observed, "We can say that after Jarry, much more than after Wilde, the distinction between art and life, long considered necessary, found itself challenged and wound up being annihilated in principle" (Breton 1997 [1940], 258). Two individuals who illustrated this principle well and became models of the Dada spirit were Arthur Cravan and Jacques Vaché. Cravan became a pataphysical saint (his day on the pataphysical calendar is the 4th As) and Vaché, whom Breton described as "Dada before Dada, Dada in all its purity, without compromise and without concessions to any snobbery" (Crastre 1952, 33–35), might perhaps also have a place on the 13th Tatane: St. Dada, Prophet. Cravan's mysterious disappearance in 1918 when sailing from Mexico to Argentina, and Vaché's death in 1919 from an overdose of opium, did much to seal their reputations as livers of *la vie imaginaire*. Both men seem to have treated their lives as an experiment in living, an experiment driven not so much by a traditional scientific spirit of inquiry, but more by an overwhelming subjectivity that produced an indifference both to themselves and to the material world.

Modern celebrity mythmaking owes much to these early models, and the idea of a self-destructive public existence, sometimes crudely called "living the dream," is itself today a cliché. Escapism, whether from oneself or from the banalities of daily existence, does seem to be a feature of pataphysics. It is probably best summed up by the image of the heads leaving the bodies in Jarry's *Days and Nights*:

Once he had read in a Chinese book this ethnology of a people foreign to China, whose heads could fly up to the trees to seize their prey, connected to their bodies by an unraveling red thread, and were then able to return and fit back on to their bleeding necklaces. But a certain wind must not blow, for should the thread break, the head would fly away over the sea. (Jarry 2006 [1897], 27)

But we should be cautious here, for pataphysics cannot simply be some kind of escapist dream. The scientific imperative implies a certain intellectual engagement. The point is that Cravan and Vaché lived exceptional lives which had little in common with the experiences of a typical drunkard

or suicide, or even the modern rock star who lives fast and dies young. A life is not more pataphysical because it contains drugs or fantasy or delusion. The key to a pataphysical life lies in the apostrophe that precedes the word 'pataphysics.

ARTHUR CRAVAN (1887–C. 1918)

Cravan's life seems to have consisted of a series of gestures that included the gesture of "dying" disguised as a disappearance. He "disappeared" several times, always reemerging in a different guise, and his apparently final disappearance seemed no different. Roger Conover records a persistent myth that he took on the persona of "Dorian Hope" and produced forged manuscripts of works by Oscar Wilde, traveling first to New York (sometimes as "James M. Hayes"), then Paris (sometimes as "Monsieur André Gide"), then Amsterdam and London. It is certainly the case that convincing forgeries of works by Wilde flummoxed experts at the time. Two of them, Vyvyan Holland and William Figgis, were still corresponding about it thirty years later:

I am interested in what you say about Dorian Hope . . . I always understood that he was my first cousin Fabian Lloyd. The Dorian came from Dorian Gray and the Hope from Adrian Hope who was one of the family trustees. He also called himself Arthur Cravan and edited a short-lived Dadaist magazine. . . . (Conover, Hale, and Lenti 1995, 20)

Cravan certainly was the nephew (rather than the son) of Oscar Wilde, and he ran *Maintenant*, a Dadaist magazine that appeared for five issues between 1912 and 1915. This periodical specialized in publicly insulting people, most famously the artist Marie Laurencin, whose self-portrait, Cravan wrote, made you feel that she "needed a good shag," a remark which prompted a challenge to a duel from her lover, Guillaume Apollinaire. Cravan's public appearances were notable for their aggression and degeneracy. At the New York Independents exhibition in 1917 he started to strip, and threw dirty laundry at his audience before being arrested. On other occasions he threatened suicide, engaged in fisticuffs, and verbally abused members of his audience. In 1916, he famously challenged the former world heavyweight champion Jack Johnson to a bout in Barcelona. He lost the fight, of course, but they both pulled in the crowd they sought. He became increasingly obsessed with his own body, its history and its functions. As Roger Conover wrote:

Dancing, fucking, boxing, walking, running, eating, swimming. He loved the taste and smell of the body's first issues—urine, shit, spit, sweat—and regarded these fun-

damental utterances as proto-texts. *"Je mangerais ma merde,"* he proudly proclaimed. His poems and essays were secondary aspirations—but in their gestural sweep and postural fix they can also be read as bodily manifestations, lines delivered or speech executed like ring exercises, by-products of a body always in motion—crossing borders, slicing sensibilities, murdering reputations, knocking heads. (Conover, Hale, and Lenti 1995, 27)

In pataphysical terms, Cravan's was an imaginary solution to the problem of living. The following excerpt from "Poet and Boxer" first appeared in March 1915 in Issue 5 of *Maintenant*, and captures something of the spirit of both his writing and his living.

Whoo-eee! Off to America in 32 hours. Only been back in London from Bucharest two days before bumping into the man I was after: the one who would meet all the expenses of a six-month tour. No contract, of course! Not that I gave a damn about that. After all, it wasn't as if I was about to dump my wife!!! Shit! And you'll never guess what I had to do: put on exhibition fights under the pseudonym of *The Mysterious Sir Arthur Cravan*, the world's shortest-haired poet, *Grandson of the Chancellor to the Queen*, of course, *Oscar Wilde's Nephew* likewise of course, and *Alfred Lord Tennyson's Great Nephew*, once again of course (I'm wising up now). The fights were to be something completely new: Tibetan rules, the most scientific known to man and even more terrible than jiu-jitsu—the slightest pressure on a single nerve or tendon, no matter which, and splat! your opponent (who was absolutely not bribed, well maybe a little bit) falls to the ground like a man struck by lightning! If that doesn't crack you up, how about this: by my reckoning this will really bring the money rolling in and if everything goes according to plan I should make some 50,000 francs out of the deal, which isn't to be sniffed at. In any event, it was much better than the spiritualism racket that I'd been working. (Conover, Hale, and Lenti 1995, 62)

JACQUES VACHÉ (1895-1919)

Vaché grew up in Nantes and, when an art student, came across *Ubu Roi* and other writings by Jarry. He modeled himself on Ubu/Jarry, carrying a revolver and walking the streets in a variety of uniforms. As André Breton, who first met him in 1916, remarked: "If he happened to walk by, he would ignore you completely and continue on his way without so much as a glance backward" (Breton 1996 [1924]).

His most famous exploit was to interrupt the première of Guillaume Apollinaire's play *Les Mamelles de Tirésias* (The Breasts of Tiresias), dressed as an English aviator, by drawing his revolver and threatening to shoot the audience. This alone secured his reputation as the progenitor of Dada, but it was his consistent indifference to the world and himself that showed such actions to be more than mere stunts.

If Cravan's life was an imaginary solution to the problem of living, then Vaché's was an imaginary solution to the problem of dying. Confronted by World War I, in which he saw active service from 1915 to 1918, Vaché witnessed the death of the established world order in the deaths of a multitude of friends, fellow soldiers, unknowns. Vaché's reaction reveals a profound sense of his own irrelevance, of life as a game in the face of death, destruction, and terror, to be played in a spirit of what he called *'umor*. He declared:

It's all rot that they put in the newspapers about the good humor of the troops, how they are arranging dances almost before they are out of the front line. We don't act like that because we are in good humor: we are in good humour because otherwise we would go to pieces. (Conover, Hale, and Lenti 1995, 204)

The *'umor*, then, was deeply ironic, slightly mocking, and dandified, leaving full scope for Vaché to wear his uniforms and strike his attitudes. It was a word that was invented to be substituted for "'pataphysics," which at that time had little currency.

Vaché discussed drugs and suicide quite frequently and casually, so his double suicide with an army colleague from an overdose of opium on 6 January 1919 seems to have been entirely in keeping with the rest of his approach to life. He never showed the slightest interest in a literary career, and certainly never intended his "Letters from the Front" to be published. With that in mind, here are a few small excerpts from a letter to André Breton, written on 18 August 1917, in which he discusses a potential joint playwriting project:

ART doesn't exist, of course—then it's useless to sing about it—nevertheless! We make art—because that's how it is and not otherwise—*Well*—what are you going to do about it? [. . .]

—O ABSURD GOD!—Because everything is contradiction—isn't it?—and will 'umor be the one who has never taken in by the hidden and sneaky life of everything?—O my alarm clock-eyes—and hypocrite—who detest me so much! . . . and will 'umor be the one who will feel the lamentable optical illusion of universal simile-symbols?

—It's in their nature to be symbolic.

—'Umor shouldn't produce—but what to do about it? [. . .] (Conover, Hale, and Lenti 1995, 227–228)

8 (1907-1948) UNCONSCIOUS PATAPHYSICS?

--

The extent to which the authors listed in this chapter were unconscious pataphysicians is of course open to question. Did they really lack the apostrophe? Joyce seems to have absorbed Jarry in much the same way as he absorbed the work of many other writers and so, by extension, did O'Brien. Roussel denied any relationship with the avant-garde, yet the surrealists were his most fervent supporters and he undoubtedly had at least heard of Jarry, since he was obliged politely to decline to answer a question on the subject posed by Benjamin Péret. Only Brisset, in the strength of his convictions and his relative isolation, seems to have been impervious, despite being ironically crowned "Prince of Thinkers" by the unanimists in Paris. As for Jorge Luis Borges: while he was apparently unaware of a pataphysical connection when he wrote most of his fictions, a typical ambiguity appears in the form of "Jesus Borrego Gil," who contributed essays to the *Subsidia* of the Collège de 'Pataphysique which discuss the writings of Borges,[1] and whose name, it will be observed, is an anagram of that of the Argentinian writer. As Gil put it: "Who isn't Borges?"[2] There is an infra-thin line between the conscious and the unconscious. The apostrophe is, after all, gone in the wink of an eye.

Borges described the metaphysicians of Tlön thus: "[They] do not seek for the truth or even for verisimilitude, but rather for the astounding. They judge that metaphysics is a branch of fantastic literature" (Borges 1981 [1940], 34). This seems a pretty fair description of those pataphysicians who, like Borges, and like Jarry himself, enjoyed playing with their erudition. Tlön is an imaginary world created by a conspiracy of intellectuals, whose existence, or nonexistence, is investigated in the story "Tlön, Uqbar, Orbis Tertius," published in 1940, set anywhere between 1940 and the seventeenth century, and updated in an anachronistic epilogue written (apparently) in 1947. Borges himself is the narrator, discovering, during a conversation with the fellow Argentinian writer Bioy Casares, the existence of a mysterious entry in an encyclopedia describing a country in Tlön called Uqbar, which is the first hint of the presence of Orbis Tertius, the "nebulous" group that lies behind the whole fiction. It emerges that the people of Tlön believe in an extreme form of idealism, and deny the existence of the world. They understand reality "not as a concurrence of objects in space, but as a heterogeneous series of independent acts" (Borges 1962, 23). As Bélisaire Monomaque, Regent of Photosophistry, remarked in *Dossier* 4 of the *Cahiers du Collège de 'Pataphysique:*

for we Pataphysicians, it is obvious that Borges celebrated, with brilliance and an unrivalled profundity, a 'Pataphysics of whose history in the works of Jarry he seems to have been unaware. For who amongst us has not been driven to the conclusion that Tlön is the Collège? (Monomaque 1958, 61–62)

Borges frequently recounted the description of a machine to aid thinking invented by Raimundo Lullio, or Ramon Llull, a Spanish philosopher of the thirteenth century, which is today known as the "Lullian Circle." It consisted of two or more disks inscribed with symbols or letters or attributes. The disks could be rotated to produce alignments of these elements, designed, in Llull's philosophy, to reveal all possible truths about knowledge and God. Ultimately it was to be a device for unifying different religious faiths, since Llull believed that they shared common truths. Borges had a rather different view of its purpose, outlined in an essay from 1937:

It [the machine] does not work, but that, to my mind, is a secondary matter. Nor do the machines that attempt to produce perpetual motion, whose plans add mystery to the pages of the most effusive encyclopaedias; metaphysical or theological theories do not work either . . . but they're well known and famous uselessness does not reduce their interest. (Borges 1999 [1937], 155)

An inutilious machine that uses chance combinations to reveal fascinating insights of an ideal nature is by now such a familiar pataphysical trope to the reader as to need no further comment. However, Borges's fictions—which, as John Sturrock points out, "dramatise the idealism of Berkeley and Schopenhauer" (Sturrock 1977, 23)—are closer to Raymond Roussel's imagined worlds than to Jarry's more subjective writing. Like Roussel, Borges preferred a neutral style in which he himself may appear as a character, yet remain mysterious. As Sturrock observes: "What the two writers share is a fierce wish to remain inexpressive, to let language and logic between them do the work" (ibid., 185).

In "The Library of Babel" (1941), therefore, Borges envisages the nightmarish possibility of the logical consequences of such self-effacement in favor of a total logic ruled by chance.

The universe (which others call the Library) is composed of an indefinite and perhaps infinite number of hexagonal galleries, with vast air shafts between, surrounded by very low railings. From any of the hexagons one can see, interminably, the upper and lower floors. The distribution of the galleries is invariable. Twenty shelves, five long shelves per side, cover all the sides except two; their height, which is the distance from floor to ceiling, scarcely exceeds that of a normal bookcase. One of the free sides leads to a narrow hallway which opens onto another gallery, identical to the first and to all the rest. To the left and right of the hallway there are two very small closets. In the first, one may sleep standing up; in the other, satisfy one's fecal necessities. Also through here passes a spiral stairway, which sinks abysmally and soars upwards to remote distances. [. . .] There are five shelves for each of the hexagon's walls; each shelf contains thirty-five books of uniform format; each book is of four hundred and ten pages; each page, of forty lines; each line, of some eighty letters which are black in color. There are also letters on the spine of each book; these letters do not indicate or prefigure what the pages will say. (Borges 1981 [1941], 78)

The books contain every possible permutation of twenty-five orthographical symbols. Most books are therefore complete gibberish, but the (increasingly suicidal) librarians who wander through this universe believe that it must contain every book ever written, or to be written, and indeed the index to the Library itself.

This universe is full of meaningless letter-atoms in a continuous descent, until a *clinamen* causes some chance collisions which create, in this case, verbal matter, and hence meaning. Nor is there a lack of absurdity, even humor, in the predicament of the inhabitants, with their dreams of a "Crimson Hexagram" filled with illustrated magical books, or a Man of the Book who has read the catalog. The idea is developed further in a later story with a title that, probably unintentionally, seems to echo Jarry: "The Book

of Sand" (Borges 1979 [1975]). Here it is the book itself that is infinite, with each page, once viewed, impossible to find again. Borges himself, as the narrator and the new owner of the book, ends up deliberately losing it in the musty shelves of the basement of the Argentine National Library, of which he was in fact the Director from 1955 to 1973.

One other pataphysical game that Borges loved to play was that of deliberate anachronism, obfuscation, or falsification, especially in relation to academic and historical information. This included creating bogus references to nonexistent books by imaginary authors written at impossible times. We see a similar mixing of fact and fiction in Jarry's "historical" novel *Messalina* and shorter texts such as "The Other Alcestis." In Borges's case, it was driven in part by a fascination with the purely fantastical, such as the creatures described in *The Book of Imaginary Beings* (Borges 2005 [1957]) or the dreams that often underpin his fiction. By failing to distinguish between the verifiably "real" and the supposedly "imaginary," he reinforced his idealism. From a pataphysical point of view, which goes as far beyond such metaphysics as they go beyond physical reality, the most interesting aspect is the point at which these overlap with one another to produce a synthesis that has a certain inherent humor, but is also an exceptional instance of an imaginary solution. Probably the best example of this is the story "Pierre Menard, Author of the *Quixote*" (Borges 1981 [1931], 62–71). This echoes the doctrine of Equivalence inspired by Faustroll's library of Equivalent Books, treating the *Quixote* as a text to be not merely copied, or plagiarized, but *rewritten* using the same words. The story deftly anticipates Roland Barthes's essay "The Death of the Author" (Barthes 1977 [1967], 142–148) by demonstrating, with a virtuosic flourish, the critical differences between two passages of exactly the same constitution produced centuries apart. In Pierre Menard, the imaginary French author of a rewritten Spanish text, and a whole body of imagined criticism, the Argentinian Borges has created a fictional entity whose pataphysical presence is as real as that of Julien Torma.

JAMES JOYCE (1882–1941)

The precise extent of Joyce's debt to Jarry has been a marginal yet intensely debated corner of scholarship for many years now. In a series of books and articles, and an exibition entitled "100 Pages from the Joyce/Jarry Project," the artist William Anastasi developed a complex account of the cross-relationships, reaching the following conclusion:

According to my reading of *Finnegans Wake*, Joyce refers to Alfred Jarry as "me innerman monophone" and "me altar's ego in miniature," and retells or recalls various

scenes from the life, as well as from every novel and theater piece, of the French author. In addition, one of the book's four main characters, Shem (a.k.a. Jerry), is based in the largest part on Jarry himself. (Anastasi 2000)

This reading does not seem to have been generally adopted by the community of Joyce scholars, which of course does not necessarily invalidate the conclusion but perhaps raises a question about the apparent lack of acknowledgment of the source in Joyce's correspondence and notes. We do know that Joyce became friends with Jarry's former lover Léon-Paul Fargue in 1921 and, according to Richard Ellman, "was always shocked by the stories Fargue told in the presence of women" (Ellman 1959, 536). This cannot fail to evoke the shade of Jarry, and it is inconceivable that he was not discussed. In *Finnegans Wake* we find both the name and memory of Jarry in the following passages, which do tend to support Anastasi's thesis:

He's the sneaking likeness of us, faith, me altar's ego in miniature . . . for ever cracking quips on himself, that merry, the jeenjakes. . . . He has novel ideas I know and he's a jarry queer fish betimes, I grant you, and cantankerous, the poisoner of his word, but lice and all and semicoloured stainedglasses, I'm enormously full of that foreigner, I'll say I am!" (Joyce 1975a [1939], 463)

You rejoice me! Faith, I'm proud of you, French davit! (Ibid., 464)

Jean-Michel Rabaté suggests that the "joyous" Joyce enjoyed the laughter or *jouissance* evoked by Jarry, and by the sound of his (or Jerry's) name in French: *je ris* (I laugh) (Rabaté 2004–2005, 187). Certainly the humor of the Wake, which is after all set in a kind of dream, with its neologisms and love of punning, seems very close in spirit to pataphysics. What seems to have been overlooked by all commentators is the similarity between the formal design of *Ulysses* and *Finnegans Wake*, taken as a pair, and Jarry's novel *Days and Nights*. Joyce's novels represent one day and one night but, just like Jarry's, they start to play with that concept, blurring the distinction between the two, describing night events as though they are happening in daytime, and vice versa. The scale is vastly different and the influence doubtless coincidental, but it betrays a certain similarity of mind and approach.

This was similarly recognized by Raymond Queneau, among others, whose scandalous novel *We Always Treat Women Too Well* (published under the pseudonym Sally Mara) (Queneau 1981 [1947]) references firstly cheap smutty novels and secondly Joyce's work, in particular *Ulysses*. Set in Dublin during the 1916 Easter Rising, it tells of a nubile beauty who finds herself trapped in the central post office when it is seized by a group of rebels, who swear by "Finnegans Wake" and sport the names of Joycean characters. The woman in question, one Gertie Girdle, is more than a match for

them, however, deploying a strategy modeled on Molly Bloom's soliloquy, whose four "cardinal points," as James Joyce explained in a letter to Frank Budgen, were "breasts, arse, womb and cunt" (Joyce 1975b, 285). Through these and other means, she renders them, in every sense, impotent.

Thieri Foulc has also pointed out that the Collège de 'Pataphysique always considered Joyce a patacessor. Dr. Sandomir was a reader of Joyce, borrowing from him the term Epiphany to express the bursting forth or the revelation of pataphysics (hence the regular column "Epiphanies" in the *Cahiers*), and the Pataphysical calendar celebrates the Bloomsday.[3]

FLANN O'BRIEN (1911–1966)

In Brian O'Nolan, *alias* Myles na gCopaleen, author of the "Cruisken Lawn" column in the *Irish Times* (between 1940 and 1966) and uncrowned King of Ireland, *alias* Flann O'Brien, author of five great comic novels, we find the first Anglophone writer who seems instinctively to have grasped the essence of pataphysics without ever (apparently) having read Jarry. The hallmarks of pataphysics are all there: the utter disrespect for established orthodoxies; the mocking of church and state; the coruscating journeys through literary and philosophical reputations; the bizarre distortions of scientific and mechanical laws; the subjective viewpoint that at the same time negates the self; and above all a biting wit and insightful humor. To appreciate what makes O'Brien's writings *pataphysical*, rather than merely humorous, takes a thorough reading with a knowledge of French pataphysics. Space does not permit the reproduction of five whole novels, so we will restrict ourselves to a few salient examples to illustrate the point.

The earliest novel, *At Swim—Two—Birds* (1938), offers three alternative openings, of which the second reads as follows:

There was nothing unusual in the appearance of Mr John Furriskey but actually he had one distinction that is rarely encountered—he was born at the age of twenty-five and entered the world with a memory but without a personal experience to account for it. His teeth were well formed but stained by tobacco, with two molars filled and a cavity threatened in the left canine. His knowledge of physics was moderate and extended to Boyle's Law and the Parallelogram of Forces. (O'Brien 2007, 5)

It is worth comparing this opening description with that of *Doctor Faustroll* reproduced in the next chapter. The similarities, and the differences, will be immediately apparent.

In *The Third Policeman* (rejected for publication in 1940, and not actually published until 1967) we are introduced by a dead narrator to a strange

land in which he encounters the ghost of the man he murdered, and a central police station populated by policemen who hold conversations with bicycles. But it is in the character of de Selby, Faustrollian inventor and scientist, whose story is entirely told in footnotes to this novel, that we encounter O'Brien's most pataphysical invention. A single, highly truncated, example (chapter 8, fn. 1) will have to suffice:

Not excepting even the credulous Kraus (see his *De Selby's Leben*), all the commentators have treated de Selby's disquisitions on night and sleep with considerable reserve. This is hardly to be wondered at since he held (a) that darkness was simply an accretion of "black air," i.e., a staining of the atmosphere due to volcanic eruptions too fine to be seen with the naked eye and also to certain "regrettable" industrial activities involving coal-tar by-products and vegetable dyes; and (b) that sleep was simply a succession of fainting-fits brought on by semi-asphyxiation due to (a). [. . .]

As in many other of de Selby's concepts, it is difficult to get to grips with his process of reasoning or to refute his curious conclusions. The "volcanic eruptions," which we may for convenience compare to the infra-visual activity of such substances as radium, take place usually in the "evening," stimulated by the smoke and industrial combustions of the "day," and are intensified in certain places which may, for the want of a better term, be called "dark places." One difficulty is precisely this question of terms. A "dark place" is dark merely because it is a place where darkness "germinates" and "evening" is a time of twilight merely because the "day" deteriorates owing to the stimulating effect of smuts on the volcanic processes. De Selby makes no attempt to explain why a "dark place" such as the cellar needs to be dark and does not define the atmospheric, physical or mineral conditions which must prevail uniformly in all such places if the theory is to stand. The "only straw offered," to use Bassett's wry phrase, is the statement that "black air" is highly combustible, enormous masses of it being instantly consumed by the smallest flame, even an electrical luminance isolated in a vacuum. "This," Bassett observes, "seems to be an attempt to protect the theory from the shock it can be dealt by simply striking matches and may be taken as the final proof that the great brain was out of gear. [. . .]" (O'Brien 2007, 325–326)

De Selby is reincarnated magnificently as an *idiot savant* in the final novel, *The Dalkey Archive* (1964), which, as Keith Donohue observes, "point[s] out the futility of the search for self-identity, but also [. . .] undermine[s] systems of authority that might guide individuals. Science, religion, secular and political authority, literature and art are exposed as incomplete and provisional systems to explain life" (Donohue 2007, xvii). The new de Selby develops a substance ("D.M.P.") capable of extracting all oxygen from an airtight enclosure, of disrupting the sequentiality of time, and of producing fine mature whiskey in a week. De Selby vows to use the substance to destroy the world in the name of God. One of the novel's narrators, Mick

Shaughnessy, also encounters Sergeant Fottrell who, like the policemen in *The Third Policeman*, has a bicycle obsession and a peculiar theory:

—Did you ever study the Mollycule Theory when you were a lad? he asked. Mick said no, not in any detail.

—That is a very serious defalcation and an abstruse exacerbation, he said severely, but I'll tell you the size of it. Everything is composed of small mollycules of itself and they are flying around in concentric circles and arcs and segments and innumerable various other routes too numerous to mention collectively, never standing still resting but spinning away and darting hither and thither and back again, all the time on the go. Do you follow me intelligently? Mollycules?

—I think I do.

—They are as lively as twenty punky leprechauns doing a jig on the top of a flat tombstone. Now take a sheep. What is a sheep only millions of little bits of cheapness whirling around doing intricate convulsions inside the baste. What else is it but that? [. . .]

—The gross and net result of it is that people who spend most of their natural lives riding iron bicycles over the rocky road-steds of the parish get their personalities mixed up with the personalities of their bicycles as a result of the interchanging of the mollycules of each of them, and you would be surprised at the number of people in country parts who are nearly half people and half bicycles. (O'Brien 1993 [1964], 75–76)

Perhaps the best summary of Flann O'Brien's pataphysical attitude is the quotation from de Selby that opens *The Third Policeman*:

Human existence being an hallucination containing in itself secondary hallucinations of day and night (the latter an insanitary condition of the atmosphere due to accretions of black air) it ill becomes any man of sense to be concerned at the illusory approach of the supreme hallucination known as death. (O'Brien 2007, 211)

RAYMOND ROUSSEL (1877-1933)

Roussel was the pataphysician's pataphysician, a crucial figure in defining an alternative style to Jarry's pataphysics, while completely unaware of his role in that respect. Michel Leiris, who became a Transcendental Satrap of the Collège de 'Pataphysique in 1957, was the son of Roussel's financial adviser, Eugène Leiris, with whom several important manuscripts were lodged by Roussel for safe keeping. Leiris was therefore a highly important early advocate of Roussel, writing several critical essays and generally helping to establish his reputation. From there, it has grown steadily, nurtured by a succession of influential critics and biographers, such as the pataphysicians Jean Ferry and François Caradec, the poet John Ashbery, and the critical theorist Michel Foucault.

In his book on Roussel, Mark Ford notes that there was a paradox in Foucault's appreciation of Roussel, in which he was encouraged by the pioneers of the *nouveau roman*, Michel Butor and Alain Robbe-Grillet: "it has no real place in the sequence of his books, and he concomitantly suggests that Roussel has no real place in the French literary tradition" (Ford 2000, 227).

Foucault's *Death and the Labyrinth: The World of Raymond Roussel* describes Roussel's *How I Wrote Certain of My Books*, which was published posthumously in 1935 and purports to reveal the secrets of the "poetic method" that underpinned most of his work. The method is based on small, *clinamen*-like, orthographical variations between similar-sounding phrases, and various puns and wordplays, which form the hidden mechanism over which Roussel constructs his dazzling *œuvre*.

Roussel's "revelatory" text is so reserved in its description of the action of the process in the work, and in turn the text is so verbose in types of deciphering, rites of threshold and lock, that it is difficult to relate How I Wrote Certain of My Books to [his] books [. . .]. Its positive function of giving an explanation as well as a formula—"It seems to me that it's my duty to reveal it, for I have the impression that writers of the future will perhaps be able to exploit it fruitfully"—quickly becomes a never-ending play of indecision, similar to that uncertain gesture on his last night, when Roussel, at the threshold, wanted perhaps to open the door, perhaps to lock it. In a way, Roussel's attitude is the reverse of Kafka's, but as difficult to interpret. Kafka had entrusted his manuscripts to Max Brod to be destroyed after his death—to Max Brod, who had said he would never destroy them. Around his death Roussel organized a simple explanatory essay which is made suspect by the text, his other books, and even the circumstances of his death.

Only one thing is certain: this "posthumous and secret" book is the final and indispensable element of Roussel's language. By giving a "solution" he turns each word into a possible trap, which is the same as a real trap, since the mere possibility of a false bottom opens, for those who listen, a space of infinite uncertainty. This does not put in question the existence of the key process nor Roussel's meticulous listing of facts, but in retrospect it does give his revelation a disquieting quality. (Foucault 1987, 11)

The "infinite uncertainty" to which Foucault alludes, while attractive to the *nouveaux romanciers* because of its apparent ultimate banality, concealing everything only to reveal nothing (Ford 2000, 224), presented Foucault with a greatly pleasurable but ultimately self-marginalizing and rather non-pataphysical conclusion.

Roussel described the method as follows:

I chose two almost identical words (reminiscent of metagrams). For example, *billard* [billiard table] and *pillard* [plunderer]. To these I added similar words capable of two different meanings, thus obtaining two almost identical phrases.

In the case of *billard* and *pillard* the two phrases I obtained were:

1. Les lettres du blanc sur les bandes du vieux billard . . . [The white letters on the cushions of the old billiard table]
2. Les lettres du blanc sur les bandes du vieux pillard . . . [The white man's letters on the hordes of the old plunderer]

In the first, "*lettres*" was taken in the sense of lettering, "*blanc*" in the sense of a cube of chalk, and "*bandes*" as in cushions.

In the second, "*lettres*" was taken in the sense of missives, "*blanc*" as in white man, and "*bandes*" as in hordes.

The two phrases found, it was a case of writing a story which could begin with the first and end with the second. [. . .]

As for the origin of *Impressions d'Afrique*, it consisted of reconciling the words *billard* and *pillard*. The "*pillard*" was Talou; the "*bandes*" his warlike hordes; the "*blanc*" Carmichael (the word *lettres* was dropped).

Expanding this method, I began to search for new words relating to *billard*, always giving them a meaning other than that which first came to mind, and each time this provided me with a further creation.

Thus *queue* [billiard cue] supplied me with Talou's gown and train. A billiard cue sometimes carries the "*chiffre*" (monogram) of its owner; hence the "*chiffre*" (numeral) stitched on the aforementioned train.

I searched for a word to accompany *bandes* and thought of the *reprises* (darns) in old *bandes* [billiard cushions]. And the word *reprises*, in its musical sense, gave me the Jeroukka, that epic sung by Talou's *bandes* (warlike hordes) whose music consisted of the continual *reprises* [repetitions] of a brief melody.

Searching for a word to go with *blanc* I thought of the *colle* [glue] which sticks the paper to the base of the cube of chalk. And the word *colle*, used in school slang to denote detention or imposition, gave me the three hours' confinement imposed on the *blanc* (Carmichael) by Talou.

Abandoning at that point the scope of *billard*, I continued along the same lines. I chose a word and then linked it to another by the preposition *à* [with]; and these two words, each capable of more than one meaning, supplied me with a further creation. (Incidentally, I used this preposition *à* in the above-mentioned groups of words: *queue à chiffre, bandes à reprises, blanc à colle*.) I should point out that the initial stages of this work were difficult and already required a great deal of time.

I would like to cite some examples:

Taking the word *palmier* I decided to consider it in two senses: as a pastry and as a tree. Considering it as a pastry, I searched for another word, itself having two meanings which could be linked to it by the preposition *à*; thus I obtained (and it was, I repeat, a long and arduous task) *palmier* (a kind of pastry) *à restauration* (catering); the other part gave me *palmier* (palmtree) *à restauration* (restoration of a dynasty). Which yielded the palm tree in Trophies Square commemorating the restoration of the Talou dynasty.

Here are some further examples:

1st. *Roue* (wheel) *à caoutchouc* (rubber); 2nd. *roue* (swagger) *à caoutchouc* (rubber tree). Which supplied the rubber tree in Trophies Square where Talou swaggeringly planted his foot on his enemy's corpse.

1st. *Maison* (house) *à espagnolettes* (window fasteners); 2nd. *maison* (royal dynasty) *à espagnolettes* (little Spaniards). Which gave the two young Spanish twins from whom Talou and Yaour were descended.

1st. *Baleine* (whale) *à ilot* (small island); 2nd. *baleine* (baleen) *à ilote* (helot); [. . .] (Roussel 1977 [1935], 3–5)

The text continues with a long, but by no means complete, list of such constructions and examples of the application of the poetic method in other works, such as *Locus Solus.*

Roussel was the heir to a personal fortune and related by marriage to Charles Ney, Duke of Elchingen and later Prince of Moscow. His literary ambitions were driven by a total belief in his own genius and assisted by his ability to fund publication of his works. He studied piano at the Paris Conservatoire, and was by all accounts a fine musician. He was also an expert chess player, and in later years published a solution to the problem of the checkmate with bishop and knight alone. The chess champion Tartakower wrote: "The chess world should celebrate the fine acquisition of the great surrealist writer Raymond Roussel who, with his discovery of a simple formula for achieving the extremely complicated checkmate with bishop and knight, reveals himself also a great thinker in chess."

His method of delivering this difficult checkmate was published in *Les Cahiers de l'Échiquier français,* January/February 1933, a journal edited by François Le Lionnais. Roussel was subsequently observed at the chessboard in the Café de la Régence, but not approached, by Marcel Duchamp.

The failure of the world to recognize Roussel's genius brought about a psychological crisis and for a time he consulted the psychiatrist Pierre Janet, whose accounts offer a fascinating insight into his mental state:

I shall reach immense heights and I am destined for blazing glory. It may take a long time, but I shall enjoy greater glory than Victor Hugo or Napoleon. Wagner died twenty-five years too soon and never knew his own glory, but I hope to live long enough to contemplate my own . . . [. . .] As the poet says: *et voilà qu'on se sent une brûlure au front . . . L'étoile que l'on porte au front resplendissante.* [And there are those who feel a burning on their forehead . . . The shining star which they carry on their brow.] Yes, I have felt that I too carry a star on my forehead, and I will never forget it. (Janet 1926)

Roussel traveled around the world in the 1920s, but seems to have shown little interest in the places he visited (India, Australia, New Zealand,

the Pacific islands, China, Japan, and America) except insofar as they were locations in the novels of Jules Verne and Pierre Loti. He spent most of his time shut in hotel bedrooms writing. Eventually he had made a *roulotte*, or mobile home, containing a bedroom, study, bathroom, and a dormitory for three domestics, in which he traveled and excited considerable interest from, among others, Mussolini and the Pope. However, as Michel Leiris observed: "It seems likely that the outside world never broke through into the universe he carried within him, and that, in all the countries he visited, he saw only that which he had put there in advance" (Ford 2000, 20).

Roussel died of a barbiturate overdose in a hotel in Palermo, Sicily, in 1933, his fortune exhausted and his dreams of glory largely unrealized. His death, in the hotel in which Wagner had composed *Parsifal* fifty years earlier, was examined in forensic detail by the Sicilian author of political thrillers and detective stories Leonardo Sciascia, who detected wordplay underlying Roussel's travels, the choice of hotel, even the direction in which the mattress on which he was discovered was facing (Sciascia 1987 [1971]).

Roussel was a reluctant participant in the avant-garde. Philippe Soupault, eager to reassure him that the surrealists held him in high regard, reported Roussel's reply: "He was, he told me politely, flattered, but that wasn't the audience he was after, for he did not believe in what was called then—and he used the term himself—the avant-garde" (Ford 2000, 166).

Roussel complained to Leiris: "People say I'm a Dadaist, but I don't even know what Dadaism is!" (Ford 2000, 23). In a letter in response to an inquiry from the surrealist Benjamin Péret, sent via his business manager Pierre Leiris (Michel's older brother), he wrote (ibid., 167–168):

10 November 1924

Monsieur,

M. Raymond Roussel telephoned me this morning from London. He thanks you for your kind letter, but finds himself unable to respond to your questions on the subject of Surrealism, for he does not class himself as belonging to any school.

Furthermore he is somewhat specialised in his reading, and he does not know Jarry's work sufficiently well to deliver a serious judgement of it. [. . .]

For "specialised" here we may read "conservative," since Roussel's reading generally avoided anything too experimental, and it seems unlikely he ever read Jarry. Nevertheless, the avant-garde were his main supporters during the riots that accompanied the stagings of his novels and plays in Paris. The theatrical adaptation of *Impressions d'Afrique* (Impressions of Africa) was staged in 1912, and that of *Locus Solus* in 1922, while the original plays *L'Étoile au front* (The Star on the Forehead) and *La Poussière de soleils* (The

Dust of Suns) were staged in 1924 and 1926 respectively. The staged novels attracted the disapproval of both students, who protested that a millionaire could afford such self-indulgence while they were so poor, and the general public, who simply failed to appreciate what was apparently absurd non-sense. Roussel's distress at this reception was very real, but the surrealists, for whom confrontation with the bourgeoisie was a matter of principle, turned up to make each performance a noisy contest between opposing factions in the audience. Roussel himself recalled the celebrated exchange between Robert Desnos and the opposition during the performance of *L'Étoile au front*:

Another tumult, another battle, but this time my supporters were far more numer-ous. During the third act the furore reached such a pitch that the curtain had to be lowered, and was only raised again after a considerable interval.

During the second act, one of my opponents cried out to those who were ap-plauding, "Hardi la claque" (Go for it, you hired band of clappers), to which Robert Desnos replied: "Nous sommes la claque et vous êtes la joue" (we are the hard band of clappers/the slap, and you are the cheek). (It's amusing to note that by inverting the l and the j one obtains "Nous sommes la claque et vous êtes jaloux" (We are the hired band of clappers/the slap, and you are jealous), a phrase which no doubt con-tained more than a grain of truth. (Ford 2000, 164)

La Poussière de soleils was to disappoint the surrealists. Breton observed, in *Fronton-Virage*:

We had no difficulty agreeing on the desperately dull character of the action that Roussel, in skimping less than ever on the scenery, seems nevertheless to have done his utmost to make interesting. In this respect, the play as such has undeniably fewer qualities than *Locus Solus* and *L'Étoile au front*, which, from a conventional theatrical standpoint, were already hardly defensible. (Ford 2000, 175)

Impressions d'Afrique is surely one of the most extraordinary books ever to have been written. The scenario is fundamentally simple: a group of travelers are shipwrecked on the shore of an imaginary Africa. Taken captive by the local chieftain, they are obliged to pass the time while awaiting the arrival of their ransoms by devising a series of entertainments. The book consists of a description of these entertainments, followed by an "explanation" of how each performance was created. However, we begin reading halfway through the book. Those people fortunate enough to have purchased one of the origi-nal editions would have found a small green insert which stated:

WARNING
Readers not initiated into the art of Raymond Roussel are advised to read this book from page 212 to page 455, and then from page 1 to page 211.

The advice was all the more ironic given that Roussel was almost completely unknown at the time. It was not even as though the "explanations" really explained the entertainments; in fact they did more to mystify and add strangeness to what was already a quite baffling sequence of bizarre machines, weird music, and eccentric individuals. The further explanations given in *How I Wrote . . .*, while making fairly clear the method by which these events were produced, do little to diminish the overall perplexity.

The title of the book, which evokes travel stories in the manner of Verne or Loti, is yet a further example of wordplay pressed into literary service. *Impression à fric* would mean something like a publication at the author's own expense. For this reason, the *Nouvelles Impressions d'Afrique* (New Impressions of Africa), published in 1932, which was a poem in four Cantos which barely mentioned Africa at all, nevertheless has an entirely logical title in Rousselian terms.

The following brief excerpt serves merely as an illustration of the pataphysical beauty of Roussel's imaginings. These combine several of the key themes of pataphysics: they are anomalous, founded on the syzygy of words, and resulting from the slight swerve of the original conception.

[. . .] After a brief interval, the Hungarian Skariofszky appeared, in his tight-fitting, red tzigane jacket, and wearing on his head a forage cap of the same colour.

His right sleeve, rolled back to the elbow, revealed a thick coral bracelet, wound six times round his arm.

He was closely supervising three black porters, who, laden with various objects, halted with him in the middle of the esplanade.

The first Negro carried in his arms a zither and a folding stand.

Skariofszky opened the stand, whose four legs rested securely on the ground. Then, on the narrow, hinged frame which opened horizontally, he set the zither, which twanged with the slight jolt.

To the left of the instrument, fixed to the frame of the stand, a metal arm rose vertically, after a slight bend, and was divided into a fork at the end; on the right, another arm, identical with the first, completed the pair.

The second Negro was carrying, without difficulty, a long transparent container, which Skariofszky placed like a bridge above the zither, fitting its two ends into the two metal forks.

This new object lent itself by its form to such a mode of installation. Shaped like a trough, it was made of four sheets of mica. The largest sheets, two rectangles of equal dimensions, comprised a sloping base, their two planes obliquely joined. In addition, two triangular sections, fitted to the narrow sides of the rectangles at opposite ends, completed the diaphanous contraption, which resembled the compartment of some huge purse, made of a stiff material and wide open. A gap the breadth of a pea ran the length of the underside of this transparent trough.

The third Negro had just set down on the earth a large earthenware pot, filled to the brim with clear water, whose weight Skariofszky requested one of us to feel.

La Billaudière-Maisonnial, pouring a tiny drop into the hollow of his hand, suddenly showed the liveliest surprise, exclaiming that the strange liquid appeared to be as heavy as mercury.

In the meantime, Skariofszky raised his right arm to his face, murmuring a few words of encouragement, in a voice full of gentle persuasiveness.

Then we saw the coral bracelet, which was actually a huge worm, as thick as an index finger, unwind its first two coils and slowly stretch itself out to the Hungarian.

La Billaudière-Maisonnial, standing up again, was obliged to lend himself to a new experiment. At the gipsy's request, he took the worm, which slithered over his open hand; his wrist suddenly gave way under the unexpected weight of the intruder, which was apparently as heavy as solid lead.

Skariofszky removed the worm, which still clung to his arm, and placed it on the edge of the mica trough.

The reptile crawled inside the empty receptacle, drawing the rest of its body after it as it glided slowly over the bare skin of the Hungarian's arm.

Soon the reptile completely blocked the gap in the ridge at the bottom, stretching horizontally along it and suspended between two narrow inner edges of the rectangular sides.

The Hungarian raised the heavy earthenware pot, not without some difficulty, and poured its contents into the trough, which was soon filled to overflowing.

Then, resting his knee on the ground, and leaning his head to one side, he placed the empty vessel underneath the zither, on a carefully chosen spot, after running his eye up and down the back of the instrument.

Having accomplished this last move, Skariofszky, getting slowly to his feet, put his hands in his pocket as if to show that thereafter his role was that of spectator.

The worm, left to its own devices, suddenly raised a section of its body, only to let it fall back immediately after.

A drop of water, having had time to slip through the gap, landed heavily on one of the strings, which, vibrating with the shock, produced a low C, loud and clear.

Further along, another convulsion of the obturant body let out a second drop, which this time struck a resounding E. A G, followed by a high C, attacked in the same way, completed the common chord, which the worm then repeated in another octave.

After the third and last C, the seven consonant notes, played all together, provided a conclusion to this trial prelude.

After tuning up in this fashion, the worm began a slow Hungarian melody, full of tender and languid sweetness.

Each drop of water, released by a deliberate contortion of its body, correctly struck the chosen string, which cut it clean in two.

A band of felt, glued in the right place on the wood of the zither, deadened the fall of the heavy liquid, which would otherwise have produced a distracting patter.

The water, gathering in round puddles, penetrated the interior of the instrument through two circular openings cut in the soundboard. Each of the two cascades had

been anticipated and fell silently on to a narrow layer of felt inside, which was specially designed to catch them.

A thin clear stream, flowing from a single outlet, soon formed beneath the zither and fell straight into the spout of the earthenware jar which Skariofszky had carefully positioned. The water, following the slope of this narrow channel, also lined with felt, ran without a sound to the bottom of the huge basin, which prevented the ground from being soaked.

The worm was still performing its musical contortions, sometimes striking two notes together, in the manner of professional zither players, who use separate sticks with their two hands.

Several tunes, both plaintive and gay, followed the first cantilena without interruption.

Then, going beyond the bounds of the usual repertory allotted to the instrument, the reptile threw itself into the polyphonic execution of a particularly lively waltz.

The accompaniment and the tune vibrated together on the zither, which is generally confined to the slender output of two simultaneous sounds.

To provide some contrast in the principal part, the worm raised itself higher, thus releasing a larger quantity of water on to the string, which shook violently.

A slightly halting rhythm unobtrusively imparted to the music the unusual timbre peculiar to Hungarian gipsy bands.

After the waltz, dances of every kind gradually emptied the transparent trough.

Underneath, the earthenware pot had been filled by the continuous stream, which was now exhausted. Skariofszky took it and emptied all its contents into the light receptacle a second time, before returning it to its place on the ground.

With his supply completely replenished, the worm broke into a *czardas*, punctuated by savage and brutal variations. Sometimes great heaves of the long, reddish-coloured body produced noisy *fortissimi*; at others, imperceptible undulations allowed only tiny droplets to escape, so that the zither, suddenly hushed, was reduced to a mere murmur.

No mechanical element entered into this personal execution, full of fire and conviction. The worm gave the impression of a virtuoso performing daily, who, according to the inspiration of the moment, played differently each time a certain ambiguous passage, whose delicate interpretation was the subject of much discussion. (Roussel 1966 [1910], 54–58)

Locus Solus is no less extraordinary a text. John Ashbery offers the best summary of the plot in his postcript to Foucault's study of Roussel:

A prominent scientist and inventor, Martial Canterel, has invited a group of colleagues to visit the park of his country estate, Locus Solus. As the group tours the estate, Canterel shows them inventions of ever-increasing complexity and strangeness. Again, exposition is invariably followed by explanation, the cold hysteria of the former giving way to the innumerable ramifications of the latter. After an aerial pile driver which is constructing a mosaic of teeth and a huge glass diamond filled

with water in which float a dancing girl, a hairless cat, and the preserved head of Danton, we come to the central and longest passage: a description of eight curious tableaux vivants taking place inside an enormous glass cage. We learn that the actors are actually dead people whom Canterel has revived with "resurrectine," a fluid of his invention which if injected into a fresh corpse causes it continually to act out the most important incident of its life. (Ashbery 1986, 198–199)

Roussel's crowning masterpiece was the poem *New Impressions of Africa*. Readers interested in this work are directed to the present author's own (unrhymed) hypertext translation (Hugill 1994), and to the rhymed translations by Kenneth Koch (Canto III only) (Roussel 1964 [1932]) and Ian Monk (Roussel 2004 [1932]). The poem comprises four enormous single-sentence Cantos, each consisting of a complex series of parentheses within parentheses, up to five deep, written in rhyming Alexandrines and with occasional footnotes, each of which in turn opens and closes many parentheses. The work has a deeply musical structure, with an underlying form that is imperceptible at the experiential level but continues to resonate after the book is closed. The difficulty of reading the text was addressed by Juan-Esteban Fassio of the Collège de 'Pataphysique in his *Machine for Reading Roussel* (Fassio 1964, 63–66), which envisages a card index system that has been somewhat supplanted by the possibilities of hypertext available today, but which nonetheless has a certain beauty all of its own.

The *New Impressions* are illustrated by a series of 59 drawings commissioned from an artist named Henri-Achille Zo, whom Roussel hired through the Goron Detective Agency (having seen his illustrations for Pierre Loti's novel *Ramuntcho*), but whom he never met. Zo was provided with short descriptions for each drawing, which he then was required to represent from the imagination only, without reading the poem. The drawings were inserted *under* the uncut pages of the eventual publication, and were therefore visible only if the reader was prepared to make the necessary cutting. The dissociation between illustrator and subject, and indeed between poet and artist, which Zo found intensely uncomfortable, resulted in images that are powerful in their banality and mysteriousness. It is an illustration of the depth of Roussel's pataphysical understanding that he deployed a method so unique yet so simple, to an end that was so original yet lacking any trace of aesthetic novelty.

JEAN-PIERRE BRISSET (1837-1919)

Brisset was an excellent example of the pataphysician *sans apostrophe*. His was an imaginary solution to the very origins of human existence itself. The

earnestness with which he pursued his ideas placed him far from the knowing anarchism of Jarry, of whom he would scarcely have approved. Yet he was drawn unwittingly into the Parisian literary milieu, driven by a fervent desire to communicate what he believed to be the great revelation of a profound truth. That the truth he revealed turned out to be more pataphysical than conventionally scientific does not diminish its importance. Unlikely as it may seem, given the extent of their "wrongness," his writings continue to attract considerable interest and to exert influence today.

The essence of Brisset's theory is that evolution is simultaneously linguistic and physical. Such a theory rests on the assumption that language, however primitive, is pervasive, across species and throughout history. In fact, Brisset, a man of deep religious convictions, proposed an entire *universe* of signification. If the Word was in the Beginning, then nothing that was created could lack meaning. He had ample time to elaborate these ideas during a career as a minor official at the Angers Saint-Serge railway station.

Brisset first really heard frogs in the marshes of La Sauvagère, in the Loire valley, at around the age of twelve. To him, these small cries were the fossils of an evolved language, the phonemic elements that form the constituents of human communication. Our ancestors therefore live among us and speak in a primitive tongue. Brisset saw physical evidence of this presence in the form of spermatozoa, who resemble "a puddle of water filled with young tadpoles." Languages evolve like frogs, building from combinations of simple homophonic utterances to more complex forms and meanings.

To support his thesis that Man is descended from the Frog, Brisset revealed the herpetological underpinnings of language through a bewildering labyrinth of puns. Here lies that "discovery of the contradictory" from which, according to Jarry, laughter is born.[4] The contradictory is encoded in the pun, which is the syzygy of words, the "momentary conjunction or opposition of meanings." Brisset's texts intercalate the puns with an explanation of their origins in frog calls, and hence their hidden chains of meaning.

These include many evolutions from archaic forms of words and historical references from classical mythology through to Christianity. Thus Jupiter evolves into God (*youpiter père, youpippi! you! you! you! didi, dii, dada, d'ai i, Dieu*); Jesus Christ offers succor and suffers for us (*Y ai suce, Jésus, je suis cri, cri sto*); and much is made of the fact that frogs urinate through their anus (*ure anus*), for Uranus was the mythical father of the gods. Adam is word incarnate (*homme, uomo, homo, au mot*) whereas Eve is hunger and infamy (*faim, femme, famé*) whom he tries to reject (*Eh! Va! Eva!*).

Brisset devoted many pages to a discussion of the emergence of sexual organs, and imagined an ancestor, looking down at himself, struggling to form the question that naturally occurs: "What's that?"

The ancestor had no apparent sexual organ; it was as it emerged that words also started to develop toward a quasi-perfection. It caused all kinds of strange sensations and surprises. *Est quoi ici? Ce qu'ai? Ai que ce?* (What's this here? What do I have? Is this all I've got?) created the word *exe*, the first word for sex.

Further questions arose: this point, do you know what it is? *Ce exe, sais que ce?* That became: *sexe.*

Sais que c'est? Sexe est, ce excès, c'est le sexe. (Know what it is? Sex it is, this protuberance, it's sex.) It's excess, it's sex. Sex was the first excess; it caused and causes all subsequent excesses.

The first thing the ancestor noticed that he could not comprehend (*je ne sais que c'est*) was a young sex, in formation: *Jeune sexe est.* (Rosière and Décimo 2001, 20–21)

Although Brisset concentrated mainly on the evolution of French, he also asserted that all languages would be found to contain similar utterances. In this, at least, he was correct, for the structure of human vocal organs means that there is a finite number of linguistic sounds that can be created. He did make some attempts to incorporate other European languages into his theory. One striking example arises from his observation that *night* is the negative of *eight*, which Brisset interprets in *Les Origines humaines* as indicative of the time of day (*aujourd'hui*).

French. . . . huit *ne huit* = nuit
Italian. . . . otto *ne otto* = notte
Spanish. . . . ocho *ne ocho* = noche
German. . . . acht *ne acht* = nacht
English. . . . eight *ne eight* = night
Swedish. . . . aetta *ne aetta* = natta

Brisset is often held up as a model of the "outsider," a naïf in the manner of Henri Rousseau or Le Facteur Cheval. It is certainly true that he has been repeatedly adopted by groups who relish the unintentional humor of his works, his insistence that Man is descended from the Frog, his obsession with puns, his repeated attempts to seek approval from the Académie Française.

The first such group was led by Jules Romains, the founder of unanimism (a philosophy which rejected individualism in favor of collective action), who famously staged a mock awards ceremony in 1913, bringing Brisset from his home in rural Angers to Paris, to be crowned "Prince of Thinkers." The surrealists were similarly fascinated. André Breton wrote, in

the *Anthology of Black Humour*: "Brisset's work draws its importance from its unique situation, commanding the line that links the *pataphysics* of Alfred Jarry [. . .] to the *paranoia-critical* activity of Salvador Dalí" (Breton 1997 [1940], 226).

The Collège de 'Pataphysique canonized Brisset and gave him a saint's day on 25 Haha (30 October) of the pataphysical calendar. Marcel Duchamp declared: "My ideal library would have contained all Roussel's writings— Brisset, perhaps Lautréamont and Mallarmé" (Duchamp 2009 [1946], 117).

Michel Foucault became interested and wrote a preface to an edition of *La Grammaire logique* entitled "7 Propos sur le Septième Ange," which perches Brisset "at an extreme point of linguistic delirium." Brisset also features in the seminal collection *Les fous littéraires* (1982)[5] by André Bla-vier, which forms a key text for the Institut International de Recherches et d'Explorations sur les Fous Littéraires (International Institute for Research and Exploration into Literary Madmen), founded in 2008.

There are few mainstream writers who would admit to having been directly influenced by Brisset, yet Joyce's *Finnegans Wake* seems a close rela-tion in its glorification of the sounds of words and sense of a universal meaning ringing out from nature. Here, language emerges from the body, from the water, from the rocks, in Brissetian fashion, and proceeds to evolve by combining utterances from many tongues into single words. At the Gen-esis of the Wake the frogs call, with Aristophanean voices: "Brékkek Kékkek Kékkek Kékkek! Kóax Kóax Kóax! Ualu Ualu Ualu! Quaouauh!"

That final call departs from Aristophanes and moves toward French. An extended "quoi?" (what?) was the first question imagined by Brisset as our ancestors crawled from the primordial soup and emerged onto the land, to be followed by "pourquoi?" (why?).

The same cry appears in Samuel Beckett's *Watt*, this time translated as the title, and, once again, the frogs call, in a celebrated passage, "[. . .] Krak!, Krek! and Krik!, at one, nine, seventeen, twenty-five, etc., and at one, six, eleven, sixteen, etc., and at one, four, seven, ten, etc., respectively [. . .]" (Beckett 1976 [1953], 135–137). Here, however, Watt fails to hear any meaning in the calls beyond the systemic permutations of their occur-rences. As always in Beckett's work, any significance is in terminal decline toward meaninglessness.

Brisset has inspired many artistic, musical, and theatrical works over the years, including: paintings by Lou Laurin Lam; theater pieces by Eugène Durif and Catherine Beau, and the Bernard Froutin company; *Dieu, grammairien* by Manuela Morgane (Morgane 1992); and three musical compositions by

Andrew Hugill: *Catalogue de Grenouilles* (1987) for massed frog calls, piano, and optional ensemble; *Brisset Rhymes* (1990) for soprano and early instruments; and *Les Origines humaines* (1995) for 36 unaccompanied voices.

Project Phonethica (Tokui et al. 2007), launched in 2004 by Takumi Endo, sets out to "explore the diversity of the world through the phonetics of its approximately 6,000 living languages." The project comprises an online tool which uses phonetic resemblances derived from the International Phonetic Alphabet's classification system to make connections between similar phonemes. Thus we can find that the French "ça va?" (how are you?) is very close to the sound of the Japanese word for mackerel (saba). The software enables creative exploration of such coincidences. It is amusing to speculate to what extent Brisset would have been able to use this tool were he alive today.

Brisset's writings present a unique challenge to the non-French-speaking reader. Because his ideas depend entirely on the *sounds* of words, the chains of puns make little sense unless some attempt is made to read the French. Since the puns are interspersed with explanations, this can be very difficult to achieve. Often it can be most revealing to ignore temporarily these explanations in order to get a sense of the evolutionary flow. As he explained in *Les Origines humaines*:

The fiery sword which guards the path to the tree of life is called the pun, the play on words. The idea that something more could be hidden behind the pun has never been properly understood, it has been forbidden knowledge. People always react with idiotic laughter, but despite their general ignorance and closed-mindedness, this truth remains. (Brisset 1980b [1913], 25)

Probably the most celebrated example of Brisset's writing was a short text from *La Science de Dieu*, reprinted in Breton's *Anthology of Black Humour*, entitled "The Great Law or The Key to Language." It is given here with its literal translation, and a translation by Martin Sorrell (Brisset 1985, 60–61) that reflects the spirit of the original:

There exist in language numerous laws, hitherto unknown, of which the most important is that a sound or a series of identical, comprehensible and clear sounds may express different things by a modification in the way of writing or of understanding those names or those sounds. All ideas uttered with similar sounds have a unique, shared origin, and all, in their very roots, bear on the same thing or object. Let us take as an example the following sounds:

Les dents, la bouche. | The teeth, the mouth. | The teeth in the mouth.
Les dents la bouchent. | The teeth block it (the mouth's entrance). | The teeth, inner mouth.
L'aidant la bouche. | With the help of the mouth. | The teeth in her mouth.

L'aide en la bouche. | The help in the mouth. | The teeth-thin 'em out.
Laides en la bouche. | Ugly in the mouth. | Thirty thin a mouth.
Laid dans la bouche. | Ugliness in the mouth. | The teething, the mouth.
Lait dans la bouche. | Milk (the teeth's whiteness) in the mouth. | The teat in a mouth.
L'est dam le à bouche. |There is damage in the mouth (decay and aching). | The tea—thin a mouth.
Les dents-là bouche. | Shut your teeth. | The tea, thinner mouth.

9 ALFRED JARRY (1873-1907)

A BRIEF LIFE

There have been many accounts of the life of Jarry, beginning with those of his contemporaries, among them Guillaume Apollinaire and Rachilde, whose *Alfred Jarry, ou le Surmâle de lettres* was published in 1928. Biographical studies in French include: *Alfred Jarry. Son œuvre* (1934) by Fernand Lot; Noël Arnaud's *Alfred Jarry: d'Ubu Roi au Docteur Faustroll* (1974); Henri Bordillon's *Gestes et opinions d'Alfred Jarry, écrivain* (1986); *Ubu sur la berge: Alfred Jarry à Corbeil (1898–1907)* by Philippe Régibier, published in 1999; and Patrick Besnier's *Alfred Jarry* (2005). The major critical biographies in English have been Roger Shattuck's *The Banquet Years: The Origins of the Avant-Garde in France, 1885 to World War I*, first published in 1958; Linda Klieger Stillman's *Alfred Jarry* (1983); Keith Beaumont's *Alfred Jarry: A Critical and Biographical Study* (1984); Jill Fell's 2010 book *Alfred Jarry*; and, most recently, Alastair Brotchie's *Alfred Jarry: A Pataphysical Life* (2011). Alongside these must be placed a vast collection of critical and biographical scholarship led by the work of the Collège de 'Pataphysique and the Société des Amis d'Alfred Jarry.

Given such a superfluity and richness of material, it might be assumed that the details of Jarry's life have been pretty well established, and there would be little difficulty in briefly recounting his 34 years of existence.

Unfortunately this is not exactly the case, partly because of some gaps in the primary information, but mainly because this was a life that was to some extent a matter of interpretation, not least by Jarry himself. The myth-making that surrounded him, mainly because of the persona of Ubu, was something in which he played an active role. Alastair Brotchie remarks:

Without Ubu, Jarry's works would look very different—impossible even—and Ubu likewise became an essential part of his daily existence. Jarry's life and character unfold as a series of paradoxes or, less dramatically, as simple contrariness. Perfectly correlated, his works reflected these contradictions in the broad outlines of an *œuvre* that would encompass both the buffoonery of Ubu, and the subtleties of Jarry's "science" of Pataphysics. (Brotchie 2011, viii)

Before embarking on a recitation of the various facts and anecdotes that have made Jarry's life so famous, it is worth recollecting that the great majority of his time was spent reading, writing, and making art. This was a man who devoted his entire short existence to the creation of original work and the forging of a literary career, regardless of the personal consequences in terms of health and wealth. It is important to remember this fact, because the many colorful stories about Jarry tend to give the impression that he was some kind of experiment in living-as-art. It is certainly true that making life "beautiful like literature" was one of his goals. "Life and exploits [. . .] are more beautiful than Thought [. . .]. Let us then Live, and we shall be the Masters," he declared in the essay "To Be and to Live" (Jarry 2001a [1894], 201). Yet, and yet again, the body of work taken as a whole is too substantial and too literary to permit only the interpretation that it was some kind of blueprint for a lived-out performance. The various incidents that have become legendary were exactly that: incidents. For the most part, they occurred only once. Nor was Jarry simply Ubu. He lived out the characteristics of *all* his principal characters. From Sengle to Emmanuel Dieu, from André Marcueil to Dr. Faustroll: all were facets of himself.

Let us begin with a few salient facts. Jarry was an unusually short man, standing at 1.61 meters (5′ 3″), who compensated for his reduced stature by a somewhat belligerent posture, frequently falling out with friends, often playing practical jokes, and mocking others without any compunction. He nevertheless had considerable charm and exerted a powerful fascination on those around him, as the contemporary accounts bear witness. He was physically very fit, enjoying riding his Clément luxe 96 racing bicycle, rowing and fishing in his mahogany skiff, fencing, and, as has been noted earlier, shooting his revolver. His clothing was a matter of frequent comment because of its eccentricity. He often wore full cycling regalia with porkpie hat and hooded cape. Apollinaire recalled:

Alfred Jarry . . . appeared to me the personification of a river, a rippling river without a beard, clad in the damp garments of a man recently drowned. His small, downward-curving mustache, his frock-coat with symmetrically flapping tails, his floppy shirt, and his cycling pumps – the whole ensemble had something limp or shapeless about it, something sponge-like; the demi-god was still damp since it seemed that only a few hours previously he had leapt out of the current of his river-bed, soaking wet. (Apollinaire 2011 [1909], 293)

He was openly homosexual, meeting up with Oscar Wilde on his arrival in Paris and (according to some accounts) attending the theater with Lord Alfred Douglas, yet he nevertheless exhibited a certain sexual confusion in his relationships (most notably that with the poet Léon-Paul Fargue) which he subsequently dramatized in the play *Haldernablou*. He was apparently dismissive of women, yet maintained a long friendship with Rachilde and several others. He exhibited an aggressively priapic personality, peppering his conversation and life with phallic references, further spiced with scatology. His attitude to religion was complex but generally blasphemous. His writings frequently portray himself in a Christ-like or God-like role, and his deathbed request for a toothpick ("un cure-dent") may have had a double meaning since, as Thieri Foulc has pointed out, *cure-dent* "is military slang for a sabre and, in 1906, he said that he had fenced against death."[1] Whatever the truth, he had in fact asked for the last rites during an episode of severe illness the previous year.

He frequently adopted a mode of speech and behavior that resembled Ubu: referring to himself using the royal "we," moving like a marionette, and talking with a machine-gun delivery that equally emphasized each syllable of speech. This was something that was already part of his behavior before *Ubu Roi* was staged in Paris. Gens d'Armes described him thus:

I found Jarry's mental processes disturbing. When he let himself go he seemed in thrall to a torrent of words outside his control. It was no longer a person speaking, but a machine controlled by a demon. His staccato voice, metallic and nasal, his abrupt puppet-like gestures, his fixed expression and uncontrollable flood of language, his grotesque and brilliant turns of phrase, ended up provoking a feeling of disquiet. He was informed, intelligent, and discriminating; he was a good person, secretly kind, perhaps even shy beneath it all [. . .] but his originality resembled nothing short of a mental anomaly. (Brotchie 2011, 39)

Later on, when he had become known as Ubu, this kind of performance became something of a burden, not least because, as Brotchie points out, "Ubu was intended to personify everything Jarry found idiotic and repellent" (ibid., 179). Jarry's contemporary, the poet Stuart Merrill, described one occasion when Jarry was clearly performing:

One day he was lunching in good bourgeois company when, at the end of the meal, the lady of the house leaned over to him. "But Monsieur Jarry, you are just like everybody else, not at all the extraordinary and extremely ill-mannered person described to me, indeed it is obvious that you have been very well brought up." "*Merdre*," Jarry replied, knowing what was expected of him. "Bring back that roast, or by my *gidouille*, I'll have you all disembrained." When the leg of lamb reappeared, Jarry grasped it with both hands and proceeded to devour it as lustily as a savage in a freak show. His hostess was in heaven, but the unfortunate Père Ubu departed with indigestion. (Merrill 1925, 255–256)

Nevertheless, he kept up the Ubu persona to the end, writing letters from his deathbed using the royal "we" and referring to himself as Ubu. His apparent indifference to his own circumstances seemed to be reinforced by this means of distancing himself from himself, of achieving an "objective humor" (to use Breton's phrase) directed at himself.

He famously had a prodigious ability to consume alcohol. Rachilde recalled:

Jarry begins the day by imbibing two liters of white wine, three absinthes spaced between 10 a.m. and noon; then, at lunch, he washes down his fish or steak with red or white wine, alternating with more absinthes. In the afternoon, a few cups of coffee fortified with brandy or spirits of which I forget the names; then at dinner, after, of course, other apéritifs, he could still tolerate at least two bottles of any vintage, of good or bad quality. (Rachilde 1928, 136)

In later life, he was reduced to drinking pure ether, often without food, as he constantly sought to maintain what Rachilde called "that permanent state of drunkenness in which he seemed to quiver instead of living normally."

A chronology of his life may be made from the series of increasingly eccentric dwellings in which he chose to live. Having been born and raised in the town of Laval, he moved in 1891 to Paris, where he lived with his mother, first in an apartment in the rue Cujas, then at no. 84 boulevard de Port-Royal. However, Madame Jarry also rented two rooms for Alfred nearby at no. 78, where he had the freedom to receive visitors and to create. He named this apartment the "Calvaire du Trucidé" (Calvary of the Massacred), and decorated it in a style that would probably today be called "gothic": everywhere dark, draped with black cloth; a skeleton and bones hung about the place; a candle inside a skull; and bloodstained handprints leading up the hallway to the front door. Here he kept owls, fascinated by their nocturnal habits which resembled his own, their oddly shaped beaks, and the "symbols of Being: two Nyctalopic Eyes, cymbals (as if announced) of circular chrome, perfectly matched—since it is identical to itself" (Jarry

2001a [1894], 201). With such eyes, one could see two opposites simultaneously, even at night.

After the death of his mother in 1893, he was obliged to return to Laval for military service between 1894 and 1895. His career as a soldier was truncated partly due to his utter unsuitability to the military life (documented in *Days and Nights*) and partly to a self-administered dose of picric acid, which put him in hospital (his discharge notice cited "gallstones") (Brotchie 2011, 113). On his return to Paris, the première of *Ubu Roi*, and the resulting scandal and fame, soaked up both his time and his inheritance. He was evicted from the boulevard de Port-Royal and, after staying for a short while with the *douanier* Henri Rousseau, in 1897 moved into new lodgings at 7 rue Cassette, just off the boulevard Saint-Germain. This was the famous second-and-a-half-floor apartment, whose ceilings were so low (the result of an unscrupulous landlord's attempt to double his rental income from high-ceilinged rooms) that only Jarry could stand upright, nevertheless brushing the ceiling plaster with the top of his head. Continuing the sacrilegious naming theme, he called this "Notre Grande Chasublerie" (Our Grand Chasublery), a reference to the manufacturer of ecclesiastical robes downstairs. Here, in some squalor, Jarry maintained a rather reclusive existence, avoiding conversation with his *concierge* by having mail delivered via a system of baskets lowered from the window, and receiving few visitors. It was also here that he wrote the bulk of *Faustroll*.

From 1898 onward he co-rented, with the Vallettes, a summer retreat at Corbeil, named the "Phalanstery" (the word comes from a design for a utopian community building by Charles Fourier), from where he would race the train by bicycle all the way to Paris, some 20 miles' distance, and, according to Rachilde, shoot nightingales which kept him awake at night. In 1900, he began renting a shack further along the banks of the Seine, near the Barrage at Le Coudray, which increasingly provided a safe haven from the attentions of creditors and other pressures of life. The shack had a dirt floor, no power, and no toilet, but Jarry was happy there, able to catch fish to eat, and to write. For four years or so he produced vast amounts of journalism, *La Chandelle verte* (The Green Candle), and *Le Surmâle* (The Supermale), cycling to and from Paris as required. In 1903–1904, he spent a winter with his friend and sometime patron, the composer Claude Terrasse, at the Bonnard family property in Le Grand-Lemps in the Isère, near Grenoble, where, according to Franc-Nohain, he became an *habitué* of the Café Brosse, whose regulars began to adopt his Ubuesque speech, including the greeting: "Monsieuye et vénéré ami et bougre d'âne!" (Mistah esteemed friend and daft old bugger!) (Franc-Nohain 1911).

In 1904–1905 he was able to purchase two small plots of land at Le Coudray on which he constructed his final famous residence, the "Tripod," so called because it stood on four (or perhaps six, according to the carpenter's invoice) stilts. This was a square wooden hut with sides measuring 3.69 meters (approximately 12 feet), which frequently flooded and offered little in the way of comfort. His bicycle had to be suspended from the ceiling to prevent the rats from eating the tires. However, illness prevented Jarry from spending much time there, and he was soon confined to bed, in a rapidly declining state, first in his sister's house in Laval (in 1906–1907) and then in the Grand Chasublery. He died in hospital on 1 November 1907, of "meningeal tuberculosis."

Many other incidents from his life have acquired the status of myths, and seem to confirm the idea that this was a man attempting to transcend his own existence. At the same time, they are mostly practical jokes. The simultaneous existence of opposites that characterizes pataphysics itself is also present in the fluctuating status of these stories. They also give rise to the notion of pataphysics as a way of life, rather than just a set of literary pursuits. So: turning up for a night at the opera wearing a paper shirt with a black tie painted on it; eating a meal in reverse, beginning with the brandy and ending with the soup; wearing yellow high heels with filthy cycling shorts to Mallarmé's funeral; challenging his friends to eat nothing but gherkins soaked in absinthe until the first one changed color and was sick; cutting his own face out of a portrait painted by Henri Rousseau because he could not stand looking at himself on his mantelpiece; engaging in target practice against a neighbor's house until the woman pleaded with him to stop in case he killed one of her children, then replying: "Should that happen, Ma-da-me, I would be happy to make some more with you"; and many more such anecdotes that have been embellished over the years, such as the story that Jarry would let off a gun under someone's nose when asked for a light (*du feu* = a light, but also *un feu* is slang for a gun) which seems to have come from an exaggeration of an anecdote by André Salmon: "Should a passerby ask directions, Père Ubu indicated the way, his upraised arm augmented by his pistol. And if someone asked for *du feu*, then Jarry's joy was boundless!" (Brotchie 2011, 185).

There was the incident recounted by Apollinaire that took place in Jarry's apartment:

On the mantel stood a large stone phallus, a gift from Félicien Rops. Jarry kept this member, which was considerably larger than life size, always covered with a violet skullcap of velvet, ever since the day the exotic monolith had frightened a certain literary lady who was all out of breath from climbing three and a half floors and at

a loss how to act in this unfurnished cell. "Is that a cast?" the lady asked. "No," said Jarry. "It's a reduction." (Apollinaire 1925)

Noël Arnaud recalled one occasion when, according to Jean Nohain,

Alfred Jarry decided to paint himself entirely green—face, hands, neck, wrists, in order to witness the amazement of the customers when he entered the café. My father heard of the joke. In haste he informed all his friends, customers and waiters. When Jarry strolled in, green, green like a green exotic parrot—no one batted an eyelid. They went on talking, drinking and reading. After a while, Jarry, quite taken aback, asked my father, "Don't you notice anything?" "No, nothing at all. Should I?" It took Jarry hours to get rid of the green. It stuck behind his ears for days. (Arnaud 1974, 430–431)

Despite all the fun and games, Jarry's relationships were often turbulent. He fell out with Remy de Gourmont (we shall see why shortly), who had been responsible for introducing him to the symbolist circle, to such an extent that the latter omitted him from the *Book of Masks*, an important compendium of the best writers of the period. His close relationship with Léon-Paul Fargue ended acrimoniously, and there are numerous other examples of his difficult character. He seemed to have a certain indifference to people's feelings, although this applied just as much to himself as to others. At the same time, he could display great sensitivity, albeit on a poetic level. Herein lies the crucial point: for Jarry the lack of distinction between life and literature meant that the quality of experience would be judged in a similar way to the qualities of poetry. Since Jarry's work contains a rich vein of humor, be it ironic, satirical, or mocking, it is not surprising to find these qualities in his life and personality. At the same time, his writing also contains great depths of erudition and imagination, all of which also permeated his being.

INFLUENCES

Of Jarry's contemporaries, probably the most directly influential on his immediate circumstances was Rachilde, the *nom de plume* of Marguerite Vallette-Eymery, a writer who achieved a certain notoriety through a number of gender-challenging works, including *Monsieur Vénus* (1884) and *La Marquise de Sade* (1887). She was a great patron and supporter of Jarry, and could reasonably be claimed to have been the first woman involved in pataphysics. She certainly did much to foster and support Jarry's imagination and Ubu persona, right up until his death. Rachilde and her husband, Alfred Vallette, hosted literary *soirées* or *mardis* (Tuesdays) at the offices of the *Mercure de France*, the review edited by them both. Here, Jarry encountered

most of the important symbolist writers who influenced his work, includ-
ing Paul Valéry, Paul Fort, and André Gide, who recalled:

You could not invent such a character [. . .] he exercised a sort of extraordinary
fascination over the Mercure at that time. Everyone, or almost everyone, attempted,
some more successfully than others, to imitate and adopt his humor; and above all,
his outlandish and relentless manner of speech, without nuance or inflection and
with an equal emphasis upon every syllable, including the silent ones. A nutcracker,
if it could speak, would sound no different. (Brotchie 2011, 74)

According to her own account of Jarry, Rachilde achieved a grudging
respect from him that only one other woman, his mother, had managed:
"Ma-dam! You have a distinctly bad character! You are an insignificant
bundle of atoms clinging together. But we grant you one quality: *you do
not cling to us!*"

She also recounted a practical joke played on him by herself and the
writer Jean de Tinan (although doubt has subsequently been cast upon
Tinan's involvement in the affair). Irritated by a regular visitor to the *mardis*
named Berthe de Courrières, the pranksters managed to convince her that
Jarry had a secret crush on her and that, if she played her cards right, he
could be swayed from his homosexuality in her direction. Now Berthe was
the mistress of Remy de Gourmont, with whom Jarry had coedited from
1894 the beautiful *revue d'estampes* (engravings review) *L'Ymagier*. She was
also a noted nymphomaniac, whose exploits had occasioned much sur-
reptitious mockery among the *mercuristes*. Berthe pursued Jarry with vigor,
writing a series of letters and eventually propositioning him in a calamitous
encounter that caused great embarrassment to all concerned, and caused a
rupture with Gourmont in 1895/6. Jarry retold the whole story, first in a
ribald poem that circulated at the *Mercure*, and then in an extremely frank
story in *L'Amour en visites* (Visits of Love) (Jarry 1993 [1898]), reproducing
Berthe's letters word for word.

The break with de Gourmont also reflected Jarry's uneasy relationship
with the symbolists. He undoubtedly absorbed their influence, especially
in their advocacy of the primacy of imagination over reality, yet he had
his own peculiar version of many of their key ideas. As Keith Beaumont
remarked, in a discussion of the essay "To Be and to Live," which begins
with some dialog from Ubu:

The epigraph chosen by Jarry must put the alert reader on his guard: it consists of
those lines from the *Guignol* [. . .] in which Ubu first presents to us his newly in-
vented science of pataphysics. Moreover, quite apart from the strangeness of certain
allusions, the very structure of Jarry's argument flies in the face of the most elemen-

tary logic: beginning with an apology for Being, he moves suddenly and quite arbitrarily to a celebration of Existence, and to a call to "destroy Being." The justification of this "casuistique licite" is [the principle of] the "identity of opposites." (Beaumont 1984, 62)

To get a fuller idea of the origins of Jarry's 'pataphysics, however, we need to look beyond his immediate literary circle. It is clear that he identified with several writers from the past, traces of whose works may be seen in many of his own writings. First and foremost among them was Rabelais, whose anticlerical and satirical attitudes, verbal inventions, and bawdy sense of humor were a constant point of reference. Ubu is given Rabelais's first name, François, and the structure of *Faustroll* owes a great deal to *Gargantua and Pantagruel*, whose first two books deal with events in the lives of the two giants, before Pantagruel sets out on an extended sea voyage in books 3, 4, and 5, encountering many friends and exotic situations during a search for the "Divine Bottle." Jarry's works are full of direct quotations, subtle allusions to and derivations from Rabelais, including many of the archaisms, deliberate misspellings, and verbal inventions of pataphysics. A typical example was reputedly Jarry's favorite word: obeliscolychny, a Greek word for a lighthouse that appears in book 4, chapter 25 of *Gargantua and Pantagruel*: "Ho, ho! I see land too; let her bear in with the harbor; I see a good many people on the beach; I see a light on an obeliscolychny."

Ben Fisher gives the following reasons for Jarry's obsession with Rabelais:

Obscenity, erudition and the use of the French language at its richest and most sonorous are Rabelaisian elements which Jarry endeavoured to put into his own writing, but there is also a simple governing consideration, according to which Rabelais is the all-purpose model for Jarry's literary career: he [. . .] obeys no single set of literary conventions. (Fisher 2000, 96)

Isidore Ducasse, the self-styled Comte de Lautréamont, was a formative influence, especially in early works such as *Haldernablou*. Like most avant-gardists, Jarry was also influenced by Baudelaire and Rimbaud. However, these influences seem to have dissipated somewhat as the symbolist connection weakened. More lasting was the constant presence of universal stories: the Christian Scriptures and an array of Ancient Greek, Roman, Norse, French, and especially Breton myths and folklore, alongside classic tales such as *The Thousand and One Nights*, Dumas's *Count of Monte Cristo*, Wyss's *Swiss Family Robinson*, Quinet's *Ahasvérus*, with the tale of the "Wandering Jew," and Cyrano de Bergerac's *L'Autre Monde* (The Other World), with its descriptions of fantastic voyages to the Moon and the Sun, whose landscape includes "springs named after the five senses flowing into rivers named 'la

Mémoire' (Memory), 'l'Imagination' (Imagination) and 'le Jugement' (Judgment)" (Fisher 2000, 27). Other readings included classical philosophers such as Aristo of Chios and Lucian of Samosata, Pliny and Cato, Heraclitus and Epicurus.

Jarry was well read in foreign literature, and alongside a good knowledge of Shakespeare, who was plundered in Ubu and other works, he was also very familiar with the works of Thomas De Quincey, the English opium-eater and author of an essay "On Murder Considered as One of the Fine Arts." Coleridge, Poe, Carlyle, Lewis Carroll, and Robert Louis Stevenson, whose curious short story "Olalla" Jarry translated (apparently quite badly), were all also influential. Edward Lear, whose poem "The Jumblies" echoes Faustroll ("They went to sea in a Sieve, they did, in a Sieve they went to sea"), was encountered unawares through the essays of C. V. Boys. Swift was important, both for Gulliver and perhaps for the essay "Human Ordure, Botanically Considered," which must be the first exhaustive discussion of merdre in literature. Also significant was Francis Bacon—the founder of modern science, as well as a noted alchemist—who is quoted in Faustroll in a Latin epigraph whose meaning can be interpreted in an alcoholic way: "Leves gustus ad philosophiam² movere fortasse ad atheismum, sed pleniores haustus ad religionem reducere" (A little/a slight sip of/ philosophy inclineth a man's mind to atheism; but depth/a fuller draft/ bringeth men's minds to religion") (Faustroll, book VIII).

Nietzsche was an influence, known to Jarry through the translations for the Mercure by Henri Albert. There are many resonances with pataphysics in Nietzsche's philosophy, such as Die fröhliche Wissenschaft (The Gay Science, 1882), which appeared in its French version in 1887. This contains not only the first instance of the celebrated statement "God is dead," but also an evocation of an archaic Provençal tradition of knight-poets who quested for knowledge through an exuberant poetry and a playful approach to life. Stephen Barker suggests that this is "genealogically rooted" in the clinamen:

This clinamen is for Nietzsche, for Jarry, for Derrida, and for the conception of the play of canonicity, what Jarry calls "la bête imprévue" (Faustroll VI, 34; OC 714), the declaration of the anticanonical within the canon, couched at its very heart, the unexpected beast of which, out of the circle of rational inclusivity, creation is made, over which logic has no control, which must insert itself, as it does in Lucretius, as the opening of difference and of play. (Barker 1989, 69)

Jarry borrowed a great deal from these predecessors, sometimes very freely. It was not that he plagiarized exactly, although there are examples of that, but he would often quote from memory without checking the precise

sources. His work is woven through with very many allusions, references, recontextualizations and intertextual readings, and "found material." It is his synthesis of sources that, perhaps surprisingly, makes his writing so original. *Ubu Roi* itself was the result of just such a process, derived from the mocking humor of generations of pupils at the Lycée in Rennes, and in particular the brothers Charles and Henri Morin, who wrote the play *Les Polonais*. This was the forerunner of *Ubu Roi*, and was performed in 1889 by Henri and Jarry in a self-built puppet theater called the Théâtre des Phynances to an audience of schoolboys.

Jarry's authorship of *Ubu* was to be famously challenged in 1921, when Charles Chassé published his book *Les Sources d'Ubu-Roi*, which claimed that the Morin brothers were the true authors. The claim foundered on several counts: it was clearly mischievous; Henri had in fact given permission to Jarry to use the material, which was in any case much shorter than *Ubu Roi*; Jarry's play was far more developed than the schoolboys' text and, crucially, he had added a whole new layer of material and context that made it relevant to the adult world of the Parisian theater. This episode provides the starkest example of how Jarry would synthesize and develop "found" materials.

Jarry never went as far as Thomas De Quincey, whose *Last Days of Immanuel Kant* (which was translated into French by Jarry's friend Marcel Schwob) consisted of an unacknowledged translation of a German text by Christoph Wasianski with a set of original footnotes by De Quincey himself (Borges was to take this practice to a new level of irony, inspired in part by De Quincey, in texts such as "Pierre Menard: Author of the *Quixote*"). Jarry was generally more subtle in his borrowings than this, but also more generous, providing plenty of references in the texts. However, given the complexity of the results of his syntheses of source materials, these acknowledgments were sometimes far from complete.

His approach to existing literature may best be summed up by the description of the library of Equivalent Books (*Livres Pairs*) in *Faustroll*. These reveal a catalog of influences, for sure, but also a certain indifference to relative importance implied by the notion of Equivalence. The Equivalent Books are as follows (Jarry goes on to select an individual scene or image from each of these that Faustroll "conjures up into the third dimension"):[3]

1. BAUDELAIRE, a volume of E. A. POE translations.
2. BERGERAC, *Works*, volume II, containing the *History of the States and Empires of the Sun, and the History of Birds*.
3. The Gospel According to SAINT LUKE, in Greek.

4. BLOY, *The Ungrateful Beggar.*
5. COLERIDGE, *The Rime of the Ancient Mariner.*
6. DARIEN, *The Thief.*
7. DESBORDES-VALMORE, *The Oath of the Little Men.*
8. ELSKAMP, *Illuminated Designs.*
9. An odd volume of the *Plays* of FLORIAN.
10. An odd volume of the *Thousand and One Nights*, in the GALLAND translation.
11. GRABBE, *Scherz, Satire, Ironie und tiefere Bedeutung*, comedy in three acts.
12. KAHN, *The Tale of Gold and Silence.*
13. LAUTRÉAMONT, *The Lays of Maldoror.*
14. MAETERLINCK, *Aglavaine et Sélysette.*
15. MALLARMÉ, *Verse and Prose.*
16. MENDÈS, *Gog.*
17. *The Odyssey*, Teubner's Edition.
18. PÉLADAN, *Babylon.*
19. RABELAIS.
20. JEAN DE CHILRA, *The Sexual Hour.*
21. HENRI DE RÉGNIER, *The Jasper Cane.*
22. RIMBAUD, *The Illuminations.*
23. SCHWOB, *The Children's Crusade.*
24. Ubu Roi.
25. VERLAINE, *Wisdom.*
26. VERHAEREN, *The Hallucinated Landscapes.*
27. VERNE, *Journey to the Centre of the Earth.*

The list contains several items that one would expect from an avant-gard-ist writer—Poe translated by Baudelaire, Lautréamont, Mallarmé, Rimbaud, Verlaine—alongside classical texts and scripture. There are several less well-known names here too. Some of them were personal friends of Jarry: Léon Bloy was a polemicist and pamphleteer who shared Jarry's misanthropy and love of obscenity; Gustave Kahn was a major poet of his day and a Belgian symbolist with whom Jarry spent time on holiday; Maeterlinck, for whom Jarry had great admiration, praising his "poetic vision that pierces infinities," wrote *Pelléas et Mélisande*, one of the most important symbolist dramas, as well as the play mentioned here; Jean de Chilra is an anagram of Rachilde; Henri de Régnier was an avant-gardist whose eventual acceptance into the Académie Française rather spoiled his reputation, but who was sufficiently interesting to Jarry at this time to become one of the dedicatees of a chapter in *Faustroll*; and Marcel Schwob, whose vast erudition contributed

to Jarry's own (Jarry called him "celui qui sait" [he who knows] in the 1899 *Almanach de Père Ubu*), was the dedicatee of *Ubu Roi*.

Other contemporaries who are mentioned may, or may not, have been personally known to Jarry, but clearly had significance for him. Georges Darien was admired by the symbolists, although not part of their literary circle, and remains a little-known figure today; he wrote novels with strong political and antimilitarist content. Max Elskamp was another sympathetic Belgian symbolist poet; Christian Dietrich Grabbe was a German drama-tist whose work was championed and translated by Jarry, including *Scherz*, which has some similarities with *Ubu Roi*; Catulle Mendès was a prolific writer, highly active in Parisian cultural circles, and also an early supporter of *Ubu*; the self-styled "Sâr" Joséphin Péladan was a mystic and founder of the Ordre de la Rose+Croix; he organized salons, exhibitions, and per-formances, and published several books of an occultist nature, somewhat inspired by the influence of Richard Wagner; Emile Verhaeren was a Bel-gian symbolist who also enthusiastically supported *Ubu Roi*, and whose works often explored irrationality and madness.

Less obviously avant-gardist are: Marceline Desbordes-Valmore, a fairly obscure actress but later praised as a romantic poet and author of several books of "improving" literature for children; Jean-Pierre Claris de Florian, author of simple fables and novellas; and Jules Verne, who of course had both fame and literary merit, but whose enormous popularity would appar-ently have made him the very opposite of an antiestablishment hero (inter-estingly, he was Raymond Roussel's favorite author).

It is worth also recording the importance of Alphonse Allais, who is not included in Faustroll's library, but whose acidly humorous pieces were of a distinctly pataphysical character, and whose enthusiasm for *Ubu* earned Jarry's reciprocal appreciation.

PATAPHYSICS AND ALCHEMY

Faustroll's apartment is entered by a M. Lourdeau, "locksmith at Paris, no. 205, rue Nicolas Flamel," who sequestrates "with the exception of a bed of polished copper mesh, twelve meters long and without bedding, of an ivory chair and of an onyx and gold table; [. . .] twenty-seven assorted vol-umes, some paper-backed and others bound" (Jarry 1965a [1911], 185). The apparently incidental appearance of the name of Flamel, the fourteenth-century alchemist whose *Exposition of the Hieroglyphical Figures* (published in 1613) described the search for the Philosopher's Stone, is a reminder of the presence of hermetic philosophy and alchemical references in Jarry's

work. In fact, alchemy is something of a hidden (or not so hidden) pres-
ence throughout pataphysics, apparently permeating the work of Marcel
Duchamp, for example, and providing an early example of a science of
imaginary solutions. It is probably true to say that the real predecessors are
not so much literary as alchemical or, perhaps, "philosophical" in a tradi-
tional sense.

Tracing the full extent of this presence would require a book twice the
size of the present volume, and would probably be an impossible task.
An example of one attempt is provided in volumes 2 and 4 of the journal
Pataphysica (Clements 2004, 2006), which are special numbers on "Pata-
physica e Alchimia," including a translation of Jarry's *La Dragonne* (The
She-Dragon). They chart Jarry's use of alchemical symbols, and suggest
that the word "pataphysics" itself, far from having a Greek origin as Jarry
pataphysically implies in his definition, in fact derives from the Sanskrit
word *patitvā*, which means a "flying off," but also "fallen," and hence is an
example of a "coincidence of opposites."

However, we should be careful here because, as is always the case with
Jarry, such matters are far from straightforward. His interests in heraldry
and mathematics introduce more layers of symbology, which intertwine
with alchemy to create a confusing mixture that is then in turn drenched
in irony. To privilege alchemy in this mixture may be to give it too much
importance. In some respects, Jarry's involvement in alchemical matters
was simply a product of the fashionable mysticism of the day. It is the
injection of Ubu that creates a path to a kind of elixir based on the tradi-
tional ends of the alchemist: self-transformation, hermaphroditism, and
control over the manner and timing of one's own death. Conversion of
base metals into gold was always only a test of the Philosopher's Stone, but
the transformation of words into phynance may be seen as an allegory of
this process.

The nature of Jarry's relationship to alchemy is summed up in the name
"Dr. Faustroll," which combines the world's greatest alchemist (Doctor
Faustus) with an ugly Norwegian creature that lives in dark places and cre-
ates mischief. Both are, of course, mythical creatures, and their combina-
tion accurately symbolizes pataphysics. Dr. Faustus, it will be recalled, in
searching for the essence of life, reaches the limits of knowledge and, frus-
trated, turns to Mephistopheles for assistance in going further. Depending
on which version of the story one reads, this leads either to Faustus's ulti-
mate downfall into the arms of Satan, or to a lucky escape. Either way, Faust
transforms himself and, in so doing, transcends earthly reality.

Jarry codirected the production of Ibsen's *Peer Gynt* that preceded *Ubu Roi* by the Théâtre de l'Œuvre. He also starred as the King of the Trolls, who asks the crucial question: "What is the difference between troll and man?" The reply given by the Old Man of the Mountain is: "Out there, where sky shines, humans say: 'To thyself be true.' In here, trolls say: 'Be true to yourself-ish.'" Peer learns this as a personal motto and becomes always himself, "whatever that is."

L'Amour en visites reads in a similar vein to old alchemical treatises, concealing its secret meanings behind an apparently allegorical tale in which Marco Polo, Genghis Khan, Prester John, and Princess Belor are destroyed in the creation of an imaginary castle paradise in which Alaodin (the chief of the Hassassins and the Old Man of the Mountain in Marco Polo's story, read by Jarry as a child) lives a hermetic existence. In the end, he is in turn destroyed by the Scythian Albain, Christian Astrologers, and Alau, Lord of the Levant, who thereby assure their own demise. The chapter ends as follows:

THE SCYTHIAN ALBAIN: There is no longer any paradise of any castle; the sun and the moon are extinguished over the double obeliscolychny; the Riffean Mountains are turning white, and we are going to die on account of the severity and spite of the mountains' cold.
THE CHRISTIAN ASTROLOGER: There never was either any paradise or any castle.
(Jarry 1993 [1898], 95)

This tale is immediately followed by a chapter entitled "Visiting Madame Ubu," in which Ubu lauds his own shape: "The sphere is the perfect form. The sun is the perfect star. In ourselves nothing is as perfect as the head, forever raised toward the sun, and reaching out toward its form; save for the eye, the mirror of that star, and comparable to it." Following this hyperbole, we descend into the latrines, and eventually encounter Ubu's conscience, who looks "rather like an eye at the bottom of a chamberpot."

In such oppositions lies the alchemy of 'pataphysics. On the face of it, they may seem like a typical example of inflation-deflation humor, of the sublime followed by the ridiculous, but what becomes clear time and again, on reading Jarry, is their equivalence. This is not as paradoxical as it may at first appear. Many of the early alchemists, in their search for the *prima materia*, worked with urine and semen, with blood and feces. The "puffers," with their portable bellows and furnaces, puffed themselves up in their claims to alchemical knowledge before defrauding a gullible populace into handing over their pewter, to be melted down in the Ubu-shaped *aludel*, the Hermetic Vase or Philosopher's Egg.

The genuine alchemists, from Roger Bacon to Philippus Aureolus Theo-phrastus Bombastus von Hohenheim (better known as Paracelsus), from St. Thomas Aquinas to Sir Isaac Newton, all recognized the importance of the union of opposites, whether chemical or spiritual. The fashionable Rosicru-cianism that infused Paris in the 1890s, inspired by seventeenth-century texts such as Johann Valentin Andreae's *Chymical Wedding of Christian Rosenkreutz* and the arcane symbologies of Michael Maier, extended these into mystic unions of Sun and Moon, Bride and Bridegroom, Days and Nights, and ultimately the hermaphrodite. These matters were part of the stuff in the crucible that made 'pataphysics.

It is worth noting that the twentieth-century alchemist Fulcanelli's *Le Mystère des cathédrales*, written in 1922 and published in 1926, which sees the Gothic cathedrals as a kind of alchemical text, contains many ideas that would be familiar to pataphysicians. In particular, the following remarks will have resonance:

Gothic art (*l'art gothique*) is simply a corruption of the word *argotique* (cant), which sounds exactly the same. [. . .] In our day, cant is spoken by the humble people, the poor, the despised, the rebels, calling for liberty and independence, the outlaws, the tramps, and the wanderers. [. . .] People think such things are merely a play on words. I agree. The important thing is that such wordplay should guide our faith to-ward certainty, toward positive and scientific truth, which is the key to the religious mystery. (Fulcanelli 1971, 42–43)

JARRY'S 'PATAPHYSICS

The aim of this section is to trace the lineaments of 'pataphysics in Jarry's writings. Now, in a very real sense, only a reproduction of the complete works could achieve this aim, since *all* the writings are, in their way, pata-physical. However, as Borges has pointed out in his story "On Exactitude in Science," a one-to-one map of a territory is practically useless:

In time, those Unconscionable Maps no longer satisfied, and the Cartographers' Guild drew a Map of the Empire whose size was that of the Empire, coinciding point for point with it. The following Generations, who were not so fond of the Study of Cartography, saw the vast Map to be Useless and permitted it to decay and fray un-der the Sun and winters. (Borges 1998, 325)

Since the present volume is so *un*pataphysical as to aspire to be usable, at least as a portal through which to perceive pataphysics, it will shun such redundancy, and instead concentrate on those texts which most explicitly deal with pataphysics or its key themes.

The first published use of the word "pataphysics" occurred in 1893 in the magazine *L'Écho de Paris littéraire illustré*, in a text entitled "Guignol." Guignol was a glove puppet character originally created in Lyon in 1808 to typify the downtrodden silk weaver. He became so famous that the term "guignol" is used in French for "glove puppetry" or even, by Jarry, for marionettes or puppetry in general. Jarry's text quotes some scenes from *Les Polyèdres* (The Polyhedra), which was later to become *Ubu cocu*. The text was reproduced under the title *Guignol. I: L'Autoclète* (an autoclete is an uninvited guest) in what must be regarded as the first book of 'pataphysics: *Les Minutes de sable mémorial* (Black Minutes of Memorial Sand, 1894),[4] an illustrated volume of poetry, with woodcuts in different colors, beautifully laid out with careful use of typography, and in a limited first edition of 216 copies.

However, the way "pataphysics" is described in this volume clearly shows that the word already existed, at least in the schoolboy *argot* of the Lycée at Rennes, where Jarry and his classmates used it in a barrage of mockery aimed at their unfortunate physics teacher, M. Félix-Frédéric Hébert. This gentleman was a classic target for schoolboy humor: fat, ineffectual, and ridiculous. Jarry would mercilessly expose his weaknesses by asking increasingly difficult questions, until Hébert was utterly flummoxed. A classmate, Henri Hertz, recalled: "There was the distinct feeling that his sarcasm went beyond the general unruliness, that something deep down inside him was taking part in this battle, something different, that his tactics arose from some powerful impulse" (Beaumont 1984, 14). A schoolboy painting by Jarry, reproduced in the *Cahiers du Collège de 'Pataphysique* 10 (6 April 1953, page 55) and more recently in color in *Jarry en ymages* (Foulc et al. 2011, 65), depicts a large man with a bulbous nose and a drooping face, entitled "Monsieur Hébert, Prophaiseur de Pfuisic."

Generations of schoolboys had woven legends around the figure of Hébert, who became transformed into a monstrous character under the name of "Père Heb," "le P. H.," and, significantly, *Ébé*, in a series of Rabelaisian adventures. His belly became the *gidouille*, he had teeth of stone, iron, and wood, and he was baptized with "essence of pataphysics." After many adventures, driven by a desire for *phynance*, he massacred his enemies with a disembraining spoon (later machine), became king of Aragon, then king of Poland, captain of dragoons, and so on. These are the recognizable events from *Ubu Roi*, which at least initially was a collaborative effort by Jarry and his chums. Jarry's original contribution was to transport it

from the schoolboy world to the Parisian stage and, crucially, to invent the name Ubu. In the process, the science of pataphysics also made its way from merely a mocking account of pedagogical inadequacies to something much more profound.

An early insight into the transition may be glimpsed in the essay "Visions actuelles et futures" (Visions of Present and Future), published in *L'Art littéraire* in May-June 1894, when Jarry was twenty. At this time, symbolism was struggling in its relationship with anarchism, whose more violent exponents had begun a bombing campaign. Some literary anarchists were drawn to texts such as Max Stirner's *The Ego and Its Own*, which advocated an extreme individualism. Evidence of the consequence of such attitudes came with Laurent Tailhade's famous comment following a bombing of the Chamber of Deputies by Auguste Vaillant: "What do the victims *matter*, so long as the gesture is beautiful."

Jarry's text was inspired by anarchism, but it nevertheless generally avoided discussing politics, preferring instead to take a symbolist poet's-eye view of the events in Paris that culminated in the arrest of Félix Fénéon, an art critic and literary editor, for possession of detonators. Here, the instruments of execution, the guillotine, the gallows, the bomb, and above all the Disembraining Machine, become animated, and the themes of Ubu—the phynances, the physick-stick, and the Palotins—make their appearance. The essay ends with the following imprecation, whose final sentence offers a typically symbolist description of the guillotine:

Close this book now with its autumnal cover, for we shall let it go at that for today.— Pataphysics is the science of these present or future beings and devices, along with the power to use them (discipulus) . . . —Definition of revealed science before venturing out into the ineffable mysteries . . . —Disc.—The mind desires that what has been revealed should be known by the most ignorant, even by the delicate Knight who complains that, in order to protect it from the emery of his gluttonous violet teeth, Your living statue of lustrous ebony and adamantine emerald has been mercifully padded, as well as the coral-red pustules of the triangular God of Gardens. (Jarry 1965b [1894], 113)

Now, although Jarry tended to avoid contemporary politics in his writing, he was nevertheless a personal friend of both Tailhade and Fénéon, and he was drawn to anarchism. There is even perhaps an echo of Tailhade's remark in Jarry's famous declaration after firing his revolver at an acquaintance in a restaurant years later: "Wasn't that just beautiful, like literature?" But therein lies a key difference: Jarry's anarchism was literary or, indeed, pataphysical, and he had little time for what he regarded as the ridiculous motives behind the direct actions of the anarchists. "Visions of

Present and Future" makes this clear in its opening sentence: "You hunt down anarchists indiscriminately, I strike down the bourgeois indiscriminately," said Émile Henry. This is the dazzling apparent logic of schoolboys, absurdity pitted against absurdity.

Another early appearance of pataphysics occurs in the introductory essay to the *Black Minutes of Memorial Sand*, entitled "Lintel." The book announces a forthcoming work by Jarry to be called "Elements of Pataphysics" (which was later to become book II of *Faustroll*). Then follows this "Lintel," in which he muses on the relationship between the writer and his audience. He first argues that the following work is "transcendently beautiful," but that its beauty will not be immediately apparent to "superficial people." This obscurity is "simplicity condensed—a diamond from coal, a unique work made of all the possible works offered to all the eyes encircling the Argus lighthouse on the periphery of our spherical skull. For the latter, *the ratio of the sentence to all the meanings which may be found at is constant*; for the former, indefinitely variable" (Jarry 2001b, 24). This is a simplicity derived from a pataphysical synthesis of complexity which presents the author with a dilemma, described thus by Jarry:

In that one writes the work: active superiority over the passivity of the audience. All the meanings the reader finds in it have been foreseen, and he will never find them all; furthermore, the author can bring others to his attention that unexpected, posterior and contradictory, in a cerebral blind man's buff.

But, 2nd Case: reader infinitely superior in intelligence to the author. Nevertheless, not having written the work, he does not penetrate it, but remains parallel, if not equal, to the reader of the 1st Case.

3rd Case: if, against all probability, he identifies with the author, the latter at least surpassed him in the past when he was writing the work, that unique moment when he saw EVERYTHING (but was far from spelling it out, as explained above, for this would merely have been (cf. *Pataph.*) a brutishly passive association of ideas, disdain (or lack) of free will or of intelligent choice, and sincerity, anti-aesthetic and contemptible).

4th Case: If, beyond this unique moment, the author forgets (and forgetting is indispensable—*timeo hominem* . . . —if one is to turn the *stilus* round one's brain again and engrave the new work therein), the variability of the aforementioned ratio is a sighting-mark enabling him to rediscover EVERYTHING. (Ibid.)

Already we can see here the future for Jarry's pataphysics. The dense writing, with its deliberate obscurity and appeals to the refinement of a few connoisseurs, is punctured by a certain "scientific" or mathematical language (the ratio) and "academic" referencing (cf. *Pataph.*). Somewhat in opposition to this is the pataphysics of Ubu, which is a mixture of the

schoolboyish humor in which it had gestated and the symbolist sensibility into which it had emerged. The vast imperturbability of Ubu is more than capable of accommodating both forces. Indeed, once again, it is the dramatic alignment of these very different spirits which produced the creative energy that drove Jarry forward.

UBU

The Ubu cycle really begins with *Caesar-Antichrist*, published in 1895, which represents a working-through of this apparent opposition toward its eventual synthesis in pataphysics. Like *Les Minutes*, this was published in a limited illustrated edition. *Caesar-Antichrist* is divided into four theatrical Acts, separated by Intervals, and each Act sets out an aspect of what became the pataphysical universe. The Prologal Act is lifted wholesale from *Les Minutes*, and introduces the figure of Caesar-Antichrist, whose transcendent metaphysics emerges from dialogs between St. Peter-Humanity and Christ, to assert a pataphysical view of death (see the earlier discussion of this in the General Introduction). In the Heraldic Act Two, a baffling array of symbols transform and mutate, apparently dictated by the antics of the physick-stick, until Ubu appears "like an egg, a pumpkin, or a flashing meteor." Act Three, the Earthly Act, is essentially *Ubu Roi*. Finally, the Taurobolium, a kind of quasi-satanic Last Judgment, reveals the full nature of Caesar-Antichrist:

I and the Christ are Janus, and I have no need to turn round to show my double face. A being with intelligence can see these two simultaneous opposites, these two infinities which coexist and could not exist otherwise, in spite of philosophers' ineradicated errors. I alone can perceive these things, for I was born to be lord over them and to see all possible worlds I look upon a single one. God—or myself—created all possible worlds; they coexist, but men cannot catch a glimpse of even one. I am infinite Intuition as you are eternal Perception, and mirrored in one another we shall see everything. (Jarry 2001b, 190)

In time, this image was to transform into the mathematical definition of God which concludes *Faustroll*, and represents another pataphysical coexistence of opposites: $0 = \infty$.

The scandal surrounding the première of *Ubu Roi* (King Ubu) given by the Théâtre de l'Œuvre, Paris, in 1896 is generally agreed to have been the explosive event which launched modern theater, and even modernism as a whole. W. B. Yeats attended, and famously wrote afterward: "After Stéphane Mallarmé, after Paul Verlaine, after Gustave Moreau, after Puvis de Chavannes, after our own verse, after all our subtle colour and nervous

rhythm, after the faint mixed tints of Conder, what more is possible? After us the Savage God" (Yeats 1955, 233–234).

The story has been told many times, and the details need scarcely concern us here except insofar as they reveal aspects of pataphysics that have not yet been discussed. Perhaps the most significant of these, given his subsequent identification with Ubu, was Jarry's relative imperturbability in the face of a wildly hostile reaction. Despite the accusations of obscenity, anarchism, and hoaxing leveled at him in the press, he remained impervious. Rachilde observed: "Alfred Jarry emerged from it all without any sense of surprise. This young newcomer, one of Providence's proper *palotins*, returned to his box, as unconcerned about the affair as a game of skittles" (Rachilde 1957, 58).

This was partly because the criticisms were, in a sense, all true. Ubu, after all, was precisely a model of the complete stupidity with which Jarry credited the bourgeois theater audiences of the day, and in presenting them with their "Double" he would scarcely have expected anything other than shock and disgust as a reaction. But, more than this, Jarry also had his mind on more profound insights, of which Ubu represented but one facet. He knew that "what makes children laugh can frighten adults" (*Ubu enchaîné*) and, as Keith Beaumont pointed out, that there is something eternal in the puerile and the childlike (Beaumont 1984, 119).

The opening scene of *Ubu Roi* introduces the famous "*merdre*," the swear word (*merde* = shit) that so incensed the early audiences, and with its added *r*, the *clinamen* that gives extra emphasis and a twist in meaning. There have been many English translations of this word, thoroughly documented by Alastair Brotchie (Brotchie, *The Problem of the Wordr*, 1991), including: *Shittr!* by Barbara Wright (1951); *Pshit!* by Keith and Legman (1953); *Shitr!* by Benedict and Wellwarth (1964); *Pschitt!* by Taylor and Connolly (1968); *She-it!* by Bierman (1971); *Sheeyit!* by Copelin (1973); and *Pppschittl!* by Milligan (1980). To these may be added Terry Hale's splendid *Fruck!* from his 2007 translation of *Ubu Roi* entitled *Chopping and Frucking*.

The plot of *Ubu Roi* effectively deconstructs Shakespeare, in particular *Macbeth*, *Hamlet*, and *Richard III*. However, this amounts to much more than just a few borrowings of plot lines and certain allusions. The dedication page to *Ubu Roi* declares, in mock archaic French: "Adonc le Père Ubu hoscha la poire, dont fût depuis nommé par les Anglois Shakespeare, et avez de lui sous ce nom maintes belles tragœdies par escript" [Theratte Lord Ubu shooke his peare-head, whence he is by the Englysshe yclept Shakespeare, and you have from him under thatte name many goodlie tragedies in his own hande.] As Yves Simon observes:

Shakespeare was neither Marlowe, nor Sir Philip Sydney, nor any of the other pre-
tenders as certain erudites believe; nor moreover was Shakespeare Shakespeare as the
majority of people wrongly believe; in reality, behind the mask of Shakespeare is
hidden Ubu. (Simon 1981, 190–191)

Ubu constantly refers to Shakespearian tropes. The green candle echoes
Macbeth's "Out, out, brief candle," and Ubu cries out for his "cheval à phy-
nances," just as Richard III would give his kingdom for a horse. But in one
important respect, *Ubu Roi* differs from Shakespeare: there are no conse-
quences for Ma and Pa Ubu, who end the play in comfortable exile. No final
scene with bodies piled high on stage.

Ubu cocu (Ubu Cuckolded) was never performed in Jarry's lifetime, and
had a complicated gestation, being reworked many times. Perhaps because
of this, it contains somewhat more elaboration of pataphysical ideas than
Ubu Roi, while retaining the central characters and spirit of the first play.
Ubu now asserts his status as a "professor of Pataphysics," obliterating the
unfortunate Achras and his own conscience, which he conveniently stores
in a suitcase (and eventually flushes down the toilet) in his overwhelming
need to get whatever he wants and whatever he can get away with. The play
also develops the characters of the *Palotins* (Palcontents), who are Ubu's
operational team, extracting phynance and administering terrible retribu-
tion (in Achras's case, impalement). Their songs, the "Hymne des palotins"
(Hymn of the Palcontents) and the subsequent "Chanson du décervelage"
(Debraining Song), have become anthems of pataphysics.

Ubu enchaîné (Ubu Bound) was completed in 1899 and published in
1900 as, according to Jarry, a "counterpart" to *Ubu Roi*. The title is a nod to
Aeschylus's *Prométhée enchaîné* (Prometheus Bound), and follows a reverse
trajectory to *Ubu Roi* in the sense that, instead of rising in social status,
Ubu descends from king to servant to slave. The play has quite a different
tone to the earlier work, no longer so childish and puerile (Ubu tries but is
unable to utter the word "*merdre*," for example), but now more overtly satir-
ical, especially of cherished notions such as liberty, equality, and fraternity.
So, the Army of Free Men systematically disobey every order they are given,
a fact to which their Corporal is wise, so he gets them to do what he wants
by commanding them to do the opposite. Ubu is introduced; understand-
ing the game, he upsets everyone by systematically *obeying* orders. Herein
lies the notion of ironic conformity that became the hallmark of many a
subsequent pataphysician. Despite the reverse trajectory and a layer of rela-
tive sophistication in his character, Ubu is still fundamentally the same. As
before, he emerges unchanged by his experiences and largely indifferent
except to self-gratification and "phynance."

DAYS AND NIGHTS

Days and Nights: Novel of a Deserter was produced in 1897 and superficially has in common with *Ubu enchaîné* a satire on the army. "Superficially" because this is, in fact, only the most immediately apparent aspect of an enormously complex and rich work which covers an array of themes and ideas interwoven with a deeply personal and intimate narrative whose precise nature still remains unclear to biographers and critics. Jarry had been conscripted in 1894, and the book describes in detail many of the episodes that occurred during his truncated and ridiculous military service. "Desertion," however, was not one of these, despite the novel's subtitle. Jarry successfully played the medical system to have himself invalided out with honor, and the military system to make life as undemanding as possible, by showing complete incompetence as a soldier and by flattering the officers by offering criticism of their literary efforts.

The "desertion" implied was therefore more an expression of an utter disregard for reality, a theme which is explored in episodes of drug-taking, through some densely symbolist writing, by way of a peculiar dissection of an intimate relationship, and by a literary device which alternates chapters set during daytimes that are described as though they are happening at night, and vice versa, until that alternation itself breaks down. Blacking army boots and whiting puttees produces a blurry line where the white and the black meet, where there is cross-pollution between the two. This is an important metaphor in the novel for the relationships between day and night, the present and the past, reality and hallucination. These are the oppositions that permeate the novel and reach a climax in the chapter entitled "Pataphysics," wherein we discover just how far that concept has traveled from its Ubuesque beginnings.

The central character, Sengle (i.e., "single"), is clearly Jarry himself, whose progress through the book is a succession of desertions: from love; from reality; from hashish; and so on. Eventually he reaches Pataphysics:

Sengle came to believe, on the strength of testing his influence on the behavior of small objects, that he had the right to assume the probable obedience of the world at large. If it is not true that the vibration of a fly's wing "makes a hump on the other side of the world," since there is nothing at the back of infinity, or perhaps because movements are transmitted in the Cartesian sense, in rings (it is clearly proven that the stars describe ellipses, or at least elliptical spirals on a narrow course, and that a man in a desert who thinks he is walking in a straight line tends to bear left, and that there are not a lot of comets); it is evident that a tiny motion radiates outward with significant displacements and that the reciprocal collapse of the world is incapable of moving a reed in such a way as to make it aware of the fact; for the selfsame reed,

swept along in the retreat—which is never a rout—of its surroundings, would remain in its rank and file and confirm that from all viewpoints its relationship to its surroundings was permanent.

As a result of these reciprocal relationships with Things, which he would habitually control through his thought processes (but we all of us can, and it is by no means certain that there is a difference, even in time, between thought, volition and act, cf. the Holy Trinity), he no longer made any distinction at all between his thoughts and actions nor between his dreaming and his waking; and perfecting Leibniz's definition, that perception is a hallucination which is true, he saw no reason not to say: hallucination is a perception which is false, or more exactly: faint, or better still: foreseen (remembered sometimes, which is the same thing). And he believed that above all there are only hallucinations, or perceptions, and that there are neither nights nor days (despite this book's title, which is why it has been chosen), and that life is continuous; yet that one would never be aware of its continuity, nor even that life exists, without these pendulum movements; and life is primarily verified by the beating of the heart. It is very important that there are heartbeats; but that the diastole is a rest for the systole, and that these little deaths support life, is merely a routine statement not an explanation, and Sengle did not give a damn for it and its formulator, some pedant or other. (Jarry 2006 [1897], 73–74)

"HOW TO CONSTRUCT A TIME MACHINE"

In the first of the two *Almanachs du Père Ubu*, published in 1899, Ubu takes a journey on an imaginary day (30 February) by "tempomobile" through the streets of Paris, "starting in the heights of Montmartre, and like a blazing meteor our *gidouille* rolls forwards at a slow and majestic pace." The tempomobile allows Ubu to "transcend the boundaries of time and space" (Dubbelboer 2009, 93).

We, Père Ubu, open up to you our knowledge of all things past, which is more accurate than any newspaper, because: where we tell you something that you have read elsewhere, universal witness will assure you of our veracity: where you can find no confirmation anywhere of what we say, our word will thereby rise in its absolute truth, without any discussion. By way of our Tempomobile, invented by our science in physics in order to explore time [. . .] we will reveal to you all future things.

H. G. Wells's story *The Time Machine* had been published in French in 1898 and had clearly inspired Jarry, although it was typical that he wished to replace Wells's social theorizing with a piece of pataphysical engineering. Jarry was also friendly with Gaston de Pawlowski, who was to publish his *Voyage au pays de la quatrième dimension* (Voyage to the Land of the Fourth Dimension) in 1912; this was itself inspired by an essay by Charles Howard Hinton published in French in 1882: "Qu'est-ce que la quatrième

dimension?" (What is the fourth dimension?). In Wells's story there is considerable discussion of what the fourth dimension might be:

"Clearly," the Time Traveler proceeded, "any real body must have extension in *four* directions: it must have Length, Breadth, Thickness, and—Duration. But through a natural infirmity of the flesh, which I will explain to you in a moment, we incline to overlook this fact. There are really four dimensions, three which we call the three planes of Space, and a fourth, Time. There is, however, a tendency to draw an unreal distinction between the former three dimensions and the latter, because it happens that our consciousness moves intermittently in one direction along the latter from the beginning to the end of our lives." (Wells 2008 [1895], 6)

Even more important than these was the publication of the French edition of Lord Kelvin's lectures in 1893, on which Jarry draws substantially. Indeed, one might consider his text a kind of ironic commentary on Kelvin's theories, in particular that elasticity is a form of motion, which he sets out to prove using weightless spring balances, gyrostats, and a hook to which a weight is attached. The whole apparatus oscillates as if were itself a spring balance, but, as Paul Edwards observes:

Jarry, perhaps not inadvertently, conjures up a spring balance of the physics classroom, recognisable by its big hooks but, moreover, notoriously inaccurate and erratic, since it tends to develop a "memory" of the previous weights attached to it. Perhaps Jarry inwardly rejoiced at including those tetchy instruments in his atomic model, knowing that *no two spring balances behave identically*. The spring balance corresponds to the Clinamen in Jarry's model [. . .]. (Edwards 2001, 319)

Jarry lifts Kelvin's ideas about gyrostats and, indeed, several actual chunks of text, but in doing so recontextualizes and pataphysicizes them into a marvelous piece that genuinely baffles the reader, for it is very difficult to see the "seam" point at which this model moves completely into the imaginary solution. Perhaps, as Edwards suggests, this occurs around the mention of the Machine "*swinging freely* in azimuth on the extremity of the horizontal gyrostatic axis" (Edwards 2001, 320). Or perhaps, as Robert Calvert said, it is the moment at which we realize Jarry might as well be describing his bicycle. Either way, this text was published in 1899 under the name "Dr. Faustroll," which is a strong indication of its pataphysical importance. It also is indicative of a change in the way Jarry understood 'pataphysics, which had matured into something more scientific and analytical. Just as Jarry had now "become" Faustroll in his own mind (despite continuing to play the role of Ubu for his friends and acquaintances), so *the* science had developed a distinctly different tone.

The final section contains a piece of reasoning that echoes *Faustroll*, and the introduction of the concept of *ethernity*:

V. *TIME AS SEEN FROM THE MACHINE*

It is worth noting that the Machine has two Pasts: the past anterior to our own pres-
ent, what we might call the real past; and the past created by the Machine when it
returns to our Present and which is in effect the reversibility of the Future.

Likewise, since the Machine can reach the real Past only after having passed
through the Future, it must go through a point symmetrical to our Present, a dead
center between future and past, and which can be designated precisely as the Imagi-
nary Present.

Thus the Explorer in his Machine beholds Time as a curve, or better as a closed
curved surface analogous to Aristotle's Ether. For much these same reasons in an-
other text (Exploits and Opinions of Doctor Faustroll, Book VIII) we make use of
the term Ethernity. Without the Machine an observer sees less than half of the true
extent of Time, much as men used to regard the Earth as flat.

From the operation of the Machine there can easily be deduced a definition of
Duration. Since it consists in the reduction of t to 0 and of 0 to $-t$, we shall say:

Duration is the transformation of
a succession into a reversion.

In other words:

THE BECOMING OF A MEMORY.

(Jarry 1965a [1911], 121)

MESSALINA AND THE SUPERMALE

The two novels *Messaline* (Messalina, 1901) and *Le Surmâle* (The Supermale,
1902) may in some senses be considered as a pair. Once again, they repre-
sent opposite sides of the same coin, which may then be seen pataphysically
sideways on. Where *The Supermale* is male and modern, *Messalina* is female
and historical. The style of the former is lucid, accessible, even somewhat
journalistic, whereas the style of the former is closer to the symbolist writ-
ing of Jarry's own past. The main subject of both books is the same: sexual
desire seen through pataphysical eyes.

Messalina is overwhelmed by sexual urges that lead her beyond the
limits of her own situation into myth, mystery and, sometimes, anach-
ronism. She easily beats the whores in the local brothel in her voracious-
ness, then desperately seeks a god (Phallus, Pan, Priapus) to satisfy her,
ending in a kind of dissolving in the Gardens of Lucullus, penetrated to
death by the point of a sword. The portrait of Ancient Rome is frequently,
and deliberately, compromised by Jarry through direct comparisons with
contemporary France, and through a literary style that transcends both its
sources (Tacitus's *Annals* book XI, Juvenal, and Suetonius) and the work

of contemporary authors of "realistic" historical fiction such as Henryk Sienkiewicz, whose hugely popular *Quo vadis?* had been published the year before.

Jarry set out his view of anachronism in a lecture delivered to the Société des Indépendants in Paris on 8 April 1902, entitled "Time in Art." He discussed the anachronisms in Pieter Brueghel the Elder's *Massacre of the Innocents* (rifles and muskets), *Quo vadis?* (contemporaneous characterization), and the visionary Anna Katherina Emmerick, who was to turn up again in *Faustroll* (John the Baptist's head on a discus). He then concluded by arguing for the eternalization of art by ignoring the requirements of accurate historical setting, a theme that recurs throughout the pataphysical literature:

> To sum up, works of art can safely dispense with the notion of time: the desire to reconstruct a period merely delays the arrival of the moment when works of art are set free from the shackles of time, that is to say when they are aureoled in glory and are found to have become immortal, eternal, everlasting. If one wants a work of art one day to become eternal, is it not simpler, by liberating it oneself from the skirts of time, to make it eternal right away? (Brotchie 2011, 210)

André Marcueil, the Supermale, also dies while trying to achieve satisfaction, in his case by proving the proposition: "The act of love is of no importance, since it can be performed indefinitely." The novel is clearly influenced by contemporary science fiction but, being a pataphysical work, flouts the conventions of that nascent genre with a mechanomorphic account of sexual energy. The Supermale is powered by an assertion that there are no limits to human force. To demonstrate this requires a series of episodes that take the characters not only beyond the limits of human endurance and sexual activity, but also beyond death itself. Two of the most celebrated chapters from the novel will serve to illustrate its pataphysics. In the first, a five-man cycling team is racing an express train from Paris to Siberia and back again. The team is powered by "Perpetual-Motion-Food," a secret formula based on alcohol and strychnine, which prevents muscular fatigue. When one of the team dies in the saddle, a kind of *rigor mortis* sets in which makes him pedal relentlessly and without feeling. As a machine, the cycling team now beats the express train. But both are overhauled by the Supermale, whose superhuman strength eschews such artificial aids. He passes them in a mysterious way, apparently effortlessly, and disappears immediately from view. It is no surprise that this novel, and Jarry's mechanomorphic tendencies in general, influenced futurism. Marinetti knew Jarry fairly well, and his play *Le Roi Bombance* (1905) was obviously based on *Ubu*.

Of course, Marcueil is, in a sense, Jarry himself. He also makes an appearance in *Messalina*, under the guise of the strange and clichéd Chinaman "Valerius the Asiatic." Although Valerius was a real person, documented in Tacitus, Jarry transforms him into a character who has no real place in either Ancient Rome or the novel. His function, along with the mime Mnester, is primarily phallic. Both he and Marcueil, like Jarry himself, seem to come from another place, to stand outside the world they inhabit, whether that world be fictional or actual.

The list of Jarry's *alter egos* includes, in the 1899 novel *L'Amour absolu* (Absolute Love), the main character called called Emmanuel Dieu. This sense of himself as an ironic God-figure recurs throughout his work, not least in *Faustroll*. When asked "Are you Christian?" Faustroll replies "I am God" (and Bosse-de-Nage follows up with an immediate "Ha ha"). But Emmanuel Dieu is many people, a study in what might be called "multiple personalities," and neither Faustroll, nor Valerius, nor Marcueil, nor indeed Ubu, is exactly Jarry himself. The pataphysical self is a necessary presence in a pataphysical universe, but is no less pataphysical for that. The idea that Jarry "became" Ubu, attractive though it is from the accounts of his life, is not followed through in a straightforward fashion. He was present in Ubu, as Ubu was in him, and just as he was present in Faustroll (whose name he also used for himself on occasions). As it is expressed in chapter 40 of *Faustroll*, entitled "Pantaphysics and Catachemy" (note "panta . . ." rather than "pata . . .," meaning "total"):

God transcendent is trigonal and the soul transcendent theogonal, consequently trigonal also.
God immanent is trihedral and the soul immanent equally trihedral.
There are three souls (cf. Plato)
Man is tetrahedral because his souls are not independent.
Therefore he is a solid, and God is a spirit.
If souls are independent, man is God (MORAL SCIENCE).
Dialogue between the three thirds of the number three.

MAN: The three persons are the three souls of God.
DEUS: *Tres animae sunt tres personae hominis.*
ENS: *Homo est Deus.*

(Jarry 1965a [1911], 253–254)

FAUSTROLL

And so we have arrived at the book that is often, somewhat misleadingly, called the "Bible of 'Pataphysics." To get there has involved bypassing many

of Jarry's other works: much of the journalism; "The Green Candle"; the "mirliton" plays; the poetry; and more besides. But, as Boris Vian observed: "everything is in *Faustroll*," which will, I hope, offer at least *some* compensation for these omissions.

Gestes et opinions du Docteur Faustroll, pataphysicien (Exploits and Opinions of Doctor Faustroll, Pataphysician)[5] is a densely written and complex text that presents numerous difficulties and challenges which the passage of time only seems to magnify as we lose a sense of the *milieu* in which it was produced and to which it refers. This is a work that is simultaneously embedded in its own time and yet eternally relevant. Jarry knew that pataphysics had become almost unknowable. As he put it, in a note on the last page of the manuscript: "This book will not be published integrally until the author has acquired sufficient experience to savor all its beauties in full."

Faustroll was completed in 1898 but remained unpublished until 1911, at least in book form (seventeen chapters were published in the *Mercure* in May 1898, and one more in *La Plume* in 1900). There were two versions of the manuscript: the one purchased by Louis Lormel in 1907 (which was completed in April 1898), and the one completed in the second half of 1898 and held by the Fasquelle family until the "Expojarrysition" of 1953. The two versions are slightly different, but it was the Fasquelle manuscript that was used for the 1911 edition. This manuscript was purchased by Tristan Tzara, a leader of the Dada movement, after the "Expojarrysition," who had it bound between 1955 and 1958.

For the pataphysician, the book is the most complete summary of pataphysics, and the annotated edition produced by the Collège de 'Pataphysique in 2010 elucidates in painstaking detail the many layers of reference, allusion, borrowing, originality, and inspiration in the text. *Faustroll* is a picture of an alternative reality, rather than a fantasy world, that follows through with remorseless pataphysical logic the full implications of Jarry's science of imaginary solutions. Citing Philippe Vauberlin, the Collège notes:

A reading of the *Gestes et Opinions* "suggests and makes possible an indefinite development of Speculation," which is the least one could expect from a work which asserts definitively that "'Pataphysics is the science [. . .] which symbolically attributes the properties of objects, described by their virtuality, to their lineaments." But we must beware: Speculation here does not consist in leading *Faustroll* toward the imaginary, the extraordinary, the rare, the fantastic, even humor, or the nth degree, or "pataphysics," since Faustroll is already there! [. . .] Speculation here consists of a "what if" [. . .], that treats this unreal navigation in the most rigorous possible way. (Jarry 2010a [1911], 21–22)

The book starts out by telling the story of an ex-bailiff called René-Isidore Panmuphle, whose name means "total philistine" (*pan-mufle*). At first, Panmuphle tries to serve a writ on Faustroll but, having seized the Doctor's assets, he is then forced to take part in a voyage from Paris to Paris by sea,[6] in a skiff full of holes, and accompanied by a dogfaced baboon named Bosse-de-Nage[7] who can only ever say, through his arse-about-face, "ha ha." Together they travel around a series of imaginary islands, each the home of a contemporary artist, poet, or musician, whose work Jarry evokes in beautiful and mysterious poetic prose. At the end of these travels, both Bosse-de-Nage and Faustroll himself die, but the Doctor continues beyond the material world, engaging further in pataphysical inquiries and communicating through telepathic letters. The final book, book VIII, contains the most philosophical of Jarry's writings and probably the most condensed description of the pataphysical universe, which Faustroll defines as "that which is the exception to oneself."

The description of Doctor Faustroll provides the first full embodiment of the principles of 'pataphysics. The Ubuesque aspects are present (notice the reference to the Ordre de la Grande Gidouille ["Order of the Great Strumpot"]), but Faustroll is an altogether more *scientific* and *exceptional* entity than Ubu:

Doctor Faustroll was sixty-three years old when he was born in Circassia in 1898 (the 20th century was (–2) years old).

At this age, which he retained all his life, Doctor Faustroll was a man of medium height, or, to be absolutely accurate, of ($8 \times 10^{10} + 10^9 + 4 \times 10^8 + 5 \times 10^6$) atomic diameters; with a golden-yellow skin, his face clean-shaven, apart from a pair of sea-green mustachios, as worn by king Saleh; the hairs of his head alternately platinum blonde and jet black, an auburn ambiguity changing according to the sun's position; his eyes, two capsules of ordinary writing-ink flecked with golden spermatozoa like Danzig schnapps.

He was beardless, apart from his mustachios, through the judicious use of baldness microbes which permeated his skin from the groin to the eyelashes and ate away all the follicles, without any need for Faustroll to fear that his scalp-hair or eyebrows might fall out, since these microbes attack only fresh young hairs. From his groin down to his feet, in contrast, he was sheathed in a satyric black fur, for he was man to an improper degree.

That morning he took his daily sponge bath of two-tone wallpaper painted by Maurice Denis, with a design of trains climbing up spirals; a long time ago he had given up water in favor of wallpaper—seasonable, fashionable, or according to his whim.

So as not to embarrass the populace, he drew on over this design a shirt made of quartz fiber; baggy trousers of dull black velvet drawn tight at the ankles; tiny little gray boots, with even layers of dust carefully preserved on them, at great expense, for

many months past, broken only by the dry geysers of ant-lions; a golden-yellow silk waistcoat, exactly the same color as his skin, with no more buttons than an under-vest, and two rubies as buttons for the breast pockets, very high up; and a greatcoat lined with blue fox fur.

On his right index finger, he piled emerald and topaz rings right up to the finger-nail—the only one of the ten which he did not bite—and the line of rings was kept in place by a specially designed linchpin made of molybdenum, screwed into the bone of the ungual phalanx, through the fingernail.

By way of a tie, he passed around his neck the ceremonial ribbon of the Great Strumpot, an Order invented by himself and patented to avoid any vulgarization.

He hanged himself by this ribbon on a specially constructed gibbet, procrastinat-ing for a few quarter-hours between the choice of the two asphyxiating make-ups called *white hanged man* and *blue hanged man*.

And, after cutting himself down, he put on a sola topee. (Jarry 1965a [1911], 182–184)

Book II of *Faustroll*, entitled *Elements of Pataphysics*, is the text that Jarry had been planning since *Black Minutes of Memorial Sand*. Jill Fell suggests that the celebrated definitions of 'pataphysics deliberately conflate "two seemingly incompatible disciplines":

On the one hand Jarry returns to the notion of Pataphysics that he conceived in 1894 in relation to Symbolist art, emphasizing the role of the lineament or contour as the sole unit of expression needed to express the "essence" of an object; on the other he steps into an abstract argument, the domain of philosophy, to define Pata-physics as "the science of imaginary solutions." (Fell 2010, 135)

The generally antipositivist discussion of pataphysical philosophy leads on to a generally antiempirical examination of the "vulgar" faith in sci-ence that had, in Jarry's view, replaced the old superstitions of religion. He launches a scathing attack upon the "prejudice" of "universal assent" and asserts that, as Keith Beaumont explains, "the 'knowledge' revealed by or acquired through the senses is entirely *relative* to the perceiver," and the "scientific instruments of measurement, far from correcting the defects and distortions of the senses, merely magnify them and increase their relativ-ity" (Beaumont 1984, 193).

Contemporary science is founded upon the principle of induction: most people have seen a certain phenomenon precede or follow some other phenomenon most often, and conclude therefrom that it will ever be thus. Apart from other considerations, this is true only in the majority of cases, depends upon the point of view, and is codified only for convenience—if that! Instead of formulating the law of the fall of a body toward a center, how far more apposite would be the law of the ascension of a vacuum toward a periphery, a vacuum being considered a unit of non-density,

a hypothesis far less arbitrary than the choice of a concrete unit of positive density such as *water*?

For even this body is a postulate and an average man's point of view, and in order that its qualities, if not its nature, should remain fairly constant, it would be necessary to postulate that the height of human beings should remain more or less constant and mutually equivalent. Universal assent is already a quite miraculous and incomprehensible prejudice. Why should anyone claim that the shape of a watch is round—a manifestly false proposition—since it appears in profile as a narrow rectangular construction, elliptic on three sides; and why the devil should one only have noticed its shape at the moment of looking at the time?—Perhaps under the pretext of utility. But a child who draws a watch as a circle will also draw a house as a square, as a façade, without any justification, of course; because, except perhaps in the country, he will rarely see an isolated building, and even in a street the façades have the appearance of very oblique trapezoids.

We must, in fact, inevitably admit that the common herd (including small children and women) is too dimwitted to comprehend elliptic equations, and that its members are at one in a so-called universal assent because they are capable of perceiving only those curves having a single focal point, since it is easier to coincide with one point rather than with two. These people communicate and achieve equilibrium by the outer edge of their bellies, tangentially. But even the common herd has learned that the real universe is composed of ellipses. (Jarry 1965a [1911], 193–194)

The similarities between Jarry's 'pataphysics and twenty-first-century physics has already been discussed, but it is worth remarking here on how much he seems to anticipate current theories of antimatter. As Douglas Cruickshank has commented:

CERN's anti-matter press release states, "Newton's historic work on gravity was supposedly prompted by watching an apple fall to earth, but would an 'anti-apple' fall in the same way? It is believed that anti-matter 'works' under gravity in the same way as matter, but if nature has chosen otherwise, we must find out how and why." To which Jarry replied, ninety-odd years before CERN asked the question, "Instead of formulating the law of the fall of a body toward a center, how far more apposite would be the law of the ascension of a vacuum toward a periphery. . . ." (Cruickshank 1995)

Jarry goes on to describe "Faustroll smaller than Faustroll" by plundering the work of Sir William Crookes (1832–1919), a noted chemist and physicist who also tried to conduct a scientific study of certain preternatural phenomena associated with mediums. His address to the Society for Psychical Research in London on 29 January 1897 had been translated into French by May 1897, and told of the experiences of a homunculus on a cabbage leaf to illustrate the relativity of sense perception.

TO WILLIAM CROOKES
Other madmen cried ceaselessly that the figure
one was at the same time bigger and smaller
than itself, and proclaimed a number of similar
absurdities as if they were useful discoveries.
—The Talisman of Oromanes

Doctor Faustroll (if one may be permitted to speak from personal experience) desired one day to be smaller than himself and resolved to explore one of the elements, in order to examine any disturbances which this change in size might involve in their mutual relationship.

For this purpose he chose that substance which is normally liquid, colorless, incompressible and horizontal in small quantities; having a curved surface, blue in depth and with edges that tend to ebb and flow when it is stretched; which Aristotle terms heavy, like earth; the enemy of fire and renascent from it when decomposed explosively; which vaporizes at a hundred degrees, a temperature determined by this fact, and in a solid state floats upon itself—water, of course! And having shrunk to the classic size of a mite, as a paradigm of smallness, he traveled along the length of a cabbage leaf, paying no attention to his fellow mites or to the magnified aspect of his surroundings, until he encountered the Water.

This was a globe, twice his size, through whose transparency the outlines of the universe appeared to him gigantically enlarged, whilst his own image, reflected dimly by the leaves' foil, was magnified to his original size. He gave the orb a light tap, as if knocking on a door: the deracinated eye of malleable glass "adapted itself" like a living eye, became presbyopic, lengthened itself along its horizontal diameter into an ovoid myopia, repulsed Faustroll by means of this elastic inertia and became spherical once more.

The doctor, taking small steps, rolled the crystal globe, with some considerable difficulty, toward a neighboring globe, slipping on the rails of the cabbage leaf's veins; coming together, the two spheres sucked each other in, tapering in the process, until suddenly a new globe of twice the size rocked placidly in front of Faustroll.

With the tip of his boot the doctor kicked out at this unexpected development of the elements: an explosion, formidable in its fragmentation and noise, rang out following the projection all around of new and minute spheres, dry and hard as diamonds, that rolled to and fro all along the green arena, each one drawing along beneath it the image of the tangential point of the universe, distorting it according to the sphere's projection and magnifying its fabulous center.

Beneath everything, the chlorophyll, like a shoal of green fishes, followed its charted currents in the cabbage's subterranean canals. . . . (Jarry 1965a [1911], 194–195)

The similarly parodistic relationship between sections of *Faustroll* and the writings of Lord Kelvin has been discussed in earlier chapters. Jarry was aware of non-Newtonian physics, and the non-Euclidian geometries of Lobachevsky, Bolyai, and especially Bernhard Riemann (1826–1866),

whose mathematics described "impossible" parallel universes of n dimensions, and laid the foundations for the development of the Theory of General Relativity. Also, significantly, in 1897, Sir J. J. Thomson had identified the electron as a particle. Book VIII, chapter 37: "Concerning the Measuring Rod, the Watch and the Tuning Fork," then, is a rewriting in pataphysical terms of Kelvin's essays on "Electrical Units of Measurement," "Steps towards a Kinetic Theory of Matter," and "The Wave Theory of Light," in which "the measuring rod, the watch, the tuning fork, the luminiferous ether, the rotating fly-wheels and linked gyrostats, even the Scottish shoemaker's wax are to be found seriously expounded in the pages of Kelvin in connection with practical scientific experiments" (Jarry 1965a [1911], 275).

The final chapter of *Faustroll* attempts to calculate the surface of God, an exercise for which, as the Collège de 'Pataphysique notes in its annotated edition, only 'pataphysics is the exact science, since neither mathematics nor theology, nor the two combined, are adequate to the task. This chapter also seems to contain the ultimate synthesis of Ubu's admiration for perfect geometries and Faustroll's "I am God," not to mention Emmanuel Dieu's self-identification. It seems, in fact, to come directly from Jarry himself, in its mixture of visionary excess and mathematical precision.

A typical instance of this is the fusion of the visions of Anna Katherina Emmerick (1774–1824), a Roman Catholic Augustinian nun, stigmatic, and mystic, with the triangle "circumscribed around" a triangle. Emmerick's vision is strangely reminiscent of the image of the hermaphrodite in Michael Maier's alchemical symbology, seeing God as the Tau, or more accurately the letter Y. Since it is the *surface* of God that is defined, perhaps we should say that Jarry "symbolically attributes the properties of God, described by His virtuality, to His lineaments."

The chapter ends with the celebrated sentence: "La Pataphysique est la science . . ." which, as noted in chapter 1 above, may be open to several nuances of translation. Watson Taylor says: "let this remain, textually, the final pataphysical mystery," a sentiment which all pataphysicians would be happy to endorse.

God is, by definition, without dimension; it is permissible, however, for the clarity of our exposition, and though he possesses no dimensions, to endow him with any number of them greater than zero, if these dimensions vanish on both sides of our identities. We shall content ourselves with two dimensions; so that these flat geometrical signs may easily be written down on a sheet of paper.

Symbolically God is signified by a triangle, but the three Persons should not be regarded as being either its angles or its sides. They are *the three apexes* of another equilateral triangle circumscribed around the traditional one. This hypothesis con-

forms to the revelations of Anna Katherina Emmerick, who saw the cross (which we may consider to be the *symbol* of the *Verb* of God) in the form of a Y, a fact which she explains only by the physical reason that no arm of human length could be out-stretched far enough to reach the nails of the branches of a Tau.

Therefore, POSTULATE:

Until we are furnished with more ample information and for greater ease in our provisional estimates, let us suppose God to have the shape and symbolic appearance of three equal straight lines of length a, emanating from the same point and having between them angles of 120 degrees. From the space enclosed between these lines, or from the triangle obtained by joining the three farthest points of these straight lines, we propose to calculate the surface.

Let x be the median extension of one of the Persons a, $2y$ the side of the triangle to which it is perpendicular, N and P the extensions of the straight line $(a + x)$ in both directions *ad infinitum*.

Thus we have:

$$x = \infty - N - a - P.$$

But

$$N = \infty - 0$$

and

$$P = 0.$$

Therefore

$$x = \infty - (\infty - 0) - a - 0 = \infty - \infty + 0 - a - 0$$
$$x = -a.$$

In another respect, the right triangle whose sides are a, x, and y give us

$$a^2 = x^2 + y^2.$$

By substituting for x its value of $(-a)$ one arrives at

$$a^2 = (-a)^2 + y^2 = a^2 + y^2.$$

Whence

$$y^2 = a^2 - a^2 = 0$$

and

$$y = \sqrt{0}.$$

Therefore the surface of the equilateral triangle having for bisectors of its angles the three straight lines a will be

$$S = y(x + a) = \sqrt{0}(-a + a)$$
$$S = 0\sqrt{0}.$$

COROLLARY: At first consideration of the radical $\sqrt{0}$, we can affirm that *the surface calculated is one line at the most;* in the second place, if we construct the figure according to the values obtained for x and y, we can determine:

That the straight line *2y*, which we now know to be $2\sqrt{0}$, has its point of intersection on one of the straight lines a in the opposite direction to that of our first hypothesis, since $x = -a$; also, that the base of our triangle coincides with its apex;

That the two straight lines a make, together with the first one, angles at least smaller than 60°, and what is more can only attain $2\sqrt{0}$ by coinciding with the first straight line a.

Which conforms to the dogma of the equivalence of the three Persons between themselves and in their totality.

We can say that a is a straight line connecting 0 and ∞, and can define God thus:

DEFINITION: *God is the shortest distance between zero and infinity.*

In which direction? one may ask.

We shall reply that His first name is not Jack, but *Plus-and-Minus*. And one should say:

± *God is the shortest distance between 0 and ∞, in either direction.*

Which conforms to the belief in the two principles; but it is more correct to attribute the sign + to that of the subject's faith.

But God being without dimension is not a line.

—Let us note, in fact, that, according to the formula

$$\infty - 0 - a + a + 0 = \infty$$

the length a is nil, so that a is not a line but a point.

Therefore, *definitively*:

GOD IS THE TANGENTIAL POINT BETWEEN ZERO AND INFINITY. Pataphysics is *the* science . . .

NOTES

--

PREFACE

1. One who practices pataphysics is generally called a pataphysician. The more logical "pataphysicist" is less frequently used. An oft-repeated cry says: "we are all pataphysicians."

2. Chameleon-eyed readers will already have noticed the curious appearances and disappearances of an apostrophe before the word. The reasons for this will be discussed in much more detail in chapter 1. For now, note that this book will follow the convention that the preceding apostrophe denotes conscious or, to express it better, *voluntary* 'pataphysics, whereas its absence signifies the opposite.

1 GENERAL INTRODUCTION

1. Recounted by Basarab Nicolescu, theoretical physicist at the Centre National de la Recherche Scientifique, Paris, in conversation with the author on 24 January 2009. Nicolescu is also the author of books on René Daumal and others, and is well acquainted with pataphysical literature.

2. Simon Watson Taylor's translation of this word (*surajoute*) was "superinduced" (Jarry 1965a [1911], 192). Here we have preferred the revised translation given by Alastair Brotchie (Brotchie 2011, 30).

3. The song was sung to Charles Pourny's tune "La Valse des pruneaux" in the lycée of Rennes. Claude Terrasse's later setting was composed for the performances at the Théâtre des Pantins in 1898.

4. A lost portrait of Jarry by Henri Rousseau reportedly depicted a chameleon perched on his shoulder (Brotchie 2011, 81).

5. Almighty God has left a hair in a brothel, and panics when it starts leaping about and making a noise that might betray his visit. "Moi, jusqu'ici, je m'étais cru le Tout-Puissant; mais, non; je dois abaisser le cou devant le remords qui me crie: 'Tu n'es qu'un misérable!' Ne fais pas de pareils bonds! Tais-toi . . . tais-toi . . . si quelqu'un t'entendait!" *Les Chants de Maldoror*, Chant III. (Up until now, I believed myself to be the All-Powerful; but no; now I am forced to hang my head in shame and admit I am a miserable wretch! Don't leap about so! Be quiet . . . be quiet . . . in case someone hears you!)

6. "Adelphism" is here a distortion of the idea of brotherly love into a homosexual love of oneself and one's own past perceived in the eye of another. "Sengle, in love with the Memory of Self, was in need of a living, visible friend, since he had no recollection of his Self, being wholly devoid of memory."

7. In the *Critique of Pure Reason* (1781) Kant describes the noumenon as a spiritual value, a thing-in-itself, which "can never be thought of as an object of the senses."

8. The opening word of *Ubu Roi* will be discussed in much more detail later, but almost amounts to a theme in its own right.

9. Keith Beaumont makes the point that "although its author subtitled it a 'novel,' [it] might just as aptly have been called a 'prose poem'" (Beaumont 1984, 169).

10. "Now what is the luminiferous æther? It is matter prodigiously less dense than air—millions and millions and millions of times less dense than air. We can form some sort of idea of its limitations. We believe it is a real thing, with great rigidity in comparison with its density: it may be made to vibrate 400 million million times per second; and yet be of such density as not to produce the slightest resistance to any body going through it." W. Thomson, "On the Wave Theory of Light," lecture, Franklin Institute, Philadelphia, 29 September 1884.

11. According to the Fasquelle manuscript of *Faustroll*, the correct orthography of this word is "EtHernité" (Collège de 'Pataphysique 2010, 432).

12. As the Collège de 'Pataphysique has pointed out, the name is given in the Fasquelle manuscript of *Faustroll* as "Ibicrate," the first three letters of which self-consciously resemble "Ubu," whereas the earlier Lormel manuscript gave it as "Ybicrate," a form that is impossible in Greek (as Jarry evidently realized).

13. In *Organographe 6*, the Collège de 'Pataphysique discusses the fragments of St. Sophrotatos in considerable detail, observing that they comprise translations by Jarry of texts in Latin which include references to the Revelation of St. John the Divine, heraldry, and a "great work" entitled *Caesar-Antichrist* written by a certain R. P. Ubu, of the Company of Jesus (Collège de 'Pataphysique 1978, 47–49).

2 (2000 ONWARD) DISOCCULTATION

1. There was much debate within the Collège, in the years leading up to this event, as to whether "2000" referred to the imminent millennium or to 2000 E.P., 2000 years after the birth of Jarry. The matter was eventually settled by an edict from the Vice-Curator.

2. Contrary to persistent rumors, it is in fact easy to join the Collège (leaving is the more difficult operation). Membership details are given on this site: <http://www.college-de-pataphysique.fr>.

3. See, for example, A. Jones, *Plunderphonics, 'Pataphysics and Pop Mechanics* (Wembley: SAF Publishing, 1995).

4. This project is based in the Institute of Creative Technologies, at De Montfort University, Leicester, UK, where Dr. Hendler, who is based at Rensselaer Polytechnic Institute, New York State, is Visiting Professor.

3 (1975-2000) OCCULTATION

1. Thieri Foulc has pointed out that these meetings at a station in the Massif Central were actually organized by the group called Banalyse (their interest was in cultivating banality or nonevents), some of whom joined the Collège. The abandoned station was situated in the middle of nowhere and was chosen because of its name, which was not "Marrant" but Les Fades (which roughly translates as "the tasteless"). (Thieri Foulc, email to the author, 23 January 2012.)

2. *La Disparition* has been translated into English more than once, but the version entitled *A Void*, translated by Gilbert Adair (and retaining the constraint), is the most readily available (Perec 1994).

4 (1964-1975) PATAPHYSICS, 'PATAPHYSICS

1. The name Hawkwind apparently came from an early band member's unappealing habit of clearing his throat (hawking) and excessive flatulence (wind).

2. A substantial archive of situationism exists online at <http://www.cddc.vt.edu/sionline/index.html>

3. "'Jargon' is doubtless a yellowish diamond of noticeably lower value than 'white' diamonds. But I decline this not very relevant eulogy, however subtly expressed." (Note by the Collège.)

5 (1959-1964) UNIVERSAL PATAPHYSICS

1. The *Organon* was the collection of six books on logic used at the Athenian Lyceum founded by Aristotle. Francis Bacon wrote his *Novum Organum* in 1620 as an attack on Aristotle's system.

2. Paul Audi has explored the Lacanian questions of desire posed by *The Supermale*: What does it mean to make love? What exactly does one do when one "makes love"? And what is this love that we say has been "made"? He makes a convincing case for Lacan as an (involuntary) pataphysician (Audi 2011).

3. Socrates, the pataphysician, could of course prove anything by asking a few questions. In this case, the exchange ends thus: "*Socrates:* Then he who does not know still has true notions of that which he does not know. *Meno:* He has." (Shattuck's note.)

4. *Clinamen* . . . creeps frequently enough into Sartre's writing to arouse suspicion. Could *L'Être et le néant* (see pp. 471 and 529; also "Réponse à Albert Camus" in *Les Temps modernes*) amount to a massive and apocryphal demonstration of the Science of Sciences? (Shattuck's note.)

5. English-speaking members of the Collège are still deliberating over the correct translation of this sentence. "'Pataphysics is the science." "'Pataphysics is the one science." "'Pataphysics is all science." "'Pataphysics is the only science." "'Pataphysics is science." "'Pataphysics is the science of . . ." (Shattuck's note.)

6. Imperturbability is not just a dignified version of "cool kick." "Playing it cool" means indifference and is, at best, an indifferent game. The pataphysician is concerned; not through engagement in an attempt to create human values, but in the manner of the child looking through a kaleidoscope or the astronomer studying the galaxy. (Shattuck's note.)

7. Valentin Brû is the unassuming hero of Raymond Queneau's 1952 novel *Le Dimanche de la vie* (The Sunday of Life).

6 (1948-1959) LE COLLÈGE DE 'PATAPHYSIQUE

1. Shakespeare and Company still performs that role today, specializing in English-language literature in the heart of Paris, and offering accommodation to "tumbleweeds," young writers who earn their keep by working in the store.

2. Note that Ubu is made Count of Sandomir by King Wenceslas in *Ubu Roi*.

3. Although Mélanie Le Plumet seems also to have been a cat.

4. His "civil pseudonym" was Emmanuel Peillet, under which he published *La Philosophie du départ* (Saint-Thibault-des-Vignes: Éd. Coclea, 1939), and a book of 36 photographs entitled *Églises & châteaux de la vallée de l'Ardre* (Reims: Chez l'auteur, 1951). Under the name Mélanie Le Plumet, he published *L'Ordre* (Paris: Éditions du ver solitaire, 1944), and as Lathis he published *L'Organiste Athée* (Collège de 'Pataphysique, 1964).

5. The Almanachs are wittily (and daringly) illustrated by Pierre Bonnard, and include contributions from Claude Terrasse, Félicien Fagus, and the publisher Ambroise Vollard.

6. See *Doctor Faustroll*, chapter 8.

7. "It should be noted that this poem describes an eschatologico-revolutionary vision of the 'landscape,' putting everything in the future; the title given by Prévert was in reality 'Le Paysage changera' (the landscape will change). The term 'changeur' (changer), a simple typo in 1938, was duly reproduced in 1944. And it was confirmed by Prévert in 1947 when he included the poem in the second edition of *Paroles*." (Foulc et al. 2008, 65)

7 (1907-1948) DADA, SURREALISM, AND 'PATAPHYSICS

1. Telegram to the Friar's Club of Beverly Hills, to which he belonged (Marx 1959, 321).

2. The Collège, like the rest of the world, seems to have been rather less interested in Zeppo and Gummo.

3. Jerry Lewis was awarded the Légion d'Honneur on his 80th birthday, and Woody Allen led the efforts to create a new Entente Cordiale between France and the USA after the row over the war in Iraq.

4. "Freedonian" has passed into popular parlance as an adjective to describe a place like Freedonia: all too believable, yet completely obscure.

5. Or "gags" if you will, since "gag" would have a wider acceptance than Imaginary Solutions. Those of Laurel and Hardy, founded on physical destruction, or those of Fields which are more, in this film at least, comedy of morals (even if Fields is to American classic comedy what Ionesco is to Molière) do not fall under the same heading of Science.

6. Michel Audiard (1920–1985) was a dialog writer and film director.

7. Chapter 23 of John Richardson's biography of Picasso, for example, is entitled "The Absence of Jarry."

8. This work, a bicycle wheel (*roue*) inverted upon a stool (*selle*), thus also secretes a homage to Roussel (Gough-Cooper and Caumont 1993, 4 June).

9. These were four of the five hearts that traveled the Jura-Paris road. However, Henderson suggests that the fifth heart on the Jura-Paris road could in fact belong to Picabia's chauffeur, Victor (Henderson 1998, 37), or indeed that the car had a five-cylinder engine.

10. See, for example, Sanouillet (1973, 47–55); Paz (1978, 134–136); and Henderson (1998, 51–57).

11. *Fountain*, for example, was reproduced in an "artist's multiple" of eight copies for distribution to leading museums in 1964.

12. "In the manuscript [. . .] Faustroll had noted a small fragment of the Beautiful that he knew, and a small fragment of the True that he knew, during the syzygy of words [. . .]" (Jarry 2006 [1897], 204).

13. See Duchamp's notes on *Cast Shadows* (Duchamp 1975, 72); and this from *À l'infinitif*: "*The shadow* cast by a 4-dim'l figure on our space is a *3-dim'l* shadow [. . .]" (ibid., 89).

14. Henderson notes that the standard translation of Duchamp's notes for *The Green Box* renders "écarts de molécules" as "distance between molecules," whereas in fact

the note should read: *"Try to find a way to distribute the 'swervings of molecules'? according to the form* of each part (roundness, flatness . . .)." The quotation marks indicate Duchamp's knowing reference to the *clinamen* (Henderson 1998, 136–137).

15. Perhaps we hear here an echo of Jarry's dialogue between Fear and Love: "La première marque l'heure, la deuxième entraîne les minutes, et la troisième, toujours immobile, éternise mon indifférence." (The first marks the hour, the second urges on the minutes, and the third, forever motionless, eternalizes my indifference) (Jarry 1993 [1898], 59).

16. I.e., *art à succès* (successful art).

8 (1907-1948) UNCONSCIOUS PATAPHYSICS?

1. For example, "L'Évangile selon H.-P. Lovecraft," in *Subsidium* 11 (2 February 1971): 115–120; "Des Hrönir" and "Des Reliefs," in *Subsidium* 16 (14 July 1972): 31–45; and "Asimov et l'Histoire," in *Subsidium* 22 (22 December 1973): 64–66.

2. Jesus Borrego Gil, "Borges à la lettre," *Dossier* 26 (8 June 1964): 71–72.

3. Thieri Foulc, email to the author, 14 February 2012.

4. "Le rire naît de la découverte du contradictoire" (Laughter is born out of the discovery of the contradictory). Jarry on Bergson in *La Revue Blanche*.

5. It is worth noting that the tradition of *fous littéraires* (literary madmen) goes back at least to Auguste Ladrague, an occultist and fake Russian, who published a book of the same title in 1883, and further to Charles Nodier, whose 1835 volume *De quelques livres excentriques* (On some eccentric books) did much to establish the idea of literary "outsiders" who nevertheless had something to contribute to more orthodox fiction.

9 ALFRED JARRY (1873-1907)

1. Thieri Foulc, email to the author, 14 February 2012.

2. Jarry was mistaken here; the phrase should be "in philosophia."

3. There are also three pictures: a poster by Toulouse-Lautrec, *Jane Avril*; a poster by Bonnard, *La Revue Blanche*; a mysterious, and probably nonexistent, *Portrait of Mr. Faustroll* by Aubrey Beardsley; and a religious print of *Saint Cado*, from the Oberthür de Rennes publishers. There are several substitutions or changes of mind about the precise contents of the library between the earlier Lormel and later Fasquelle manuscripts of *Faustroll*, but the list of authors remained the same.

4. As Paul Edwards points out (Edwards 2001, 271), each word of this title has three meanings, giving a total of eighteen possible translations. *Minutes* = time/formal

document/small writing in a book of spells. *Sable* = sand (in an hourglass)/heraldic black/mourning weeds. *Mémorial* = memorial/memoirs/the Remembering.

5. The subtitle "roman néo-scientifique" ("neoscientific novel") appears only in the published version and not in the Lormel manuscript.

6. The street names that appear in *Faustroll* seem to suggest that the voyage might in fact follow the ancient bed of the River Seine (Jarry 2010a [1911], 89).

7. As with many of Jarry's characters, Bosse-de-Nage is in part a mocking portrait of a contemporary, in this case the Belgian poet Christian Beck, with whom Jarry had an altercation in 1897. However, equally typically, he is not *only* a parody. Beck functioned merely as a pretext for a character that fulfills a range of purposes in the parallel universe of *Faustroll*.

REFERENCES

This is not intended to be a comprehensive bibliography of pataphysics. Such a thing, even if it were possible, would occupy several volumes. Instead, this section lists only those sources which were consulted during the writing of the present book.

Anastasi, William. 1999. "Alfred Jarry and l'Accident of Duchamp." *Tout-fait: The Marcel Duchamp Studies Online Journal* (December). Available at http://www.toutfait .com/ (accessed 26 November 2010).

Anastasi, William. 2000. "Jarry, Joyce, Duchamp and Cage." *Tout-fait: The Marcel Duchamp Studies Online Journal* (May). Available at http://www.toutfait.com/ (accessed 22 November 2010).

Anastasi, William. 2004. "A Public Conversation with Jean-Michel Rabaté on Joyce and Duchamp via Jarry." Available at http://slought.org/content/11192/

Anastasi, William. 2005. *William Anastasi's Pataphysical Society: Jarry, Joyce, Duchamp and Cage.* Ed. Aaron Levy and Jean-Michel Rabaté. Contemporary Artist's Series No. 3. Philadelphia: Slought Books.

Apollinaire, Guillaume. 1925. *Il y a.* Paris: Albert Messein.

Apollinaire, Guillaume. 2006. *Œuvres en prose complètes.* Vol. 4. Ed. Louis Arman. Paris: Bibliothèque de la Pléiade.

Apollinaire, Guillaume. 2011 [1909]. Extract from "Feu Alfred Jarry." Trans. Stanley Chapman. In Alastair Brotchie, *Alfred Jarry: A Pataphysical Life*, 293. Cambridge, Mass.: MIT Press

Arnaud, Noël. 1974. *Alfred Jarry: d'Ubu Roi au Docteur Faustroll.* Paris: La Table Ronde.

Arnaud, Noël. 2002. "Des lieux il en est de toutes sortes . . ." *Restaurant Polidor.* Available at http://www.polidor.com/ (accessed 23 October 2010).

Arrivé, Michel. 1972. *Les Langages de Jarry, essai de sémiotique littéraire.* Paris: Éditions Klincksieck.

Arrivé, Michel. 1976. *Lire Jarry.* Brussels: Éditions Complexe, Collection "Dialectiques."

Artaud, Antonin. 1958 [1938]. *The Theater and Its Double.* New York: Grove Weidenfeld.

Artaud, Antonin. 1963. *Artaud Anthology.* San Francisco: City Lights.

Artaud, Antonin. 1971. *Collected Works of Antonin Artaud*. Trans. Victor Corti. London: Calder and Boyars.

Ashbery, John. 1956. "The Instruction Manual." In Ashbery, *Some Trees*. 14–18. New York: Georges Borchardt.

Ashbery, John. 1986. "On Raymond Roussel." In Michel Foucault, *Death and the Labyrinth*. 189–204. New York: Continuum.

Ashbery, John. 2000. *Other Traditions*. Cambridge, MA: Harvard University Press.

Audi, Paul. 2011. *Le Théorème du Surmâle: Lacan selon Jarry*. Lagrasse: Éditions Verdier.

Aulard, Marie-Louise. 1961. "Mythe et littérature." *Dossiers du Collège de 'Pataphysique* 15 (29 June): 89–96.

Aulard, Marie-Louise. 1965. "Prolepses." *Subsidia du Collège de 'Pataphysique* 0 (10 August): 9.

Baigent, Michael, Richard Leigh, and Henry Lincoln. 1983. *The Holy Blood and the Holy Grail*. London: Corgi.

Ballard, James Graham. 1973a. "The Assassination of John Fitzgerald Kennedy as a Downhill Motor Race." In *Evergreen Review* 96 (Spring). Available at http://jgballard .com/

Ballard, James Graham. 1973b. *Crash*. London: Jonathan Cape.

Ballard, James Graham. 2001. *The Complete Short Stories*. Vol. 1. London: Flamingo.

Barker, Stephen. 1989. "Canon-fodder: Nietzsche, Jarry, Derrida (The Play of Discourse and the Discourse of Play)." *Journal of Dramatic Theory and Criticism* (Fall): 69–83.

Barnes, Julian. 1996. "Gnossienne." In *Cross Channel*, 115–128. London: Jonathan Cape.

Barthes, Roland. 1977 [1967]. "The Death of the Author." In *Image, Music, Text*, 142–148. London: Fontana.

Baudrillard, Jean. 1992. "Pataphysics of the Year 2000." University of Texas at Arlington. Available at http://www.egs.edu/faculty/jean-baudrillard/articles /pataphysics-of-year-2000/ (accessed 15 November 2011).

Baudrillard, Jean. 2001. *Fragments: Conversations with François L'Yvonnet*. Trans. Chris Turner. New York: Routledge.

Baudrillard, Jean. 2002. *Pataphysique*. Paris: Sens & Tonka.

Baudrillard, Jean. 2005. *The Intelligence of Evil or the Lucidity Pact*. Trans. Chris Turner. Oxford: Berg.

Beaumont, Keith. 1984. *Alfred Jarry: A Critical and Biographical Study*. Leicester: Leicester University Press.

Beaumont, Keith. 1987. *Jarry: Ubu Roi*. London: Grant and Cutler.

Beckett, Samuel. 1976 [1953]. *Watt*. London: John Calder.

Beebe, Aaron, Zoe Beloff, Amy Herzog, and Norman Klein. 2009. *The Coney Island Amateur Psychoanalytic Society and Its Circle*. New York: Christine Burgin.

Bellos, David. 1993. *Georges Perec: A Life in Words*. London: Harvill.

Bénabou, Marcel. 1986. *Pourquoi je n'ai écrit aucun de mes livres*. Paris: Hachette.

Bens, Jacques. 2005 [1980]. *Genèse de l'Oulipo 1960–1963*. Paris: Le Castor astral.

Bergson, Henri. 1900. *Le Rire. Essai sur la signification du comique*. Paris: Revue de Paris.

Besnier, Patrick. 2005. *Alfred Jarry*. Paris: Fayard.

Blavier, André. 1982. *Les Fous littéraires*. Paris: Veyrier.

Bloom, Harold. 1972. "Clinamen or Poetic Misprision." *New Literary History* 3: 373–391.

Bök, Christian. 1994. *Chrystallography*. Toronto: Coach House Books.

Bök, Christian. 2001. *Eunoia*. Toronto: Coach House Books.

Bök, Christian. 2002. *'Pataphysics: The Poetics of an Imaginary Science*. Illinois: Northwestern University Press.

Bordillon, Henri. 1986. *Gestes et opinions d'Alfred Jarry, écrivain*. Laval: Éditions Siloë.

Borges, Jorge Luis. 1962. *Ficciones*. New York: Grove Press.

Borges, Jorge Luis. 1964 [1942]. "The Analytical Language of John Wilkins." In *Other Inquisitions 1937–1952*, 101–105. Trans. Ruth Simms. Austin: University of Texas Press.

Borges, Jorge Luis. 1979 [1975]. *The Book of Sand*. Harmondsworth: Penguin.

Borges, Jorge Luis. 1981. *Labyrinths*. Ed. and trans. Donald A. Yates and James E. Irby. Harmondsworth: Penguin.

Borges, Jorge Luis. 1998. *Collected Fictions*. Ed. and Trans. Andrew Hurley. New York: Viking.

Borges, Jorge Luis. 1999 [1937]. "Ramon Lull's Thinking Machine." In *The Total Library: Non-fiction 1922–1986*, 155–160. Ed. Eliot Weinberger. Trans. Esther Allen, Suzanne Jill Levine, and Eliot Weinberger. Harmondsworth: Penguin.

Borges, Jorge Luis. 2005 [1957]. *The Book of Imaginary Beings*. New York: Viking.

Borsky. 2005. *Clinamen blog*. Available at http://clinamen23.blogspot.com (accessed 19 August 2010).

Boudard, Alphonse, and Luc Étienne. 1970. *La Méthode à Mimile*. Paris: La Jeune Parque.

Breton, André. 1995 [1951]. "Alfred Jarry as Precursor and Initiator." In *Free Rein*, 247–256. Trans. Michel Parmentier and Jacqueline d'Amboise. Lincoln: University of Nebraska Press.

Breton, André. 1996 [1924]. *The Lost Steps*. Trans. Mark Polizzotti. Lincoln: University of Nebraska Press.

Breton, André. 1997 [1940]. *Anthology of Black Humour*. Trans. Mark Polizzotti. London: Telegram.

Bridgeman, Teresa. 1991. "Innovation and Ambiguity: Sources of Confusion in Personal Identity in *Les Jours et Les Nuits*." *French Studies. Quarterly Review* (July): 295–307.

Brisset, Jean-Pierre. 1870. *La Natation ou l'art de nager appris seul en moins d'une heure*. Paris: Garnier Frères.

Brisset, Jean-Pierre. 1980a [1878]. *La Grammaire logique*. Paris: Baudouin.

Brisset, Jean-Pierre. 1980b [1913]. *Les Origines humaines*. Paris: Baudouin.

Brisset, Jean-Pierre. 1985. "The Great Law." In *Atlas Anthology III*, trans. Martin Sorrell, 60–61. London: Atlas Press.

Brisset, Jean-Pierre. 2005. "L'Apparition du sexe." In *Le Brisset sans peine*, ed. Gilles Rosière, 26–28. Paris: Gingko.

Brotchie, Alastair. 1991. *The Problem of the Wordr*. London: Atlas Press.

Brotchie, Alastair, ed. 1995. *A True History of the College of 'Pataphysics*. Trans. Paul Edwards. *The Printed Head III* (10/11).

Brotchie, Alastair. 1997. "Jarry et l'Angleterre: Bibliographie." *L'Étoile-Absinthe* 73–74: 4–23.

Brotchie, Alastair, ed. 2001. *Alfred Jarry: Adventures in 'Pataphysics*. Trans. Paul Edwards. London: Atlas Press.

Brotchie, Alastair. 2011. *Alfred Jarry: A Pataphysical Life*. Cambridge, Mass.: MIT Press.

Brotchie, Alastair, and Stanley Chapman. 2007. *Alfred Jarry, Necrologies*. London: Atlas Press/London Institute of 'Pataphysics.

Brotchie, Alastair, et al. 2003. *'Pataphysics: Definitions and Citations*. Departmental Papers of the LIP, Department of Dogma and Theory. Vol. 1. London: London Institute of Pataphysics.

Bryars, Gavin. 1990. "The Sinking of the Titanic at Xebec." Available at http://www
.gavinbryars.com/Pages/titanic_xebec.html (accessed 8 March 2010).

Bullin, Til. 1995. "Third Manifesto of the College of 'Pataphysics." Trans. Paul
Edwards. *The Printed Head III* (10/11): 93–97.

Cabanne, Pierre. 1971. *Dialogues with Marcel Duchamp*. London: Thames and
Hudson.

Calvino, Italo. 1977 [1957]. *The Baron in the Trees*. Trans. Archibald Colquhoun.
Orlando: Mariner Books.

Calvino, Italo. 1981 [1957]. "Le Château des destins croisés." In Oulipo, *Atlas de lit-
térature potentielle*, 382–386. Paris: Gallimard.

Calvino, Italo. 1982 [1979]. *If on a Winter's Night a Traveller*. Trans. William Weaver.
London: Picador.

Calvino, Italo. 1984. "Comment j'ai écrit un de mes livres." *Bibliothèque oulipienne* 2
(20).

Calvino, Italo. 2002 [1965]. *The Complete Cosmicomics*. New York: Penguin.

Caradec, François. 1997 [1972]. *Raymond Roussel 1877–1933*. Paris: Fayard.

Caradec, François, and Jean Nohain. 1967. *Le Pétomane 1857–1945*. Los Angeles:
Sherbourne.

Carelman, Jacques. 1969. *Catalogue d'objets introuvables*. 2 vols. Paris: Éditions
Balland.

Carrouges, Michel. 1975. *Le macchine celibi / The Bachelor Machines*. Venice: Alfieri.

Carter, Angela. 1972. *The Infernal Desire Machines of Doctor Hoffman*. Harmonds-
worth: Penguin.

Cathé, Philippe. 2004. *Claude Terrasse*. Paris: L'Hexaèdre.

Chapman, Stanley. 1978. "Note to A Hundred Thousand Billion Poems." *Prospice* 8:
57–66.

Chapman, Stanley. 1993. "Lettre [à Yves Simon]." *Xiana* 2 (13): 64.

Chassé, Charles. 1921. *Sous le masque d'Alfred Jarry? Les sources d'Ubu Roi*. Paris: H.
Floury.

Chassé, Charles. 1947. *Dans les coulisses de la gloire: d'Ubu Roi au douanier Rousseau*.
Paris: Éditions de la Nouvelle revue critique.

Clair, René. 1924. *Entr'acte*. Film directed by René Clair. Produced by Rolf de Maré.
Performed by Francis Picabia, Marcel Duchamp, Man Ray, Jean Börlin, et al. Music
by Erik Satie.

Clements, Cal, ed. 2002. *Pataphysica.* Lincoln, NE: Writers Club Press.

Clements, Cal, ed. 2004. *Pataphysica 2: Pataphysica e Alchimia.* Lincoln, Nebr.: Writers Club Press.

Clements, Cal, ed. 2006. *Pataphysica 4: Pataphysica e Alchimia 2.* Lincoln, Nebr.: Writers Club Press.

Collège de 'Pataphysique. 1950–1957. *Cahiers du Collège de 'Pataphysique.* 28 vols. Paris: Collège de 'Pataphysique.

Collège de 'Pataphysique. 1957–1965. *Dossiers du Collège de 'Pataphysique.* 28 vols. Paris: Collège de 'Pataphysique.

Collège de 'Pataphysique. 1965–1975. *Subsidia Pataphysica.* 28 vols. Paris: Collège de 'Pataphysique.

Collège de 'Pataphysique. 1967. *Peintures, gravures et dessins d'Alfred Jarry.* Paris: Collège de 'Pataphysique.

Collège de 'Pataphysique. 1970. *Promptuaire: Publications du Collège de 'Pataphysique.* Paris: Collège de 'Pataphysique.

Collège de 'Pataphysique. 2000–2007. *Carnets Trimestriels du Collège de 'Pataphysique.* 28 vols. Paris: Collège de 'Pataphysique.

Collège de 'Pataphysique. 2008–. *Le Correspondancier du Collège de 'Pataphysique.* 18+ vols. Paris: Collège de 'Pataphysique.

Collège de 'Pataphysique. *Collège de 'Pataphysique.* Available at http://www.college-de-pataphysique.fr/ (accessed 22 January 2012).

College of 'Pataphysics. 1993. *The True, the Good, the Beautiful: An Elementary Chrestomathy of 'Pataphysics.* Trans. Andrew Hugill, Antony Melville, and Iain White. Vols. II, 11/12. London: Atlas Press /The Printed Head.

College of 'Pataphysics. 1993. [1961]. "'Pataphysics as Apostasy." Trans. Antony Melville. *Printed Head* II (11/12):5.

Conover, Roger, Terry Hale, and Paul Lenti, eds. 1995. *Arthur Cravan, Jacques Rigaut, Julien Torma, and Jacques Vaché: 4 Dada Suicides.* Trans. Terry Hale, Paul Lenti, and Iain White. London: Atlas Press.

Corliss, William Roger. 1974–. *The Sourcebook Project (Catalog of Anomalies).* Available at http://www.science-frontiers.com/sourcebk.htm (accessed 23 February 2009).

Crastre, Victor. 1952. *André Breton.* Paris: Arcanes.

Crookes, William. 1898. "Writings by Sir William Crookes on Psychical Research." In O'Neill, Kevin. *Regarding Psychic Research.* Available at http://www.oneillselectronicmuseum.com/crookesnotes1.html (accessed 17 December 2010).

Cruickshank, Douglas. 1995. "Why Anti-matter Matters." *Review of Arts, Literature, Philosophy and the Humanities* 11 (2) (Summer). Available at http://www.ralphmag .org/jarry.html (accessed 19 November 2011).

Cymbalum Pataphysicum. 1975–1983. *Organographes du Cymbalum Pataphysicum.* 22 vols. Paris: Collège de 'Pataphysique.

Cymbalum Pataphysicum. 1986. "L'Organisation collégiale." *Monitoires du Cymbalum Pataphysicum* 1 (14 July): 46–47.

Cymbalum Pataphysicum. 1986–1996. *Monitoires du Cymbalum Pataphysicum.* 41 vols. Paris: Collège de 'Pataphysique.

Cymbalum Pataphysicum. 1996–2000. *L'Expectateur.* 16 vols. Paris: Collège de 'Pataphysique.

Dalí, Savador. 1935. *La Conquête de l'irrationel.* Paris: Éditions Surréalistes.

Daumal, René. 1954 [1932]. "Traité des patagrammes." *Cahiers du Collège de 'Pataphysique* 16 (September 8): 1–26.

Daumal, René. [1938] 1969. *La Grande Beuverie.* Paris: Gallimard.

Daumal, René. 1972. *L'Évidence absurde: essais et notes, I (1926–1934).* Paris: Gallimard.

Daumal, René. 1991a. *The Powers of the Word: Selected Essays and Notes 1927–1943.* Trans. Mark Polizzotti. San Francisco: City Lights.

Daumal, René. 1991b [1929]. "Pataphysics and the Revelation of Laughter." In *The Powers of the Word: Selected Essays and Notes 1927–1943,* 15–22. Trans. Mark Polizzotti. San Francisco: City Lights.

Daumal, René. [1952] 2004. *Mount Analogue: A Tale of Non-Euclidian and Symbolically Authentic Mountaineering Adventures.* Cosman, Carol, (trans.). New York: Overlook Press.

de Duve, Thierry. 1996. *Kant after Duchamp.* Cambridge, Mass.: MIT Press.

De Nederlandse Academie voor 'Patafysica. *De Nederlandse Academie voor 'Patafysica.* Available at http://www.batafysica.nl.

Debord, Guy. 1981 [1958]. "Theory of the Dérive." In *Situationist International Anthology,* 50–54. Trans. Ken Knabb. Berkeley: Bureau of Public Secrets.

Debord, Guy. 2002 [1967]. *The Society of the Spectacle.* Trans. Ken Knabb. London: Rebel Press.

Debord, Guy and Wolman, Gil. 1981 [1956]. "Methods of Détournement." In *Situationist International Anthology,* 8–14. Trans. Ken Knabb. Berkeley: Bureau of Public Secrets.

Décimo, Marc. 1986. *Jean-Pierre Brisset, prince des penseurs*. Paris: Éditions Ramsey.

Décimo, Marc. 2001. *Jean-Pierre Brisset: prince des penseurs, inventeur, grammairien et prophète*. Dijon: Les Presses du Réel.

Décollage de 'Pataphysique. 2008. *Ubundão*.Available at http://www.ubundao .blogspot.com/ (accessed 16 July 2011).

Deleuze, Gilles. 1997 [1993]. "An Unrecognized Precursor to Heidegger: Alfred Jarry." [Un précurseur mal connu de Heidegger: Alfred Jarry.] In *Essays Critical and Clinical*, 91–98. Trans. Daniel W. Smith and Michael A. Greco. Minneapolis: University of Minnesota Press.

Deleuze, Gilles. 2004. *Desert Islands and Other Texts*. Ed. David Lapoujade. Trans. Michael Taormina. New York: Semiotext(e).

Derrida, Jacques. 1997 [1978]. "The Theater of Cruelty and the Closure of Representation." In Timothy Murray, ed., *Mimesis, Masochism and Mime: The Politics of Theatricality in Contemporary French Thought*, 40–60. Ann Arbor: University of Michigan Press.

d'Harnoncourt, Anne, and Kynaston L. McShine. 1973. *Marcel Duchamp*. New York: Museum of Modern Art.

Donohue, Keith. 2007. "Introduction to the novels of Flann O'Brien." In *The Complete Novels by Flann O'Brien*, ix–xvii. New York: Random House.

Douzet, André. 2004. "A strange document, signed 'de Chérisey'." *Société Perillos*. Available at http://www.perillos.com/aa_review.html (accessed 17 January 2010).

Drake, David. 2002. *Intellectuals and Politics in Post-War France*. New York: Palgrave.

Drucker, Johanna. 2009. *Speclab: Digital Aesthetics and Projects in Speculative Computing*. Chicago: University of Chicago Press.

Drucker, Johanna, and Bethany Nowviskie. 2004. "Speculative Computing: Aesthetic Provocations in Humanities Computing." In Susan Schreibman, Ray Siemens, and John Unsworth, eds., *A Companion to Digital Humanities*, 431–447. Oxford: Blackwell.

Dubbelboer, Marieke. 2009. "'Ubusing' Culture: Alfred Jarry's Subversive Poetics in the Almanachs du Père Ubu." *PhD Thesis*. Groningen: Rijksuniversiteit Groningen.

Dubuffet, Jean. 1961. "Musique Brut." Liner notes. Time Records. Available at http:// www.ubu.com/sound/dubuffet.html (accessed 9 June 2010).

Dubuffet, Jean. 1965. "Lettre à Latis." In *Prospectus et tous écrits suivants*, 391–392. Paris: Gallimard.

Dubuffet, Jean. 1986. *Batons rompus*. Paris: Les Éditions de Minuit.

Duchamp, Marcel. 1968. Interview by Joan Bakewell. *The Late Show Line Up*. BBC. 5 June.

Duchamp, Marcel. 1975. *Marchand du Sel: The Essential Writings of Marcel Duchamp*. Ed. Michel Sanouillet and Elmer Peterson. Trans. George Heard Hamilton. London: Thames and Hudson.

Duchamp, Marcel. 2009 [1946]. "Painting at the service of the mind." In Gloria Moure, *Marcel Duchamp: Works, Writings and Interviews*, 116–117. Berkeley: University of California Press.

Duchamp, Marcel, and Vitaly Halberstadt. 1932. *L'Opposition et les cases conjuguées sont réconciliées*. Paris: L'Échiquier.

Eco, Umberto. 1987. *Travels in Hyperreality*. London: Pan.

Eco, Umberto. 1992. *Interpretation and Overinterpretation*. New York: Cambridge University Press.

Eco, Umberto. 1994. *How to Travel with a Salmon and Other Essays*. Trans. William Weaver. New York: Harcourt.

Eco, Umberto. 2005. *Pastiches et postiches*. Trans. Bernard Guyader. Paris: LGF/Livre de poche.

Edwards, Paul. 1995. "fn. 16." In Alastair Brotchie, ed., *A True History of the College of 'Pataphysics*, 43. London: Atlas Press.

Edwards, Paul. 2001. "Notes to Essays." In *Alfred Jarry: Adventures in 'Pataphysics*, 312–320. London: Atlas Press.

Ellman, Richard. 1959. *James Joyce*. Oxford: Oxford University Press.

Enns, Anthony. 2002. "'Beyond Laughter': Nietzsche and Pataphysics." *Pataphysica* 1: 42–55.

Esslin, Martin. 1961. *The Theater of the Absurd*. New York: Peregrine.

Étienne, Luc. 1956. *L'Art du contrepet*. Paris: Jean-Jacques Pauvert.

Étienne, Luc. 1984. "Faut-il prendre la Pataphysique au sérieux?" Trans. Andrew Hugill. Oleyres: Centre de Recherches Périphériscopiques. Available at http://www .college-de-pataphysique.org (accessed 20 November 2011).

Fassio, Juan Esteban. 1964. "La Machine à lire Roussel." *Bizarre* 34/35 (2nd Trimester): 63–66.

Faustroll, Dr. 2009. *Dr Faustroll's Blog*. Available at http://drfaustrollwritesthewrongs. com (accessed 15 July 2011).

Fechner, Gustav Theodor. [1860] 1966. *Elements of Psychophysics*. Adler, Helmut E., (trans.). New York: Holt, Rinehart, and Winston.

Fechner, Gustav Theodor (Dr. Mises). 2011a [1825]. "The Comparative Anatomy of Angels." Trans. Malcolm Green. *Journal of the London Institute of 'Pataphysics* 1: 11–40.

Fechner, Gustav Theodor. [1904] 2011b. *The Little Book of Life after Death*. Memphis: General Books.

Feeney, Leonard Fr. 1943. *The Menace of Puns*. London: Longman.

Fell, Jill. 2000. "Breton, Jarry and the Genealogy of Paranoia-Critique." In Ramona Fotiade, ed., *André Breton: The Power of Language*, 111–123. Exeter: Elm Bank Publications.

Fell, Jill. 2010. *Alfred Jarry*. London: Reaktion.

Ferry, Jean. 1953. *Une Étude sur Raymond Roussel*. Paris: Arcanes.

Ferry, Jean. 1964. "Une autre étude sur Raymond Roussel." *Bizarre* 34/35 (2nd Trimester): 106–152.

Ferry, Jean. 1967. *L'Afrique des Impressions*. Paris: Jean-Jacques Pauvert.

Firmin, Gilles. 2008. "Sa Magnificence le Docteur Sandomir: Vice-Curateur Fondateur." In Thieri Foulc et al., *Le Cercle des pataphysiciens*, 53–57. Paris: Mille et une nuits.

Fisher, Ben. 2000. *The Pataphysician's Library: An Exploration of Alfred Jarry's livres pairs*. Liverpool: Liverpool University Press.

Ford, Mark. 2000. *Raymond Roussel and the Republic of Dreams*. London: Faber and Faber.

Foucault, Michel. 1970. *Sept propos sur le septième ange*. Paris: Fata Morgana.

Foucault, Michel. 1987. *Death and the Labyrinth: The World of Raymond Roussel*. Trans. Charles Ruas. London: Athlone Press.

Foulc, Thieri, et al. 2000. *Les Très Riches Heures du Collège de 'Pataphysique*. Paris: Fayard.

Foulc, Thieri, et al. 2008. *Le Cercle des pataphysiciens*. Paris: Mille et une nuits.

Foulc, Thieri, et al. 2011. *Jarry en ymages*. Paris: Gallimard.

Fournel, Paul. 1995. "Suburbia." In *Oulipo Laboratory*, i–16. Trans. Harry Mathews and Ian Monk. London: Atlas Press.

Franc-Nohain. 1911. "Pantagruel au Café Brosse." *Comoedia* (January).

Fulcanelli. 1971. *Le Mystère des Cathédrales*. Trans. Mary Sworder. Dartmouth: Neville Spearman.

Gardner, Martin. 1957. *Fads and Fallacies in the Name of Science*. Mineola, NY: Dover.

Gayot, Paul. 1973. "Pataphysique et science-fiction." *Subsidia Pataphysica* 22 (22 December): 45–54.

Gayot, Paul. 2008. "Umberto Eco, Satrape." In Thieri Foulc et al., *Le Cercle des pataphysiciens*, 96–99. Paris: Mille et une nuits.

Gayot, Paul, and Bélisaire Monomaque. 1971. "Approches historiques d'une praxis marxiste: rhétorique et action." *Subsidia Pataphysica* 11 (2 February): 135–140.

Genet, Jean. 2006. *Plays*. Vol. 1. London: Methuen.

Genet, Jean. 2009a [1958]. *The Blacks*. London: Faber and Faber.

Genet, Jean. 2009b [1946]. *The Maids*. London: Faber and Faber.

Genosko, Gary. 1993. "Fellow Doctors of Pataphysics: Ubu, Faustroll and Baudrillard." In Chris Rojek and Brian S. Turner, eds., *Forget Baudrillard?*, 146–159. New York: Routledge.

Gens d'Armes, Gandilhon. (January 1922.) Alfred Jarry au Lycée Henri IV. *Les Marges* 23 (91): 43.

Gervais, André. 1991. "Connections: Of Art and Arrhe." In Thierry de Duve, ed., *The Definitively Unfinished Marcel Duchamp*, 397–425. Cambridge, Mass.: MIT Press.

Giddings, Seth. 2007. "A 'Pataphysics Engine: Technology, Play, and Realities." *Games and Culture* 2 (4): 392–403.

Gide, André. 1946. "Le Groupement littéraire qu'arbritait le 'Mercure de France'." *Mercure de France* (October).

Gilchrist, Bruce, and Jo Joelson. 2002. *"The Hancock Project." Dora 4.* London: Institutum Pataphysicum Londiniense.

Goudemare, Sylvain. 1987. *Collègues de 'Pataphysque: Du Docteur Faustroll au Docteur Sandomir.* Paris: Librairie S. Goudemare.

Gough-Cooper, Jennifer, and Jacques Caumont. 1993. *Marcel Duchamp.* London: Thames and Hudson.

Gourmont, Remy de. 1994 [1898]. *Le Livre des masques*, ed. Andrew Mangravite. London: Atlas Press.

Griffith, Bill. 2002. "Understanding Zippy." *Zippy the Pinhead.* Available at http://www.zippythepinhead.com/ (accessed 21 August 2010).

Gunn, James Alexander. 2008. *Bergson and His Philosophy.* Toronto: Bastian Books.

Hale, Terry. 1995. "Julien Torma." In Conover et al., eds., *Arthur Cravan, Jacques Rigaut, Julien Torma, and Jacques Vaché: 4 Dada Suicides*, 132–148. London: Atlas Press.

Harris, Sharon. 2005. *Fun with 'Pataphysics*. Toronto: BookThug.

Henderson, Linda Dalrymple. 1998. *Duchamp in Context*. Princeton: Princeton University Press.

Hensher, Philip. 2008. "The Loo That Shook the World: Duchamp, Man Ray, Picabia." *The Independent* (21 February).

Hertz, Henri. 1924. "Alfred Jarry, Ubu Roi et les professeurs." *Nouvelle Revue Française* (September): 263–273.

Hierogamous Enterprises. 1978. *Jootsy Calculus*. Ed. Michael Halm. Available at http://michaelhalm.tripod.com/jootsy.htm (accessed 14 June 2010).

Home, Stewart. 1996. *What Is Situationism? A Reader*. Edinburgh: AK Press.

Hughes, H. Stuart. 2001. *The Obstructed Path: French Social Thought in the Years of Desperation, 1930–1960*. Piscataway, NJ: Transaction Publishers.

Hugill, Andrew. (writing as Andrew Thomson). 1987. "Mots relatifs aux Actes de Raymond Roussel—Selections from the critical writings about Roussel's theatre." In *Raymond Roussel*, Atlas Anthology 4: 13–24. London: Atlas Press.

Hugill, Andrew. 1994. *New Impressions of Africa*. Available at http://andrewhugill.com/nia/introduction.html (accessed 19 November 2011).

Hugill, Andrew. 2000. "Beckett, Duchamp and Chess in the 1930s." *Samuel Beckett. net*. Available at http://www.samuel-beckett.net/hugill.html (accessed 18 November 2009).

Hugill, Andrew. 2006. *'Pataphysics*. CD with booklet. London: Sonic Arts Network.

Ionesco, Eugène. 1980. "Entretien avec Eugène Ionesco." In Line McMurray, *Quatre leçons et deux devoirs de pataphysique*, 123–136. Trans. Mark S. P. Mason. Montreal: Liber.

Ionesco, Eugène. 1994. *Four Plays: The Bald Soprano; The Lesson; Jack, or the Submission; The Chairs*. New York: Grove Press.

Ionesco, Eugène. 2000. *Rhinoceros, The Chairs, and The Lesson*. London: Penguin Classics.

Istituto Patafisico Partenopeo. *Istituto di Patafisica Partenopeo*. Available at http://www.xoftp.com (accessed 15 July 2011).

Jacob, François. 1997. *Réception de M. François Jacob: discours prononcé dans la séance publique*. Paris: Académie Française.

Janet, Pierre. 1926. *De l'angoisse à l'extase*. Paris: Alcan.

Janis, H., and S. Janis. 1945. "Marcel Duchamp: Anti Artist." In J. Masheck, ed., *Marcel Duchamp in Perspective*, 18. Englewood Cliffs, NJ: Prentice-Hall, 1975.

Jarry, Alfred. 1953 [1896]. *King Turd*. Trans. Beverley Keith and George Legman. New York: Boar's Head.

Jarry, Alfred. 1965a [1911]. *Selected Works of Alfred Jarry*. Trans. Roger Shattuck and Simon Watson Taylor. London: Methuen.

Jarry, Alfred. 1965b [1894]. "Visions of Present and Future." In *Selected Works of Alfred Jarry*, 109–113. Trans. Roger Shattuck and Simon Watson Taylor. London: Methuen.

Jarry, Alfred. 1968a [1902]. *The Supermale*. Trans. Barbara Wright. London: Cape Editions.

Jarry, Alfred. 1968b. *The Ubu Plays*. Trans. Cyril Connolly and Simon Watson Taylor. London: Methuen.

Jarry, Alfred. 1972, 1987, 1988. *Œuvres complètes*. 3 vols. Paris: Gallimard, Pléiade series.

Jarry, Alfred. 1993 [1898]. *Visits of Love*. Trans. Iain White. London: Atlas Press.

Jarry, Alfred. 2001a [1894]. "To Be and to Live." In *Adventures in 'Pataphysics*, 199–201. Trans. Paul Edwards. London: Atlas Press.

Jarry, Alfred. 2001b. *Adventures in 'Pataphysics: Black Minutes of Memorial Sand; Caesar-Antichrist; Essays; Siloquies, Superloquies, Soliloquies and Interloquies in 'Pataphysics*. Trans. Paul Edwards and Antony Melville. Atlas Anti-Classic 8. London: Atlas Press.

Jarry, Alfred. 2004 [1901]. *Œuvres*. Paris: Robert Laffont.

Jarry, Alfred. 2006 [1897]. *Three Early Novels: Days and Nights; Exploits and Opinions of Doctor Faustroll, Pataphysician; Absolute Love*. Trans. Alexis Lykiard and Simon Watson Taylor. London: Atlas Press.

Jarry, Alfred. 2007 [1896]. *Chopping and Frucking. Ubu Roi*. Trans. Terry Hale. Hull: University of Hull.

Jarry, Alfred. 2010a [1897–1898]. *Gestes et opinions du Docteur Faustroll, pataphysicien*. Ed. Collège de Pataphysique. Paris: Éditions de la Différence.

Jarry, Alfred. 2010b [1894]. "Filiger." Trans. Dennis Duncan. *Journal of the London Institute of 'Pataphysics* 1: 41–49.

Jones, Andrew. 1995. *Plunderphonics, 'Pataphysics and Pop Mechanics*. Wembley: SAF Publishing.

Jorn, Asger. 1961. "La Pataphysique: une religion en formation." *Internationale Situationniste* 6 (August): 29–32.

Joseph, Chris. 2008. "After 391: Picabia's early multimedia experiments." Available at http://www.chrisjoseph.org/after391/ (accessed 12 November 2010).

Joyce, James. 1975a [1939]. *Finnegans Wake*. London: Faber.

Joyce, James. 1975b. *Selected Letters of James Joyce*. London: Faber and Faber.

Judt, Tony. 1992. *French Intellectuals: 1944–1956*. Los Angeles: University of California Press.

Klein, Norman M. 2009. "Freud in Coney Island." In Aaron Beebe, Zoe Beloff, Amy Herzog, and Norman Klein, *The Coney Island Amateur Psychoanalytic Society and Its Circle*, 19–50. New York: Christine Burgin.

Knabb, Ken, ed. and trans. 2006. *Situationist International Anthology*. Berkeley: Bureau of Public Secrets.

Kossy, Donna. 1994. *Kooks: A Guide to the Outer Limits of Human Belief*. Port Townsend, WA: Feral House.

Kostelanetz, Richard. 2001. *A Dictionary of the Avant-Gardes*. New York: Routledge.

LaBelle, Maurice M. 1980. *Alfred Jarry, Nihilism and the Theater of the Absurd*. New York: Gotham Library of the New York University Press.

La Lumière, Zekleyre. 2006. *La Pataphysique*. Available at http://oublogpo.over-blog.com/ (accessed 12 September 2010).

Latis. 1959. "Boris Vian." *Dossiers du Collège de 'Pataphysique* 7 (25 June): i–iv.

Launoir, Ruy. 2005. *Clefs pour la 'Pataphysique*. Paris: L'Hexaèdre.

Lebel, Robert. 1967. *Marcel Duchamp*. London: Penguin.

LeBrun, Annie. 1990. *Le Surmâle d'Alfred Jarry*. Paris: Ramsay-Jean-Jacques Pauvert.

LeBrun, Annie. 2010. *Vagit-Prop, Lâchez tout et autres textes*. Paris: Éditions du Sandre.

Le Lionnais, François. 1971. "Les Structures du roman policier: qui est le coupable?" *Subsidia Pataphysica* 15 (23 February): 16–18.

Le Lionnais, François. 1973. "La Lipo (Le premier manifeste)." In Oulipo, *La Littérature potentielle*, 15–18. Paris: Gallimard.

Lennon, Nigey. 1984. *Alfred Jarry: The Man with the Axe*. Los Angeles: Panjandrum.

Lennon, Nigey. 1995. *Being Frank. My Time with Frank Zappa*. Los Angeles: California Classic Books.

Lescure, Jean. 1973. "Petite histoire de l'Oulipo." In Oulipo, *La Littérature potentielle*, 28–40. Paris: Gallimard.

Leymarie, Michel. 2007. *Les Intellectuels et la politique en France*. Paris: Presses Universitaires de France.

Limbour, Georges. 1959. "Aperçus sur la vie d'un Satrape." *Dossiers du Collège de 'Pataphysique* 10–11 (March 30): 15–36.

Locks, Marian. 1990. *"A Conversation with Thomas Chimes."* In *Thomas Chimes: Exhibition May 1–31 1990*, 19–20. Philadelphia: Marian Locks Gallery.

Lopez, Pablo. 2007. *Pataphor and Pataphors*. Available at http://www.pataphor.com (accessed 20 August 2010).

Lot, Fernand. 1934. *Alfred Jarry. Son Œuvre*. Paris: Éditions de la Nouvelle Revue Critique.

Lucretius. 1975. *De rerum natura*. Trans. W. H. Rouse. vol. 2. Cambridge, Mass.: Harvard University Press.

Lucretius. 2007. *On the Nature of Things*. Trans. W. E. Leonard. Forgotten Books. http://www.forgottenbooks.org/info/9781440080296 (accessed 12 December 2011).

Lucretius. 2008. "The Project Gutenberg EBook of *Of the Nature of Things*." *Project Gutenberg*. Ed. William Ellery Leonard. Available at http://www.gutenberg.org/dirs/7/8/785/785.txt (accessed 29 January 2010).

Ludic Society. 2005. *Ludic Society*. Available at http://www.ludic-society.net/ (accessed 15 July 2011).

Lugné-Poe, Aurélien. 1930. *La Parade: Le Sot du Tremplin*. 3 vols. vol. I. Paris: Gallimard.

Lullio, Raimundo. 1305. *Ars Magna*. Madrid: Biblioteca del Monasterio del Escorial.

Lussier, Veronica. 2008. *Veronica Lussier*. Available at http://www.veronicalussier.net/ (accessed 15 July 2011).

McMahan, Alison. 2006. *The Films of Tim Burton: Animating Live Action in Contemporary Hollywood*. New York: Continuum.

McMurray, Line. 1980. *Quatre leçons et deux devoirs de pataphysique*. Montreal: Liber.

Mallarmé, Stéphane. 1868. "Lettre à Henri Cazalis." In *Œuvres Complètes*, trans. Michael Zeleny, 278–279. Paris: Nouvelle Revue Française.

Manguel, Alberto. 2006. *With Borges*. London: Telegram.

Marinetti, Filippo Tommaso. 1972. *Selected Writings*. Ed. R. W. Flint. London: Secker & Warburg.

Marx, Groucho. 1959. *Groucho and Me*. New York: Da Capo Press.

Maschek, J., ed. 1975. *Marcel Duchamp in Perspective*. Englewood Cliffs: Prentice Hall.

Mathews, Harry. 1962. *The Conversions*. New York: Random House.

Mathews, Harry. 1966. *Tlooth*. New York: Doubleday.

Mathews, Harry. 1988. *Singular Pleasures*. New York: The Grenfell Press.

Mathews, Harry. 1989. *The Way Home: Collected Longer Prose by Harry Mathews*. London: Atlas Press.

Mathews, Harry, and Alastair Brotchie. 1998. *Oulipo Compendium*. London: Atlas Press.

Matisse, Pierre, ed. 1980. Notes 4, 9, and 11. In *Marcel Duchamp: Notes*. Paris: Musée National d'Art Moderne, Centre Georges Pompidou.

Mauvoisin, Janvier. 1995 [1956]. "Ingest: Anorexia, Dysorexia, Aplestia." Trans. Antony Melville. *The Printed Head II* (11/12): 10–12.

Melbourne Institute of Pataphysics. 2008. *YouTube—School of Fish*. Available at http://www.youtube.com/watch?v=VrojOnZ8vYk (accessed 14 June 2010).

Merrill, Stuart. 1925. *Prose et Vers, Œuvres posthumes*. Paris: Albert Messein.

Miles, Barry. 1997. *Paul McCartney: Many Years from Now*. New York: Random House.

Mittenberg, Corey. 2007. "Proto-Absurdist Strides and Leanings: Alfred Jarry's Shakespearean Spirit in Ubu Roi." MA Thesis, New York: State University of New York.

Mollet, Jean. 1959. "Message de Sa Magnificence le Baron Jean Mollet Vice-Curateur du Collège de 'Pataphysique, Président par Interim Perpétuel du Conseil Suprême des Grands Maîtres de l'Ordre de la Grande Gidouille, Au Monde Civilisé ou Non." *Dossier* 7 (June 8): 3–6.

Mollet, Jean. 1962. "Jarry Inconnu." In *Collection Haha*. Paris: Collège de 'Pataphysique.

Mollet, Jean. 1995. "Message to the World, Civilized or Not." Trans. Paul Edwards. *The Printed Head III* (10/11): 91.

Mollet, Jean. 2008 [1963]. *Les Mémoires du Baron Mollet*. Paris: Éditions du Promeneur.

Monomaque, Bélisaire. 1958. "Borgès, l'Infamie, l'Éthernité et les Pompiers." *Dossier* (14 July): 61–62.

Moréas, Jean. 1886. "Le Symbolisme." *Le Figaro* (18 September). Available at http://www.berlol.net/chrono/chr1886a.htm (accessed 25 November 2011).

Morgane, Manuela. 1992. *Dieu, grammairien*. Paris: Séquences.

Motte, Warren F. 1986. *Oulipo: A Primer of Potential Literature*. Lincoln, Nebr.: University of Nebraska Press.

Musée-Galerie de la Seita. 1989. *Ubu: Cent ans de règne*. Paris: Musée-Galerie de la Seita.

Musée Patamécanique. 2010. *Musée Patamécanique: notes*. Available at http://www .museepata.org/notes.html (accessed 24 January 2010).

Museum of Jurassic Technology. 2010. *Permanent Collections*. Los Angeles: Museum of Jurassic Technology.

Nash, Matthew. 2006. "La Musée Patamécanique." *Big RED & Shiny* (19 November). Available at http://www.bigredandshiny.com/ (accessed 31 August 2010).

Ngai, Sianne. 2005. *Ugly Feelings*. Cambridge, Mass.: Harvard University Press.

Nicolescu, Basarab, and Jean-Philippe de Tonnac. 2008. *René Daumal ou le perpétuel incandescent*. Paris: Le Bois d'Orion.

O'Brien, Flann. [1964] 1993. *The Dalkey Archive*. London: Flamingo.

O'Brien, Flann. 2007. *The Complete Novels*. New York: Alfred A. Knopf.

O'Doherty, Damian P. 2007. "The Question of Theoretical Excess: Folly and Fall in Theorizing Organization." *Organization* 14 (November): 837–867.

Orledge, Robert. 1998. "Understanding Satie's 'Vexations'." *Music and Letters* 79 (3) (August): 386–395.

Oulipo. 1973. *La Littérature potentielle: créations, re-créations, récréations*. Paris: Gallimard.

Oulipo. 1987 [1974]. *La Bibliothèque oulipienne*. Paris: Ransay.

Oulipo. 1988 [1981]. *Atlas de littérature potentielle*. Paris: Gallimard.

Oulipo. 2002a. *Abrégé de littérature potentielle*. Paris: Mille et une nuits.

Oulipo. 2002b. "Aux origines du langage." *La Bibliothèque oulipienne* 121.

OuLiPo. 2011. *OuLiPo Accueil*. Available at http://www.oulipo.net/ (accessed 15 July 2011).

Paintlust. 2009. *Paintlust*. Available at http://www.paintlust.com (accessed 15 July 2011).

Parshall, Brian. 2007a. "The British Are Coming . . . along just fine, thank you, but they still have quite a way to go." *Pataphysica* 4: 213–285.

Parshall, Brian. 2007b. "Introduction." *Pataphysica* 4: xi–xxix.

Patachromo. 2008. *Patachromo*. Available at http://superbien.fr/patachromo (accessed 15 July 2011).

Patafisic Design Studio. 2009. *patafisic | . . .* Available at http://www.patafisic.it /patafisic/ (accessed 15 July 2011).

Pataphysical Longing Productions. 2006. Available at http://www.pataphysicallong ingproductions.com/ (accessed 15 July 2011).

de Pawlowski, Gaston. 2009 [1912]. *Journey to the Land of the Fourth Dimension.* Trans. Brian Stableford. Encino: Black Coat Press.

Paz, Octavio. 1978. *Marcel Duchamp: Appearance Stripped Bare.* New York: Viking.

Perec, Georges. 1969. *La Disparition.* Paris: Gallimard.

Perec, Georges. 1970. "Le Grand Palindrome." *Change* 6: 217–223.

Perec, Georges. 1972. *Les Revenentes.* Paris: Éditions Julliard.

Perec, Georges. 1978. *La Vie mode d'emploi.* Paris: Hachette.

Perec, Georges. 1981. "Quatre figures pour La Vie mode d'emploi." In Oulipo, *Atlas de littérature potentielle*, 387–393. Paris: Gallimard.

Perec, Georges. 1987 [1978]. *Life: A User's Manual.* Trans. David Bellos. London: Collins Harvill.

Perec, Georges. 1994 [1969]. *A Void.* Trans. Gilbert Adair. London: Harvill.

Perec, Georges. 1996 [1972]. "The Exeter Text: Jewels, Secrets, Sex." In *Three*, trans. Ian Monk. London: Harvill.

Perron, Mireille. 2007. "The Laboratory of Feminist Pataphysics." *The Laboratory of Feminist Pataphysics.* Available at http://www.acad.ab.ca/ (accessed 2 November 2010).

Picabia, Francis. 1924. "Journal d'Instantéiseme." *391* (19).

Prévert, Jacques. 1951. *Sur l'humour.* Paris: La Nef.

Prévert, Jacques. 1990 [1945]. *Paroles.* Trans. Lawrence Ferlinghetti. San Francisco: City Lights.

Puiu, Dana. 2007. *Alfred Jarry—Hermétique et herméneutique de l'impossible.* Simpozionul Catedrei de Limbi Moderne. Baia Mare: Universitatea de Nord.

Queneau, Raymond. 1961. *Cent mille milliards de poèmes.* Paris: Gallimard.

Queneau, Raymond. 1965. *Bâtons, chiffres et lettres.* Paris: Gallimard.

Queneau, Raymond. 1977 [1952]. *Le Dimanche de la vie.* Trans. Barbara Wright. London: New Directions.

Queneau, Raymond. 1978. [1961]. "A Hundred Thousand Billion Poems." Trans. Stanley Chapman. *Prospice* 8:57–66.

Queneau, Raymond. 1979 [1947]. *Exercices de style.* Trans. Barbara Wright. London: John Calder.

Queneau, Raymond [writing as Sally Mara]. 1981 [1947]. *On est toujours trop bon avec les femmes.* Trans. Barbara Wright. London: John Calder.

Queneau, Raymond. 1982 [1959]. *Zazie dans le métro*. Trans. Barbara Wright. London: John Calder.

Queneau, Raymond. 1987 [1944]. *The Skin of Dreams*. Trans. H. J. Kaplan. London: Atlas Press.

Queneau, Raymond. 1998 [1961]. *100,000,000,000,000 Poems*. In Harry Mathews and Alastair Brotchie, *Oulipo Compendium*, trans. Stanley Chapman, 15–33. London: Atlas Press.

Queneau, Raymond. 1999 [1937]. *Odile*. Trans. Carol Saunders. London: Dalkey Archive Press.

Queneau, Raymond, et al. 1995. *Oulipo Laboratory*. Trans. Harry Mathews, Iain White, and Warren F. Motte Jr. London: Atlas Press.

Rabaté, Jean-Michel. 2004–2005. Joyce and Jarry "Joyeux." *Papers on Joyce* 10/11: 187–197.

Rachilde. 1928. *Alfred Jarry, ou le Surmâle de lettres*. Paris: Grasset.

Rachilde. 1957 [1896–1897]. "Jarry vu par Rachilde: d'*Ubu Roi* au Roman d'un Déserteur *Les Jours et les Nuits*." *Cahiers du Collège de 'Pataphysique* 26–27 (May): 57–58.

Rachilde. 1982 [1923]. "L'Homme qui raille dans les cimetières." Paris: Cymbalum Pataphysicum.

Rasula, Jed, and Steve McCaffery. 1998. *Imagining Language: An Anthology*. Cambridge, Mass.: MIT Press.

Redfern, Walter. 2001. *All Puns Intended: The Verbal Creation of Jean-Pierre Brisset*. Oxford: Legenda.

Régibier, Philippe. 1999. *Ubu sur la berge: Alfred Jarry à Corbeil (1898–1907)*. Paris: Collection LPM-actualité.

Renaud, Philippe. 2009. "Marcel Duchamp ou les Mystères de la Porte." Available at http://www.coaltar.net (accessed 28 November 2009).

Renseiw, Sam. 2005. *Space-Two PataLab*. Available at http://patalab02.blogspot.com (accessed 15 July 2011).

Richardson, John. 1996. *A Life of Picasso*. Vol. 1. New York: Random House.

Rosière, Gilles, and Marc Décimo. 2001. *Le Brisset sans peine*. Paris: La Compagnie des Indes Oniriques: Éditions Deleatur.

Roussel, Raymond. 1964 [1932]. "Canto III from *New Impressions of Africa*." Trans. Kenneth Koch. *Art & Literature* 2.

Roussel, Raymond. 1966 [1910]. *Impressions of Africa*. Trans. Rayner Heppenstall. London: John Calder.

Roussel, Raymond. 1977 [1935]. *How I Wrote Certain of My Books*. Trans. Trevor Winkfield. New York: SUNY.

Roussel, Raymond. 1983 [1914]. *Locus Solus: A Novel*. Trans. Rupert Copeland Cunningham. London: John Calder.

Roussel, Raymond. 2004 [1932]. *New Impressions of Africa*. Trans. Ian Monk. London: Atlas Press.

Rowe, Beverley Charles. 2010. "Queneau's Poems." Available at http://www.bevrowe .info/Queneau/QueneauHome_v2.html (accessed 18 October 2010).

Ruby, Harry, Bert Kalmar, and Grover Jones. 1933. "Duck Soup." *The Internet Movie Script Database*. Available at http://www.imsdb.com/scripts/Duck-Soup.html (accessed 2009).

Salvador, Henri, Béatrice Arnac, and Boris Vian. 1959. "Les Cahiers du Collège de 'Pataphysique: Les Grandes Revues Littéraires." *Institut National Audiovisuel*. 05 25. Available at http://www.ina.fr/ (accessed 1 October 2010).

Sandomir, Irénée-Louis. 1949a. *Harangue Inaugurale*. Paris: Collège de 'Pataphysique.

Sandomir, Irénée-Louis. 1949b. *Statuts du Collège de 'Pataphysique*. Paris: Collège de 'Pataphysique.

Sandomir, Irénée-Louis. 1959 [1956]. *Testament*. Paris: Collège de 'Pataphysique.

Sandomir, Irénée-Louis. 1960a [1949]. "Inaugural Harangue." Trans. Roger Shattuck. *Evergreen Review* 4 (13):169–173.

Sandomir, Irénée-Louis. 1960b [1959]. "Extract from the *Testament* of Dr. I. L. Sandomir." Trans. Roger Shattuck. *Evergreen Review* 4 (13):178–180.

Sandomir, Irénée-Louis. 1993 [1965]. *The Apostrophe in Pataphysics*. In *The True, The Good, The Beautiful: An Elementary Chrestomathy of 'Pataphysics*, trans. Antony Melville. Vol. II 11/12, 87. London: The Printed Head.

Sandomir, Irénée-Louis. 1995 [1949]. "Statutes." In *A True History of the College of 'Pataphysics*. Ed. Alastair Brotchie. Trans. Paul Edwards. *The Printed Head III* (10/11): 39–44. London: Atlas Press.

Sanouillet, Michel. 1973. "Marcel Duchamp and the French Intellectual Tradition." In Anne d'Harnoncourt and Kynaston McShine, eds., *Marcel Duchamp*, 47–55. New York: Museum of Modern Art.

Sanouillet, Michel. 2009 [1965]. *Dada in Paris*. Trans. Sharmila Ganguly. Cambridge, Mass.: MIT Press.

Sarlo, Beatriz. 1993. *Jorge Luis Borges: A Writer on the Edge*. New York: Verso.

Sartre, Jean-Paul. 1943. *L'Être et le néant*. Paris: Gallimard.

Sartre, Jean-Paul. 1952. "Réponse à Albert Camus" *Les Temps modernes* 82 (August): 345.

Satie, Erik. 1979. *Écrits*. Ed. Ornella Volta. Paris: Champ Libre.

Satie, Erik. 1980 [1914]. "Theatricalities." In *The Writings of Erik Satie*, ed. and trans. Nigel Wilkins, 61–62. London: Eulenberg.

Satie, Erik. 1996 [1921–1924]. *A Mammal's Notebook*. Ed. Ornella Volta. Trans. Antony Melville. London: Atlas Press.

Schumacher, Claude. 1984. *Alfred Jarry and Guillaume Apollinaire*. London: Macmillan.

Schwarz, Arturo. 1969. *The Complete Works of Marcel Duchamp*. London: Thames and Hudson.

Sciascia, Leonardo. 1987 [1971]. "Acts Relative to the Death of Raymond Roussel." In *Raymond Roussel*, Atlas Anthology 4: 124–146. Trans. Alec Gordon. London: Atlas Press.

Semiophagy: A Journal of Pataphysics and Existential Semiotics. 2008. Ed. Christopher M. Drohan. Available at http://www.semiophagy.com/ (accessed 9 June 2010).

Senninger, Serge. 1964. "Tocsin." *Subsidia Pataphysica* 0 (10 August): 3–6.

Shattuck, Roger. 1955. "Translation, Traduction, Transposition, Anglifications de Jarry." *Cahiers du Collège de 'Pataphysique* 20 (June 29): 37–43.

Shattuck, Roger. 1960a. "What Is 'Pataphysics?" *Evergreen Review* 4 (13): 3–192.

Shattuck, Roger. 1960b. Superliminal Note. *Evergreen Review* 4 (13):24–33.

Shattuck, Roger. 1968 [1958]. *The Banquet Years: The Origins of the Avant-Garde in France, 1885 to World War I*. New York: Random House.

Shattuck, Roger. 1974. "Marcel Duchamp, Alfred Jarry, and Pataphysics." *Marcel Duchamp Lecture Series. Museum of Modern Art Achives* 7: 21.

Shattuck, Roger. 2003. *The Innocent Eye: On Modern Literature and the Arts*. Boston: MFA Publications.

Shlain, Leonard. 1991. *Art & Physics*. New York: William Morrow.

Sigoda, Pascal. 2008. "René Daumal, patacesseur." In Thieri Foulc et al., *Le Cercle des pataphysiciens*, 47–52. Paris: Mille et une nuits.

Simon, Yves. 1981. "Jarry et l'Angleterre: Monsieur Dieu, Shakespeare et Moi." *Europe* (March-April): 183–197.

Situationist International Online. 2003. *Situationist International Online*. Available at http://www.cddc.vt.edu/sionline/index.html (accessed 28 August 2010).

Smith, Brian Reffin. 2006. *Zombie 'Pataphysics*. Available at http://zombiepataphys ics.blogspot.com (accessed 15 July 2011).

Stas, André. 2008. "Fernando Arrabal, Satrape." In Thieri Foulc et al., *Le Cercle des pataphysiciens*, 101–103. Paris: Mille et une nuits.

Stillman, Linda Klieger. 1974. "Physics and Pataphysics: The sources of Faustroll." *Kentucky Romance Quarterly* (October): 81–92.

Stillman, Linda Klieger. 1983. *Alfred Jarry*. Boston: Twayne.

Stillman, Linda Klieger. 1985. "Le Vivant et l'artificiel: Jarry, Villiers de L'Isle-Adam, Robida." *L'Étoile-Absinthe* 25–28 (May): 107–116.

Stillman, Linda Klieger. 1994. "Alfred Jarry." In David Baguley, ed., *A Critical Bibliography of French Literature*, 5: 1202–1222. New York: Syracuse University Press.

Stockhammer, Morris, ed. 1972. *Kant Dictionary*. New York: Philosophical Library.

Sturrock, John. 1977. *Paper Tigers: The Ideal Fictions of Jorge Luis Borges*. Oxford: Oxford University Press.

Svitek, Darko. 2006. *Ill.Posed Software*. Available at http://www.illposed.com/philos ophy/pataprogramming.html (accessed 9 June 2010).

Swans Commentary. 2001. "Le Déserteur." *Swans Commentary*. Available at http://www.swans.com/library/art7/xxx071.html (accessed 1 May 2010).

Sweeney, James Johnson. 1946. Interview with Marcel Duchamp. *Bulletin of the Museum of Modern Art* 8 (4–5).

Taylor, Michael. 2007a. "Painting and 'Pataphysics from Max Ernst to Thomas Chimes." *Philadelphia Museum of Art: Lectures*. Philadelphia: Philadelphia Museum of Art.

Taylor, Michael. 2007b. *Thomas Chimes: Adventures in 'Pataphysics*. Philadelphia: Philadelphia Museum of Art.

Teh, David. 2006. "Baudrillard, Pataphysician." *International Journal of Baudrillard Studies*. (January). Available at http://www.ubishops.ca/baudrillardstudies/vol3_1 /teh.htm (accessed 24 November 2011).

Terrasse, Claude. 1893. "La Chanson du décervelage." *Répertoire des Pantins*. vol. 4. Paris: Éditions du Mercure de France.

TheatreHistory.com. 2006. "The Bald Soprano." *Theatre History*. Available at http:// www.theatrehistory.com/misc/bald_soprano.html (accessed 11 November 2010).

The Beatles. 1969. "Maxwell's Silver Hammer." *Abbey Road*. Apple Records.

The Last Tuesday Society. 2010. *History*. Available at http://www.thelasttuesdaysoci ety.org/ (accessed 17 January 2010).

Thirkell, P. 2005. *From the Green Box to Typo/Typography: Duchamp and Hamilton's Dialogue in Print.* London: Tate Papers.

Thomson, William (Lord Kelvin). 1884. "On the Wave Theory of Light." Lecture. Philadelphia: Franklin Institute.

Thomson, William (Lord Kelvin). 1889 [1883]. "Lecture on Electrical Units of Measurement." In *Popular Lectures and Addresses*, vol. 1. London: Macmillan.

Thomson, William (Lord Kelvin). 1893. *Conférences scientifiques et allocutions.* Paris: Gauthier-Villars et Fils.

Tokui, Nao, et al. 2007. *Project Phonethica.* Available at http://www.phonethica.net (accessed 17 January 2010).

Tomkins, Calvin. 1998. *Duchamp: A Biography.* New York: Henry Holt & Co.

Torma, Julien. 2002. *Écrits définitivement incomplets.* Paris: Collège de 'Pataphysique.

tout-fait.com. 1999. *tout-fait: The Marcel Duchamp Studies Online Journal.* Available at http://www.toutfait.com/ (accessed 13 July 2011).

Turek, Frank. 2004. *Ubu Studio.* Available at http://www.ubustudio.com/ (accessed 15 July 2011).

Tzara, Tristan. 1977. *Seven Dada Manifestos and Lampisteries.* Trans. Barbara Wright. London: John Calder.

Ubuland. 2008. *ubuland.* Available at http://digilander.libero.it/ubuland/index.html (accessed 29 August 2010).

UbuWeb. 1996. *UbuWeb.* November 1996. Available at http://www.ubuweb.com/ (accessed 14 June 2010).

Vaché, Jacques. 1993. *War Letters.* III, 1. London: Atlas Press: The Printed Head.

Vestrogotiska Patafysica Institutet. 2005. "Patafysik." *Vestrogotiska Patafysica Institutet TALAR* 20–21.

Vian, Boris. 1950. *L'Herbe Rouge.* Paris: Toutain.

Vian, Boris. 1988a [1946]. *L'Écume des jours.* (Froth on the Daydream). Trans. Stanley Chapman. London: Quartet Encounters.

Vian, Boris. 1988b. *Round about Close to Midnight: The Jazz Writings of Boris Vian.* Trans. Mike Zwerin. London: Quartet.

Vian, Boris. 2006 [1953]. *L'Arrache-cœur.* (Heartsnatcher.) Trans. Stanley Chapman. Champaign, IL: Dalkey Archive Press.

Vollard, Ambroise. 2007 [1937]. *Souvenirs d'un marchand de tableaux.* Paris: Albin Michel.

Wall, Mick. 1999. "The Egos Have Landed." *Mojo* (September).

Wallis, Clarrie. 2011. "The Business Is in the Making." In *Barry Flanagan: Early Works 1965–1982*. London: Tate Britain.

Weiss, Beno. 1993. *Understanding Italo Calvino*. Columbia, South Carolina: University of South Carolina Press.

Wells, H. G. 2008 [1895]. *The Time Machine: A Melancholy Satire*. Rockville, MD: Phoenix Pick.

Wershler-Henry, Darren. 1994. "Canadian 'Pataphysics: Geognostic Interrogations of a Distant Somewhere." In Jordan Zinovich, ed., *Canadas*, 66–78. New York: Semiotext(e) / Peterborough: Marginal Editions.

Weschler, Lawrence. 1995. *Mr. Wilson's Cabinet of Wonder*. New York: Random House.

White, Edmund. 1994. *Genet: A Biography*. New York: Vintage Books.

Wilson, Robert Anton, et al. 2005. *Only Maybe*. Available at http://maybelogic.blogspot.com/ (accessed 24 July 2011).

Wright, Barbara. 2001. "Reading Raymond Queneau." *Dalkey Archive Press: Context* 9 (Fall). Available at http://www.dalkeyarchive.com/ (accessed 18 October 2010).

Wynd, Viktor. 2010. *Hackney's Leading Curiosity Shop*. Available at http://viktor wyndofhackney.co.uk/ (accessed 14 January 2010).

d'Y, Sylvain. 1995. "What Is the College of 'Pataphysics?" Trans. Paul Edwards. *The Printed Head III* (10/11): 101–104.

Yeats, William Butler. 1955. *The Autobiographies of W. B. Yeats*. London: Macmillan.

Zeleny, Michael. 2005. "no ptyx." *larvatus prodeo*. Available at http://larvatus.live journal.com/17988.html (accessed 17 November 2010).

Žižek, Slavoj. 2006. *The Pervert's Guide to Cinema*. Available at http://www.theper vertsguide.com (accessed 25 November 2010).

INDEX

--

Entries in **bold** indicate substantial discussions.
To use this index pataphysically, simply refer to any other book of
equivalent length.